EUROPEAN ILLUSTRATION 1980/81

EUROPEAN
ILLUSTRATION

1 9 8 0 - 8 1

Edited by/Edité par/Herausgegeben von
Edward Booth-Clibborn

The seventh annual of European editorial, book, poster,
advertising, unpublished work, film animation and
design art.

Septième annuaire européen d'illustration de presse,
du livre, de l'affiche, de publicité, d'oeuvres non
publiées, du film d'animation et du design.

Der siebente Band des Jahrbuches
'European Illustration' über die Illustration auf
redaktionellem Gebiet, im Buch, auf Plakat und Poster,
in der Werbung, in unveröffentlichten Arbeiten,
im Trickfilm und in der Gebrauchsgraphik.

EUROPEAN ILLUSTRATION
12 Carlton House Terrace, London SW1Y 5AH

Book designed by/Maquettiste du livre Buch gestaltet von Nick Thirkell, Ashted Dastor.

The exhibition of original artwork in this book will be shown in: L'Exposition d'oeuvres d'art de ce livre aura lieu à: Die Originalarbeiten werden ausgestellt in: London and Paris–1980, Amsterdam–1981.

If you are a photographer working in Europe, why not submit your work to European Photography 81? Write for details to European Photography, 12 Carlton House Terrace, London SW1Y 5AH.

Si vous êtes photographe et travaillez en Europe, pourquoi ne pas soumettre votre travail à European Photography 81? Pour plus de details, écrivez à European Photography, 12 Carlton House Terrace, London SW1Y 5AH.

Wenn Sie als Photograph in Europa tätig sind, dann legen Sie doch Ihre Arbeit der European 81 vor. Zwecks Einzelheiten schreiben Sie bitte an European Photography, 12 Carlton House Terrace, London SW1Y 5AH.

The following companies hold the exclusive distribution rights for European Illustration 80/81:

France: Editions Gallimard, Paris. Germany, Switzerland, Austria, Liechtenstein: Otto Maier Verlag, Ravensburg. Japan: Kodansha Ltd., Tokyo. Italy: Libreria Salto, Milan. Brazil: Paulo Gorodetchi & Cia Ltda, Sao Paulo. Spain: Commercial Atheneum, Barcelona. USA/Canada: Harry N Abrams Inc, New York. UK and the rest of the world: D&AD/European Illustration, 12 Carlton House Terrace, London SW1Y 5AH. Tel: 01-839 2464.

Printed in Japan by Dai Nippon. Paper: 128 GSM matt coated. Typeface: Goudy Old Style, Goudy Catalogue, Goudy Extra Bold. Filmset by Filmcomposition, London.

Published by Polygon Editions S.A.R.L., Basel Copyright © 1980

CONTENTS

When you look through this, the seventh edition of European Illustration, you'll see how some of the most accomplished European illustrators approached the business of visual communications in the mass media.

You'll notice, too, that much of the best work has originated from sources hardly represented before in the Annual: in particular, many fine examples of work by Austrian artists and illustrators have been entered this year. It's heartening to see not only the prolific amount of creative work coming from this country, but also the practical encouragement of their art by German art directors and designers.

A number of exhibits were also entered from Russia, Poland, Czechoslovakia and Rumania. While few were chosen by Juries, it is good to have work coming in from these countries, and it's to be hoped that they will enter more material next year.

You will also see – perhaps with disappointment – that some of the artists and illustrators who've been represented in previous editions of European Illustration have produced work which, despite its undoubted merit, shows relatively little progression from the work they've done in the past.

And you'll see that, of all the paintings and drawings selected by the Jury, only one illustration for advertising purposes was accepted.

This last point may strike some people as not only paradoxical, but controversial. After all, two of this year's Jury are practising Art Directors working in well-known advertising agencies. Surely they would have found something of merit within the thousands of items submitted for selection? The fact that they didn't is not so much a reflection on the standard of illustrative work being commissioned by advertising agencies, but more a mark of the very high standards set by the Jury. It also bears out the approach taken by all the European Illustration Juries. What they each look for is excellence in execution allied to imaginative thinking: an original concept backed by technique.

In general then, this edition of European Illustration represents only the peak of a mountain of work sifted through, assessed and judged by the Jury. Though much of what we saw was mediocre, we did see some fine examples of work.

We saw, too, as I've already said, some stagnation in the work of the better-known illustrators. Perhaps it's the case that, like many other creative and interpretive artists, successful illustrators get into a rut. The acceptance of what was once an avant garde approach dulls the edge of their adventurous spirit. If so, then success – for an illustrator – may spell disaster. I know it takes great courage to move forward into new ways of thinking. But for those illustrators who have that courage, the rewards are enormous. The satisfaction to be derived from stretching one's talent to the utmost is exhilarating, and the new horizons it may reveal can be limitless. Indeed, it is these illustrators – some of whose work is in this book – who will be represented when the first-ever major exhibition of illustration opens at the Musée des Arts Décoratifs in Paris in 1983, to mark the tenth anniversary of European Illustration.

Quand vous parcourrez cette septième édition de European Illustration vous pourrez voir comment certains des illustrateurs européens les plus accomplis ont abordé la question des communications visuelles des moyens d'information du grand public.

Vous remarquerez, aussi, qu'une grande partie du meilleur travail provient de sources à peine représentées auparavant dans l'Annuaire: en particulier, de nombreux exemples de travail de qualité par des artistes et illustrateurs autrichiens ont été présentés cette année. Il est encourageant de voir non seulement l'étendue du travail créateur provenant de ce pays, mais aussi l'aide stimulante qui leur est accordée dans leur art par les Directeurs Artistiques et les Décorateurs allemands.

Nombre de pièces venant de Russie, de Pologne, de Tchécoslovaquie et de Roumanie ont été soumises. Bien que les Jurys n'en aient retenu que quelques unes, il est bon de recevoir du travail provenant de ces pays, et il faut espérer qu'ils présenteront davantage de pièces l'année prochaine.

Vous constaterez également – et peut-être serez-vous déçus – que certains artistes et illustrateurs qui étaient présents dans de précédentes éditions de European Illustration ont produit du travail qui, malgré son mérite incontestable, montre relativement peu de progression sur les années passées.

Et vous verrez que, de toutes les peintures et tous les dessins sélectionnés par le Jury, un seul pour des fins publicitaires a été accepté.

Ce dernier point pourra sembler à certaines personnes non seulement paradoxal mais sujet à controverse. Après tout, deux des membres du Jury de cette année sont directeurs artistiques actifs et travaillent pour des agences de publicité bien connues. Sans doute auraient-ils pu trouver quelque chose de valeur parmi les milliers de pièces soumises à la sélection? Qu'ils n'aient rien retenu n'est pas tant une atteinte à la qualité du travail d'illustration commandé en ce moment par les agences de publicité que la preuve du très haut niveau exigé par le Jury. Cela confirme la position prise par tous les Jurys de European Illustration. Ce qu'ils recherchent c'est l'excellence dans l'exécution accompagnée d'une pensée imaginative: un concept original renforcé par une bonne technique.

En général, donc, cette édition de European Illustration ne présente que le sommet d'une montagne de travaux passés au tamis, évalués et jugés par le Jury. Malgré la médiocrité de beaucoup de ce que nous avons vu, nous avons découvert de beaux exemples de travail venant en particulier d'Autriche.

Nous avons constaté, également, comme je l'ai déjà dit, une certaine inertie dans le travail des illustrateurs les plus connus. Peut-être est-il vrai, comme pour beaucoup d'autres artistes créateurs et interprétatifs, que le succès endort l'imagination des illustrateurs. La vulgarisation de ce qui était auparavant un abord d'avant-garde émousse leur esprit d'aventure. S'il en est ainsi, peut-être le succès– pour un illustrateur–précipite-t-il au désastre. Je sais qu'il faut beaucoup de courage pour faire évoluer ses façons de penser. Mais pour ceux des illustrateurs

Wenn Sie durch diese siebte Auflage der European Illustration blättern, dann bekommen Sie einen Eindruck, wie einige der führenden europäischen Illustratoren die visuelle Kommunikation auffassen.

Sie werden darüberhinaus feststellen, daß ein Großteil der herausragendsten Arbeiten aus Quellen stammen, die vorher kaum in diesem Jahrbuch vertreten waren. Es wurden in diesem Jahr viele ausgezeichnete Arbeiten vor allem von österreichischen Künstlern und Illustratoren vorgelegt. Es ist ermutigend, nicht nur die quantitativ fruchtbaren kreativen Arbeiten aus diesem Land, sondern auch die praktische Unterstützung ihrer Kunst durch deutsche Art Direktoren und Designer zu sehen.

Auch aus Rußland, Polen, der Tschechoslowakei und Rumänien kamen eine Reihe von Einsendungen. Obwohl nur wenige von der Jury ausgewählt wurden, so ist es doch positiv, daß wir Arbeiten aus diesen Ländern bekommen, und wir hoffen, daß im nächsten Jahr noch mehr Material eingesandt wird.

Und vielleicht werden Sie nicht ganz ohne Enttäuschung feststellen, daß einige Künstler und Illustratoren, die bereits in früheren Auflagen der European Illustration vertreten waren, Arbeiten vorgelegt haben, die trotz ihrer unbestrittenen Qualität verhältnismäßig wenig Fortschritte gegenüber vergangenen Leistungen erkennen lassen.

Auch werden Sie sehen, daß von allen von der Jury ausgewählten Gemälden und Zeichnungen nur eine Arbeit zu Werbezwecken in Auftrag gegeben wurde.

Dieser letzte Punkt mag einigen Leuten nicht nur paradox, sondern auch widersprüchlich vorkommen. Schließlich handelt es sich bei zwei der diesjährigen Jury-Mitglieder um aktive Art Direktoren, die bei bekannten Werbeagenturen tätig sind. Gewiß doch hätten sie unter den tausenden zur Auswahl eingesandten Arbeiten etwas Brauchbares finden können? Die Tatsache, daß dies nicht der Fall war, ist nicht so sehr ein qualitatives Spiegelbild der Illustrationsarbeiten, die von den Werbeagenturen in Auftrag gegeben worden, als vielmehr ein Hinweis auf das außerordentlich hohe Niveau, das von der Jury gesetzt worden ist. Sie unterstreicht ebenfalls die von allen Jurys der European Illustration vertretene Einstellung. Jede dieser Jurys sucht nach hohen Leistungen in der Ausführung in Verbindung mit Einfallsreichtum: Eine schöpferische Idee, technisch vollendet.

Ganz allgemein also stellt diese Ausgabe der European Illustration die Spitze des Eisbergs aus gesichteten und beurteilten Arbeiten dar. Obwohl ein Großteil davon nur mittelmäßig war, bekamen wir doch eine Reihe sehr gefälliger Arbeiten zu Gesicht.

Wie ich bereits eingangs erwähnte, stellten wir auch eine gewisse Stagnation in den Werken von bekannteren Illustratoren fest. Vielleicht ist es bei erfolgreichen Illustratoren nicht anders als bei vielen anderen kreativen und interpretativen Künstlern so, daß sie in einen gewissen Trott verfallen. Daß heute akzeptiert wird, was einst als avantgardistischer Versuch galt, läßt ihren Abenteuergeist abstumpfen. Wenn dies stimmt, dann könnte Erfolg – für einen Illustrator – eine Katastrophe bedeuten. Ich bin mir

Between now and then, European Illustration will have gone into three more editions. And, between now and then, I hope to have seen more work from more illustrators whether it comes from students, from regularly employed illustrators or from painters who take only occasional commissions. Then we can be sure that each successive edition of European Illustration presents the best of the work being done and maintains its position as one of the finest galleries in the world for the art of the illustrator.

qui ont ce courage, les récompenses sont énormes. La satisfaction que l'on ressent à pousser son talent à l'extrême, et les nouveaux horizons ainsi révélés, sont sans limite. En effet, ce sont ces illustrateurs-là, dont une partie du travail est dans ce livre, qui seront représentés lors de l'inauguration de la toute première grande exposition d'illustration au Musée des Arts Décoratifs à Paris en 1983, pour marquer le dixième anniversaire de European Illustration.

D'ici là, European Illustration aura connu trois nouvelles éditions. Pendant ce temps, j'espère avoir eu à examiner les oeuvres de nombreux illustrateurs, qu'elles proviennent d'étudiants, de professionnels ou de peintres qui ne travaillent qu'occasionnellement sur commande. Alors nous serons sûrs que chaque édition successive de European Illustration présentera le meilleur de tout ce qui se fait dans ce domaine et gardera sa situation comme une des plus belles galeries du monde pour l'art de l'illustrateur.

des Mutes bewußt, den ein Vorstoß in neue Denkrichtungen erfordert. Doch der Lohn ist immens für jene Illustratoren, die diesen Mut besitzen. Die Befriedigung, die sich daraus ergibt, sein eigenes Talent bis an die Grenzen des Möglichen zu dehnen, ist äußerst anregend, und die neuen Horizonte, die sich da auftun, können grenzenlos sein. Gerade diese Illustratoren – von einigen finden Sie Werke in diesem Buch – werden vertreten sein, wenn die erste große Ausstellung der Illustrationen überhaupt im Jahre 1983 im Pariser Musée des Arts Decoratifs anläßlich des zehn jährigen Bestehens von European Illustration ihre Pforten öffnet.

Bis dahin wird European Illustration in drei weiteren Ausgaben erschienen sein. Und bis dahin, so hoffe ich, werde ich mehr Arbeiten von noch mehr Illustratoren – ob von Studenten, festangestellten Illustratoren oder nur gelegentlich Auftragsarbeiten akzeptierenden Malern – zu Gesicht bekommen. Dann können wir sicher sein, daß jede einzelne Ausgabe der European Illustration die besten unter den hergestellten Arbeiten enthält und seine Stellung als eine der herausragenden Galerien in der Welt der Illustrationkunst bewahren wird.

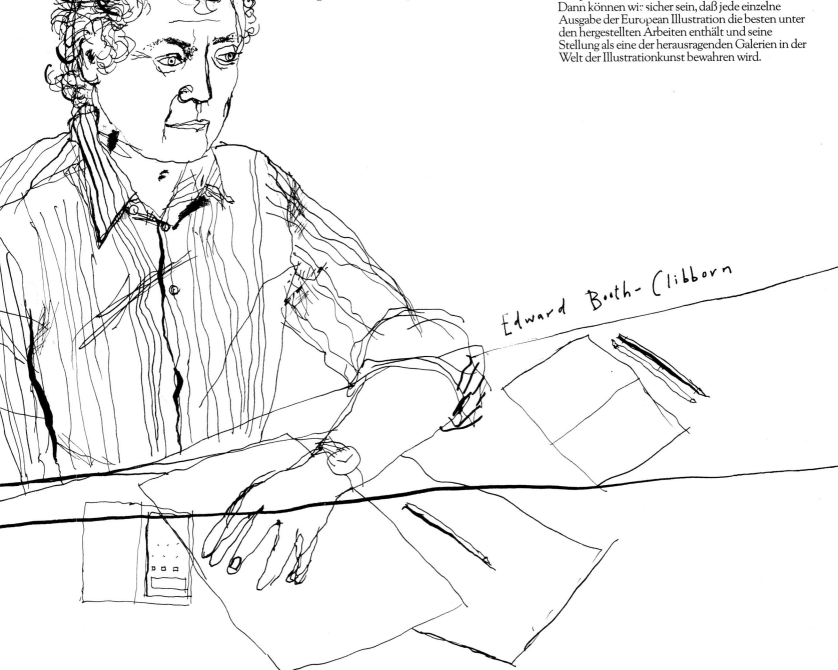

Edward Booth-Clibborn

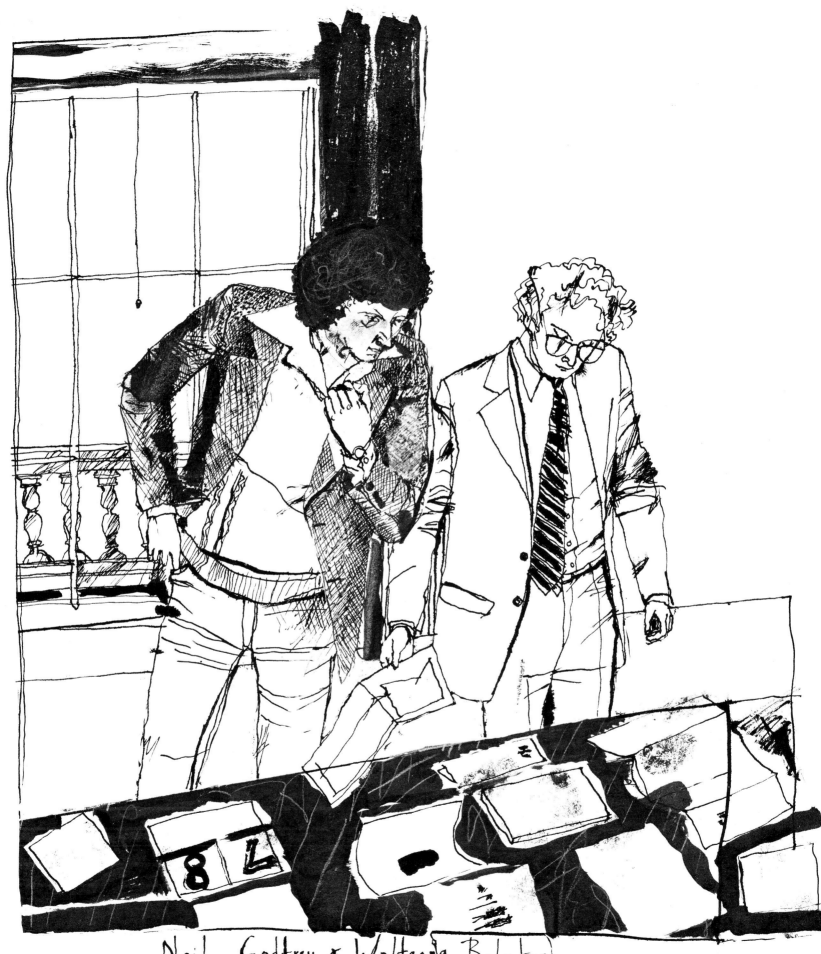

Neil Godfrey & Wolfgang Behnken

JURY

WOLFGANG BEHNKEN
Art Director, Stern Magazine, Hamburg

Wolfgang Behnken studied visual communications at the Wuppertal College of Applied Art, during which time he won an award for his film about children's education. After leaving college, he worked for an advertising agency on the Social Democrats' General Election campaign. He then moved to Stern Magazine, where he still works as Art Director and illustrator.

NEIL GODFREY
Art Director, Collett Dickenson Pearce & Partners, London

Neil Godfrey studied illustration at Sheffield College of Art from 1953 to 1956, and graphic design at the Royal College of Art from 1958 to 1961. Since 1961 he has worked as Art Director for Doyle Dane Bernbach Ltd, New York and London, and as Creative Director at Wells Rich Greene and at Collett Dickenson Pearce & Partners. His work has won a number of international awards.

WOLFGANG BEHNKEN
Directeur Artistique, Stern Magazine, Hamburg

Wolfgang Behnken a étudié les communications visuelles à l'Institut d'Art Appliqué de Wuppertal, et pendant son séjour il y a gagné un prix pour son film sur l'éducation des enfants. Après avoir quitté l'Institut et après avoir travaillé dans une agence de publicité pour la campagne électorale des Socio-Démocrates, il est venu à Stern, ou il travaille encore comme Directeur Artistique et Illustrateur.

NEIL GODFREY
Directeur Artistique, Collett Dickenson Pearce & Partners, London

Neil Godfrey a étudié l'illustration au Sheffield College of Art de 1953 à 1956, et le design graphique au Royal College of Art de 1958 à 1961. Depuis 1961 il a travaillé comme Directeur Artistique pour Doyle Dane Bernbach Ltd, à New York et Londres, et comme Directeur de Création chez Wells Rich Greene et chez Collett Dickenson Pearce & Partners. Son travail lui a valu nombre de prix internationaux.

WOLFGANG BEHNKEN
Art Direktor, Stern Magazin, Hamburg

Wolfgang Behnken studierte visuelle Kommunikation am Wuppertaler Institut für angewandte Kunst. In seiner Studienzeit gewann er eine Auszeichnung für seinen Film über Kindererziehung. Nach seiner Mitarbeit bei einer Werbeagentur für den Wahlkampf der Sozialdemokratischen Partei verliess er das Institut und ging zum Stern Magazin, wo er auch heute als Art Direktor und Illustrator tätig ist.

NEIL GODFREY
Art Direktor, Collett Dickenson Pearce & Partners, London

Von 1953 bis 1956 studierte Neil Godfrey Illustration am Sheffield College of Art, und graphische Kunst am Londoner Royal College of Art von 1958 bis 1961. Seit 1961 war er für Doyle Dane Bernbach Ltd in New York und London als Art Direktor tätig später wurde er Kreativ Direktor bei Wells Rich Greene und Collett Dickenson Pearce & Partners. Mehrere seiner Arbeiten erhielten internationale Auszeichnungen.

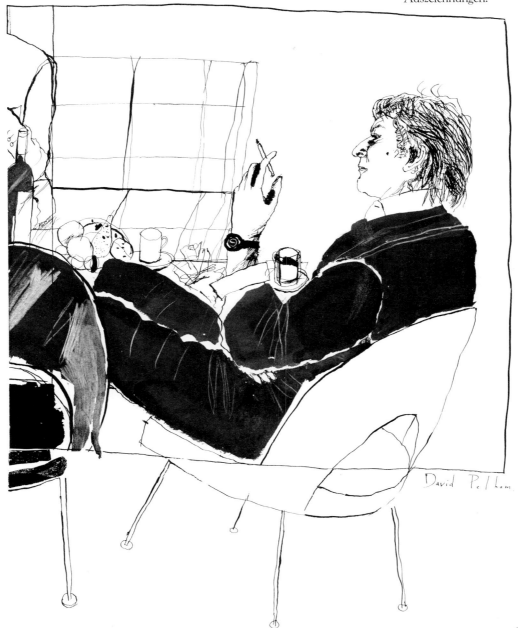

Daniel Malissen · Pierre Marchand

DANIEL MALISSEN
Creative Director, Taurus, Paris

Daniel Malissen studied art at College Estienne, Paris between 1955 and 1959. Thereafter he spent a year working as Designer for Galeries Lafayette and then became Junior Art Director and illustrator for the Jardin des Modes group of shops. During his career he has held various posts: Art Director at Technico agency; Art Director at Collett Dickenson Pearce, Paris; Creative Director at Havas Conseil; Associate Director and Creative Director at HMMS agency. From 1978 to 1980 he was Associate Director and Creative Director at Taurus agency in Paris and worked on such accounts as Loïs Jeans; Havas Voyages; Dames de France; Balency.

Since 1980 he has been working on creative projects and as an illustrator on a freelance basis.

DANIEL MALISSEN
Directeur de Création, Taurus, Paris

Daniel Malissen a été étudiant au Collège Estienne, à Paris entre 1955 et 1959. Ensuite il a passé un an comme Décorateur pour les Galeries Lafayette puis il a été Directeur Artistique associé et illustrateur pour le groupe de magasins du Jardin des Modes. Au long de sa carrière il a tenu divers postes: Directeur Artistique à l'agence Technico; Directeur Artistique chez Collett Dickenson Pearce à Paris; Directeur de Création chez Havas Conseil; Directeur Adjoint et Directeur de Création à l'agence HMMS. De 1978 à 1980 il a été Directeur Adjoint et Directeur de Création à l'agence Taurus à Paris et a travaillé en particulier pour Loïs Jeans; Havas Voyages; Dames de France; Balency.

Depuis 1980 il travaille sur des projects de création et comme illustrateur pour son propre compte.

PIERRE MARCHAND
Directeur du Département de Livres d'Enfants, Editions Gallimard, Paris

Pierre Marchand a commencé sa carrière comme apprenti chez un imprimeur. Pendant son Service Militaire, il a gagné assez d'argent comme illustrateur et caricaturiste pour pouvoir offrir à boire à ses amis. Il a ensuite travaillé dans la publicité jusqu'en 1962 date à laquelle il est entré chez l'éditeur parisien Fleurus comme Adjoint de Design; lorsqu'il quitta, quelques années plus tard, il était devenu Directeur Artistique. Avant d'entrer chez Gallimard, il a lancé le magazine nautique Voiles et Voiliers avec Jean-Olivier Héron et d'autres amis de voile; et c'est grâce à lui que Gallimard est devenu un éditeur spécialisé dans les sports nautiques avec Voiles Gallimard.

Encore en collaboration avec Jean-Olivier Héron, Pierre Marchand a créé le département de livres d'enfants des Editions Gallimard en 1973. Le département est devenu l'un des principaux éditeurs de livres d'enfants en France, et sa place dans le monde de l'édition française peut se mesure par son emprise sur l'illustration graphique.

DANIEL MALISSEN
Kreativ Direktor, Taurus, Paris

Daniel Malissen studierte von 1955 bis 1959 Kunst am Collège Estienne in Paris. Anschliessend arbeitete er ein Jahr lang als Designer für die Galeries Lafayette und wurde dann zweiter Art Direktor und Illustrator für die Ladenkette Jardin des Modes. Seine Laufbahn umfasst eine ganze Reihe von Stellungen: Art Direktor bei der Technico Agentur, Art Direktor bei Collett Dickenson Pearce in Paris, Kreativ Direktor bei Havas Conseil, Co-Direktor und Kreativ Direktor der HMMS Agentur. Von 1978 bis 1980 war er Co-Direktor und Kreativ Direktor bei der Agentur Taurus in Paris, wo er u.a. für die Budgets für Loïs Jeans, Havas Voyages, Dames de France und Balency zuständig war.

Seit 1980 befasst er sich mit Kreativ-Projekten und arbeitet als freiberuflicher Illustrator.

PIERRE MARCHAND
Direktor, Abteilung Kinderbücher, Editions Gallimard, Paris

Pierre Marchand begann seine Karriere als Druckerlehrling. Während seiner Militärdienstzeit verdiente er als Illustrator und Cartoon-Zeichner genug, um seine Freunde auf ein Glas einzuladen. Anschliessend arbeitete er in der Werbung, bis er 1962 Design-Assistant beim Pariser Verlagshaus Fleurus wurde. Als er einige Jahre später den Verlag verliess, war er Art Direktor. Bevor er zu Gallimard ging, rief er gemeinsam mit Jean-Olivier Héron und anderen Segelfreunden das Wassersport-Magazin "Voiles et Voiliers" ins Leben. Ihm verdankt es Gallimard, dass der Verlag auch mit "Voiles Gallimard" im Wassersportbereich tätig wurde.

Wiederum gemeinsam mit Jean-Olivier Héron gründete Pierre Marchand 1973 die Abteilung Kinderbücher der Editions Gallimard. Diese Abteilung ist inzwischen zu einem der grössten Kinderbuchverlage Frankreichs geworden und sein Rang auf der französischen Verlagsszene lässt sich an dem Einfluss messen, den sie auf das graphische Gestaltungswesen gehabt hat.

PIERRE MARCHAND
Director of the Children's Book Department,
Editions Gallimard, Paris

Pierre Marchand began his career as a printer's
apprentice. During his National Service he earned
enough as an illustrator and cartoonist to buy drinks
for his friends. He has worked in advertising until
1962, when he joined the Paris publisher Fleurus as
Design Assistant; by the time he left, a few years later,
he was Art Director. Before joining Gallimard, he
launched the nautical magazine Voiles et Voiliers
with Jean-Olivier Héron and other sailing friends;
and it is thanks to him that Gallimard has become a
nautical publisher, with Voiles Gallimard.

Again in partnership with Jean-Olivier Héron, Pierre
Marchand set up the children's book department of
Editions Gallimard in 1973. The department has
now become one of the major children's book
publishers in France, and its place in the French
publishing scene can be measured by the impact it
has had on graphic design.

DAVID PELHAM
Art Director, Penguin Books, London

David Pelham has won a number of major awards
for design and his work is represented in museums in
Europe and the USA. Formerly Art Director at
Studio International and Harpers Bazaar, and for
twelve years Art Director at Penguin Books, he now
has his own Design Consultancy. He is the author of
The Penguin Book of Kites, published in 1976.
David Pelham is a member of the D&AD Executive
Committee.

ROBERT PRIEST
Art Director, Esquire, New York

Robert Priest is Art Director of Esquire Magazine,
New York. He was previously Art Director of
Weekend Magazine in Toronto, of Radio Times in
London, and of other periodicals. His work has won
major awards in New York, London and Toronto. A
member of several design and illustration juries in
Europe and North America, he was recently
Chairman of the American Institute of Graphic
Arts.

DAVID PELHAM
Directeur Artistique, Penguin Books, London

David Pelham a reçu nombre de prix importants
pour le design et son travail se trouve représenté
dans les musées d'Europe et des Etats-Unis.
Précédemment Directeur Artistique à Studio
International et Harpers Bazaar, et pendant douze
ans Directeur Artistique chez Penguin Books, il a
maintenant son propre cabinet de conseil design. Il
est l'auteur du Penguin Book of Kites, publié en
1976. David Pelham est membre du Comité Exécutif
de D&AD.

ROBERT PRIEST
Directeur Artistique, Esquire, New York

Robert Priest est Directeur Artistique de Esquire
magazine, New York. Il a précédemment été
Directeur Artistique de Weekend Magazine à
Toronto, de Radio Times à Londres, et d'autres
périodiques. Son travail a été récompensé par
d'importants prix à New York, Londres et Toronto.
Membre de plusieurs jurys de design et d'illustration
en Europe et en Amérique du Nord, il était,
récemment, Président de l'American Institute of
Graphic Arts.

DAVID PELHAM
Art Direktor, Penguin Books, London

David Pelham hat eine Reihe von grossen Preisen für
Gestaltung gewonnen, und seine Arbeiten sind in
Museen in Europa und in den U.S.A. zu sehen. Der
frühere Art Direktor für Studio International und
Harpers Bazaar war zwölf Jahre lang Art Direktor bei
Penguin Books und leitet heute ein eigenes
Beratungsbüro für Gestaltung.

Er verfasste das "Penguin Book of Kites" (Das
Penguin-Buch der Drachen), das 1976 veröffentlicht
wurde. David Pelham ist Mitglied des D&AD
Vorstandes.

ROBERT PRIEST
Art Direktor, Esquire, New York

Robert Priest ist Art Direktor beim Esquire
Magazine in New York. Zuvor war er als Art Direktor
bei Weekend Magazine in Toronto, Kanada, bei
Radio Times in London und anderen Zeitschriften
tätig. Seine Arbeit hat ihm mehrere Auszeichnungen
in New York, London and Toronto eingebracht. Er
ist Mitglied mehrerer Gestaltungs–und
Illustrations–Jurys und wurde vor kurzem zum
Präsidenten des American Institute of Graphic Arts
bestellt.

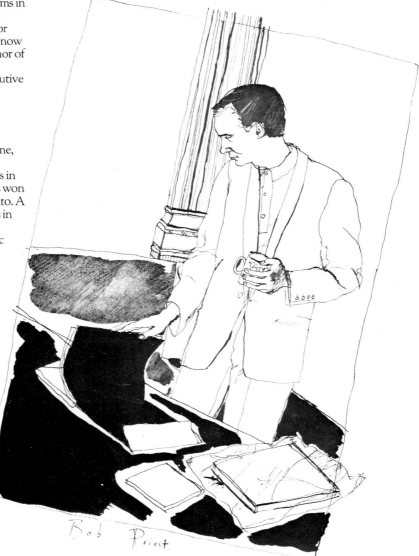

Bob Priest

EDITORIAL

This section includes illustrations for newspapers, magazines and all forms of periodical publications.

Cette section comprend des illustrations pour journaux, magazines et périodiques de toutes sortes.

Dieser Abschnitt umfasst Illustrationen für Zeitungen, Zeitschriften und andere regelmässig erscheinende Veröffentlichungen aller Art.

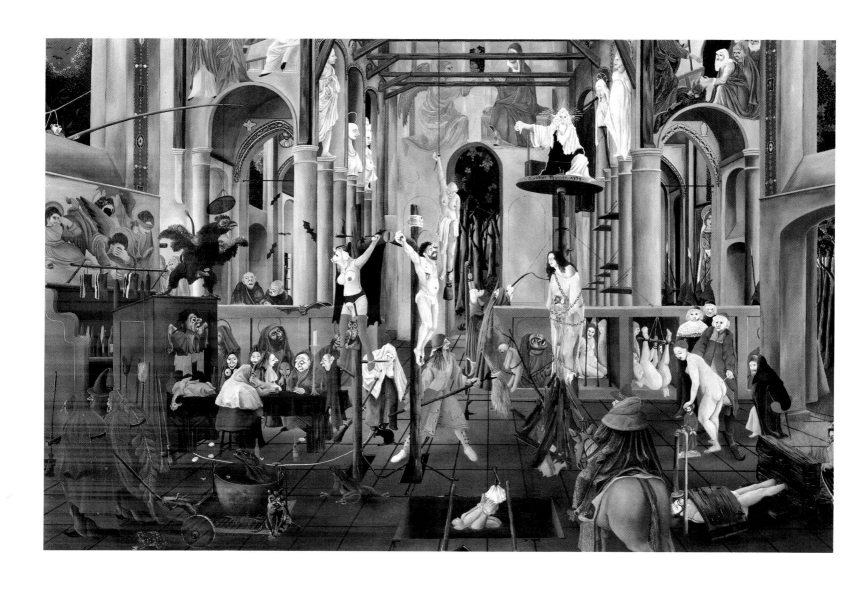

14

Artist/Artiste/Künstler/**Günther Thumer**
Designer/Maquettiste/Gestalter/**George Guther**
Art Director/Directeur Artistique/**Rainer Wörtmann**
Publisher/Editeur/Verlag/**Heinrich Bauer Verlag**

Illustration for "Hexen" (Witches) by Gerd Prause, in German 'Playboy' 1979. Oil on wood.

Illustration pour "Hexen" (Sorcières) par Gerd Prause, dans 'Playboy' allemand 1979. Huile sur bois.

Illustration für "Hexen" von Gerd Prause, im Deutschen 'Playboy' 1979. Öl auf Holz.

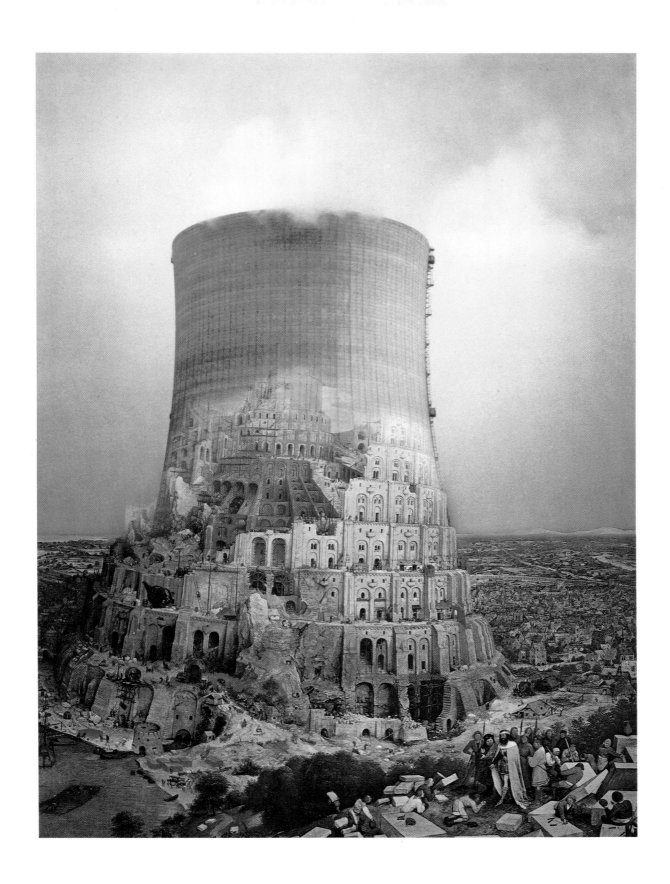

15

Artists/Artistes/Künstler/**Pierre Brauchli, Pieter Breughel**
Designer/Maquettiste/Gestalter/**Franz Epping**
Art Director/Directeur Artistique/**Rolf Gillhausen**
Publisher/Editeur/Verlag/**Gruner & Jahr AG & Co**

Cover illustration entitled "Babylon Heute" (Babylon Today), in 'Stern'.
In colour, part acrylic, part photo-montage.

Illustration de couverture intitulée "Babylon Heute" (Babylone Aujourd'hui)
dans 'Stern'. En couleur, partie acrylique, partie photo-montage.

Umschlagillustration betitelt "Babylon Heute" in 'Stern'. Farbig, teils Acryl,
teils Fotomontage.

Artist/Artiste/Künstler/**Peter Till**
Art Editor/Rédacteur Artistique/Kunstredakteur/**Patrick Burton**
Publisher/Editeur/Verlag/**Building Publishers Limited**

Illustration for an article "VAT – The Counter Productive Tax" by
George Henderson, In 'Building' 22 February 1980. Black and white, in pen and ink.

Illustration pour un article "VAT – The Counter Productive Tax" (La TVA – Taxe
Contre Productive) par George Henderson, dans 'Building' le 22 février 1980.
Noir et blanc, en plume et encre.

Illustration für einen Artikel "VAT – The Counter Productive Tax"
(Mehrwertsteuer – Die Bumerangsteuer) von George Henderson, in 'Building'
22. Februar 1980. Schwarzweisse Federzeichnung.

17

Artist/Artiste/Künstler/**Tony McSweeney**
Art Director/Directeur Artistique/**Terry Seago**
Publisher/Editeur/Verlag/**The Observer Limited**

Illustration for "Downfall of the Anti-Social Climbers" by Duncan Campbell and
Peter Chippendale, in 'The Observer Magazine' 6 April 1980. Water-colour,
gouache and pencil.

Illustration pour "Downfall of the Anti-Social Climbers" (La Chute des Montés en
l'Air) par Duncan Campbell et Peter Chippendale, dans
'The Observer Magazine' le 6 avril 1980. Aquarelle, gouache et crayon.

Illustration für "Downfall of the Anti-Social Climbers" (Der Sturz der
Gesellschaftsfeindlichen Streber) von Duncan Campbell und Peter Chippendale,
in 'The Observer Magazine' 6. April 1980. Wasserfarben, Gouache und Bleistift.

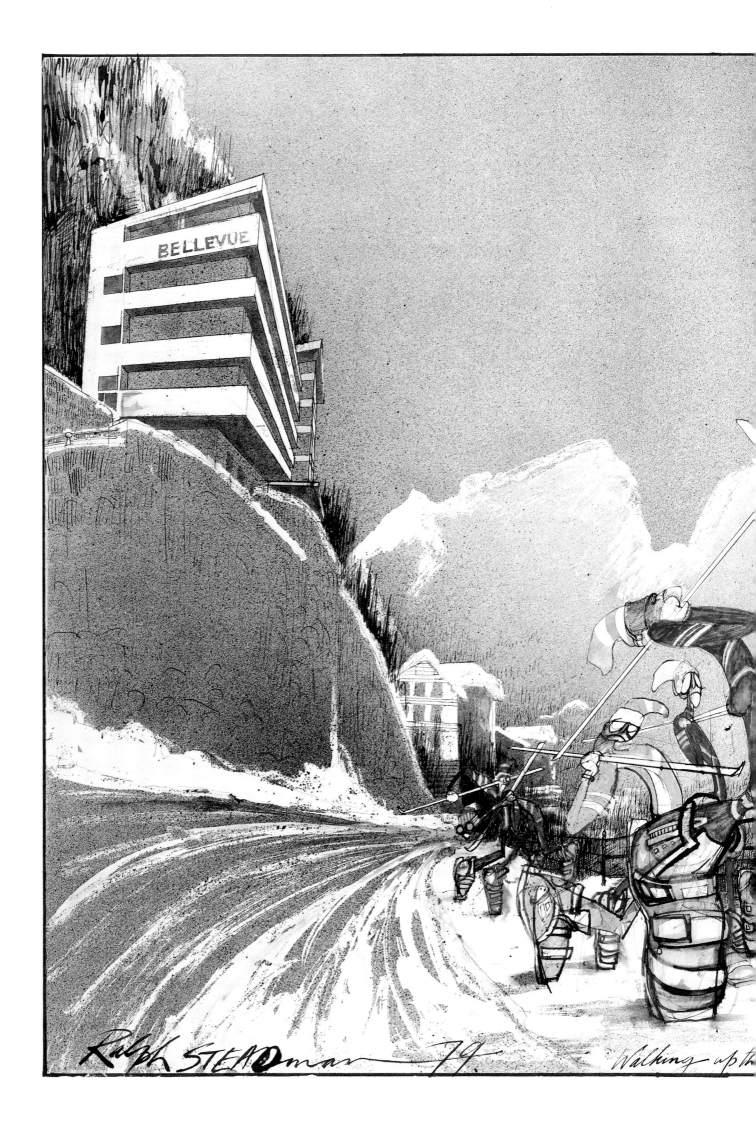

BELLEVUE

Ralph STEADman — 79. Walking up th

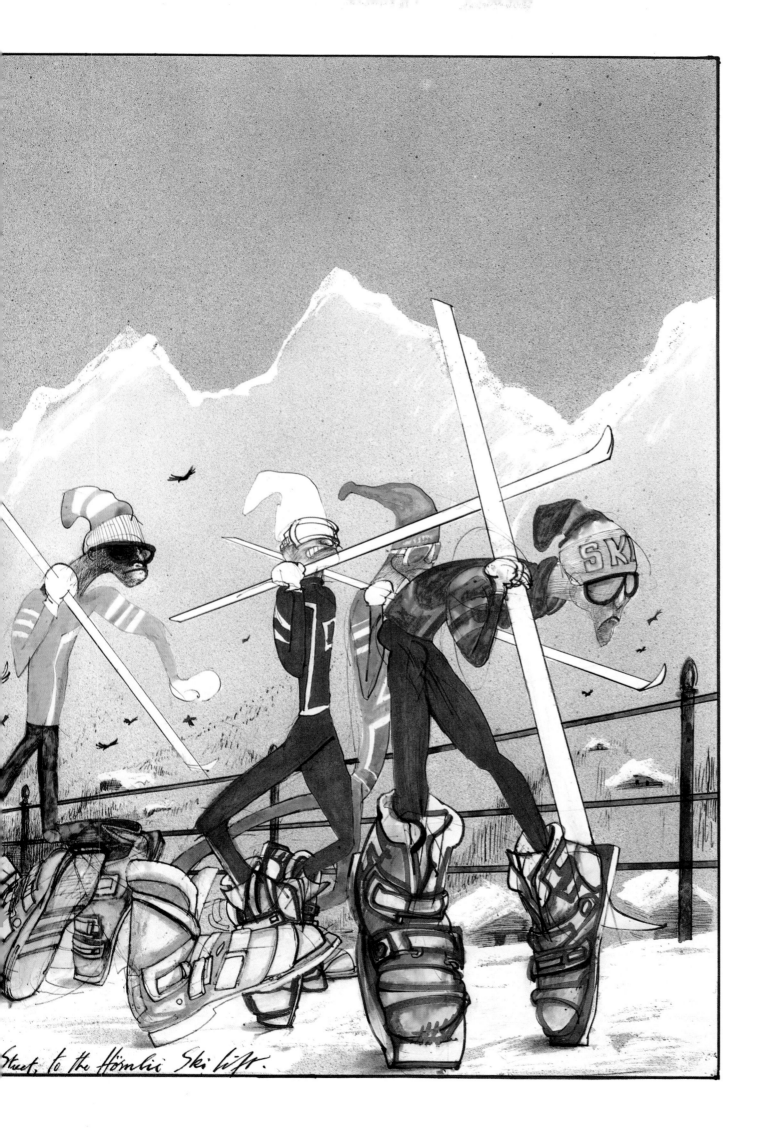

Street, to the Hörnlie Ski lift.

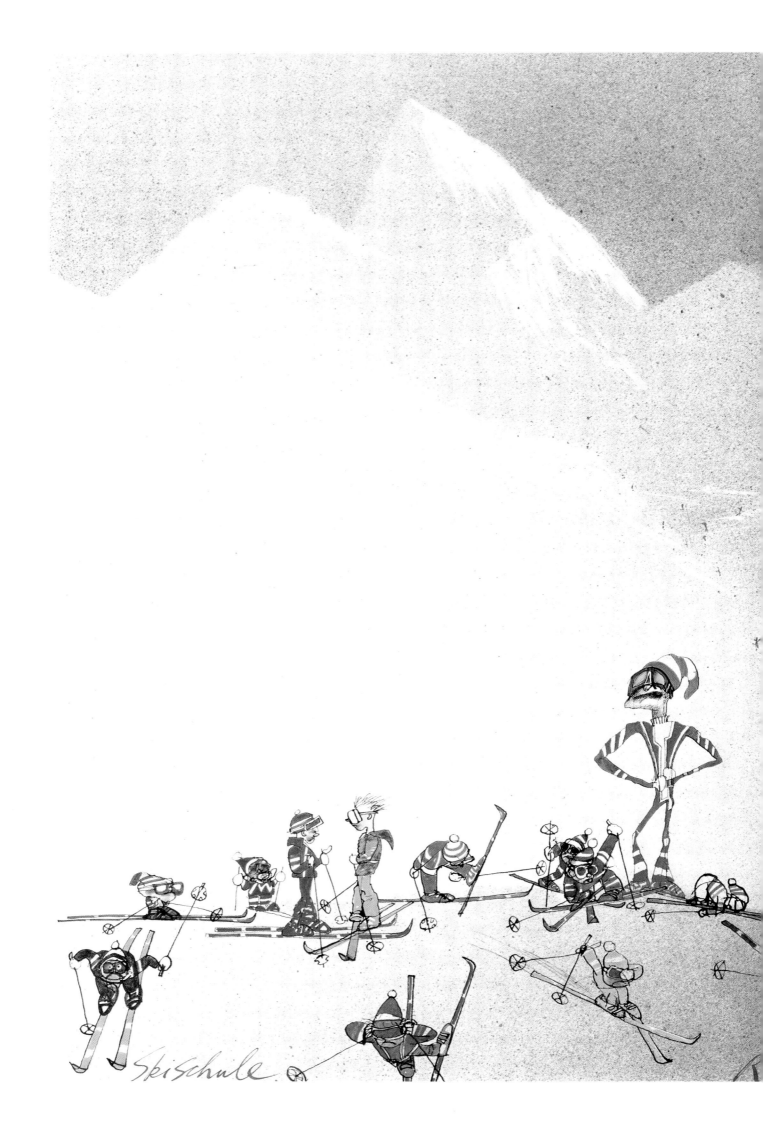

Skischule

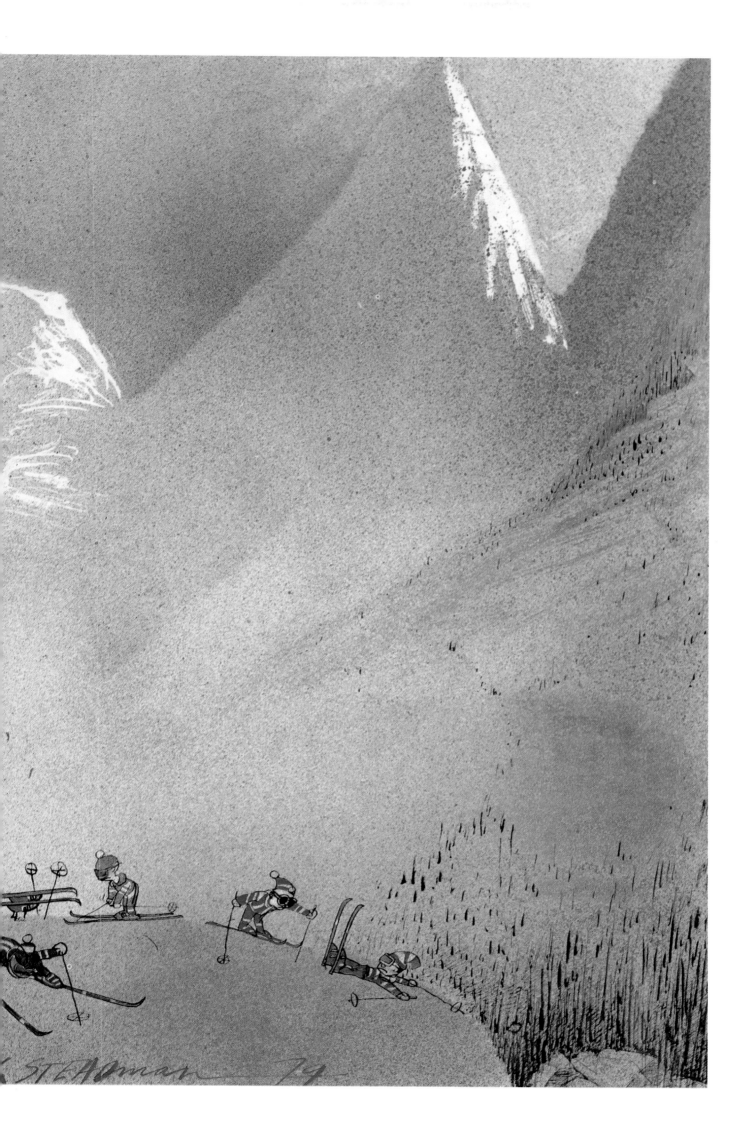

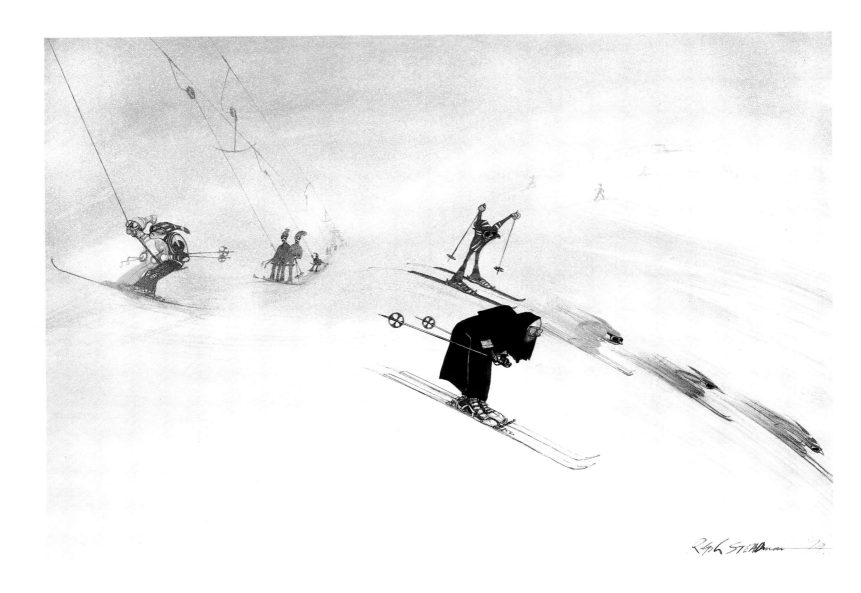

18, 19, 20, 21, 22

Artist/Artiste/Künstler/**Ralph Steadman**
Art Director/Directeur Artistique/**Geoff Axbey**
Publishing Company/**The Sunday Telegraph Limited**

Illustrations for an article "Taking to the Slippery Slopes," in
'The Sunday Telegraph Magazine' 2 December 1979. Coloured inks and gouache.

Illustrations pour un article "Taking to the Slippery Slopes"
(Sur les Pentes Enneigées), dans 'The Sunday Telegraph Magazine' le 2 décembre
1979. Encres de couleur et gouache.

Illustrationen für einen Artikel "Taking to the Slippery Slopes"
(Auf die schiefe Bahn geraten), in 'The Sunday Telegraph Magazine' 2. Dezember
1979. Farbtusche und Gouache.

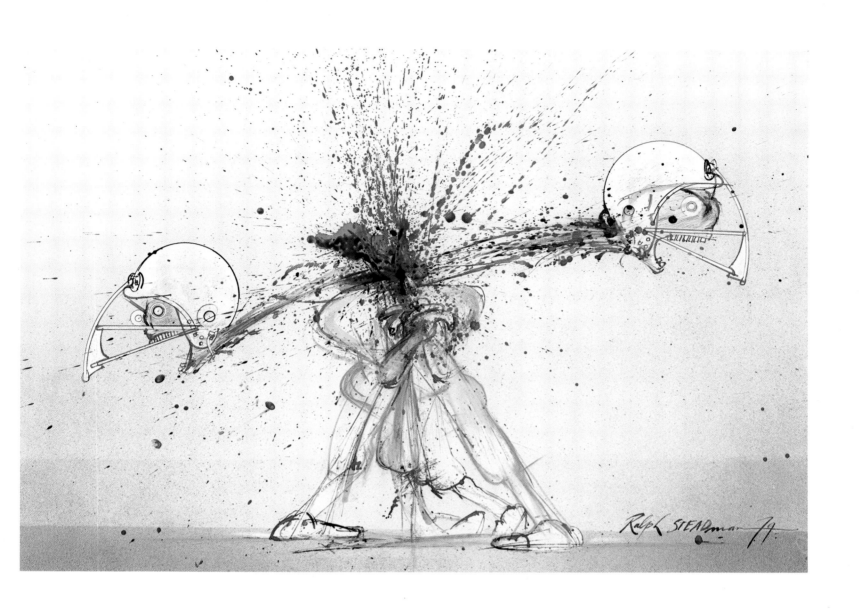

Artist/Artiste/Künstler/**Ralph Steadman**
Art Director/Directeur Artistique/**Sue Howe**
Publisher/Editeur/Verlag/**Penthouse Publications Limited**

Illustration for "This Sporting Violence" by Angela Patmore, in 'Penthouse'
February 1980. Ink and pencil, in colour.

Illustration pour "This Sporting Violence" (La Violence du Sport)
par Angela Patmore, dans 'Penthouse' février 1980. Encre et crayon, en couleur.

Illustration zu "This Sporting Violence" (Sport als Gewalt) von Angela Patmore,
in 'Penthouse' Februar 1980. Farbige Tusche und Bleistift.

Artist/Artiste/Künstler/**Ramon Gonzalez Teja**
Designer/Maquettiste/Gestalter/**Ramon Gonzales Teja**
Publisher/Editeur/Verlag/**Ciudadano SA**

Illustration for an article "The Risk of Birth in Spain" by Oscar Caballero, in 'Ciudadano' October 1979. Water-colour and coloured pencils.

Illustration pour un article "The Risk of Birth in Spain" (Les Risques de la Naissance en Espagne) par Oscar Caballero, dans 'Ciudadano' octobre 1979. Aquarelle et crayons de couleur.

Illustration für einen Artikel "The Risk of Birth in Spain" (Das Geburtenrisiko in Spanien) von Oscar Caballero, in 'Ciudadano' Oktober 1979. Wasserfarben und Farbstifte.

Artist/Artiste/Künstler/**Kinuko Craft**
Designer/Maquettiste/Gestalter/**George Guther**
Art Director/Directeur Artistique/**Rainer Wörtmann**
Publisher/Editeur/Verlag/**Heinrich Bauer Verlag**

Illustration for "Kennen Sie diesen Mann?" (Do You Know This Man?)
by James Whitman, in German 'Playboy' 1979. Oil on wood.

Illustration pour "Kennen Sie diesen Mann?" (Connaîssez-vous Cet Homme?)
par James Whitman, dans 'Playboy' allemand 1979. Huile sur panneau.

Illustration für "Kennen Sie diesen Mann?" von James Whitman,
im Deutschen 'Playboy' 1979. Öl auf Holz.

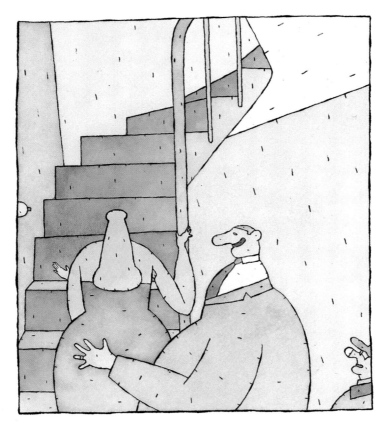

L'amie de M. Bughenoute riait fort. M. Beulemans a respiré son parfum.

26, 27

Artist/Artiste/Künstler/**Lionel Koechlin**
Designer/Maquettiste/Gestalter/**Lionel Koechlin**
Art Director/Directeur Artistique/**Lionel Koechlin**
Publisher/Editeur/Verlag/**Editions Du Kiosque**

Illustration "L'amie de M. Bughenoute riait fort. M. Beulemans a respire son parfum"
(The female friend of Mr. Bughenoute laughed loudly. Mr. Beulemans smelled her
perfume) for a feature "M. Beulemans à Paris" (Mr. Beulemans in Paris) by
Philippe Paringaux, in 'Rock and Folk' August 1979. Water-colour.

Illustration "L'amie de M. Bughenoute riait fort. M. Beulemans a respire son parfum"
pour un article vedette "M. Beulemans à Paris" par Philippe Paringaux, dans 'Rock
and Folk' aôut 1979.

Illustration "L'amie de M. Bughenoute riait fort. M. Beulemans a respire son parfum"
(Herm Bughenoute's Freundin lachte laut. Herr Beulemans hat ihr Parfum bemerkt)
für den Artikel "M. Beulemans à Paris" (Herr Beulemans in Paris) von
Philippe Paringaux, in 'Rock and Folk' August 1979. Wasserfarben.

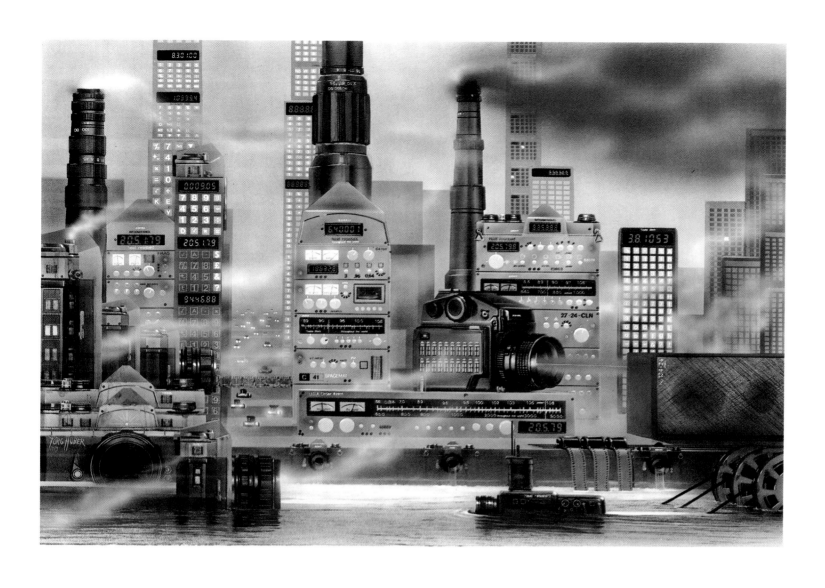

Artist/Artiste/Künstler/**Jörg Huber**
Art Director/Directeur Artistique/**Ernst Pavlovic**
Publisher/Editeur/Verlag/**Trend Magazine**

Illustration for an article "Elektronopolis" by Rainer Knoche, in 'Trend' June 1979.
Gouache.

Illustration pour un article "Elektronopolis" (Electromonopole) par Rainer Knoche,
dans 'Trend' juin 1979. Gouache.

Illustration für einen Artikel "Elektronopolis" von Rainer Knoche,
in 'Trend' Juni 1979. Gouache.

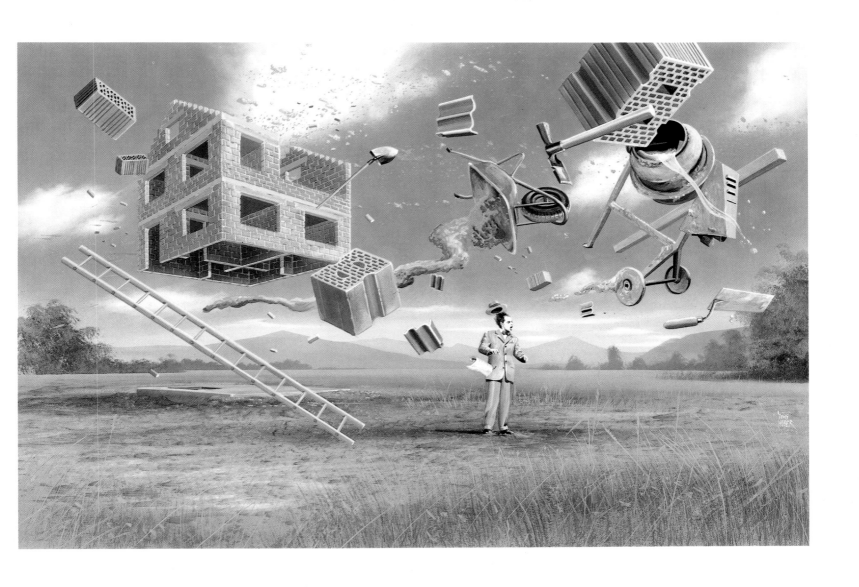

Artist/Artiste/Künstler/Jörg Huber
Art Director/Directeur Artistique/Ernst Pavlovic
Publisher/Editeur/Verlag/Trend Magazine

Illustration for an article "Wie Sie als Bauherr am Bau werden"
(Become a Builder-Owner and Master of the House too) by Erika Folkes,
in 'Trend' October 1978. Gouache.

Illustration pour un article "Wie Sie als Bauherr Herr am Bau werden"
(Comment le Constructeur devient le Maître de la Construction) par Erika Folkes,
dans 'Trend' octobre 1978. Gouache.

Illustration zum Artikel "Wie Sie als Bauherr Herr am Bau werden"
von Erika Folkes, in 'Trend' Oktober 1978. Gouache.

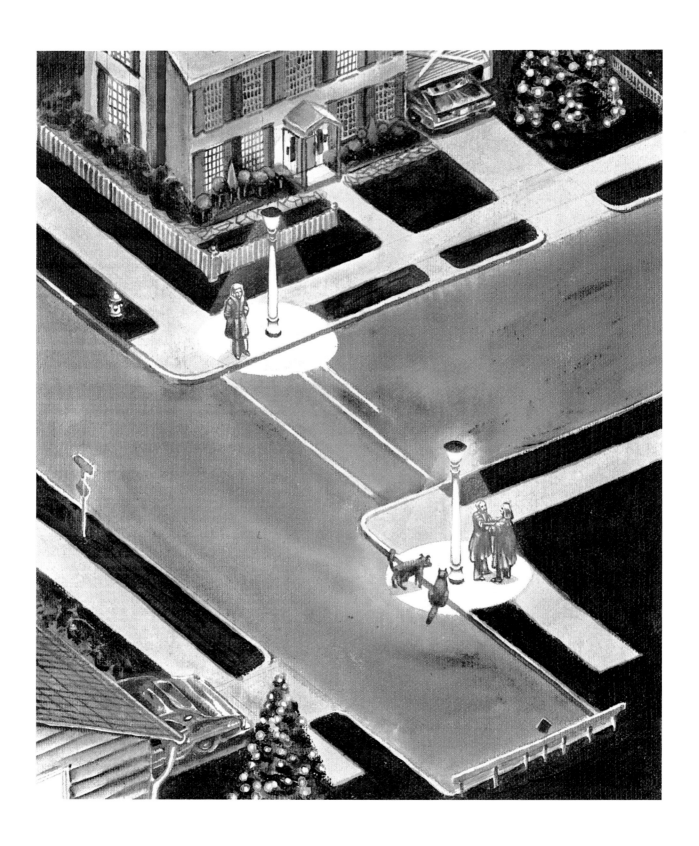

30

Artist/Artiste/Künstler/**Frans Evenhuis**
Art Director/Directeur Artistique/**Dick De Moei**
Publisher/Editeur/Verlag/**De Geïllustreerde Pers BV**

Illustration for "Domestic Life in America" by John Updike, in 'Avenue Literair'
October 1979. Water-colour.

Illustration pour "Domestic Life in America" (La Vie Domestique en Amérique)
par John Updike, dans 'Avenue Literair' octobre 1979. Aquarelle.

Illustration für "Domestic Life in America" (Häusliches Leben in Amerika)
von John Updike, in 'Avenue Literair' Oktober 1979. Wasserfarben.

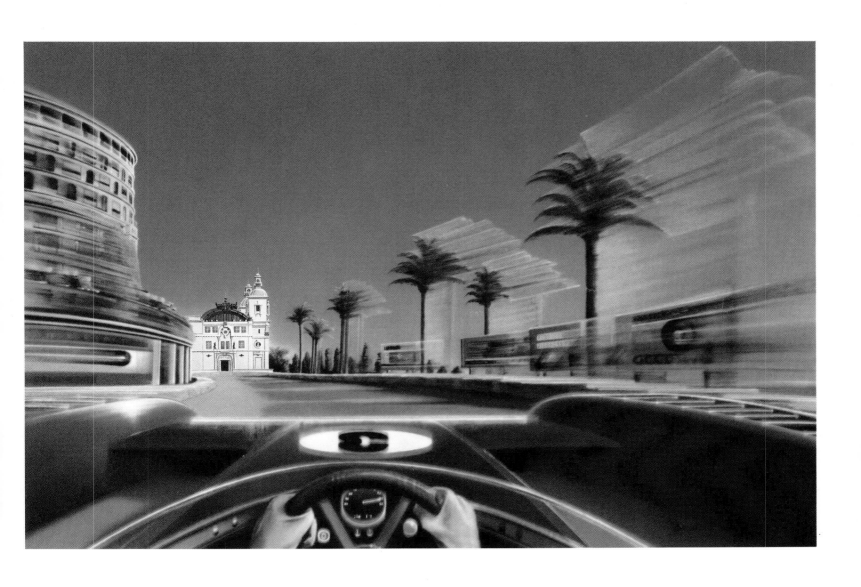

31

Artist/Artiste/Künstler/**Rainer C Friz**
Designer/Maquettiste/Gestalter/**Angi Bronder**
Art Director/Directeur Artistique/**Rainer Wörtmann**
Publisher/Editeur/Verlag/**Heinrich Bauer Verlag**

Illustration for "Ein Fehler und Du bist weg vom Fenster" (One Mistake and You are Dead) by Herbert Völker, in German 'Playboy' 1979. Airbrush.

Illustration pour "Ein Fehler und Du bist weg vom Fenster" (Une Erreur et tu es mort) par Herbert Völker, dans 'Playboy' allemand 1979. Aérographe.

Illustration für "Ein Fehler und Du bist weg vom Fenster" von Herbert Völker, im Deutschen 'Playboy' 1979. Spritzpistole.

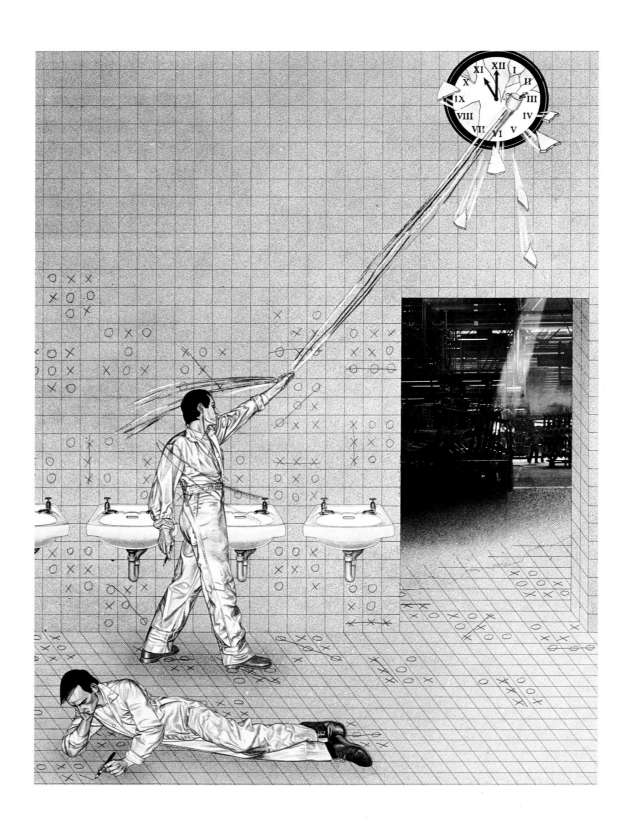

Artist/Artiste/Künstler/**Robin Harris**
Art Director/Directeur Artistique/**Roland Schenk**
Group Art Editor/Rédacteur Artistique/Kunstredakteur/**Patricia Brock**
Publisher/Editeur/Verlag/**Management Publications Limited**

Illustration for "A Car Worker's 40% Year," in 'Management Today' February 1980.
Water-colour, ink, enamel, spray and collage.

Illustration pour "A Car Worker's 40% Year" (L'Année 40% des Ouvriers
Automobile), dans 'Management Today' février 1980. Aquarelle, encre,
peinture au pistolet et collage.

Illustration zur Reportage "A Car Worker's 40% Year" (Das 40% Jahr eines
Automobilfacharbeiters), in 'Management Today' Februar 1980. Wasserfarben,
Tusche, Emaille, Spritzpistole und Collage.

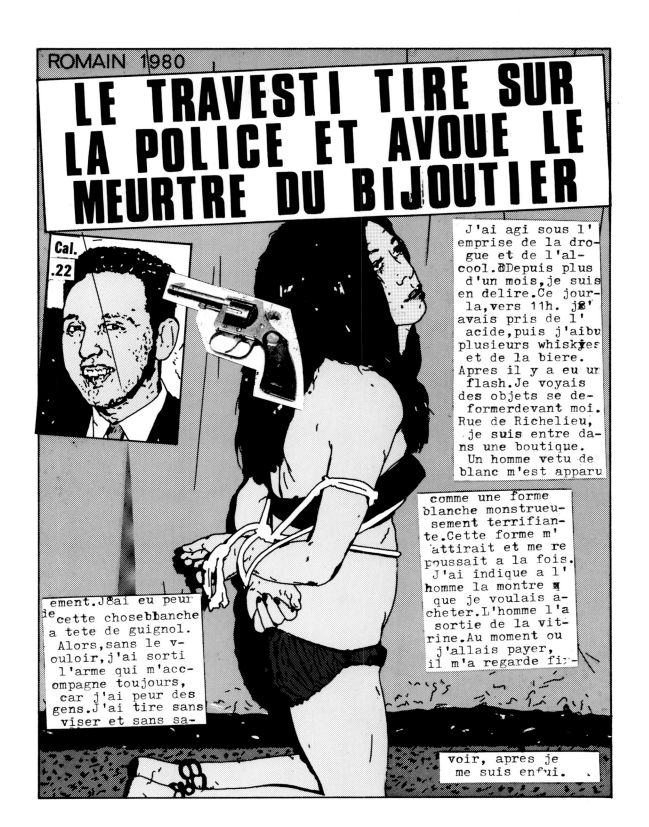

Artist/Artiste/Künstler/**Romain Slocombe**
Art Directors/Directeurs Artistiques/**Françoise Clavel, Frederic Pierret**
Publisher/Editeur/Verlag/**Société Nouvelle Press Communication**

Illustration for news item "Le Travesti Tire sur la Police" (The Transvestite shoots
at the Police), in 'Sandwich' (weekly supplement of 'Libération') 1 March 1980. Ink,
Letraset and collage.

Illustration pour un fait divers "Le Travesti Tire sur la Police," dans 'Sandwich'
(supplément hébdomadaire de 'Libération') le 1 mars 1980.
Encre, Letraset et collage.

Illustration für eine Zeitungsnotiz "Le Travesti Tire sur la Police" (Der Transvestit
schiesst auf die Polizei), in 'Sandwich' (Beilage zu 'Libération') 1. März 1980.
Letraset und Collage.

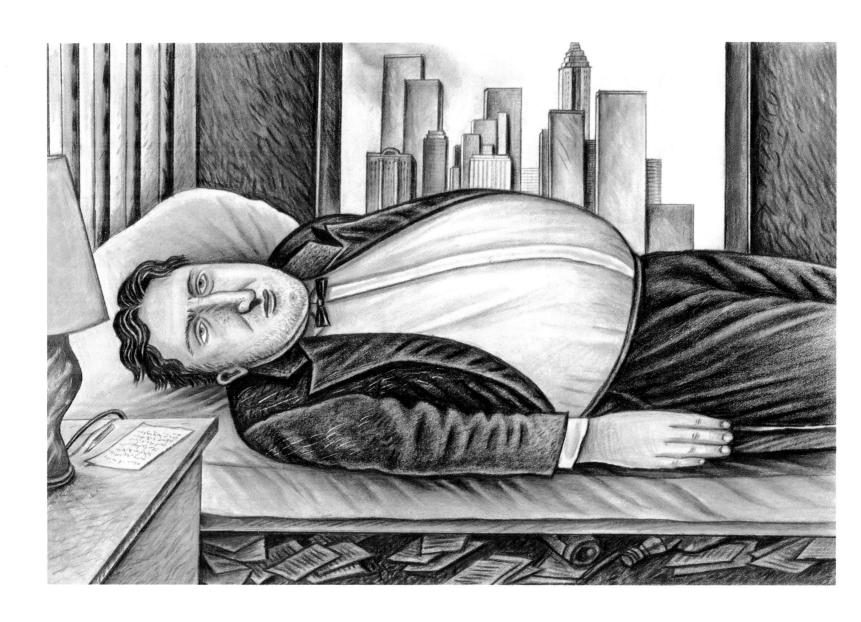

Artist/Artiste/Künstler/**Anne Howeson**
Art Director/Directeur Artistique/**Robert Priest**
Publisher/Editeur/Verlag/**Montreal Standard Incorporated**

Illustration for an article on famous alcoholics, "Dead Drunks"
by David MacFarlane, in 'Weekend Magazine' 25 August 1979.
The portrait, in crayon, is of Brendan Behan.

Illustration pour un article sur les alcooliques célèbres, "Dead Drunks" (Ives Morts)
par David MacFarlane, dans 'Weekend Magazine' le 25 aôut 1979. Le portrait,
au pastel, est de Brendan Behan.

Illustration zu einem Artikel über berühmte Trinker, "Dead Drunks"
(Sinnlos Betrunkene) von David MacFarlane in 'Weekend Magazine'
25. August 1979. Die Kreidezeichnung ist von Brendan Behan.

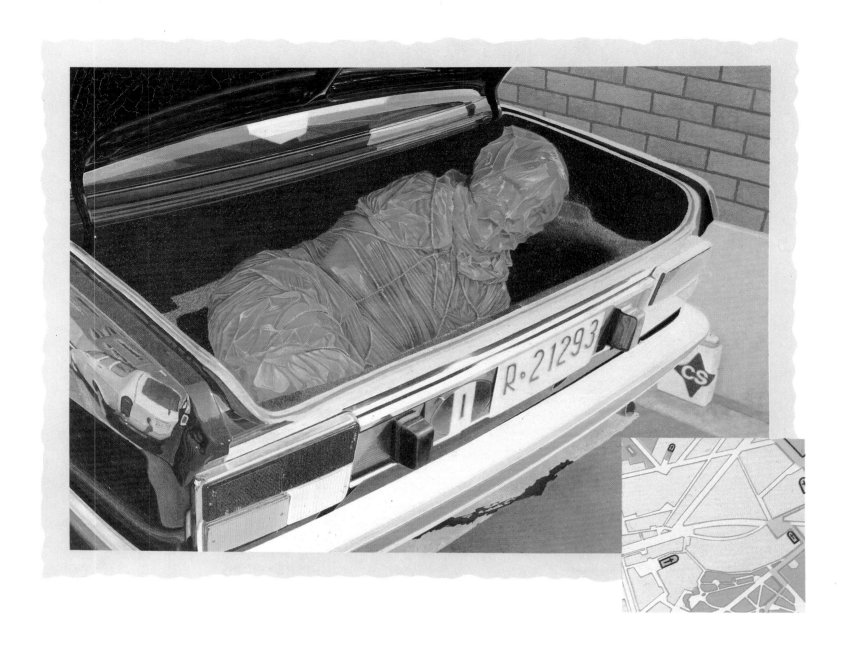

Artist/Artiste/Künstler/**Guillemot Navares**
Art Director/Directeur Artistique/**Francisco Crosta**
Publisher/Editeur/Verlag/**Editorial Zeta**

Illustration for an article "Las Brigadas Rojas" (The Red Brigade) by Jacento Perez de Ereartae, 'Penthouse' 1980. Oil on wood.

Illustration pour un article "Las Brigadas Rojas" (Les Brigades Rouges) par Jacento Perez de Ereartae, 'Penthouse' 1980. Huile sur bois.

Illustration für einen Artikel "Las Brigadas Rojas" (Die Roten Brigaden) von Jacento Perez de Ereartae, 'Penthouse' 1980. Öl auf Holz.

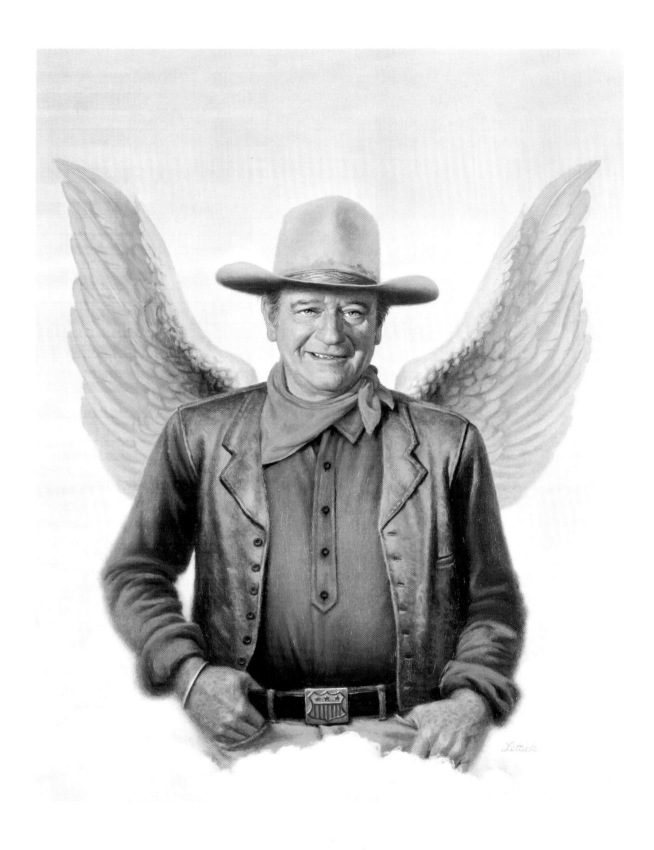

36

Artist/Artiste/Künstler/**Birney Lettick**
Designers/Maquettistes/Gestalter/**April Silver, Derek Ungless**
Art Director/Directeur Artistique/**Robert Priest**
Publisher/Editeur/Verlag/**Esquire Incorporated**

Cover illustration, entitled "Somewhere the Duke is Smiling," for 'Esquire' April
1980. Oils.

Illustration de couverture intitulée "Somewhere
the Duke is Smiling"
(Quelque Part le "Géant" Sourit), pour 'Esquire' avril 1980. Huile.

Illustrierte titelseite zum Artikel "Somewhere the Duke is Smiling"
(Irgendwo lächelt der Fürst), 'Esquire' April 1980. Ölfarben.

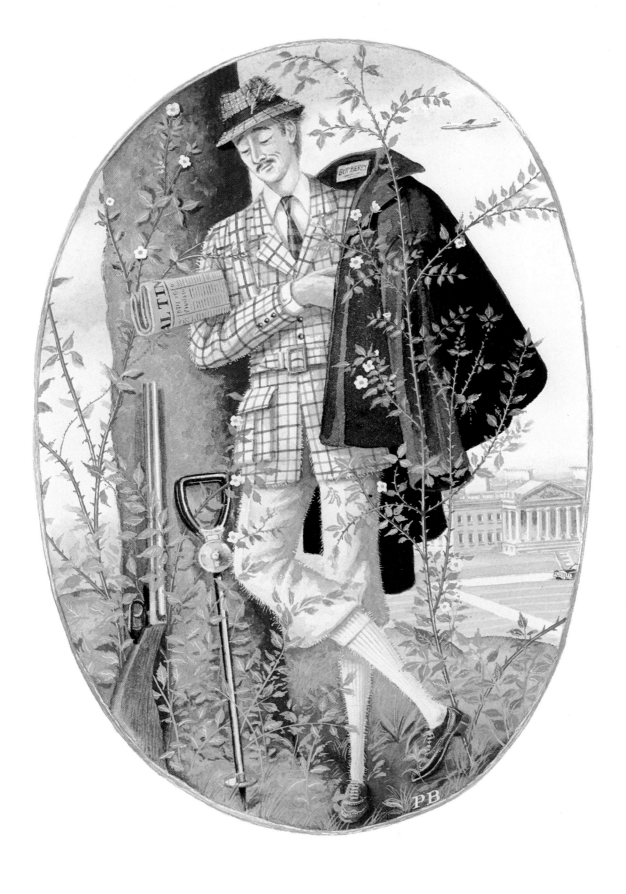

37

Artist/Artiste/Künstler/**Peter Brookes**
Art Director/Directeur Artistique/**Tony Garrett**
Publishers/**IPC Magazines Limited**

Cover illustration for an article "Is There Still a Ruling Class?" by Anthony Giddens,
in 'New Society' 4 October 1979. Water-colour.

Illustration de couverture pour un article "Is There Still a Ruling Class?"
par Anthony Giddens, dans 'New Society' publiée le 4 octobre, 1979. Aquarelle.

Umschlagillustration zum Artikel "Is There Still a Ruling Class?"
(Gibt es noch eine herrschende Klasse?) von Anthony Giddens, in 'New Society'
4. Oktober 1979. Wasserfarben.

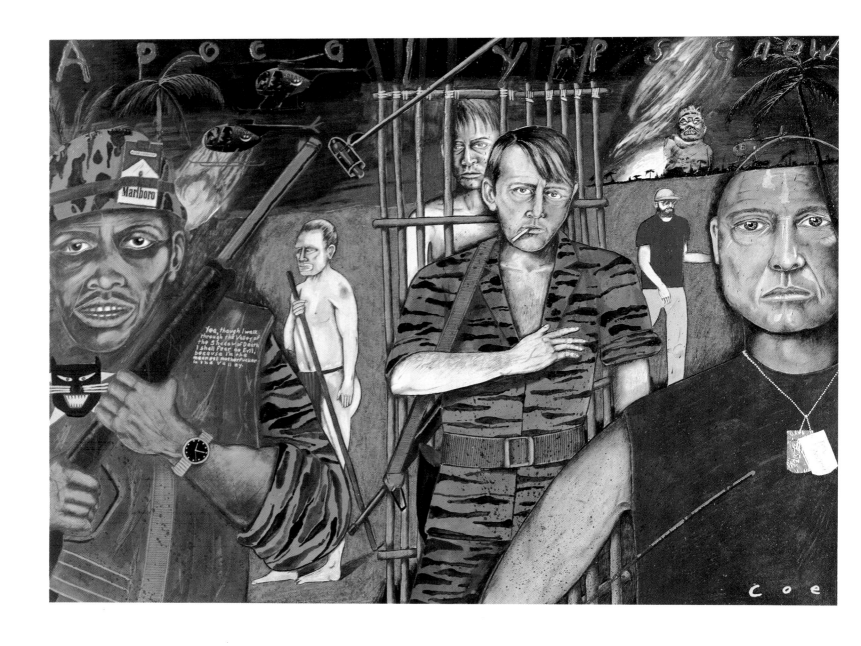

Artist/Artiste/Künstler/Sue Coe
Designers/Maquettistes/Gestalter/Barbara Jane Galbraith, Derek Ungless
Art Director/Directeur Artistique/Robert Priest
Publisher/Editeur/Verlag/Montreal Standard Incorporated

Illustration for "Immortality Now" by Martin Knelman, in 'Weekend Magazine'
August 1979. Acrylic paint.

Illustration pour "Immortality Now" (L'Immortalité dès à Présent)
par Martin Knelman, dans 'Weekend Magazine' aôut 1979. Peinture acrylique.

Illustration für "Immortality Now" (Unsterblichkeit Heute) von Martin Knelman,
in 'Weekend Magazine' August 1979. Acrylfarbe.

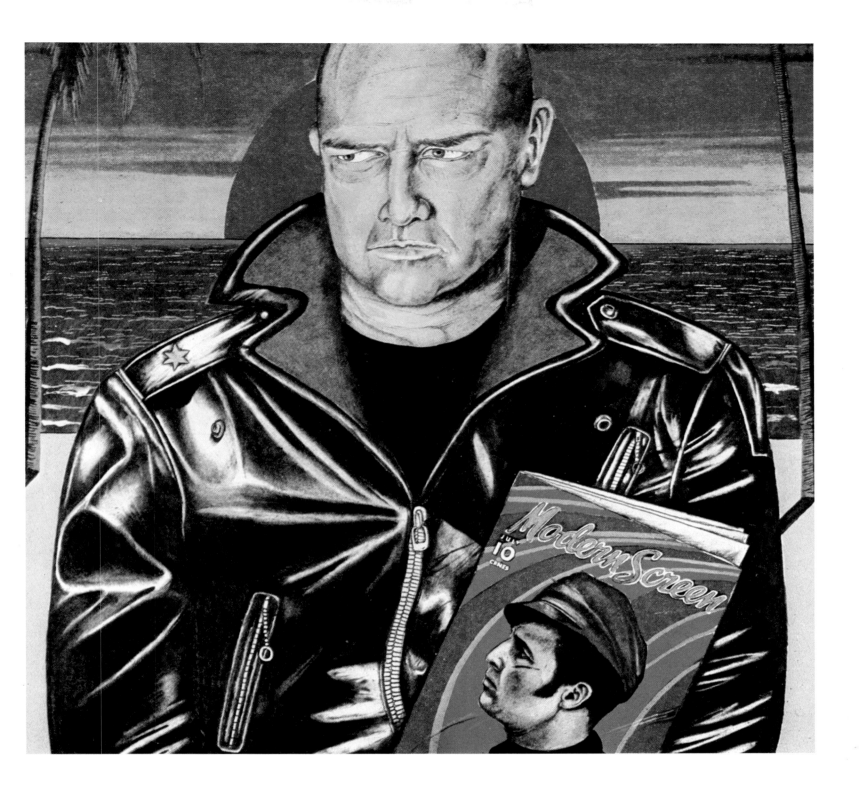

Artist/Artiste/Künstler/**Sue Coe**
Designer/Maquettiste/Gestalter/**Derek Ungless**
Art Director/Directeur Artistique/**Robert Priest**
Publisher/Editeur/Verlag/**Montreal Standard Incorporated**

Cover illustration for "Marlon Brando's Burden" by Larry Grobel,
in 'Weekend Magazine' August 1979. Acrylic paint and pencil.

Illustration de couverture pour "Marlon Brando's Burden"
(Les soucis de Marlon Brando) par Larry Grobel, dans 'Weekend Magazine'
aôut 1979. Peinture acrylique et crayon.

Titelseite für "Marlon Brando's Burden" (Marlon Brandos Bürde)
von Larry Grobel, in 'Weekend Magazine' August 1979.
Acrylfarben.

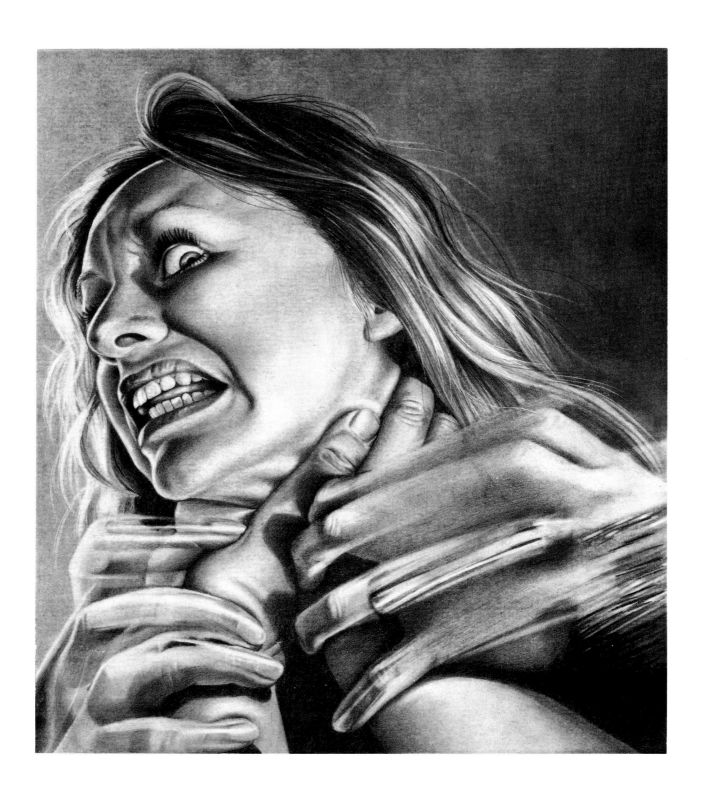

40

Artist/Artiste/Künstler/**Gil Funccius**
Designer/Maquettiste/Gestalter/**Franz Epping**
Art Director/Directeur Artistique/**Wolfgang Behnken**
Publisher/Editeur/Verlag/**Gruner & Jahr AG & Co**

Illustration for a short story "Wege der Liebe" (This is How Love Can Go)
by Elia Kazan, in 'Stern'. Black and white, in pencil.

Illustration pour une nouvelle "Wege der Liebe" (Les Chemins de l'Amour)
par Elia Kazan, dans 'Stern'. Noir et blanc, en crayon.

Illustration zu einer Kurzgeschichte "Wege der Liebe" von Elia Kazan, erschienen in
'Stern'. Schwarzweisse Bleistiftzeichnung.

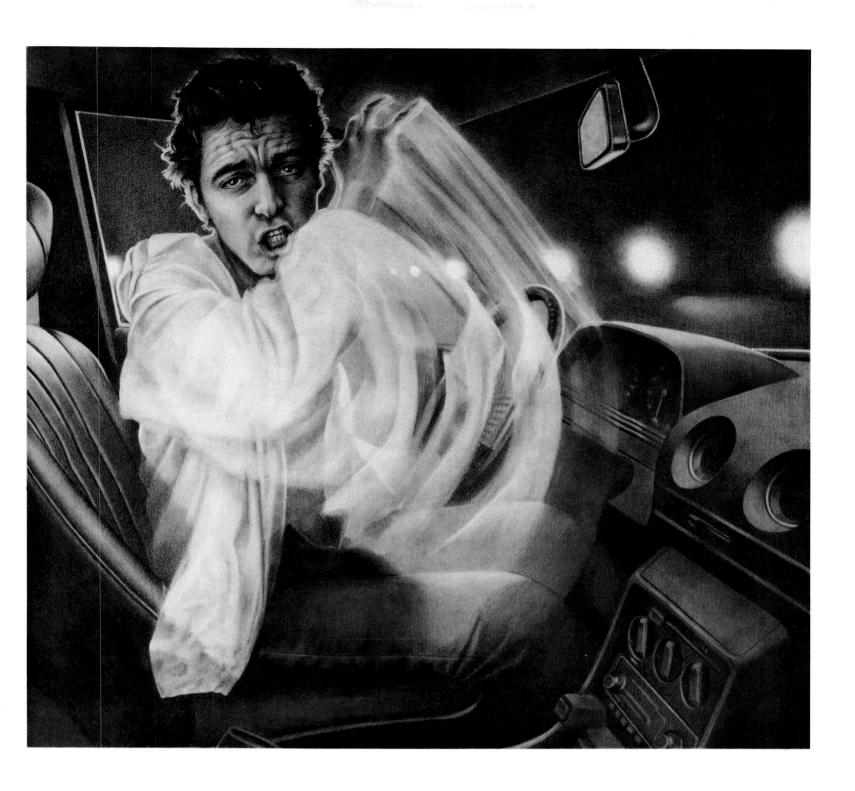

41

Artist/Artiste/Künstler/**Gil Funccius**
Designer/Maquettiste/Gestalter/**Franz Epping**
Art Director/Directeur Artistique/**Wolfgang Behnken**
Publisher/Editeur/Verlag/**Gruner & Jahr AG & Co.**

Illustration for a short story "Wege der Liebe" (This is How Love Can Go)
by Elia Kazan, in 'Stern'. Black and white, in pencil.

Illustration pour une nouvelle "Wege der Liebe" (Les Chemins de l'Amour)
par Elia Kazan, dans 'Stern'. Noir et blanc, en crayon.

Illustration für die Kurzgeschichte "Wege der Liebe" von Elia Kazan, erschienen in
'Stern'. Schwarzweiss, Bleistift.

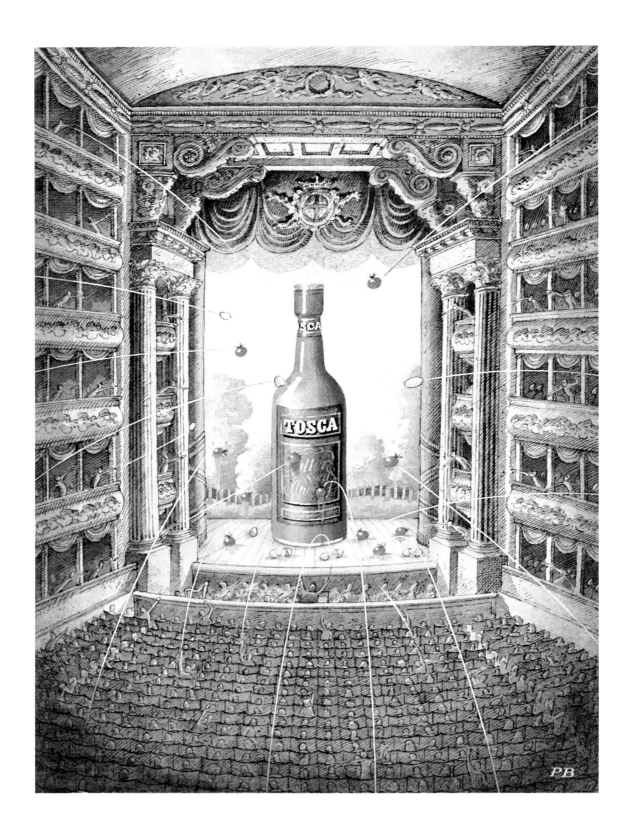

42

Artist/Artiste/Künstler/**Peter Brookes**
Art Director/Directeur Artistique/**Clive Crook**
Publisher/Editeur/Verlag/**Times Newspapers Limited**

Illustration for "They said Anything Could Happen" by Robin Young,
in 'The Sunday Times Magazine' 4 May 1980. Pen and wash.

Illustration pour "They said Anything Could Happen" (Ils ont bien dit que tout
Pouvait Arriver) par Robin Young, dans 'The Sunday Times Magazine'
le 4 mai 1980. Plume et lavis.

Illustration für "They said Anything Could Happen" (Es Wurde Behauptet Alles
Mögliche könnte Passieren) von Robin Young, in 'The Sunday Times Magazine'
4. Mai 1980. Bleistift und Tuschzeichnung.

43

Artist/Artiste/Künstler/**Ri Kaiser**
Art Director/Directeur Artistique/**Wolfgang Behnken**
Publisher/Editeur/Verlag/**Gruner & Jahr AG & Co**

Cover Illustration for article on T-shirts, 'Stern' 2 August 1979.
Water-colour and air brush.

Illustration de couverture pour un article sur les tee-shirts, 'Stern' le 2 aôut 1979.
Aquarelle, aérographe.

Titelseite der Zeitschrift 'Stern' zur Illustration eines Artikels über T-Shirts,
2. August 1979. Wasserfarben, Spritzpistole.

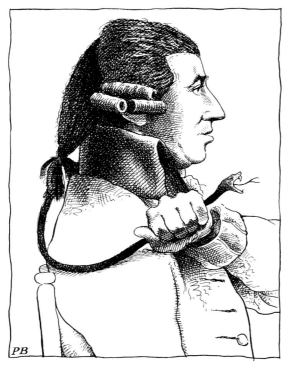

Artist/Artiste/Künstler/**Peter Brookes**
Designer/Maquettiste/Gestalter/**Jenny Fleet**
Art Editor/Rédacteur Artistique/Kunstredakteur/**Brian Thomas**
Publisher/Editeur/Verlag/**BBC Publications**

Illustrations for two articles in 'Radio Times', "Monteverdi," 4 August 1979 and
"Haydn for la Fidelta Premiata," 11 August 1979. Black and white, in ink.

Deux illustrations pour le 'Radio Times', "Monteverdi," le 4 aôut 1979 et "Haydn for
la Fidelta Premiata," 11 aôut 1979. Noir et blanc, en encre.

Zwei Illustrationen für 'Radio Times', "Monteverdi" 4. August 1979 und "Haydn for
la Fidelta Premiata," 11. August 1979. Schwarzweiss, Tusche.

45

Artist/Artiste/Künstler/**Adrian George**
Designer/Maquettiste/Gestalter/**Jenny Fleet**
Art Editor/Rédacteur Artistique/Kunstredakteur/**Brian Thomas**
Publisher/Editeur/Verlag/**BBC Publications**

Illustration for "Sibelius," in 'Radio Times' 26 August 1979. Black and white, in ink.

Illustration pour "Sibelius," dans 'Radio Times' le 26 aôut 1979. Noir et blanc, en encre.

Illustration für "Sibelius," in 'Radio Times' 26. August 1979. Schwarzweiss, Tusche.

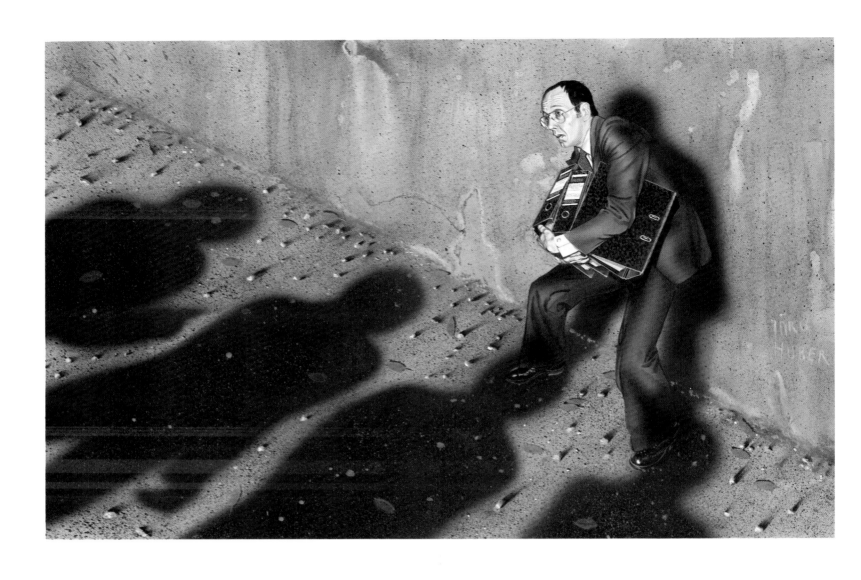

46

Artist/Artiste/Künstler/**Jörg Huber**
Art Director/Directeur Artistique/**Ernst Pavlovic**
Publisher/Editeur/Verlag/**Trend Magazine**

Illustration for an article "Treibjagd auf Steuersünder: Hände hoch–Bücher auf–
Hosen runter" (Witchhunt for Tax Dodgers: Hands up–Books Open–
Trousers down) by Peter Muzik and Helmut Gansterer, in 'Trend' April 1978.
Water-colour, gouache.

Illustration pour un article "Treibjagd auf Steuersünder: Hände hoch–Bücher auf–
Hosen runter" (La Chasse aux Fraudeurs de Fisc: Haut les Mains–
Ouvrez les Livres–Déshabillez-vous) par Peter Muzik et Helmut Gansterer, dans
'Trend' avril 1978. Aquarelle et gouache.

Illustration für einen artikel "Treibjagd auf Steuersünder: Hände hoch–Bücher auf–
Hosen runter" von Peter Muzik und Helmut Gansterer, in 'Trend' April 1978.
Wasserfarben und Gouache.

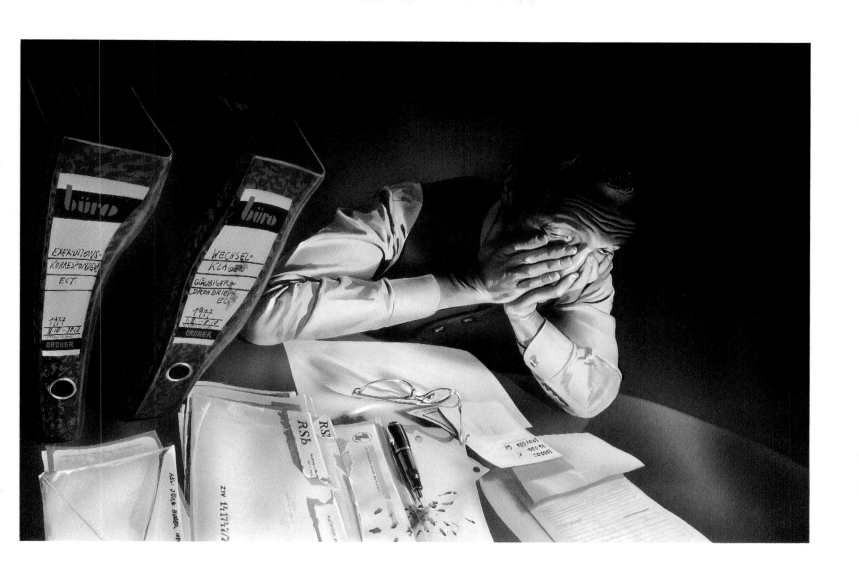

47

Artist/Artiste/Künstler/**Jörg Huber**
Art Director/Directeur Artistique/**Ernst Pavlovic**
Publisher/Editeur/Verlag/**Trend Magazine**

Illustration for an article "Insolvenzen: Wie unsere Unternehmer Versagen"
(Insolvencies: Why and How our Entrepreneurs Fail) by Nikolaus Gerstmayer,
in 'Trend' January 1978. Water-colour and gouache.

Illustration pour un article "Insolvenzen: Wie unsere Unternehmer Versagen"
(Insolvabilité: Comment nos Entrepreneurs font Faillite) par Nikolaus Gerstmayer,
dans 'Trend' janvier 1978. Aquarelle et gouache.

Illustration zu einem Artikel "Insolvenzen: Wie unsere Unternehmer Versagen"
von Nikolaus Gerstmayer, in 'Trend' Januar 1978. Wasserfarben und Gouache.

Artist/Artiste/Künstler/**Peter Brookes**
Designer/Maquettiste/Gestalter/**Jenny Fleet**
Art Editor/Rédacteur Artistique/Kunstredakteur/**Brian Thomas**
Publisher/Editeur/Verlag/**BBC Publications**

Illustration for "The Silicon Future," in 'Radio Times' 15 March 1980. Black and white, in ink.

Illustration pour "The Silicon Future" (L'avenir Programmé), dans 'Radio Times' le 15 mars 1980. Noir et blanc, en encre.

Illustration für "The Silicon Future" (Die Silicon-Zukunft), in 'Radio Times' 15. März 1980. Schwarzweiss, Tusche.

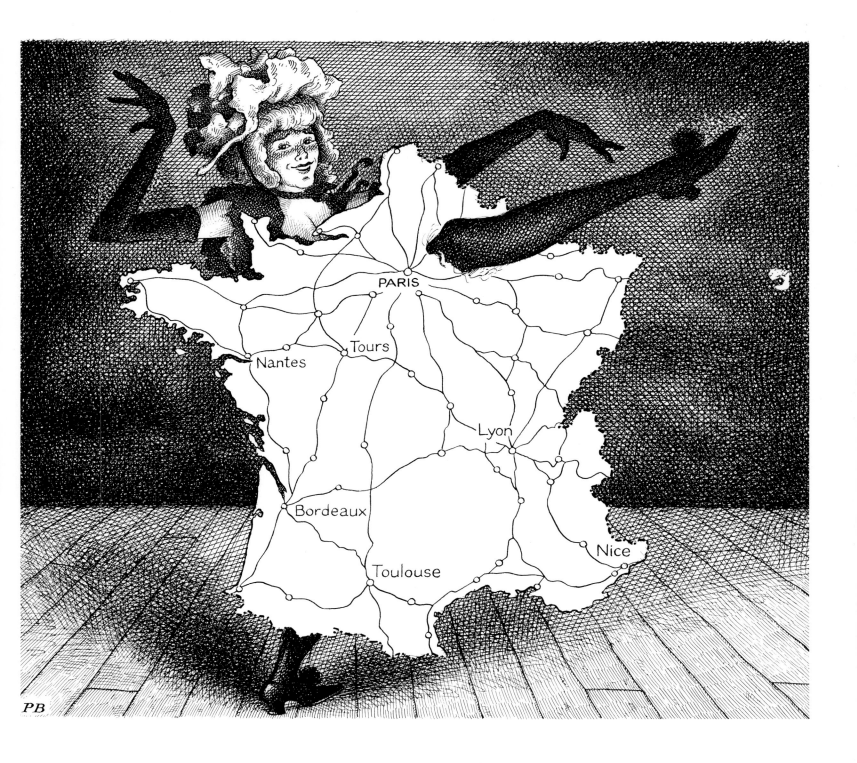

Artist/Artiste/Künstler/**Peter Brookes**
Art Director/Directeur Artistique/**Edwin Taylor**
Publisher/Editeur/Verlag/**Times Newspapers Limited**

Illustration for "French Leave," in 'The Sunday Times' 30 December 1979. Black and white, in ink.

Illustration pour "French Leave" (Loisirs en France), dans 'The Sunday Times' le 30 décembre 1979. Noir et blanc, en encre.

Illustration für "French Leave" (Abschied auf französisch), in 'The Sunday Times' 30. Dezember 1979. Schwarzweisse Federzeichnung.

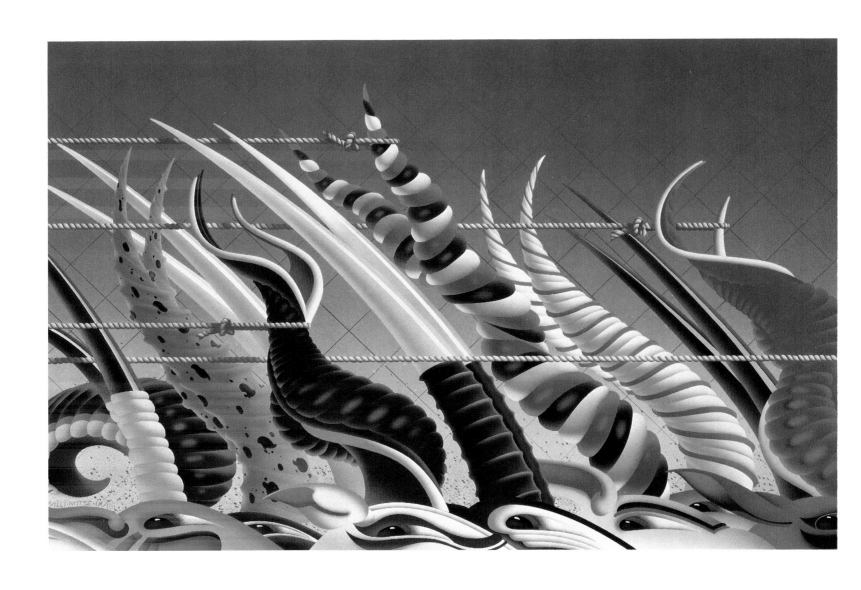

50

Artist/Artiste/Künstler/**Willi Mitscka**
Designer/Maquettiste/Gestalter/**Christl Böhm**
Art Director/Directeur Artistique/**Rainer Wörtmann**
Publisher/Editeur/Verlag/**Heinrich Bauer Verlag**

Illustration for "Morgen fangen wir den Albino" (Tomorrow We Will Catch the
Albino), in German 'Playboy' 1979. Airbrush.

Illustration pour "Morgen fangen wir den Albino" (Demain nous attraperons
l'Albino), dans 'Playboy' allemand 1979. Aérographe.

Illustration für "Morgen fangen wir den Albino," im Deutschen
'Playboy' 1979. Spritzpistole.

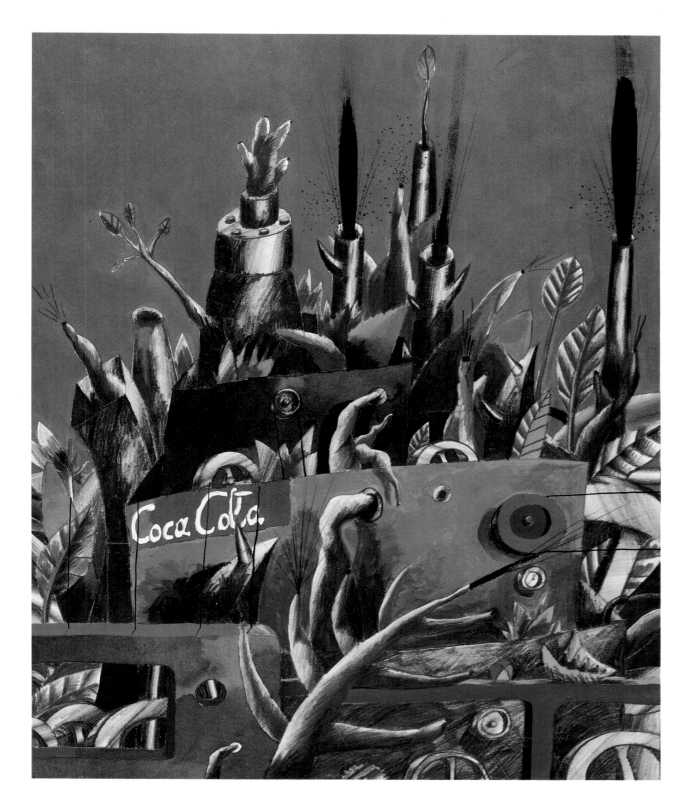

51

Artist/Artiste/Künstler/**Federico Maggioni**
Art Director/Directeur Artistique/**Romano Ragazzi**
Publisher/Editeur/Verlag/**Arnoldo Mondadori Editore**

Illustration for an article by Romano Giachetti/Piero Fortuna/Alberto Salani
"The New Quality of Life" in 'Epoca'. In water-colour, acrylic, pencil and
coloured crayons.

Illustration pour un article par Romano Giachetti/Piero Fortuna/Alberto Salani
"The New Quality of Life" (La Nouvelle Qualité de Vie) dans 'Epoca'.
Aquarelle, acrylique, crayon et pastels.

Illustration für einen Artikel von Romano Giachetti/Piero Fortuna/Alberto Salani
"The New Quality of Life" (Die Neue Lebensqualität) in 'Epoca'.
Wasserfarben, Acrylstift und Farbstifte.

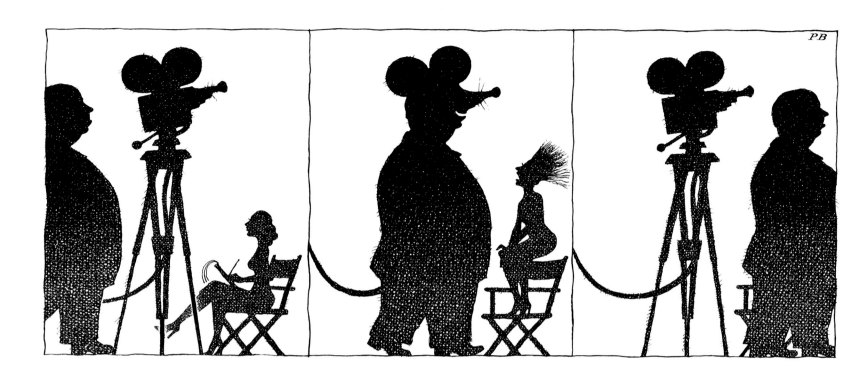

Artist/Artiste/Künstler/**Peter Brookes**
Designer/Maquettiste/Gestalter/**Jenny Fleet**
Art Editor/Rédacteur Artistique/Kunstredakteur/**Brian Thomas**
Publisher/Editeur/Verlag/**BBC Publications**

Illustration for article on forthcoming season of Hitchcock films on BBC Television,
in 'Radio Times' August 1979. Black and white, in pen and ink.

Illustration pour un article de publicité dans le 'Radio Times' pour une série de
présentations de films Alfred Hitchcock à la BBC Télévision. Noir et blanc,
à la plume et encre.

Illustration zu einem Artikel für eine Hitchcock-Film-Saison im BBC Fernsehen,
in 'Radio Times', August 1979. Schwarzweisse Federzeichnung.

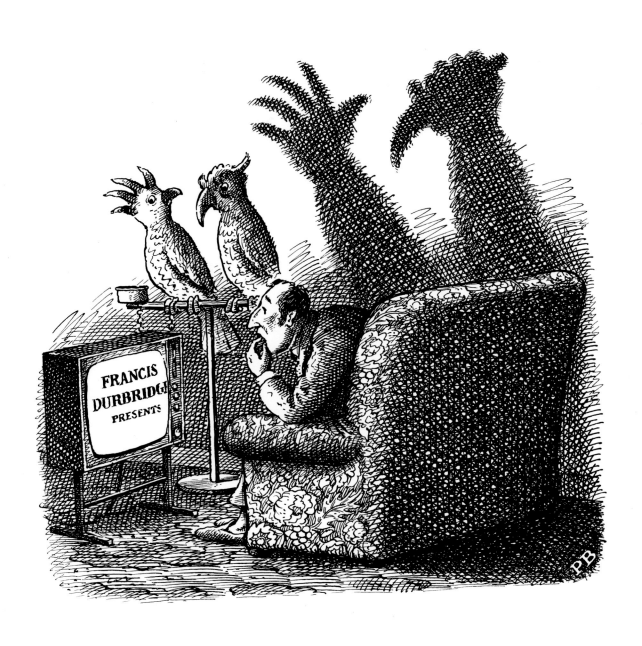

Artist/Artiste/Künstler/**Peter Brookes**
Art Editor/Rédacteur Artistique/Kunstredakteur/**Brian Thomas**
Publisher/Editeur/Verlag/**BBC Publications**

Illustration to publicise Francis Durbridge serial on BBC Television, in 'Radio
Times' 8 March 1980. Black and white, in ink.

Illustration pour un article de publicité, dans le 'Radio Times' pour une série de
présentations de films Francis Durbridge à la BBC télévision. Noir et blanc, en encre.

Illustration zu einem Artikel für eine Francis-Durbridge-Film-serie im BBC
Fernsehen, in 'Radio Times' August 1979. Schwarzweisse Federzeichnung.

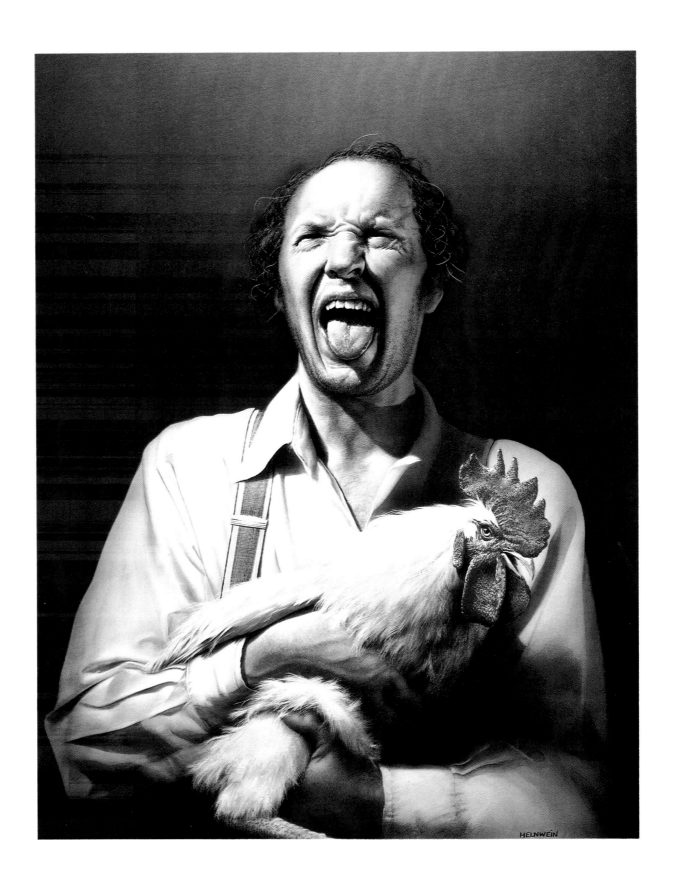

54

Artist/Artiste/Künstler/**Gottfried Helnwein**
Art Director/Directeur Artistique/**Manfred Manke**
Publisher/Editeur/Verlag/**Zeit Magazine**

Illustration for an article "Ein See von Selbstgebranntem"
(A Sea of Self-Immolation) by Michail Bulgakow, in 'Zeit'. Water-colour.

Illustration pour un article "Ein See von Selbstgebranntem" (Une Mer de Sacrifiés)
par Michail Bulgagow, dans 'Zeit'. Aquarelle.

Illustration für einen Artikel "Ein See von Selbstgebranntem"
von Michail Bulgakow, in 'Zeit'. Wasserfarben.

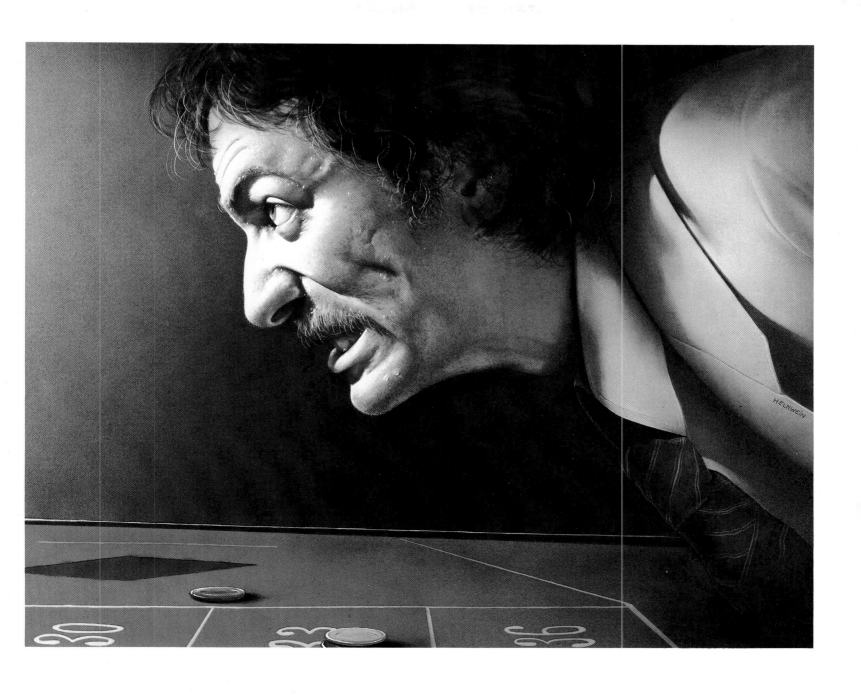

55

Artist/Artiste/Künstler/**Gottfried Helnwein**
Art Director/Directeur Artistique/**Karl-Heinz Wendlandt**
Publisher/Editeur/Verlag/**New Mag**

Illustration for a story "Die Spieler" (The Players) by Otto Walter Haseloff,
in 'Lui'. Water-colour.

Illustration pour un conte "Die Spieler" (Les Joueurs) par Otto Walter Haseloff,
dans 'Lui'. Aquarelle.

Illustration zur Erzählung "Die Spieler" von Otto Walter Haseloff, in 'Lui'.
Wasserfarben.

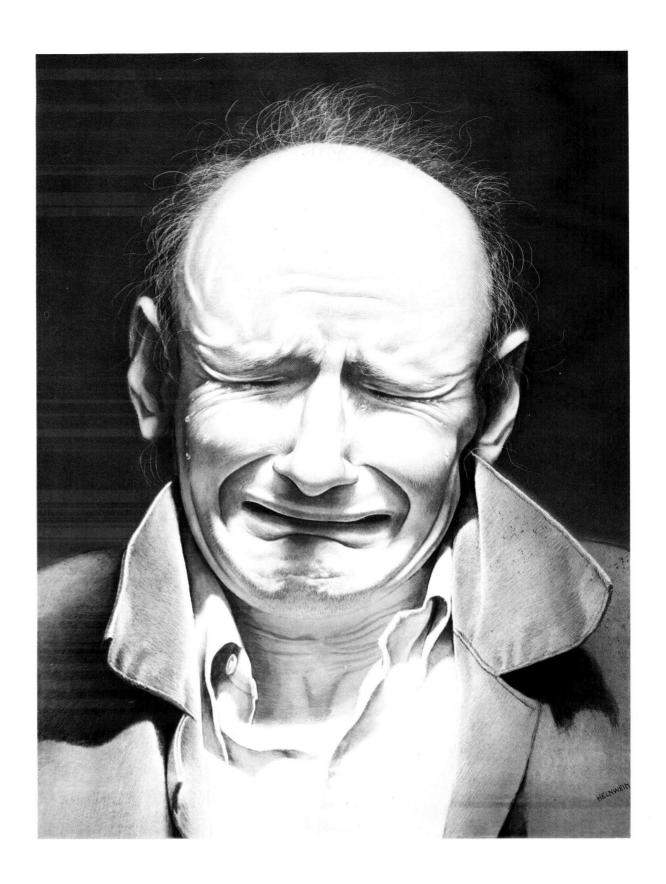

56

Artist/Artiste/Künstler/**Gottfried Helnwein**
Art Director/Directeur Artistique/**Rainer Wörtmann**
Publisher/Editeur/Verlag/**Heinrich Bauer Verlag**

Illustration for "Wie dem Tod die Tränen kamen" (How Death Came to Be in Tears)
by Thomas Brasch, in German 'Playboy' March 1979. Water-colour.

Illustration pour "Wie dem Tod die Tränen kamen"
(Comment les Larmes sont Venues à la Mort) par Thomas Brasch, dans 'Playboy'
allemand mars 1979. Aquarelle.

Illustration fur "Wie dem Tod die Tränen kamen" von Thomas Brasch,
im Deutschen 'Playboy' März 1979. Wasserfarben.

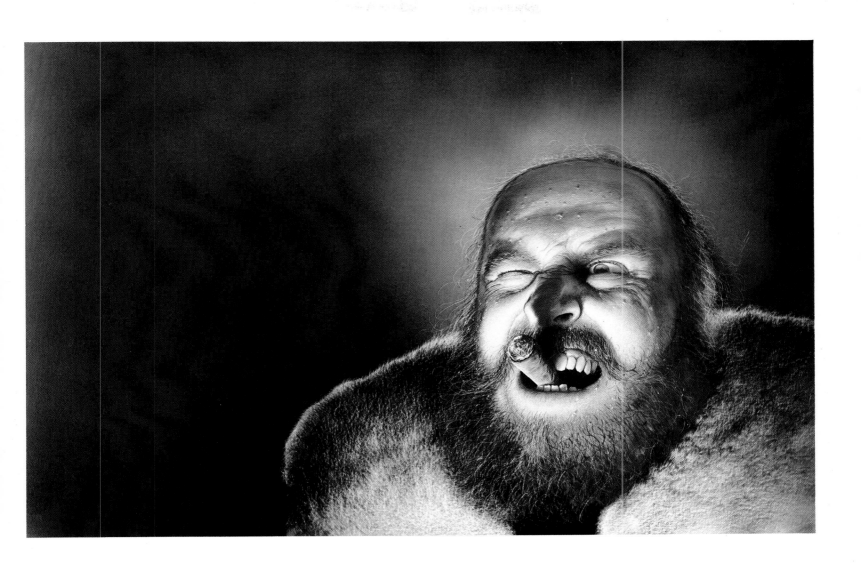

57

Artist/Artiste/Künstler/**Gottfried Helnwein**
Art Director/Directeur Artistique/**Karl-Heinz Wendlandt**
Publisher/Editeur/Verlag/**New Mag**

Illustration for a story "Jakeleffs Gier" (Jakeleff's Greed) by Mattias Weigold, in 'Lui'.
Water-colour.

Illustration pour un conte "Jakeleffs Gier" (L'Avidité de Jakeleff)
par Mattias Weigold, dans 'Lui'. Aquarelle.

Illustration zu einer Erzählung "Jakeleffs Gier" von Mattias Weigold, in 'Lui'.
Wasserfarben.

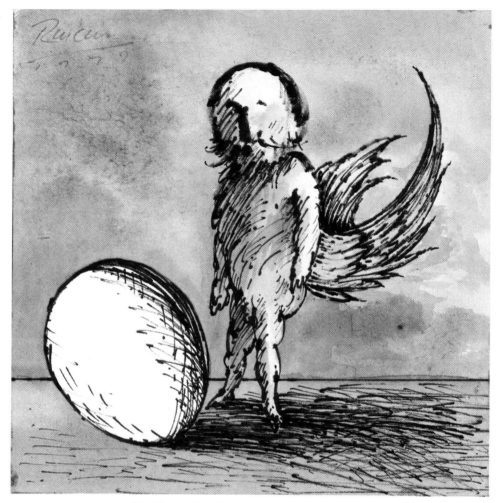

Artist/Artiste/Künstler/**Ken Rinciari**
Designer/Maquettiste/Gestalter/**Henk Maas**
Publisher/Editeur/Verlag/**Media 2000 BV**

Illustration for an article by Prof P C Paardekooper "Een Ik-Verhaal Uit Vlaanderen"
(A Story in the First-Person from Flanders), in 'Zero' March 1980.
Inks and coloured pencils.

Illustration pour un article par Prof P C Paardekooper "Een Ik-Verhaal Uit
Vlaanderen' (Histoire de Flandres à la Première Personne), dans 'Zero' mars 1980.
Encres et crayons de couleur.

Illustration für einen Artikel von Prof P C Paardekooper "Een Ik-Verhaal Uit
Vlaanderen" (Eine Ich-Geschichte aus Flandern), in 'Zero' März 1980.
Tusche und Farbstift.

59

Artist/Artiste/Künstler/**Ken Rinciari**
Designer/Maquettiste/Gestalter/**Henk Maas**
Publisher/Editeur/Verlag/**Media 2000 BV**

Illustration for "De Waalse Agressie" (The Walloon Aggression) by Prof.
P C Paardekooper, in 'Zero' October 1979. Inks and coloured pencils.

Illustration pour "De Waalse Agressie" (L'Agression Wallonne) par Prof.
P C Paardekooper, in 'Zero' octobre 1979. Encres et crayons de couleur.

Illustration für "De Waalse Agressie" (Die Wallonische Agression) von Prof.
P C Paardekooper, in 'Zero' Oktober 1979. Tusche und Farbstifte.

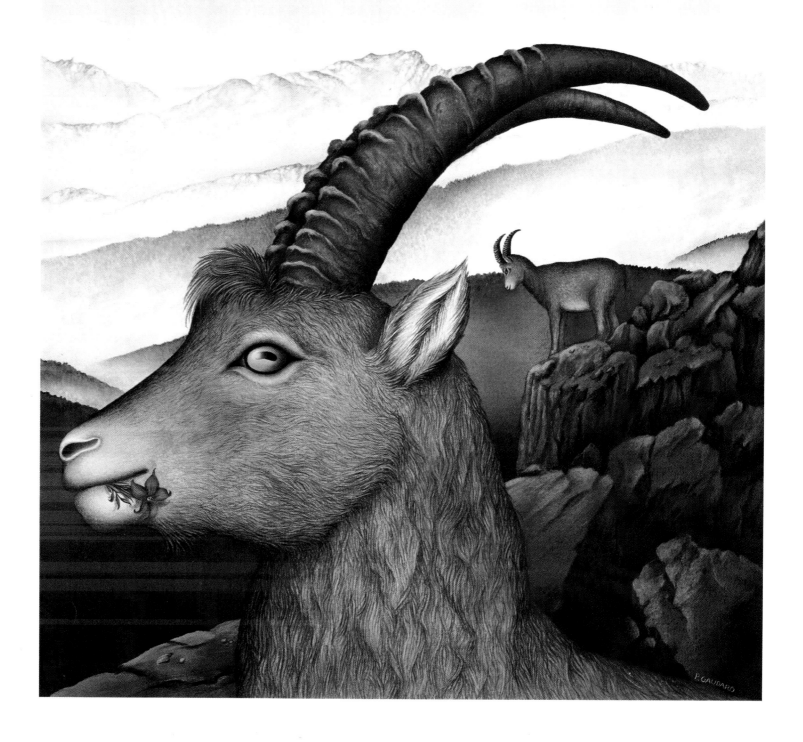

Artist/Artiste/Künstler/**Patrick Gaudard**
Designer/Maquettiste/Gestalter/**Patrick Gaudard**
Art Director/Directeur Artistique/**Etienne Delessert**
Publisher/Editeur/Verlag/**Sonor SA**

Illustration for "Dix Mille Seigneurs" (Ten Thousand Noblemen), in 'La Suisse
Weekend'. Water-colour and inks.

Illustration pour "Dix Mille Seigneurs," dans 'La Suisse Weekend'. Aquarelle et
encres.

Illustration für "Dix Mille Seigneurs" (Zehntausend Adelige), in 'La Suisse
Weekend'. Wasserfarben und Tusche.

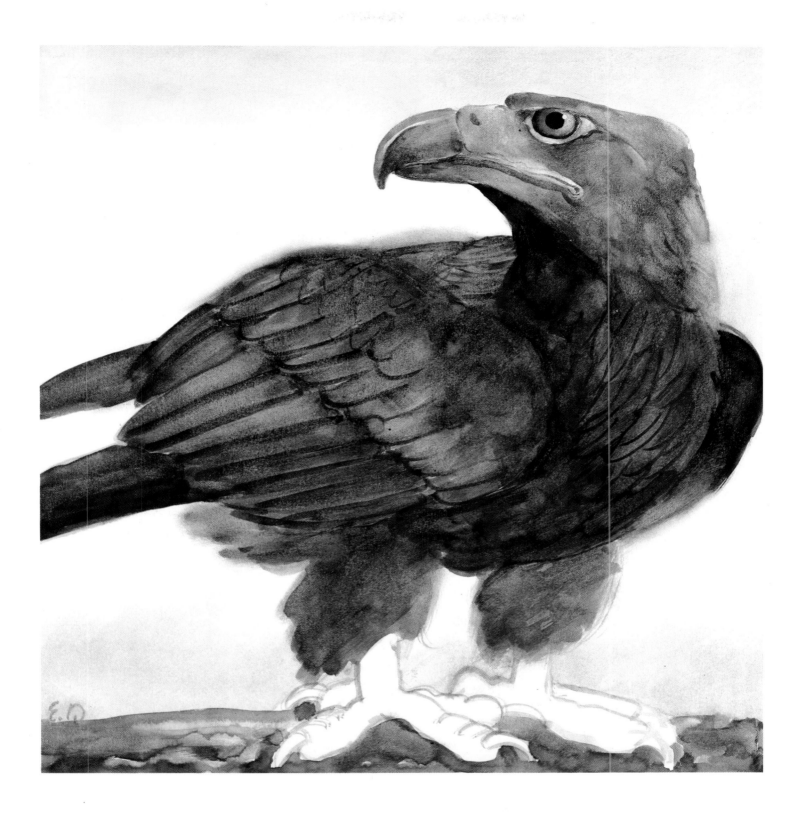

61

Artist/Artiste/Künstler/**Etienne Delessert**
Art Director/Directeur Artistique/**Etienne Delessert**
Publisher/Editeur/Verlag/**Sonor SA**

Illustration for "Les Aigles ou la Vie de Château" (Eagles or Chateau Life), in
'La Suisse Weekend'. Water-colour.

Illustration pour "Les Aigles ou la Vie de Château," dans 'La Suisse Weekend'.
Aquarelle.

Illustration für "Les Aigles ou la Vie de Château" (Die Adler oder Das Leben auf
dem Schloss), in 'La Suisse Weekend'. Wasserfarben.

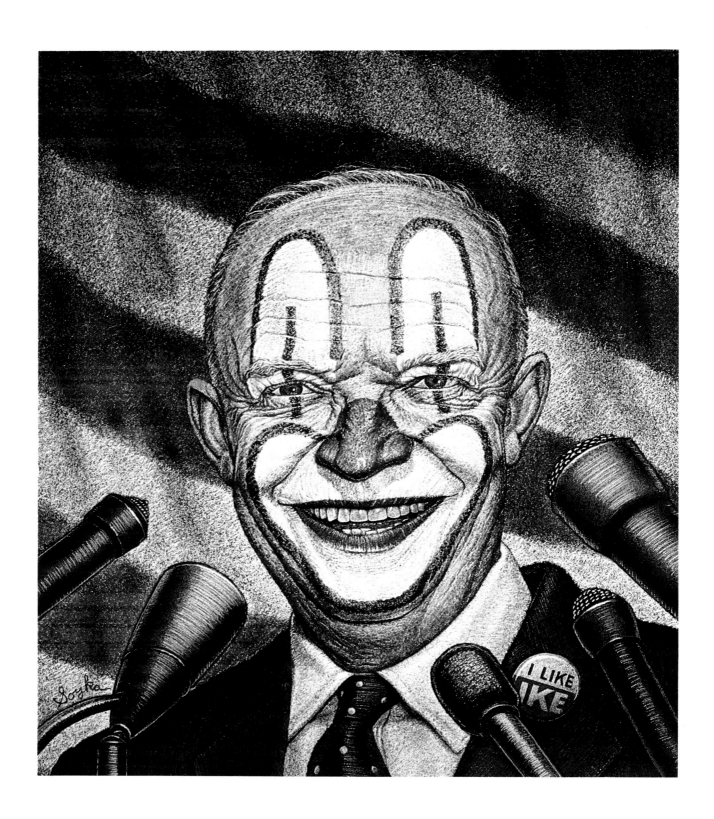

62

Artist/Artiste/Künstler/**Ed Soyka**
Designers/Maquettistes/Gestalter/**Barbara Jane Galbraith, Derek Ungless**
Art Director/Directeur Artistique/**Robert Priest**
Publisher/Editeur/Verlag/**Montreal Standard Incorporated**

Illustration for "The Eisenhower Years" by James Eayrs, in 'Weekend Magazine'
March 1979. Acrylic paint.

Illustration pour "The Eisenhower Years" (Les Années Eisenhower) par
James Eayrs, dans 'Weekend Magazine' mars 1979. Peinture acrylique.

Illustration für "The Eisenhower Years" (Die Eisenhower-Ära) von James Eayrs,
in 'Weekend Magazine' März 1979. Acrylfarbe.

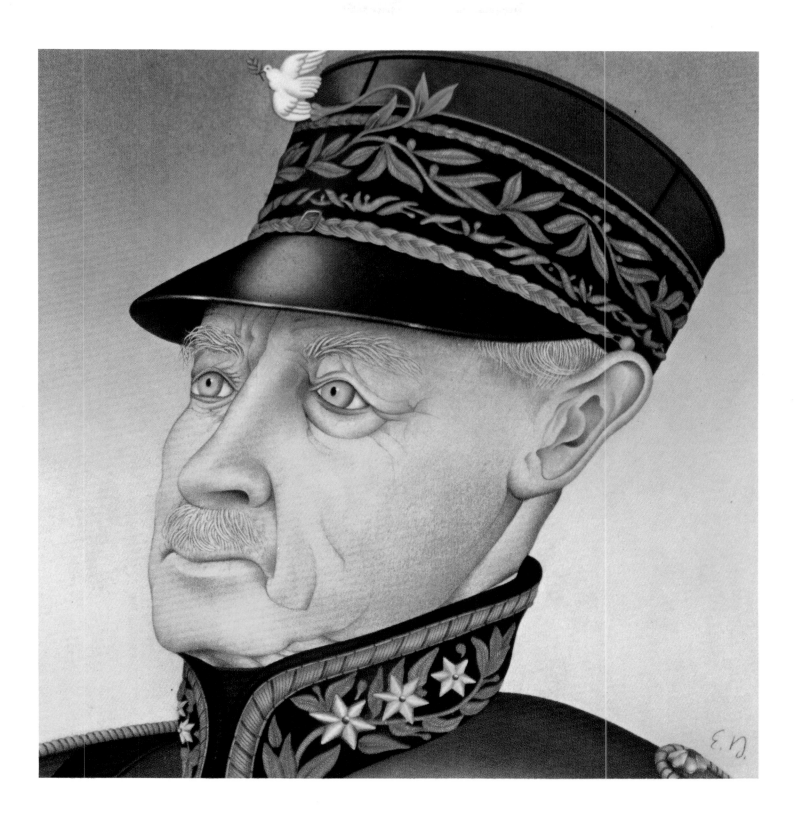

63

Artist/Artiste/Künstler/**Etienne Delessert**
Art Director/Directeur Artistique/**Etienne Delessert**
Publisher/Editeur/Verlag/**Sonor SA**

Illustration for "Les Trois Premiers Jours" (The Three First Days), a portrait of
General Guisan, in 'La Suisse Weekend' supplement. Inks and pencil.

Illustration pour "Les Trois Premiers Jours," un portrait du Général Guisan, dans le
supplément de 'La Suisse Weekend.' Encres et crayon.

Illustration für "Les Trois Premiers Jours" (Die ersten drei Tage), Bildnis des
General Guisan, in 'La Suisse Weekend' Beilage. Tusche und Bleistift.

64

Artist/Artiste/Künstler/**Guy Merat**
Art Director/Directeur Artistique/**Etienne Delessert**
Publisher/Editeur/Verlag/**Sonor SA**

Illustration for "Diane Dufresne: Je suis Folle!" (Diane Dufresne: I am Crazy!), in 'La Suisse Weekend'. Inks and pencil.

Illustration pour "Diane Dufresne: Je suis Folle!," dans 'La Suisse Weekend'. Encres et crayon.

Illustration für "Diane Dufresne: Je suis Folle!" (Diane Dufresne: Ich bin Wahnsinnig!), in 'La Suisse Weekend'. Tusche und Bleistift.

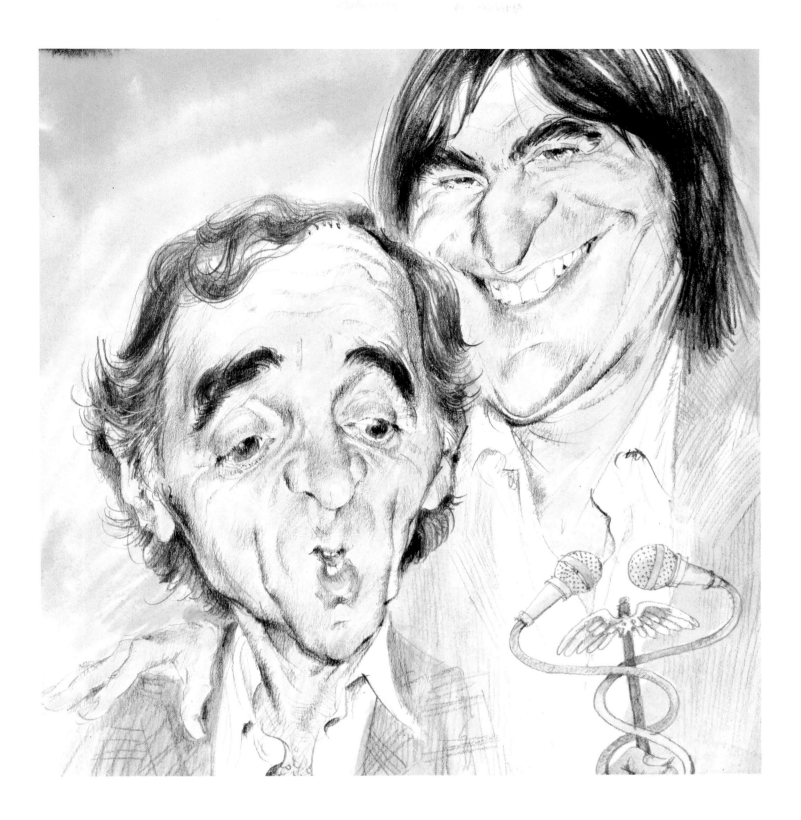

65

Artist/Artiste/Künstler/**Paul-Perret**
Art Director/Directeur Artistique/**Etienne Delessert**
Publisher/Editeur/Verlag/**Sonor SA**

Illustration for "Aznavour-Lama: La Grande Java," in 'La Suisse Weekend'. Charcoal
and water-colour.

Illustration pour "Aznavour-Lama: La Grande Java," dans 'La Suisse Weekend'.
Fusain et aquarelle.

Illustration für "Aznavour-Lama: La Grande Java" in 'La Suisse Weekend'. Kohle
und Wasserfarben.

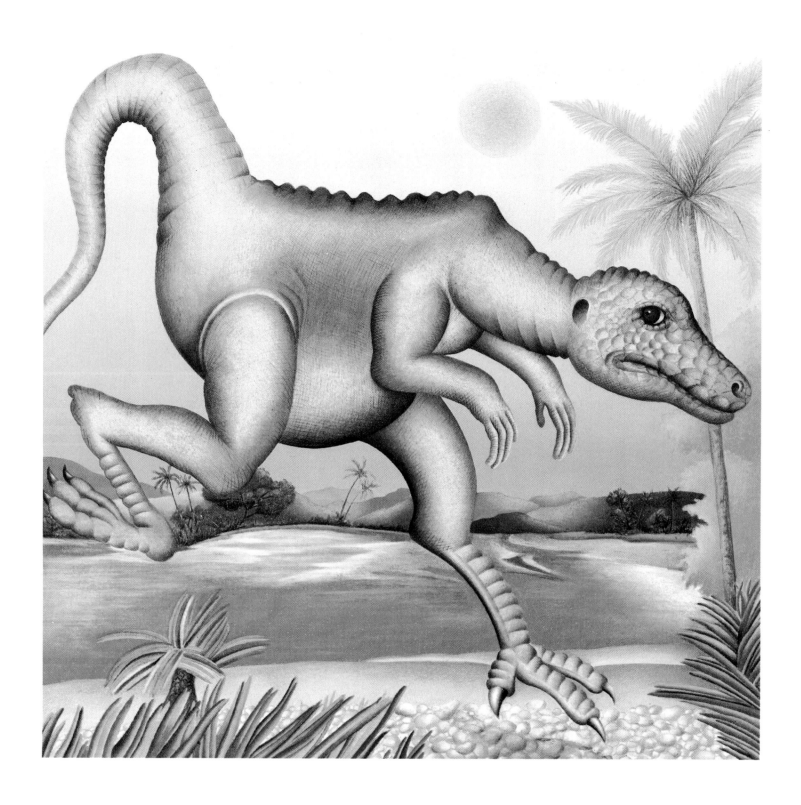

66

Artist/Artiste/Künstler/**Etienne Delessert**
Art Director/Directeur Artistique/**Etienne Delessert**
Publisher/Editeur/Verlag/**Sonor SA**

Cover illustration for "La Rivière des Dinosaures," in 'La Suisse Weekend'
supplement. Inks and pencil.

Illustration de couverture pour "La Rivière des Dinosaures" dans le supplément
de 'La Suisse Weekend'. Encres et crayon.

Illustration für die Titelseite zu "La Rivière des Dinosaures" (Die Riviera der
Dinosaurier), in 'La Suisse Weekend' Beilage. Tusche und Bleistift.

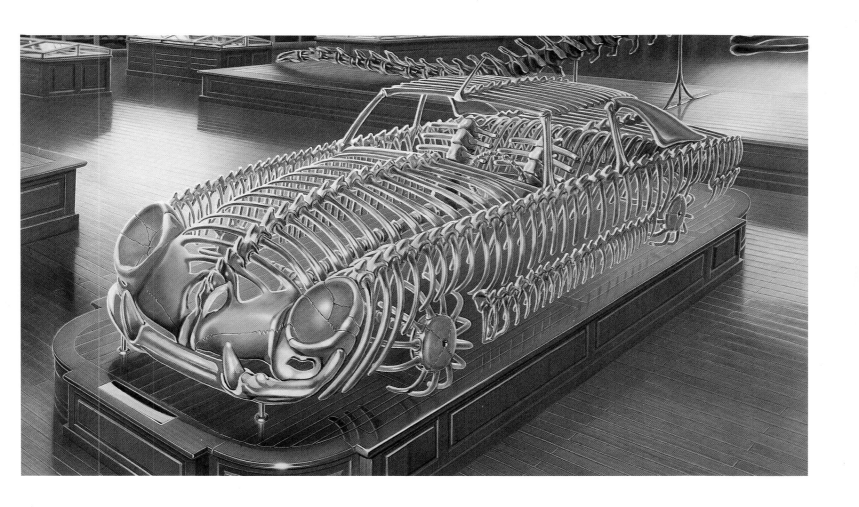

67

Artist/Artiste/Künstler/**Jean Luc Falque**
Art Director/Directeur Artistique/**Jean-Marie Moisan**
Publisher/Editeur/Verlag/**Shell Française**

Illustration for "La Vitesse c'est la Préhistoire" (Speed is Prehistoric), in
'New Drivers'. Acrylic and air brush.

Illustration pour "La Vitesse c'est la Préhistoire," dans 'New Drivers'.
Acrylique et aérographe.

Illustration für "La Vitesse c'est la Préhistoire" (Geschwindigkeit ist Prähistorisch),
in 'New Drivers'. Acryl und Spritzpistole.

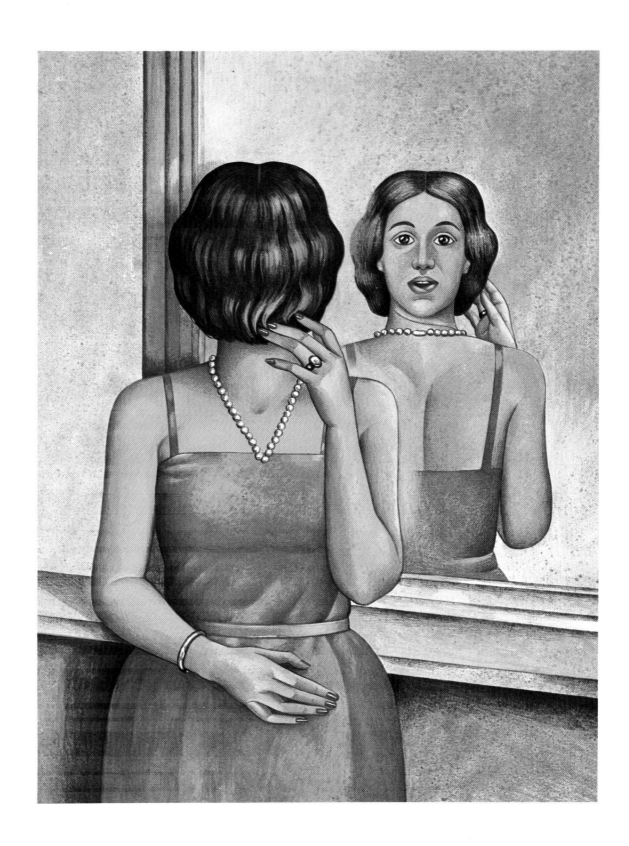

68

Artist/Artiste/Künstler/**Iris de Paoli**
Art Director/Directeur Artistique/**Rodolfo Rinaldini**
Publisher/Editeur/Verlag/**Gruppo Rizzoli – Corriere Della Sera**

Illustration for "Torcicollo, Che Fare?" (Stiff Neck – What to Do?) by
Vittorio Massaari, in 'Salve' October 1979. Full colour, in acrylic paint.

Illustration pour "Torcicollo, Che Fare?" (Torticolis, que faire?) par Vittorio
Massaari, dans 'Salve' octobre 1979. Couleur, en acrylique.

Illustration für "Torcicollo, Che Fare?" (Steifer Nacken – Was Kann Man Tun?) von
Vittorio Massaari, in 'Salve' Oktober 1979. Acrylfarbe.

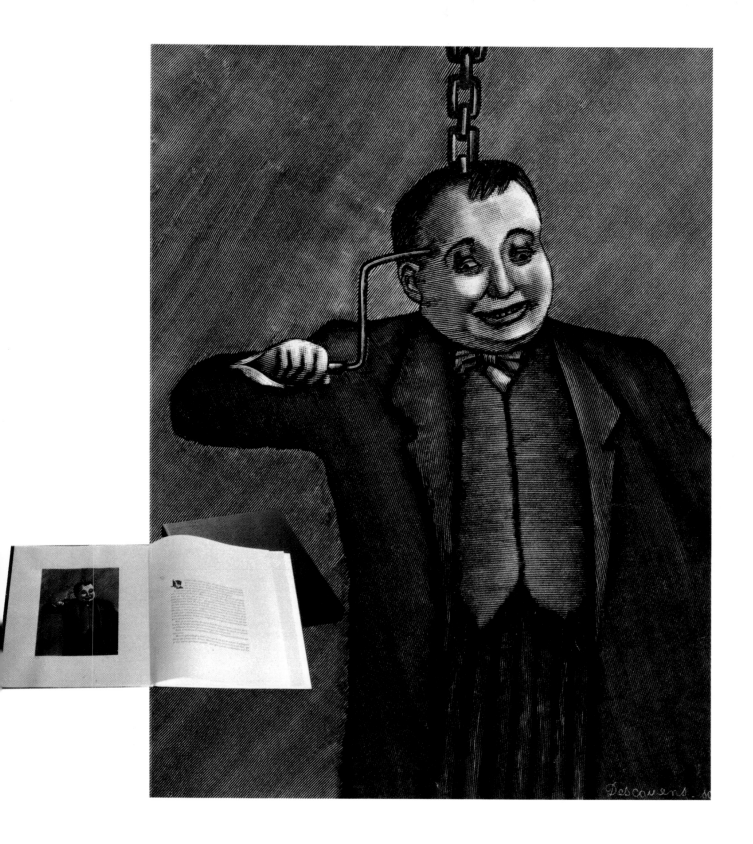

69

Artist/Artiste/Künstler/**Roland Topor**
Designer/Maquettiste/Gestalter/**Louis Voogt**
Art Director/Directeur Artistique/**Dick de Moei**
Publisher/Editeur/Verlag/**De Geïllustreerde Pers BV**

Illustration for "Gallery Avenue," an interview with Roland Topor by Jan Kuijper
and Cathy Hemmer, in 'Avenue' April 1980. Coloured engraving.

Illustration pour "Gallery Avenue," une interview avec Roland Topor par
Jan Kuijper et Cathy Hemmer, dans 'Avenue' avril 1980. Gravure en couleur.

Illustration für "Gallery Avenue," ein Interview mit Roland Topor von Jan Kuijper
und Cathy Hemmer, in 'Avenue' April 1980. Farbgravierung.

70

Artist/Artiste/Künstler/**Russell Mills**
Art Editor/Rédacteur Artistique/Kunstredakteur/**Christine Jones**
Publisher/Editeur/Verlag/**IPC Magazines Limited**

Front and back cover illustration entitled "Past, Imperfect, Future Tense" – an
advent calendar depicting topics featured in 'New Scientist', Christmas 1979 issue.
Water-colour.

Illustration de couverture dessus et dessous intitulée "Past, Imperfect, Future Tense"
(Temps passé, imparfait et futur) – calendrier de l'Avent montrant les sujets traités
dans 'New Scientist', numéro de Noel 1979. Aquarelle.

Titel und Rückseiten Illustration betitelt "Past, Imperfect, Future Tense"
(Vergangenheit, Imperfekt, Zukunft) – ein Adventskalender der die Themen in 'New
Scientist' darstellt, Weihnachtsausgabe 1979. Wasserfarben.

71

Artist/Artiste/Künstler/**Russell Mills**
Designers/Maquettistes/Gestalter/**Barbara Jane Galbraith, Derek Ungless**
Art Director/Directeur Artistique/**Robert Priest**
Publisher/Editeur/Verlag/**Montreal Standard Incorporated**

Illustration for "The Strange Case of Jeremy Thorpe" by Auberon Waugh, in
'Weekend Magazine' April 1979. Water-colour and collage.

Illustration pour "The Strange Case of Jeremy Thorpe" (Le Cas Étrange de
Jeremy Thorpe) par Auberon Waugh, dans 'Weekend Magazine' avril 1979.
Aquarelle et collage.

Illustration für "The Strange Case of Jeremy Thorpe" (Der merkwürdige Prozess
des Jeremy Thorpe) von Auberon Waugh, in 'Weekend Magazine' April 1979.
Wasserfarben und Collage.

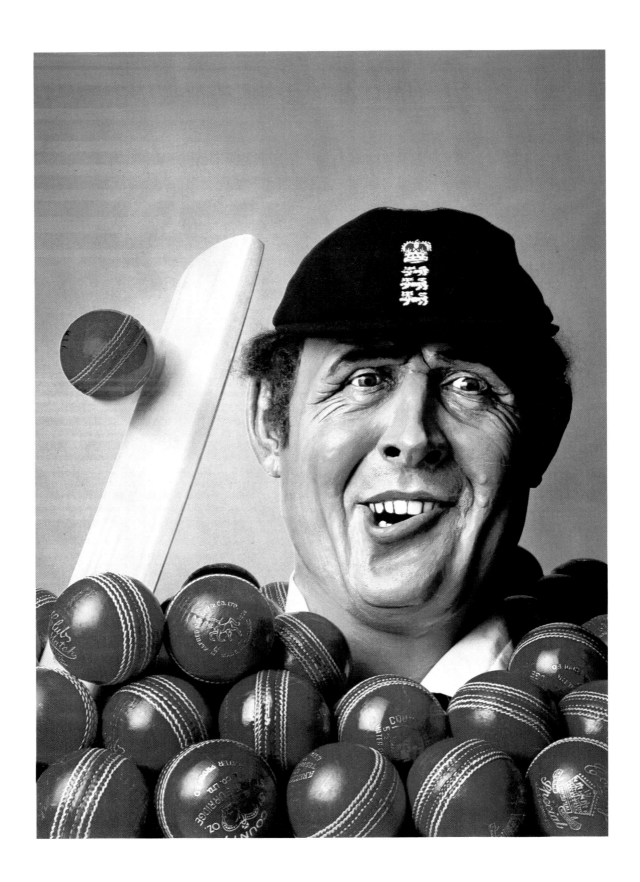

72

Artist/Artiste/Künstler/**Vince Farrell**
Art Director/Directeur Artistique/**Sue Howe**
Art Editor/Rédacteur Artistique/Kunstredakteur/**Tom Reynolds**
Publisher/Editeur/Verlag/**Cavenham Communications Limited**
Photographer/**Peter Hall**

Illustration of Geoff Boycott for a feature by Angela Patmore, "Mysteries of the Master Batsman," in 'Now!' 22 February 1980. Model, in full colour.

Illustration de Geoff Boycott pour un article par Angela Patmore, "Mysteries of the Master Batsman" (Les Mystères du Maître Batteur), dans 'Now!' le 22 février 1980. Modèle, en couleur.

Illustration von Geoff Boycott für einen Bericht von Angela Patmore, "Mysteries of the Master Batsman" (Die Geheimnisse um den Kricketstar) in 'Now!' 22. Februar 1980. Farbmodell.

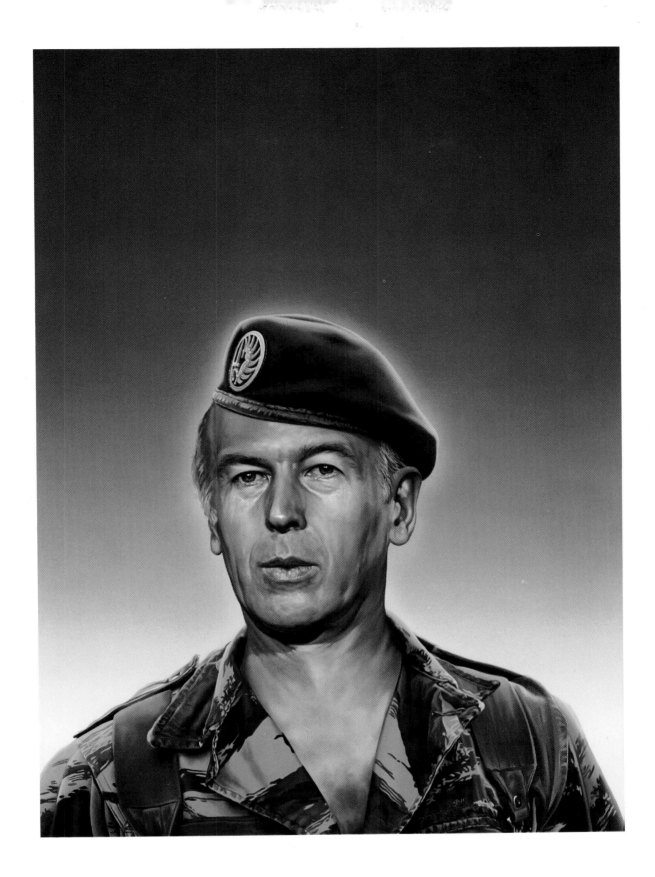

73

Artist/Artiste/Künstler/**Pierre Peyrolle**
Art Director/Directeur Artistique/**Georges Lacroix**
Publisher/Editeur/Verlag/**Journal Express**

Cover illustration for an article, "L'Interventionnisme Militaire de
Valéry Giscard d'Estaing en Afrique" (Valéry Giscard d'Estaing's Military
Interventionism in Africa), 'L'Express' 14 July 1979. Oils.

Illustration de couverture pour un article, "L'Interventionnisme
Militaire de Valéry Giscard d'Estaing en Afrique," 'L'Express' 14 juillet 1979. Huile.

Illustrierte Titelseite zum Artikel "L'Interventionnisme Militaire de
Valéry Giscard d'Estaing en Afrique" (Valéry Giscard d'Estaing's militärisches
Eingreifen in Afrika), 'L'Express' 14. Juli 1979. Ölfarben.

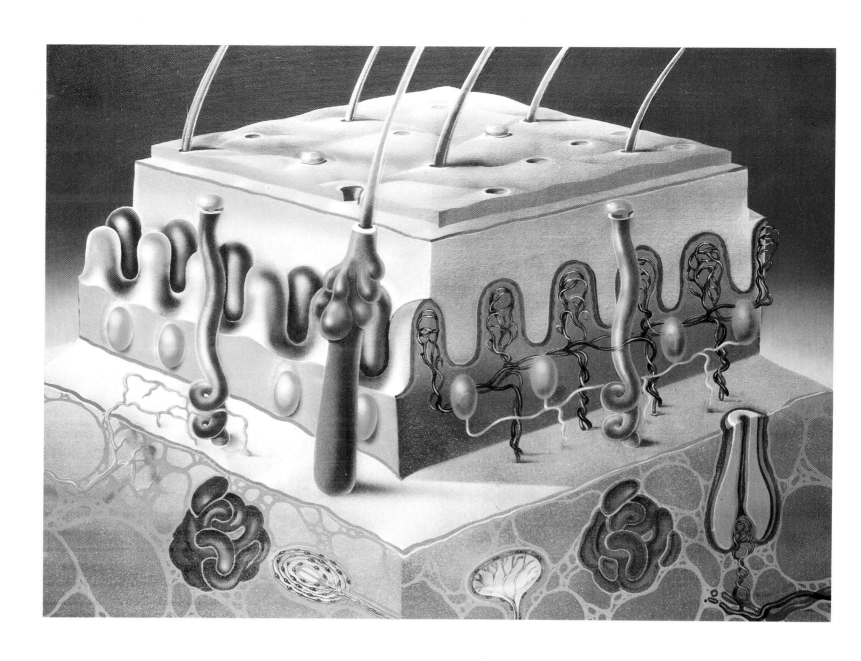

Artist/Artiste/Künstler/**Ulrich Österwalder**
Art Directór/Directeur Artistique/**Dieter Meyer**
Publisher/Editeur/Verlag/**Gruner & Jahr AG & Co**

Illustration for "Gesundheitslexikon für die Frau" (Woman's Health Dictionary),
section by Regina Rusch, in 'Brigitte' 9 January 1980. Acrylic paint.

Illustration pour "Gesundheitslexikon für die Frau" (Dictionnaire de Santé de la
Femme), section par Regina Rusch, dans 'Brigitte' le 9 janvier 1980. Acrylique.

Illustration für "Gesundheitslexikon für die Frau" Beitrag von Regina Rusch, in
'Brigitte' 9. Januar 1980. Acrylfarben.

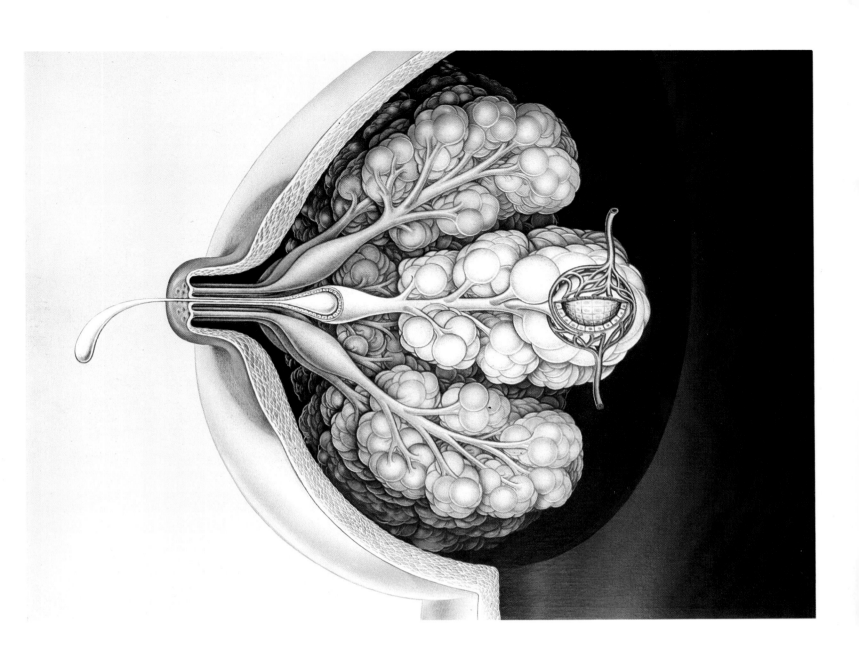

Artist/Artiste/Künstler/**Ulrich Österwalder**
Art Director/Directeur Artistique/**Dieter Meyer**
Publisher/Editeur/Verlag/**Gruner & Jahr AG & Co**

Illustration for "Gesundheitslexikon für die Frau" (Woman's Health Dictionary),
section by Renate Scholz, in 'Brigitte' 2 April 1980. Acrylic paint.

Illustration pour "Gesundheitslexikon für die Frau" (Dictionnaire de Santé de la
Femme), section par Renate Scholz, dans 'Brigitte' le 2 avril 1980. Acrylique.

Illustration für "Gesundheitslexikon für die Frau" Beitrag von Renate Scholz, in
'Brigitte' 2. April 1980. Acrylfarben.

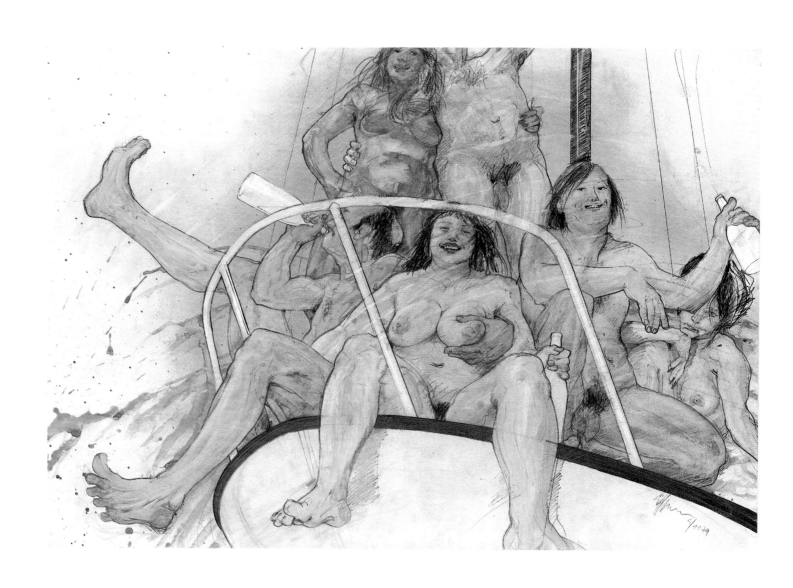

Artist/Artiste/Künstler/**Erhard Göttlicher**
Designer/Maquettiste/Gestalter/**George Guther**
Art Director/Directeur Artistique/**Rainer Wörtmann**
Publisher/Editeur/Verlag/**Heinrich Bauer Verlag**

Illustration for an article "Der Betriebsunfall" (Industrial Accident) by Georg Lentz,
in German 'Playboy' September 1979. Pencil and water-colour.

Illustration pour un article "Der Betriebsunfall" (L'Accident Industriel)
par Georg Lentz, dans 'Playboy' allemand 1979. Crayon et aquarelle.

Illustration für einen Artikel "Der Betriebsunfall" von Georg Lentz, im Deutschen
'Playboy' September 1979. Bleistift und Wasserfarben.

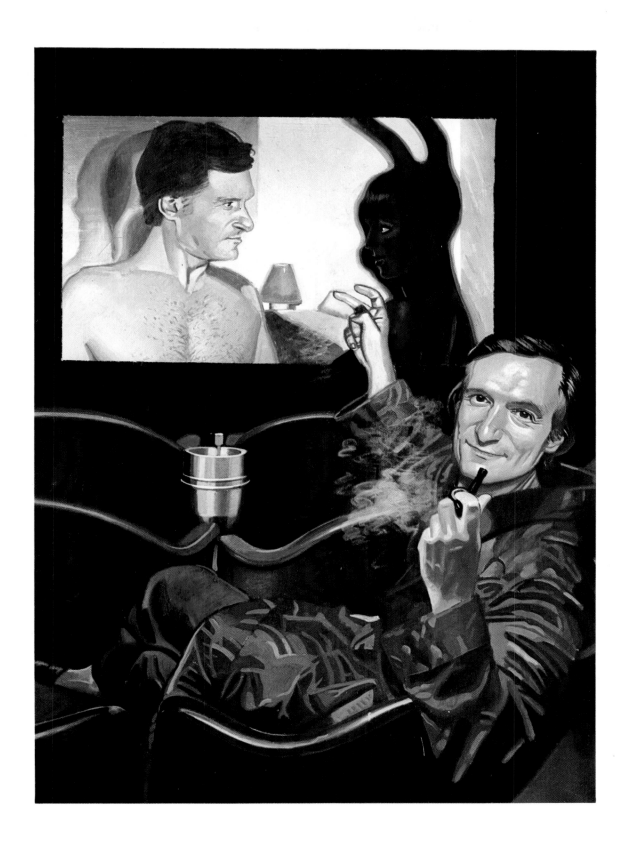

Artist/Artiste/Künstler/**Julian Allen**
Designer/Maquettiste/Gestalter/**April Silver**
Art Director/Directeur Artistique/**Robert Priest**
Publisher/Editeur/Verlag/**Esquire Incorporated**

Illustration for "The Erotic History of Hugh Heffner" by Gay Talese, in 'Esquire'
December 1979. Oils.

Illustration pour "The Erotic History of Hugh Heffner"
(L'histoire Érotique de Hugh Heffner) par Gay Talese,
dans 'Esquire' décembre 1979. Huile.

Illustration für "The Erotic History of Hugh Heffner"
(Die Erotische Geschichte von Hugh Heffner) von Gay Talese,
in 'Esquire' Dezember 1979. Ölfarben.

Artist/Artiste/Künstler/**André Thijssen**
Designer/Maquettiste/Gestalter/**André Thijssen**
Art Editor/Rédacteur Artistique/Kunstredakteur/**Dick de Moei**
Publisher/Editeur/Verlag/**De Geïllustreerde Pers BV**

Illustration for an article "Gorgonzola, Drie Blauwe Kazen"
(Gorgonzola, Three Blue Cheeses) by Wina Born, in 'Avenue' January 1979.
Gouache and coloured pencils.

Illustration pour un article intitulé "Gorgonzola, Drie Blauwe Kazen"
(Gorgonzola, Trois Fromages Bleues) par Wina Born, dans 'Avenue' janvier 1979.
Gouache et crayons de couleur.

Illustration für einen Artikel betitelt "Gorgonzola, Drie Blauwe Kazen"
(Gorgonzola, Drei Blaue Käse) von Wina Born, in 'Avenue' Januar 1979.
Gouache und Farbstifte.

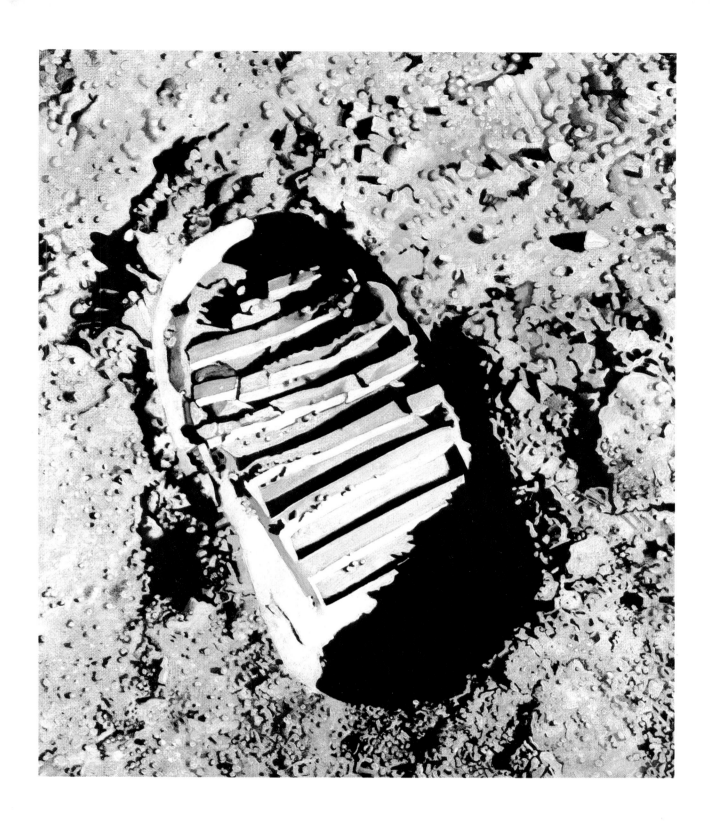

79

Artist/Artiste/Künstler/**Julian Allen**
Designer/Maquettiste/Gestalter/**Derek Ungless**
Art Director/Directeur Artistique/**Robert Priest**
Publisher/Editeur/Verlag/**Montreal Standard Incorporated**

Cover illustration for "Man on the Moon," in 'Weekend Magazine' July 1979.
Acrylic paint.

Illustration de couverture pour "Man on the Moon" (L'homme sur la Lune),
dans 'Weekend Magazine' juillet 1979. Peinture acrylique.

Titelseite zu "Man on the Moon" (Der Mann auf dem Mond),
in 'Weekend Magazine' Juli 1979. Acrylfarben.

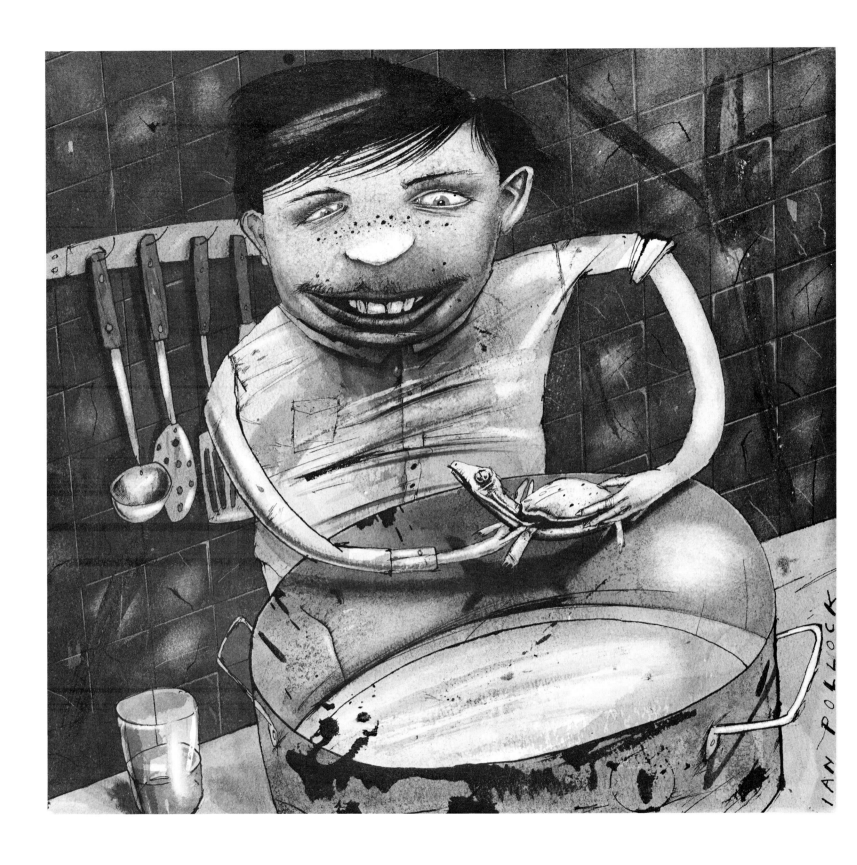

80

Artist/Artiste/Künstler/**Ian Pollock**
Art Editor/Rédacteur Artistique/Kunstredakteur/**Janice Butler**
Publisher/Editeur/Verlag/**IPC Magazines Limited**

Illustration for a story "The Terrapin" by Patricia Highsmith, in 'Honey' March 1980.
Black and white, in ink.

Illustration pour une histoire "The Terrapin" (Le Terrapin) par Patrica Highsmith,
dans 'Honey' mars 1980. Noir et blanc, en encre.

Illustration für eine Erzählung "The Terrapin" (Die Dosenschildkröte)
von Patrica Highsmith, in 'Honey' März 1980. Schwarzweisse Federzeichnung.

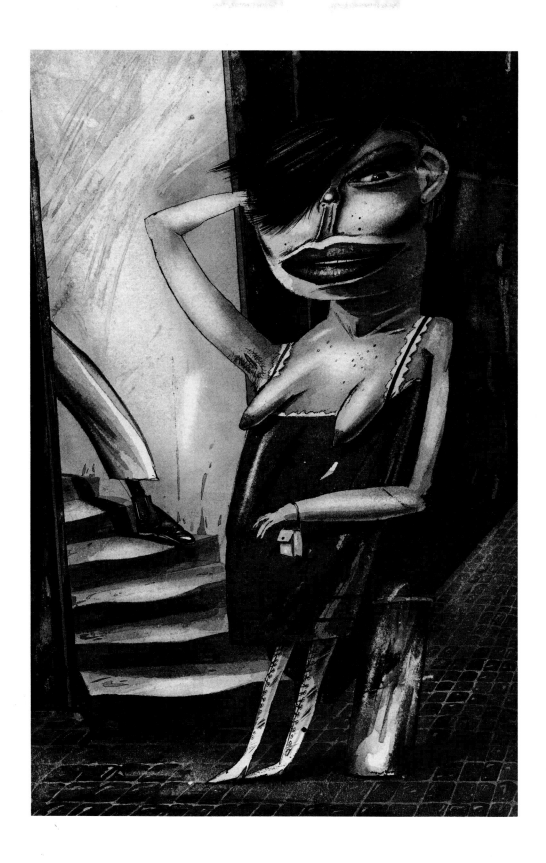

81

Artist/Artiste/Künstler/**Ian Pollock**

Unpublished illustration entitled "Whore by Steps," one of a series of drawings
of prostitutes. Black and white, in rotoring ink.

Illustration non publiée intitulée "Whore by Steps" (Prostituée par de Marches),
un d'une série de dessins de prostituées. Noir et blanc, en encre rotorique.

Unveröffentlichte Illustration betitelt "Whore by Steps" (Prostituierte vor Treppe),
Zeichnung einer Serie über Prostituierte. Schwarzweiss, Tusche.

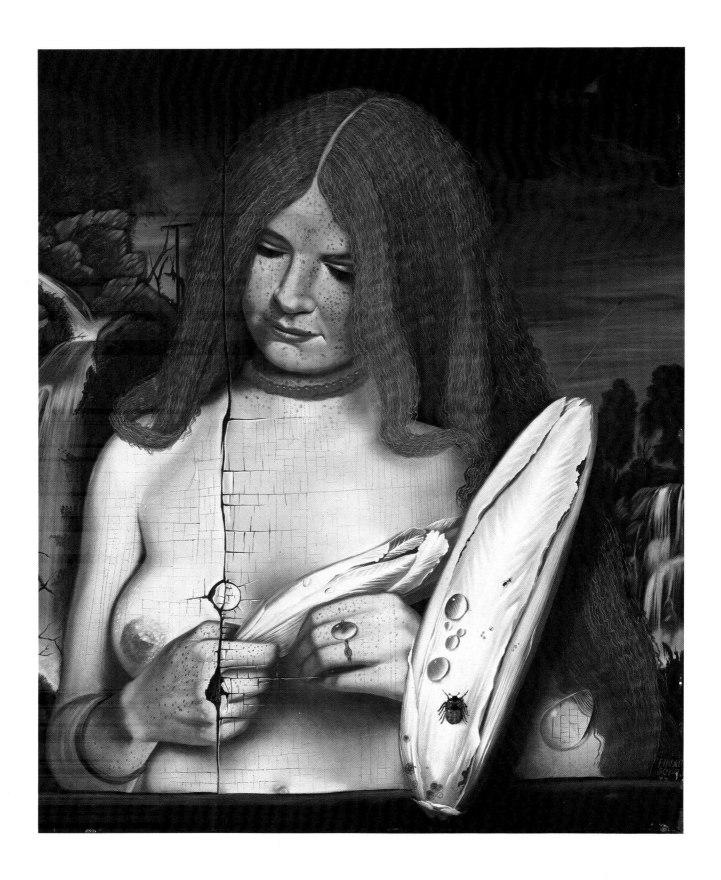

Artist/Artiste/Künstler/**Manfred Scharpf**
Designer/Maquettiste/Gestalter/**Christl Böhm**
Art Director/Directeur Artistique/**Rainer Wörtmann**
Publisher/Editeur/Verlag/**Heinrich Bauer Verlag**

Illustration for "Chicoree macht Sinnlich" (Chickory Makes You Naughty) by
Günter Schweinsberg, in German 'Playboy' 1979. Acrylic on wood.

Illustration pour "Chicoree macht Sinnlich" (La Chicorée rend Sensuel) par
Günter Schweinsberg, dans 'Playboy' allemand 1979. Acrylique sur bois.

Illustration zu "Chicoree macht sinnlich" von Günter Schweinsberg, im deutschen
'Playboy' 1979. Acryl auf Holz.

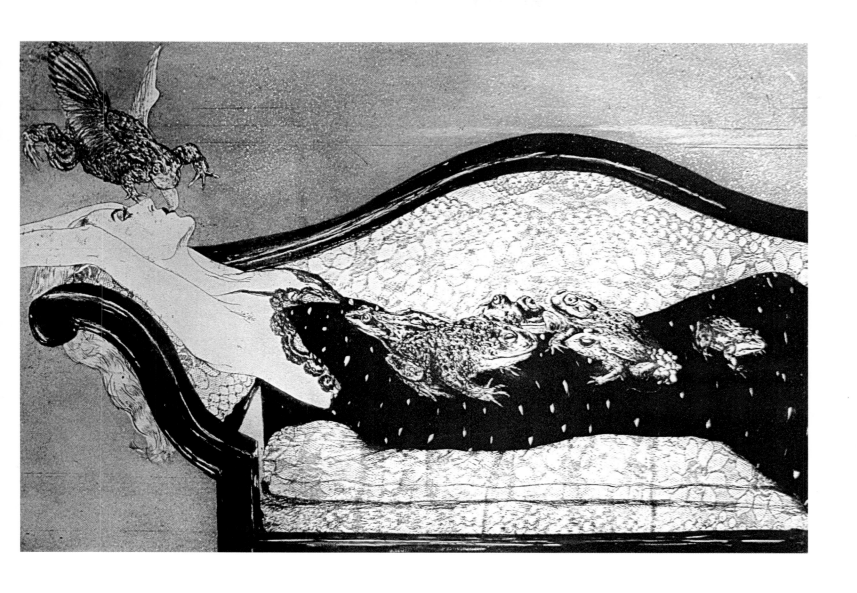

83
Artist/Artiste/Künstler/Tom Wenner
Unpublished illustration for artists's own portfolio. Etching.
Illustration non-publiée pour le propre carton de l'artiste. Eau-forte.
Unveröffentlichte Illustration für die persönliche Mappe des Künstlers. Radierung.

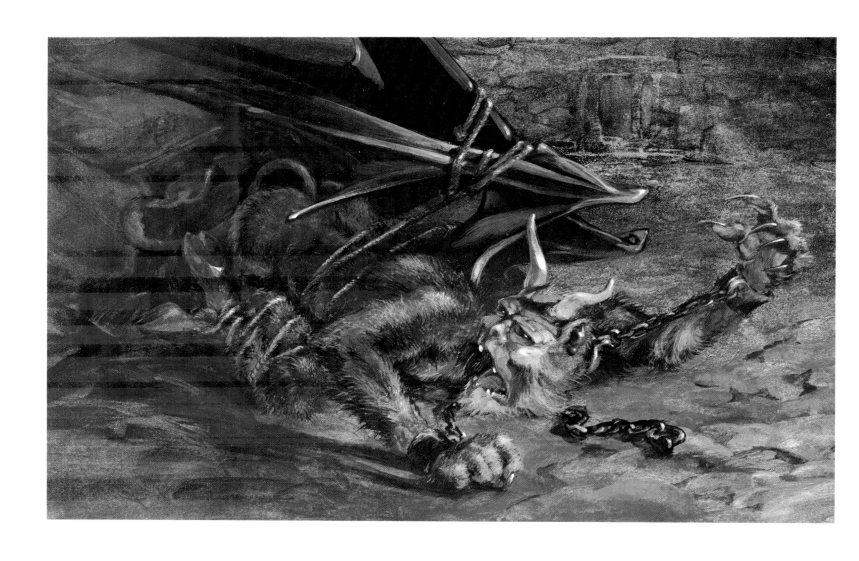

84

Artist/Artiste/Künstler/**Manus Hüller**
Art Director/Directeur Artistique/**Siegfried Rieschen**
Publisher/Editeur/Verlag/**Gruner & Jahr AG & Co**

Illustration for a story by P J Blumenthal, K Gröper and P Moosleitner,
"Der Teufel ist Doch Längst Entmachtet – Oder?" (The Devil has been out of Power
for a long Time – Or Has He?), in 'P.M'. April 1980. Tempera-colour.

Illustration pour une histoire de P J Blumenthal, K Gröper und P Moosleitner,
"Der Teufel ist Doch Längst Entmachtet – Oder?" (Le Diable est-il vraiment Resté
Longtemps Incapable d'Action?), dans 'P.M'. avril 1980. Détrempé.

Illustration zu einer Erzählung von P J Blumenthal, K Gröper und P Moosleitner,
"Der Teufel ist Doch Längst Entmachtet – Oder?," in 'P.M'. April 1980. Temperafarbe.

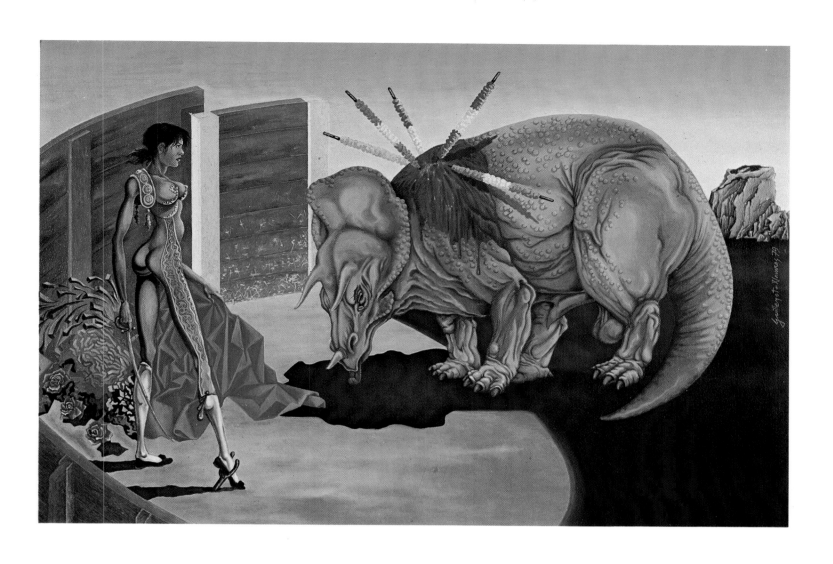

Artist/Artiste/Künstler/**Guillemot Navares**
Art Director/Directeur Artistique/**Francisco Crosta**
Publisher/Editeur/Verlag/**Editorial Zeta**

Illustration for "La Tauromachie" (The Bullfight) by Alicia Tomas, the first lady
bullfighter, in 'Penthouse' January 1980. Oil on wood.

Illustration pour "La Tauromachie" par Alicia Tomas, la première femme toréro,
dans 'Penthouse' janvier 1980. Huile sur bois.

Illustration für "La Tauromachie" (Der Stierkampf) von Alicia Tomas, der erste
weibliche Matador, in 'Penthouse' Januar 1980. Öl auf Holz.

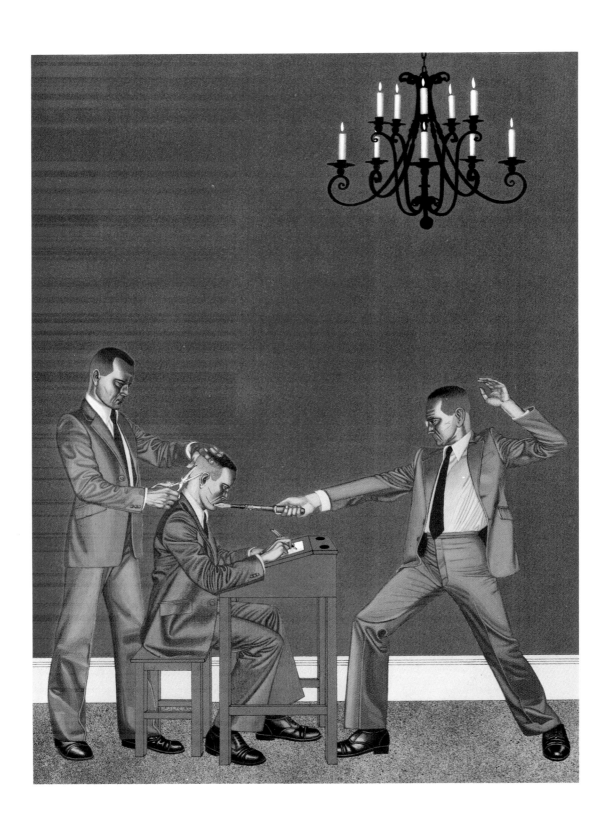

86

Artist/Artiste/Künstler/**Robin Harris**
Art Director/Directeur Artistique/**Van Pulmen**
Publisher/Editeur/Verlag/**Manager Magazin Verlagsgesellschaft**

Illustration for a feature "Ritual and Ratio" by Prof Dr Reinhard Höhns, in
'Manager Magazin' 10 October 1979. Acrylic paint.

Illustration pour un article "Ritual and Ratio" (Rites et Raison) par Prof
Dr Reinhard Höhns, dans 'Manager Magazin' le 10 octobre 1979. Peinture acrylique.

Illustration für einen Bericht "Ritual and Ratio" (Ritual und Ratio) von Prof
Dr Reinhard Höhns, in 'Manager Magazin' 10. Oktober 1979. Acrylfarbe.

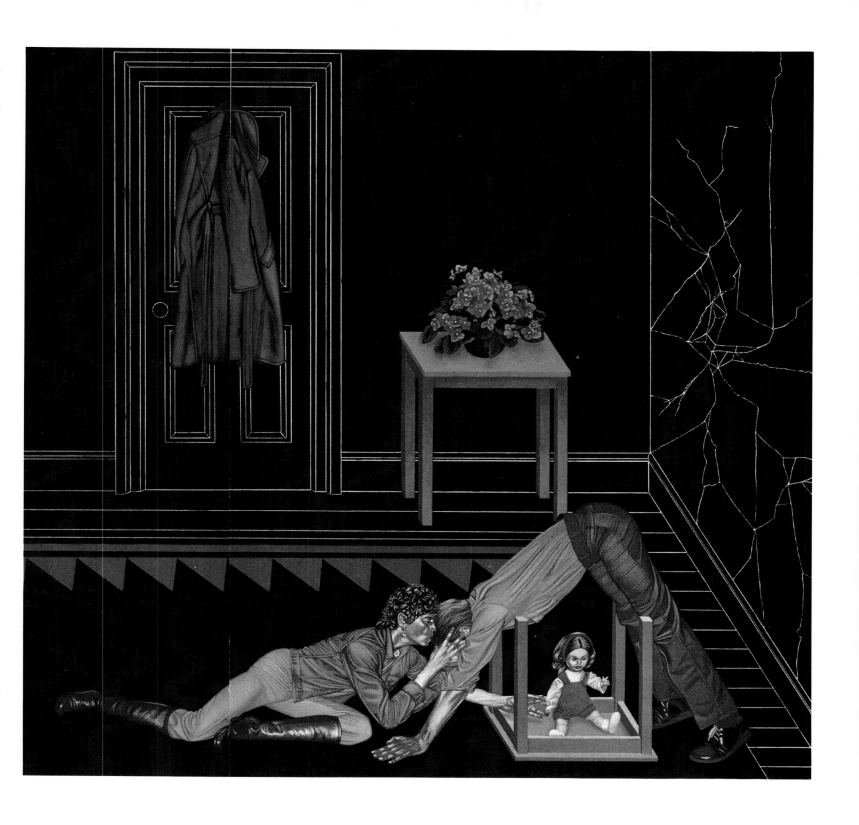

87

Artist/Artiste/Künstler/**Robin Harris**
Designer/Maquettiste/Gestalter/**Derek Ungless**
Art Director/Directeur Artistique/**Robert Priest**
Publisher/Editeur/Verlag/**Esquire Incorporated**

Illustration for a story "An Old Three a.m. Story" by John Clayton, in 'Esquire'
January 1980. Acrylic paint.

Illustration pour une histoire "An Old Three a.m. Story" par John Clayton
(Une vieille histoire de trois heures du matin), dans 'Esquire' janvier 1980.
Peinture acrylique.

Illustration zu einer Erzählung "An Old Three a.m. Story" von John Clayton
(Eine alte Geschichte für drei Uhr morgens), erschienen im 'Esquire' Januar 1980.
Acryl.

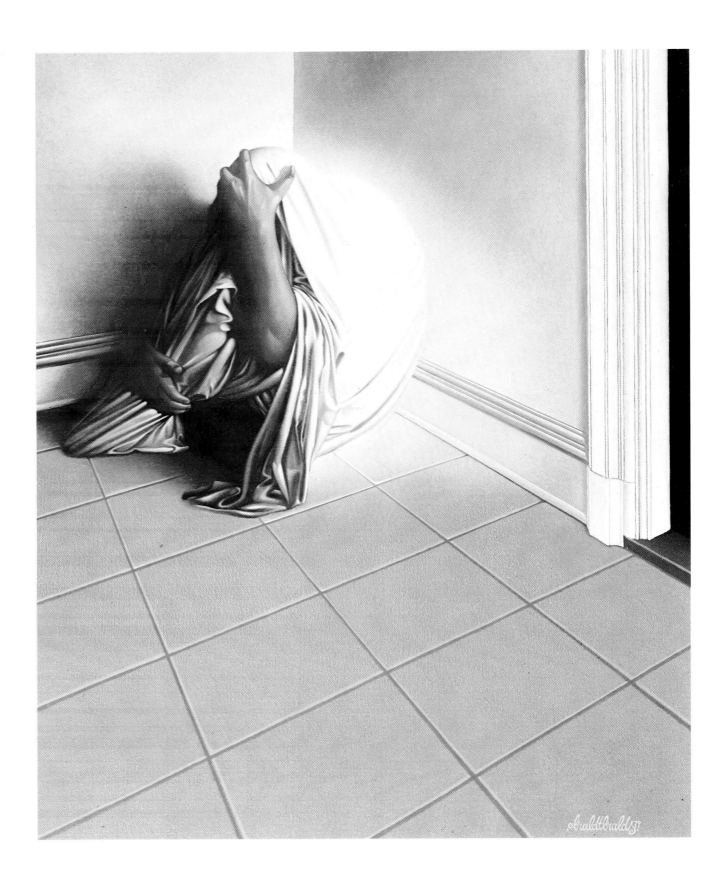

Artist/Artiste/Künstler/**Braldt Bralds**
Designer/Maquettiste/Gestalter/**Hans van Blommenstein**
Art Director/Directeur Artistique/**Dick de Moei**
Publisher/Editeur/Verlag/**De Geillustreerde Pers BV**

Illustration for "Psoriasis" by Joke Schretlen, in 'Avenue' February 1980. Oils.

Illustration pour "Psoriasis" par Joke Schretlen, dans 'Avenue' février 1980. Huile.

Illustration für "Psoriasis" von Joke Schretlen, in 'Avenue' Februar 1980. Ölfarben.

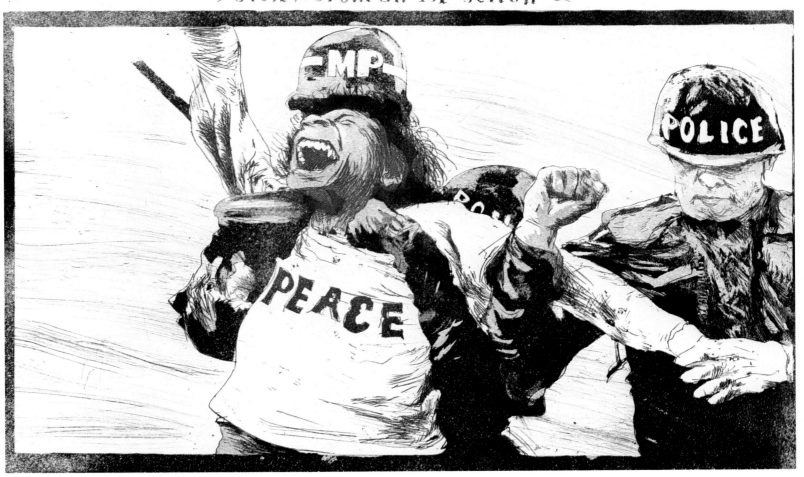

89

Artist/Artiste/Künstler/**Tom Wenner**

Unpublished illustration entitled "Peace," for artist's own portfolio. Etching.

Illustration non publiée intitulée "Peace" (Paix), pour le propre carton de l'artiste.
Eau-forte.

Unveröffentlichte Illustration betitelt "Peace" (Frieden), für die persönliche Mappe
des Künstlers. Radierung.

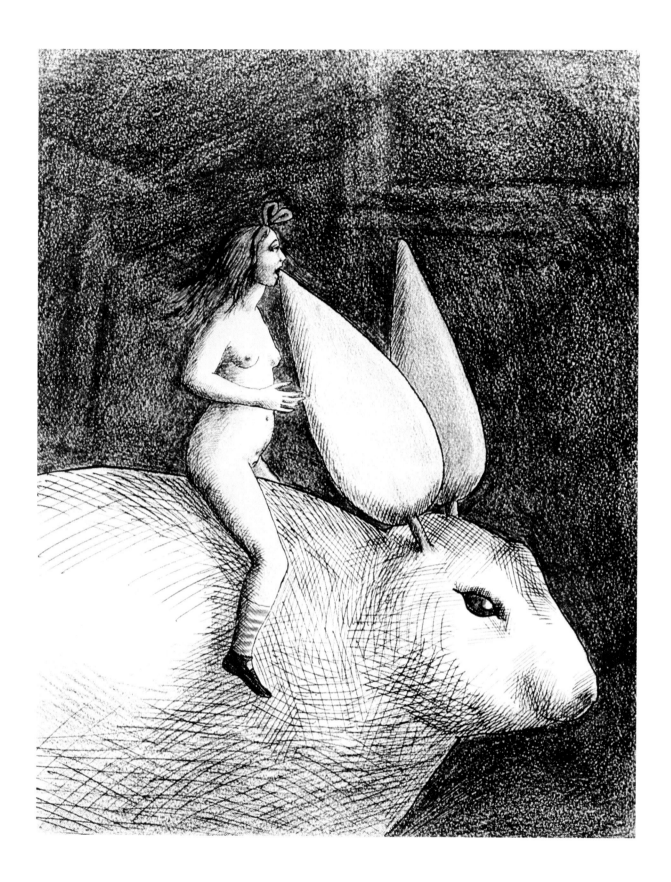

Artist/Artiste/Künstler/Peter Till
Art Editor/Rédacteur Artistique/Kunstredakteur/Robert Priest
Publisher/Editeur/Verlag/**Montreal Standard Incorporated**

Illustration for an article reassessing the media theories of Marshall McLuhan, in
'Weekend Magazine' 28 July 1979. Pen, ink and coloured pencils.

Illustration pour un article réévaluant les théories des média de Marshall McLuhan,
dans 'Weekend Magazine' le 28 juillet 1979. Plume, encre et crayons de couleur.

Illustration zu einem Artikel, in dem die Medien-Theorien von Marshall McLuhan
neu durchdacht werden, in 'Weekend Magazine' 28. Juli 1979. Schreibfeder, Tusche
und Farbstifte.

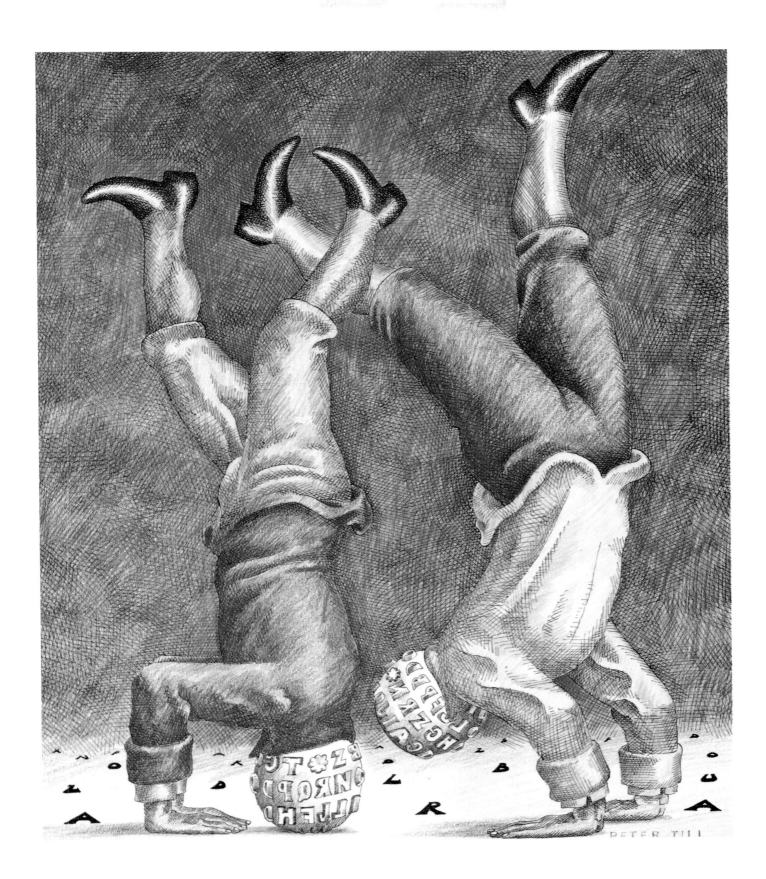

91

Artist/Artiste/Künstler/**Roland Topor**
Designer/Maquettiste/Gestalter/**Louis Voogt**
Art Director/Directeur Artistique/**Dick de Moei**
Publisher/Editeur/Verlag/**De Geïllustreerde Pers BV**

Illustration for "Gallery Avenue," an interview with Roland Topor by Jan Kuijper
and Cathy Hemmer, in 'Avenue' April 1980. Coloured engraving.

Illustration pour "Gallery Avenue," une interview avec Roland Topor par Jan
Kuijper et Cathy Hemmer, dans 'Avenue' avril 1980. Gravure en couleur.

Illustration für "Gallery Avenue," ein Interview mit Roland Topor von Jan Kuijper
und Cathy Hemmer, in 'Avenue' April 1980. Farbgravierung.

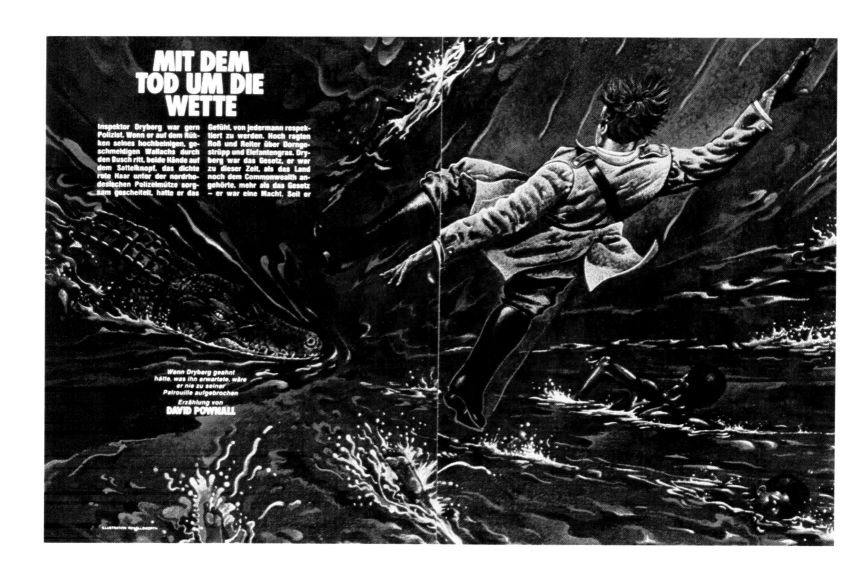

MIT DEM TOD UM DIE WETTE

Inspektor Dryberg war gern Polizist. Wenn er auf dem Rükken seines hochbeinigen, geschmeidigen Wallachs durch den Busch ritt, beide Hände auf dem Sattelknopf, das dichte rote Haar unter der nordrhodesischen Polizeimütze sorgsam gescheitelt, hatte er das Gefühl, von jedermann respektiert zu werden. Hoch ragten Roß und Reiter über Dorngestrüpp und Elefantengras. Dryberg war das Gesetz, er war zu dieser Zeit, als das Land noch dem Commonwealth angehörte, mehr als das Gesetz – er war eine Macht. Seit er

Wenn Dryberg geahnt hätte, was ihn erwartete, wäre er nie zu seiner Patrouille aufgebrochen

Erzählung von
DAVID POWNALL

92

Artist/Artiste/Künstler/**Keith McEwan**
Designer/Maquettiste/Gestalter/**George Guther**
Art Directors/Directeurs Artistiques/**Wolf Thieme, Rainer Wörtmann**
Publisher/Editeur/Verlag/**Heinrich Bauer Verlag**

Illustration for a story "Mit dem Tod um die Wette" (A Race with Death)
by David Pownell, in German 'Playboy' 1979. Oils.

Illustration pour une histoire "Mit dem Tod um die Wette"
(Une Course avec la Mort) par David Pownell, dans 'Playboy' allemand 1979.
Huile.

Illustration für "Mit dem Tod um die Wette" von David Pownell, im Deutschen
'Playboy' 1979. Ölfarbe.

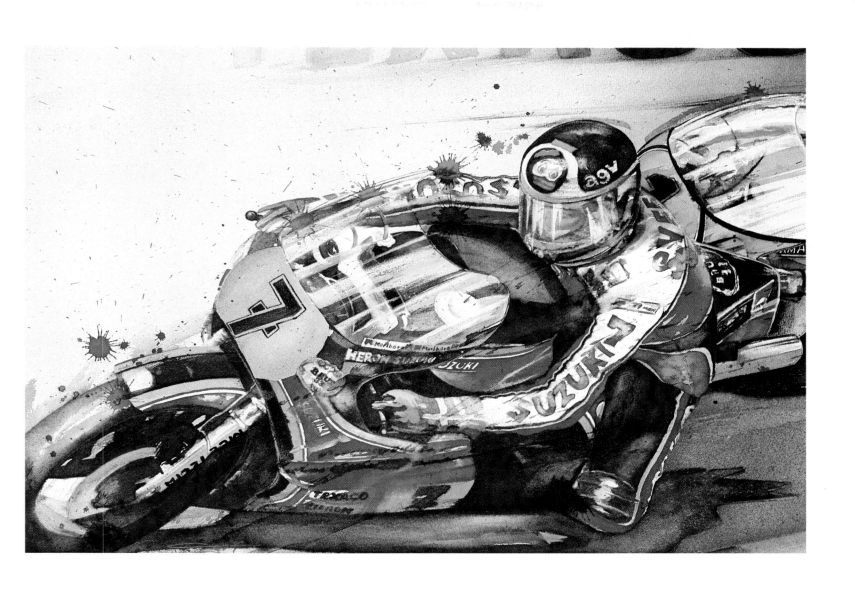

93

Artist/Artiste/Künstler/**Rolf Witt**
Art Director/Directeur Artistique/**Rainer Wörtmann**
Publisher/Editeur/Verlag/**Heinrich Bauer Verlag**

Illustration for the Barry Sheene story "Gib Gas und Knie Nieder" (Accelerate and Kneel Down) by Herbert Völker, in German 'Playboy' February 1980. Water-colour.

Illustration pour l'histoire de Barry Sheene "Gib Gas und Knie Nieder" (À Fond et Genou Plié) par Herbert Völker, dans 'Playboy' allemand février 1980. Aquarelle.

Illustration für die Barry Sheene Erzählung "Gib Gas und knie nieder" von Herbert Völker, im Deutschen 'Playboy' Februar 1980. Wasserfarben.

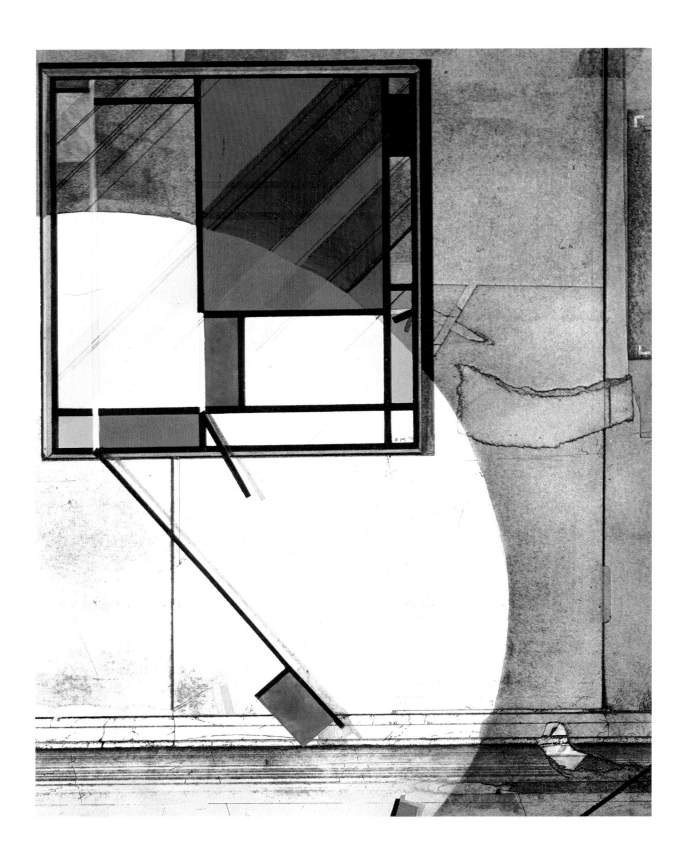

94

Artist/Artiste/Künstler/**Russell Mills**
Designers/Maquettistes/Gestalter/**Louise Moreau, Derek Ungless**
Art Director/Directeur Artistique/**Robert Priest**
Publisher/Editeur/Verlag/**Montreal Standard Incorporated**

Illustration for an article "Taking Pictures" by Winston Collins, in 'Weekend Magazine'. The illustration is one of a series of four works entitled "Art Theft – Taking Pictures." Mixed media.

Illustration pour un article "Taking Pictures" (Prise de Tableaux) de Winston Collins, dans 'Weekend Magazine'. L'illustration provient d'une série de quatre oeuvres intitulée "Vol d'oeuvres d'art – Prise de Tableaux." Moyens divers.

Illustration für einen Artikel "Taking Pictures" (Bildaufnahme) von Winston Collins, in 'Weekend Magazine'. Die Illustration gehört zu einer Reihe von vier Werken betitelt "Kunstdiebstahl – Bildaufnahme." Mediakombination.

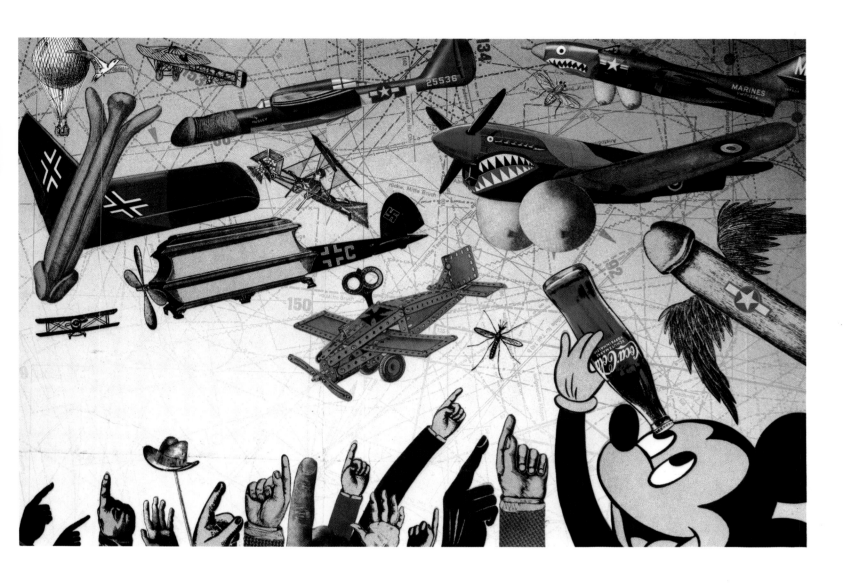

95

Artist/Artiste/Künstler/**Bohumil Stepan**
Designer/Maquettiste/Gestalter/**George Guther**
Art Director/Directeur Artistique/**Rainer Wörtmann**
Publisher/Editeur/Verlag/**Heinrich Bauer Verlag**

Illustration for "Veteranen der Lüfte" (Veterans of the Skies) by Rudolf Braunberg,
in German 'Playboy' 1979. Painted collage.

Illustration pour "Veteranen der Lüfte" (Vétérans de l'Air) par Rudolf Braunberg,
dans 'Playboy' allemand 1979. Collage peint.

Illustration zu "Veteranen der Lüfte" von Rudolf Braunberg,
im Deutschen 'Playboy' 1979. Bemalte Collage.

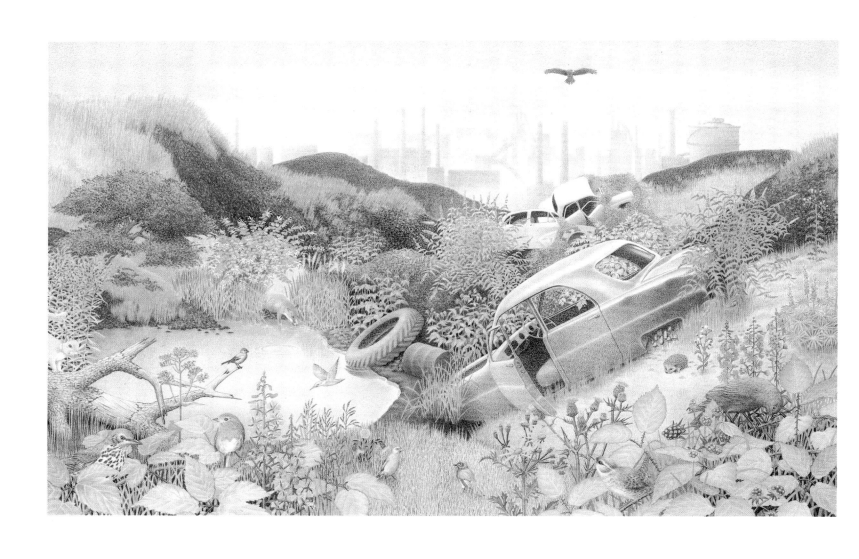

Artist/Artiste/Künstler/**Angus Grey-Burbridge**
Designer/Maquettiste/Gestalter/**Angus Grey-Burbridge**
Publisher/Editeur/Verlag/**The Observer Limited**

Illustration for "The Teeming Wildlife of an Urban Blightscape" by Ena Kendall,
in 'The Observer Magazine'. Coloured crayon.

Illustration pour "The Teeming Wildlife of an Urban Blightscape" (La Faune
Grouillante d'un Paysage Urbain Désolé) par Ena Kendall, dans 'The Observer
Magazine'. Pastel de couleur.

Illustration für "The Teeming Wildlife of an Urban Blightscape" (Das wimmelnde
Dschungelleben der städtischen Betonlandschaft) von Ena Kendall, in
'The Observer Magazine'. Bunte Kreide.

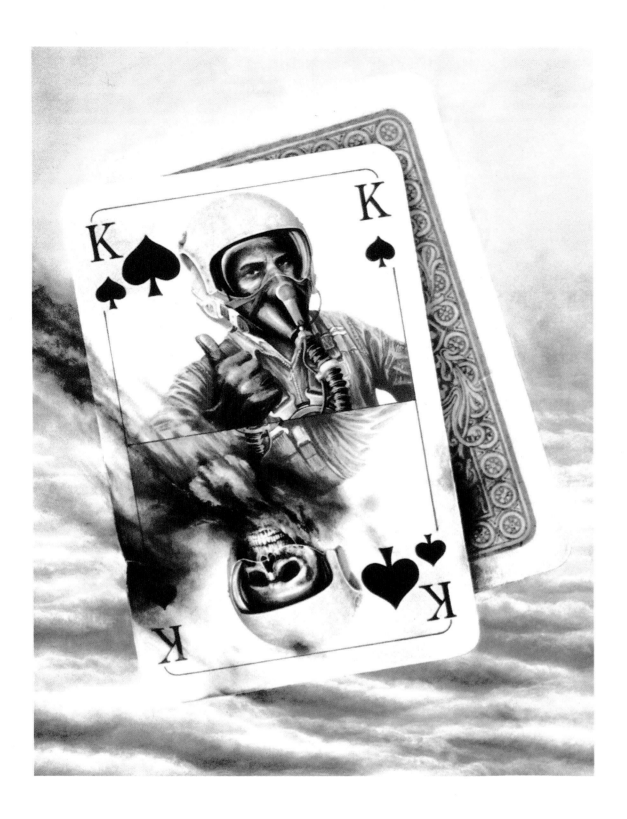

97

Artist/Artiste/Künstler/**Gunter Blum**
Designer/Maquettiste/Gestalter/**Karin Schmidt-Polex**
Art Directors/Directeurs Artistiques/**Wolf Thieme, Rainer Wörtmann**
Publisher/Editeur/Verlag/**Heinrich Bauer Verlag**

Illustration for an article "Testpiloten" (Test Pilots) by Gunter Steuer,
in German 'Playboy' February 1979. Full colour, in gouache.

Illustration pour un article "Testpiloten" (Les Pilotes d'Essai) par Gunter Steuer,
dans 'Playboy' allemand février 1979. Couleur, en gouache.

Illustration für einen Artikel "Testpiloten" von Gunter Steuer,
im Deutschen 'Playboy' Februar 1979. Farbe, in Gouache.

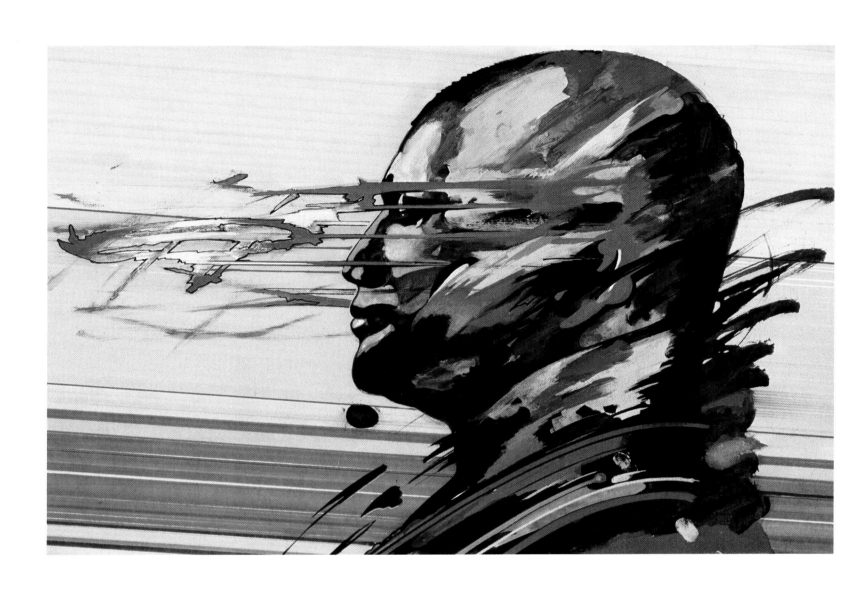

98

Artist/Artiste/Künstler/**Christian Piper**
Designer/Maquettiste/Gestalter/**George Guther**
Art Director/Directeur Artistique/**Rainer Wörtmann**
Publisher/Editeur/Verlag/**Heinrich Bauer Verlag**

Illustration for "Botho Muss Sterben" (Botho Must Die)
by Hans-Heinrich Ziemann, in German 'Playboy' 1979. Tempora-colour.

Illustration pour "Botho Muss Sterben" (Botho Doit Mourir)
par Hans-Heinrich Ziemann, dans 'Playboy' allemand 1979. Détrempe.

Illustration für "Botho Muss Sterben" von Hans-Heinrich Ziemann,
Im Deutschen 'Playboy' 1979. Temperafarbe.

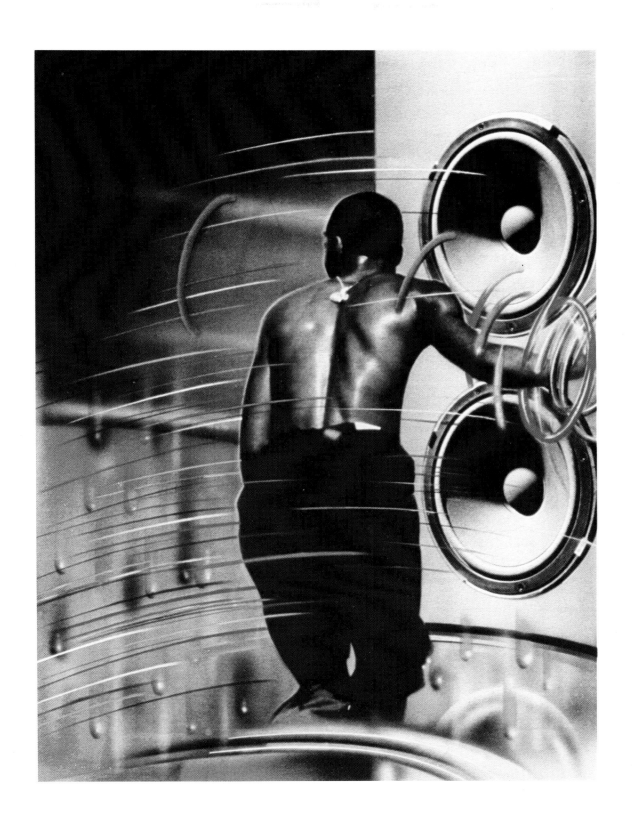

99

Artist/Artiste/Künstler/**Christian Piper**
Designer/Maquettiste/Gestalter/**George Guther**
Art Director/Directeur Artistique/**Rainer Wörtmann**
Publisher/Editeur/Verlag/**Heinrich Bauer Verlag**

Illustration for "Ein Sound Macht Karriere" (Career made by Sound)
by Andrew Kopkind, in German 'Playboy' September 1979. Mixed media.

Illustration pour "Ein Sound Macht Karriere" (La Carrière faite par un Son)
par Andrew Kopkind, dans 'Playboy' allemand septembre 1979. Média divers.

Illustration für "Ein Sound Macht Karriere" von Andrew Kopkind,
im Deutschen 'Playboy' September 1979. Mediakombination.

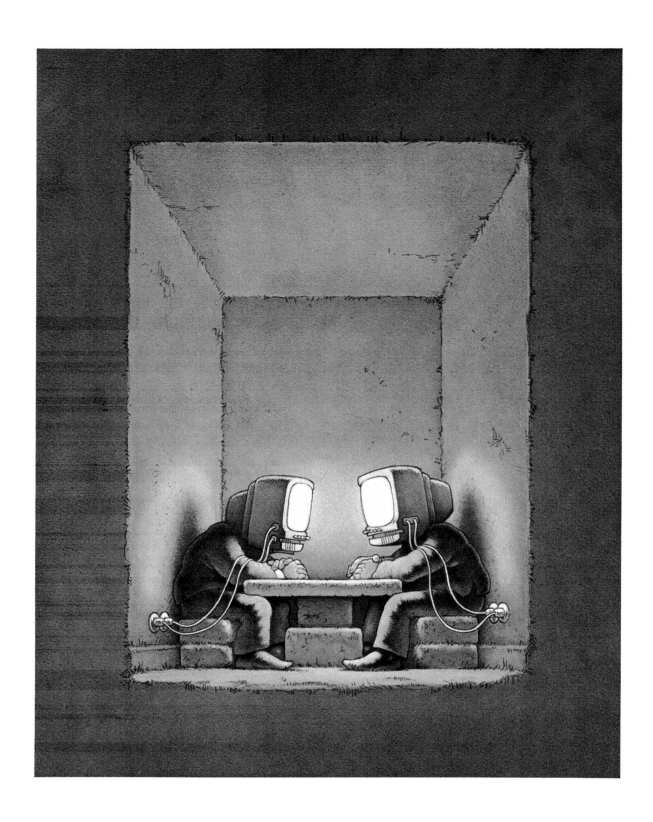

100

Artist/Artiste/Künstler/**Peter Schössow**
Designer/Maquettiste/Gestalter/**Peter Schössow**
Publisher/Editeur/Verlag/**Szene Verlag Klaus Heidorn KG**

Cover illustration of 'Szene' for an article entitled "Kabelfernsehen – Endstation Sehsucht" (Cable Television – The End in Sight) by Wolfgang Hain. Pencil and water-colour.

Illustration de couverture de 'Szene' pour un article intitulé "Kabelfernsehen – Endstation Sehsucht" (Télévision par Cable – le Dernier Poste pour se voir) by Wolfgang Hain. Crayon et aquarelle.

Umschlagillustration für einen Artikel in 'Szene' betitelt "Kabelfernsehen – Endstation Sehsucht" von Wolfgang Hain. Bleistift und Wasserfarben.

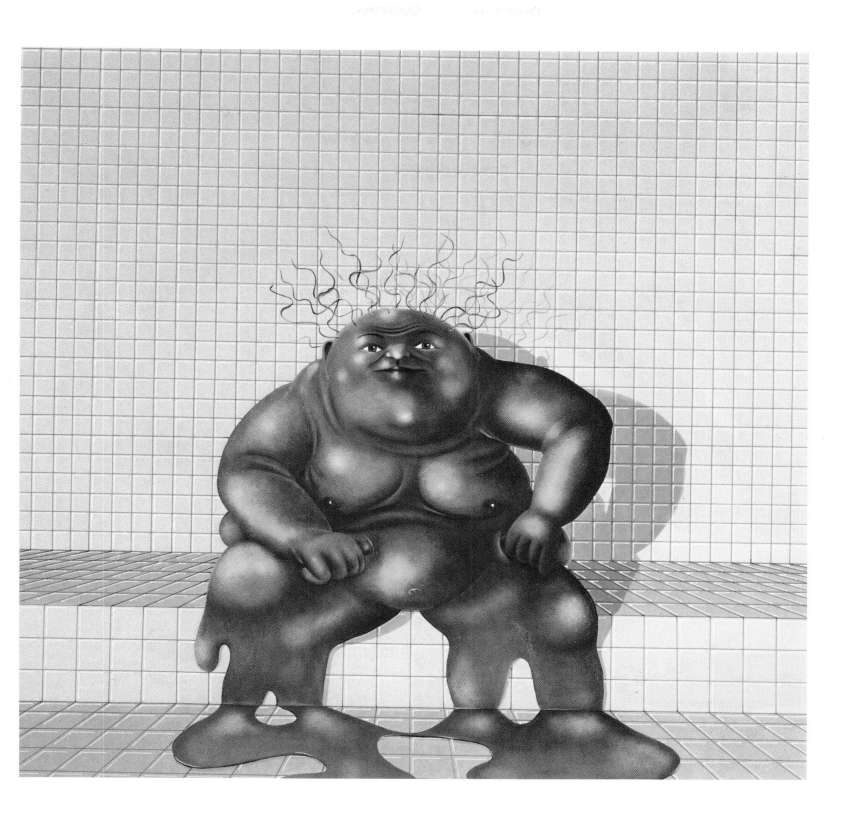

101

Artist/Artiste/Künstler/**Christian Desbois**
Designer/Maquettiste/Gestalter/**Christian Desbois**
Art Director/Directeur Artistique/**Prof C Von Mannstein**
Publisher/Editeur/Verlag/**Bayer Industries**

Illustration for an article "Les Champignons" (Mushrooms) by Christian Desbois,
in 'Medical Innovation'. Oils.

Illustration pour un article "Les Champignons" par Christian Desbois dans
'Medical Innovation'. Huile.

Illustration für einen Artikel "Les Champignons" (Die Pilze) von Christian Desbois
in 'Medical Innovation'. Ölfarben.

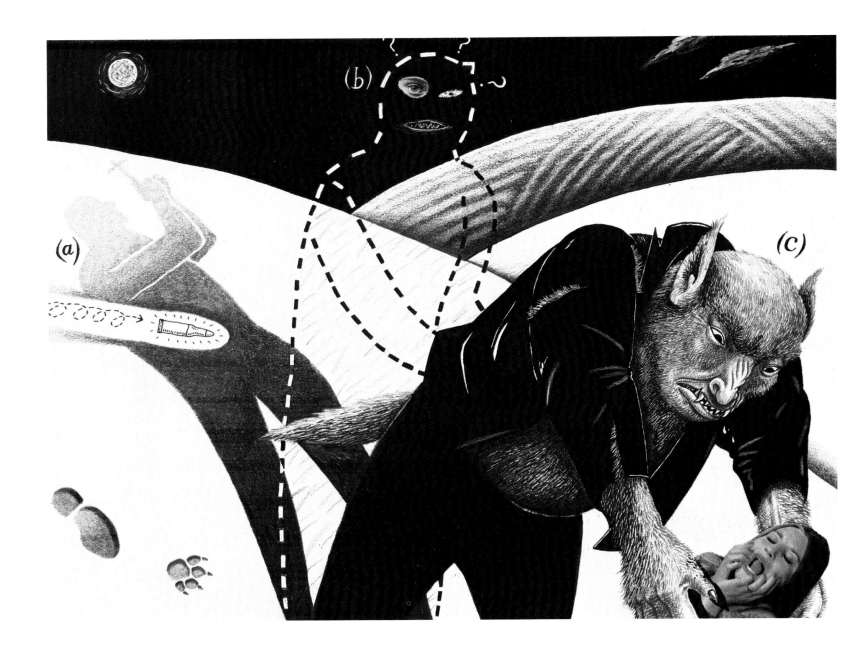

Artist/Artiste/Künstler/**Robert Mason**
Designer/Maquettiste/Gestalter/**Sue Aldworth**
Art Director/Directeur Artistique/**Jenny Fleet**
Publisher/Editeur/Verlag/**BBC Publications**

Illustration "Werewolves" for an article on the history of Lycanthropy, in
'Radio Times' Christmas 1979 issue. Pencil, ink and collage.

Illustration "Werewolves" (Loups-garous) pour un article sur l'histoire de la
Lycanthropie, dans le numéro de Noël 1979 de 'Radio Times'.
Crayon, encre et collage.

Illustration "Werewolves" (Werwölfe) für einen Artikel über die Geschichte der
Lycanthropie, in der Weihnachtsausgabe der 'Radio Times' 1979. Bleistift, Tusche
und Collage.

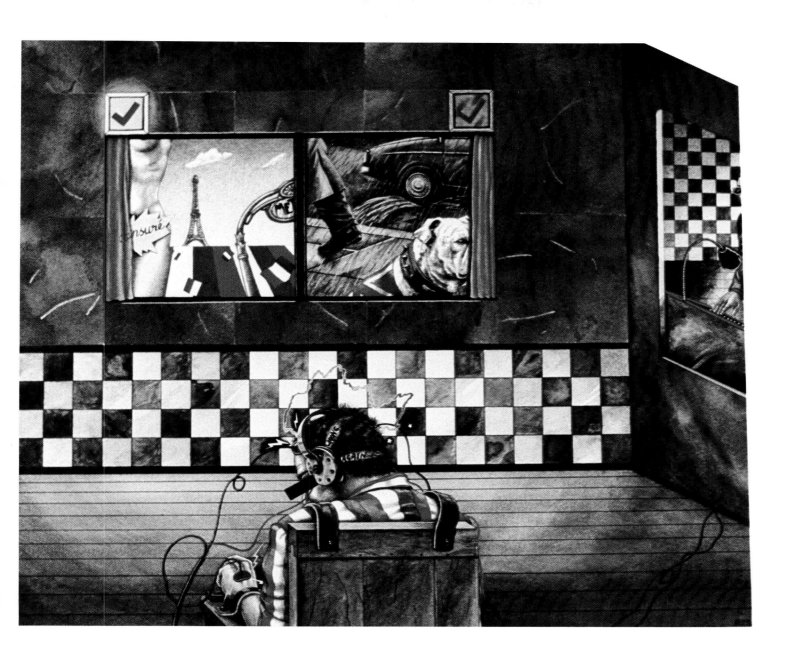

103

Artist/Artiste/Künstler/**Robert Mason**
Designers/Maquettistes/Gestalter/**Barbara Jane Galbraith, Derek Ungless**
Art Director/Directeur Artistique/**Robert Priest**
Publisher/Editeur/Verlag/**Montreal Standard Incorporated**

Illustration for "Mouthwash" by Michael Posner, in 'Weekend Magazine' May 1979.
Water-colour.

Illustration pour "Mouthwash" (Rinçage) par Michael Posner, dans
'Weekend Magazine' mai 1979. Aquarelle.

Illustration für "Mouthwash" (Mundwasser) von Michael Posner, in 'Weekend
Magazine' Mai 1979. Wasserfarben.

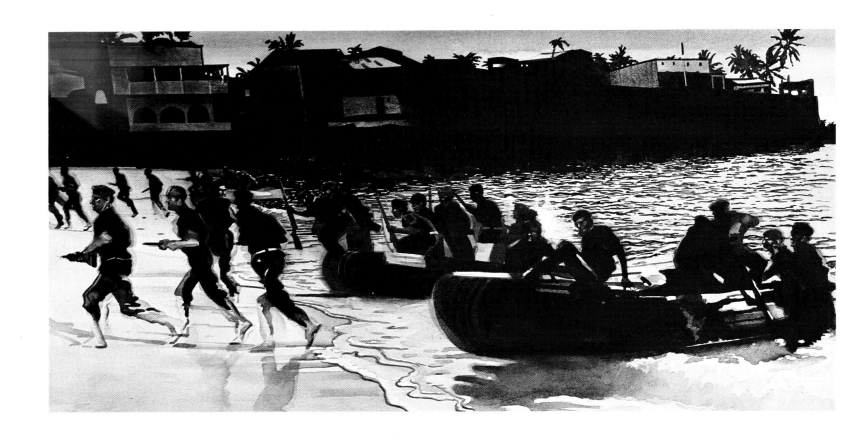

104

Artist/Artiste/Künstler/**Julian Allen**
Designer/Maquettiste/Gestalter/**Milton Glaser**
Art Director/Directeur Artistique/**Milton Glaser**
Publisher/Editeur/Verlag/**Esquire Incorporated**

"Beach Landing," illustration for an article
"The Man who Would be King" by Jon Bradshaw, in 'Esquire'. Water-colour.

"Beach Landing" (Débarquement sur une Plage), illustration
pour un article "The man who Would be King" (L'Homme qui
veut être Roi) par Jon Bradshaw, dans 'Esquire'. Aquarelle.

"Beach landing" (Die Landung am Strand), illustration zu einem Artikel
"The Man who Would be King" (Der Mann der König sein
wollte) von Jon Bradshaw, in 'Esquire'. Wasserfarben.

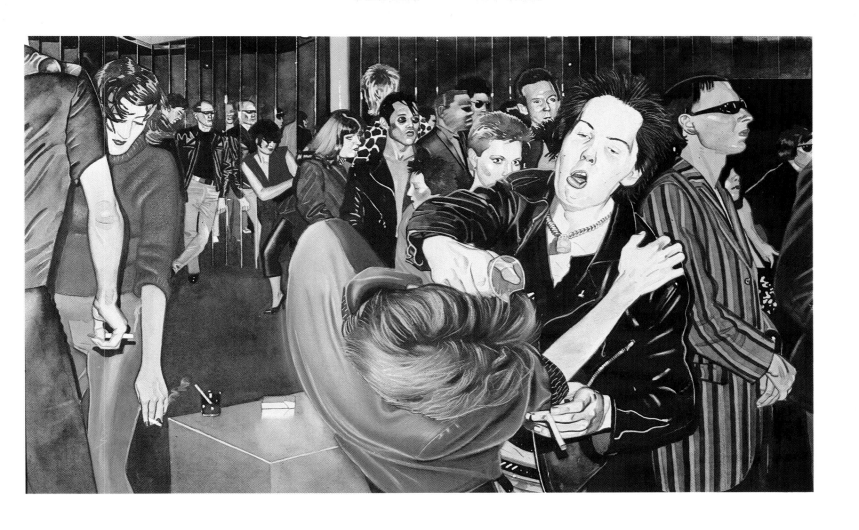

Artist/Artiste/Künstler/**Julian Allen**
Art Director/Directeur Artistique/**Richard Jester**
Publisher/Editeur/Verlag/**New York Magazine Company Incorporated**

"Sid (Vicious) at Hurrah's," illustration for an article "Anger to Go"
by Charlie Hoas, in 'New West'. Water-colour and pastel.

"Sid (Vicious) at Hurrah's" (Sid (Vicious) chez Hurrah), illustration pour un article
"Anger to Go" par Charlie Hoas, dans 'New West'. Aquarelle et pastel.

"Sid (Vicious) at Hurrah's" (Sid (Vicious) bei Hurrah), illustration für einen Artikel
"Anger to Go" (Sucht) von Charlie Hoas, in 'New West'. Wasserfarben und Pastell.

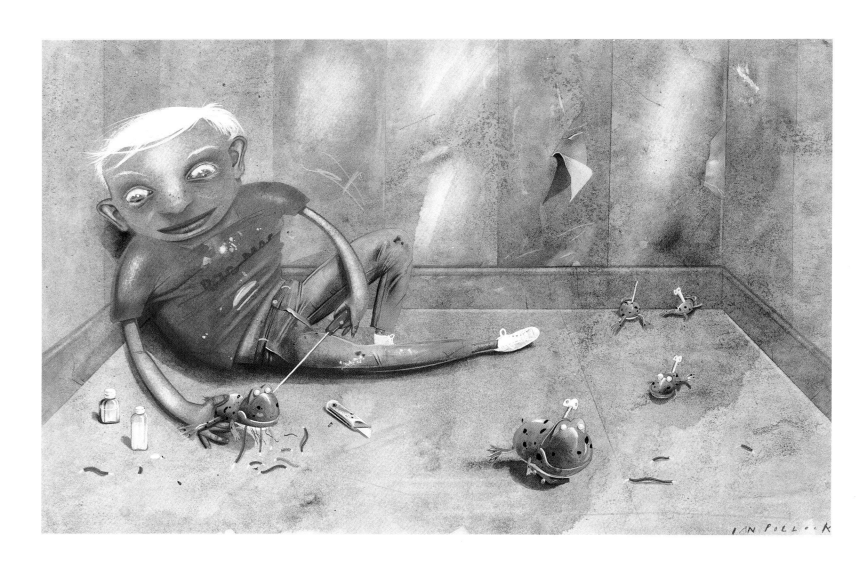

Artist/Artiste/Künstler/**Ian Pollock**
Art Director/Directeur Artistique/**Sue Howe**
Publisher/Editeur/Verlag/**Penthouse Publications Limited**

Illustration for a story "The Big Croak" by Richard Owen, in 'Penthouse' 1980.
Water-colour, ink and gouache.

Illustration pour un conte "The Big Croak" (Le Grand Coassement)
par Richard Owen, dans 'Penthouse' 1980. Aquarelle, encre et gouache.

Illustration zu einer Erzählung "The Big Croak" (Das Grosse Jammern)
von Richard Owen, in 'Penthouse' 1980. Wasserfarben, Tusche und Gouache.

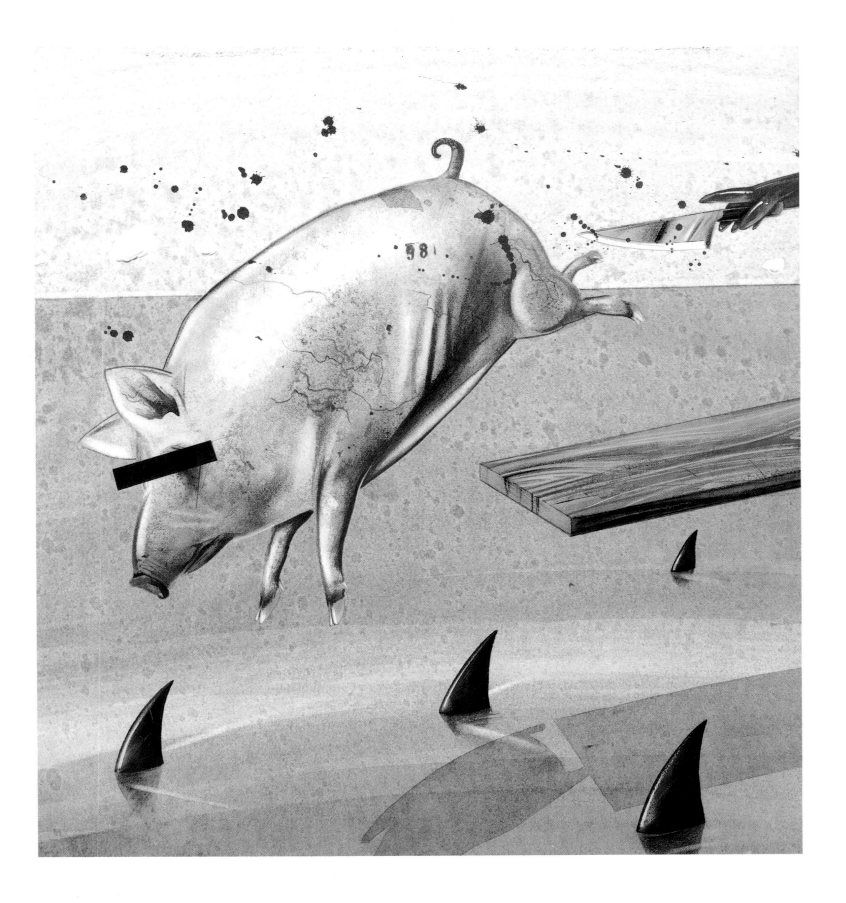

107

Artist/Artiste/Künstler/**Ian Pollock**
Art Editor/Rédacteur Artistique/Kunstredakteur/**Christine Jones**
Publisher/Editeur/Verlag/**IPC Magazines Limited**

Cover illustration for an article "Save the Pig from Stress," in 'New Scientist'
22 November 1979. Water-colour.

Illustration de couverture pour un article "Save the Pig from Stress"
(Éviter au Cochon toute Tension), dans 'New Scientist' novembre 1979. Aquarelle.

Umschlagillustration zum Artikel "Save the Pig from Stress"(Rettet die Schweine
vor Stress), im 'New Scientist' 22. November 1979. Wasserfarben.

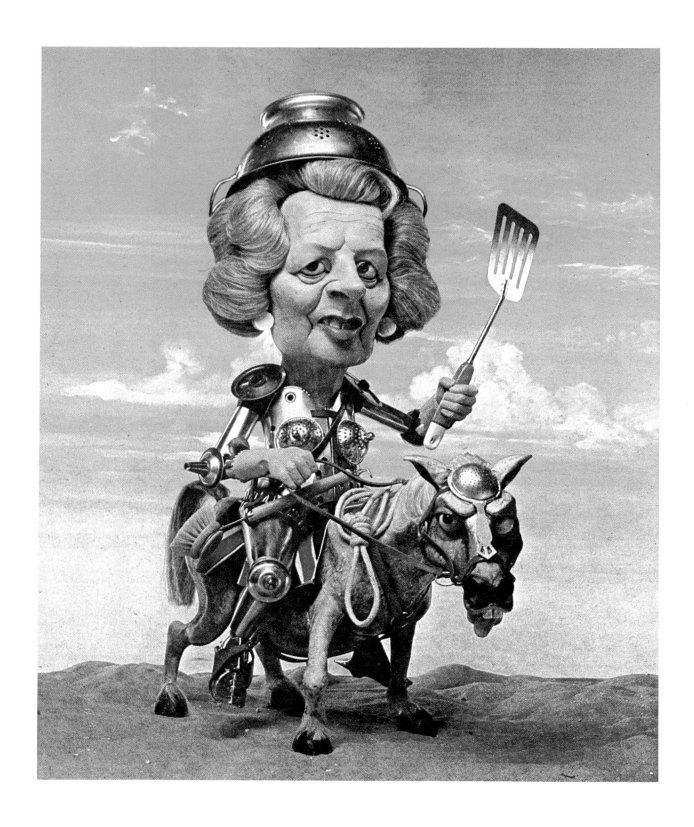

108
Artist/Artiste/Künstler/**Luck & Flaw**
Designers/Maquettistes/Gestalter/**Barbara Jane Galbraith, Derek Ungless**
Art Director/Directeur Artistique/**Robert Priest**
Publisher/Editeur/Verlag/**Montreal Standard Incorporated**

Illustration for "Daughter of the Empire," an article on
Mrs Margaret Thatcher, by Helen Lawrenson in 'Weekend Magazine'
September 1979. Plasticene models photographed in colour.

Illustration pour "Daughter of the Empire" (Fille de l'Empire),
un article sur Mme. Magaret Thatcher, par Helen Lawrenson dans
'Weekend Magazine' septembre 1979. Pâte à modeler, photographiée en couleur.

Illustration zu "Daughter of the Empire" (Tochter des Weltreichs),
ein Artikel über Magaret Thatcher, von Helen Lawrenson in 'Weekend Magazine'
September 1979. Plasticienmodelle, farbig fotografiert.

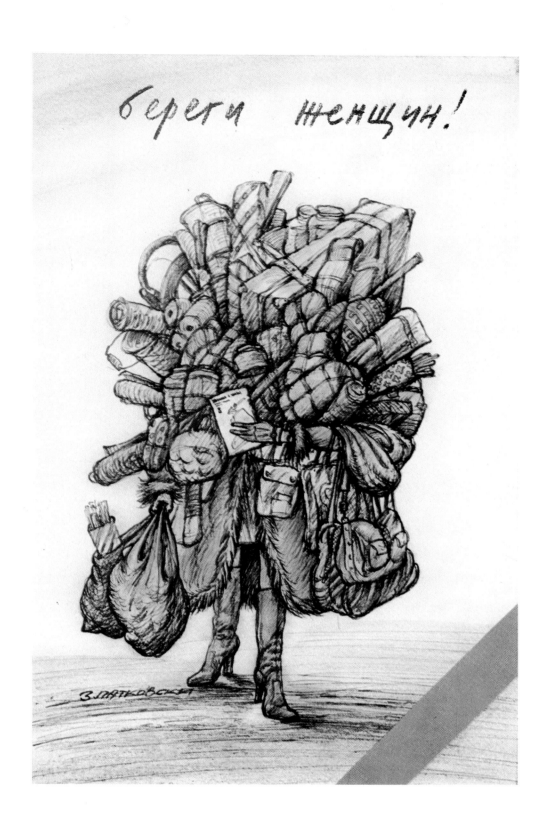

Artist/Artiste/Künstler/**Michail Zlatkovski**
Illustration entitled "Save Women." In inks.
Illustration intitulée "Save Women" (Sauvez les femmes). Encres.
Illustration betitelt "Save Women" (Rettet die Frauen). Tusche.

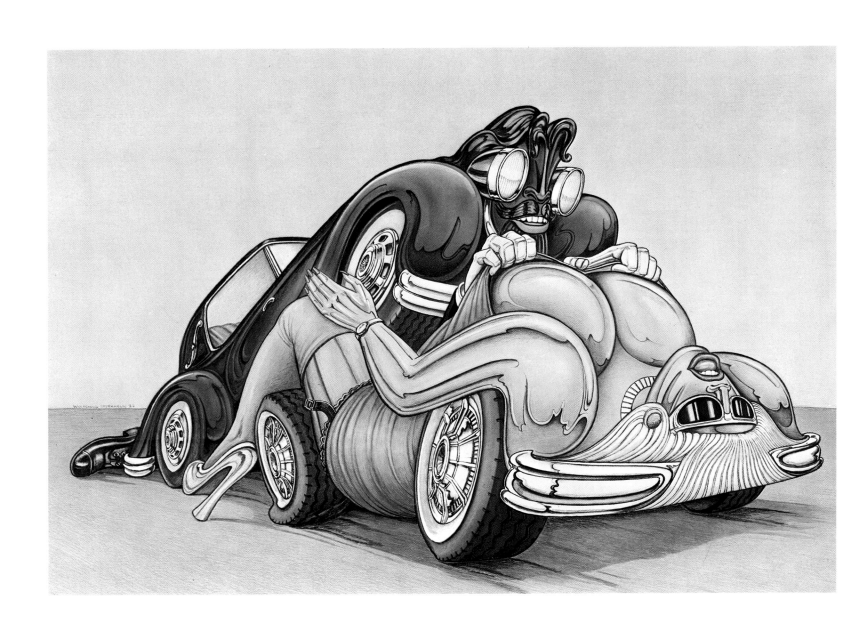

Artist/Artiste/Künstler/**Wolfgang Oppermann**
Art Director/Directeur Artistique/**Wolfgang Behnken**
Publisher/Editeur/Verlag/**Gruner & Jahr AG & Co**

Illustration entitled "Autoträume" (Car Dreams), in 'Stern' 1979. Gouache.

Illustration intitulée "Autoträume" (Rêves de Voiture), dans 'Stern' 1979. Gouache.

Illustration betitelt "Autoträume," in 'Stern' 1979. Gouache.

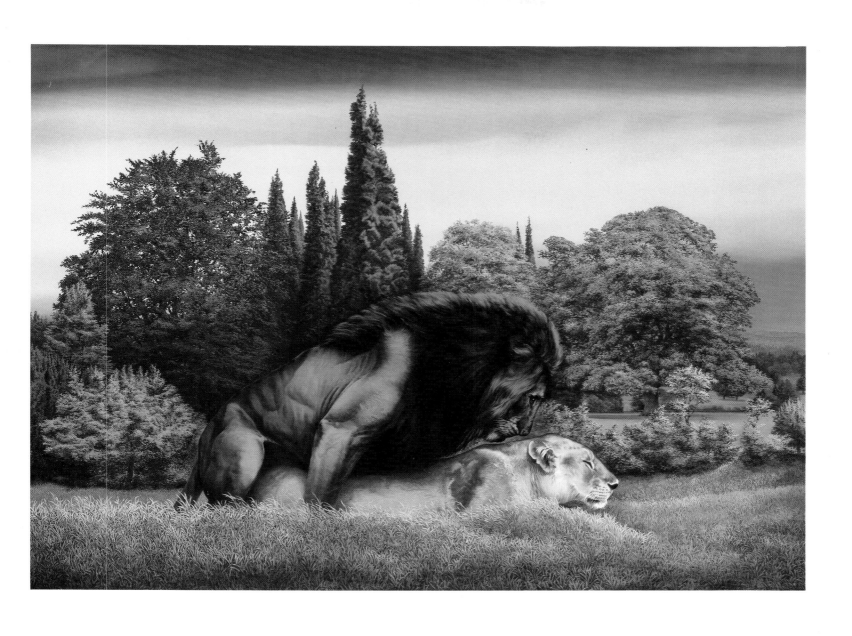

111

Artist/Artiste/Künstler/**Larry Learmonth**

Untitled illustration. Oil on canvas.

Illustration sans titre. Huile sur toile.

Unbetitelte Illustration. Öl auf Leinwand.

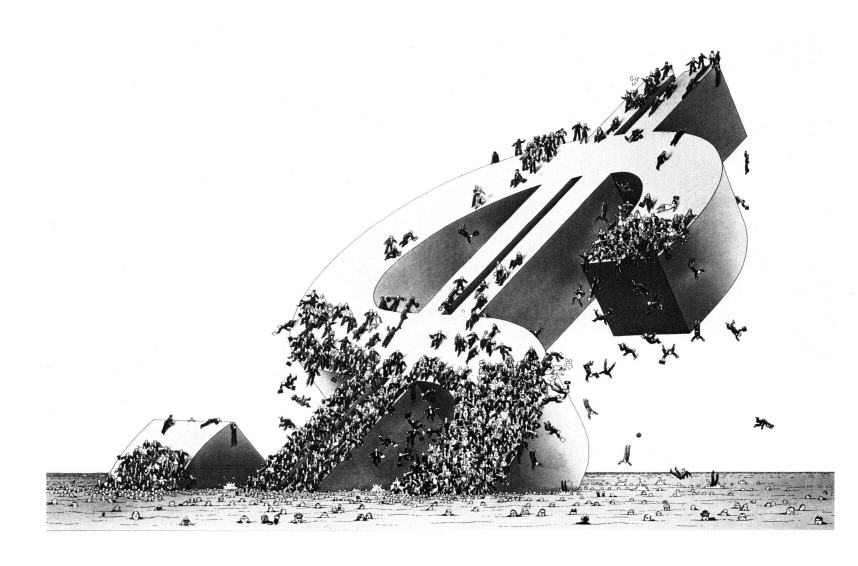

112

Artist/Artiste/Künstler/Joachim Widmann
Art Director/Directeur Artistique/Wolfgang Behnken
Publisher/Editeur/Verlag/Gruner & Jahr AG & Co

Illustration for 'Stern'. Pen and wash.

Illustration pour 'Stern'. Plume et encre.

Illustration für 'Stern'. Bleistift und Kohlezeichnung.

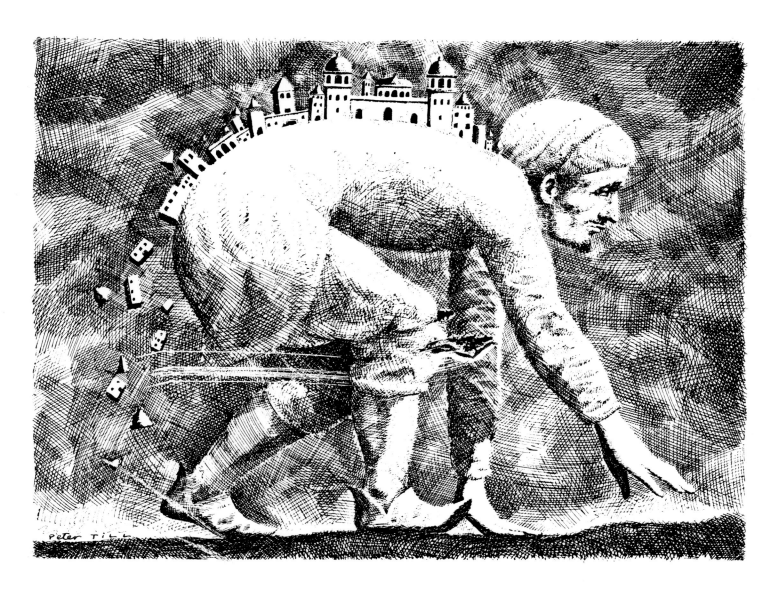

Artist/Artiste/Künstler/**Peter Till**
Designer/Maquettiste/Gestalter/**Sue Aldworth**
Art Editor/Rédacteur Artistique/Kunstredakteur/**Jenny Fleet**
Publisher/Editeur/Verlag/**BBC Publications**

Illustration for an article on a play "Tughlaq" by Girish Karnad, in 'Radio Times'
24 November 1979. Black and white, in ink.

Illustration pour un article sur une pièce "Tughlaq" par Girish Karnad, dans
'Radio Times' le 24 novembre 1979. Noir et blanc, en encre.

Illustration zu einem Artikel über das Theaterstück "Tughlaq" von Girish Karnad,
erschienen in 'Radio Times' 24. November 1979. Schwarzweiss, Tusche.

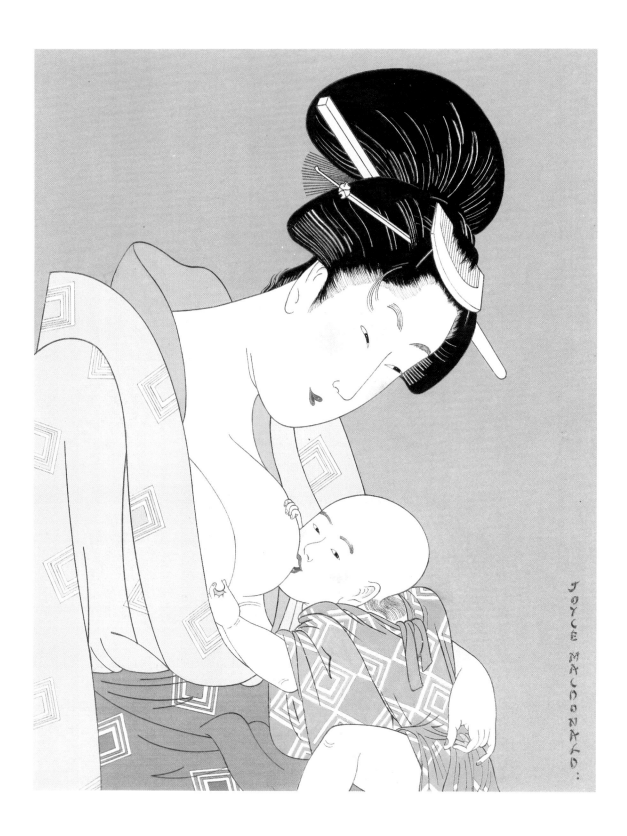

Artist/Artiste/Künstler/**Joyce MacDonald**
Designer/Maquettiste/Gestalter/**Joyce MacDonald**
Art Director/Directeur Artistique/**J C Suarès**
Publisher/Editeur/Verlag/**New York Magazine**

Illustration for a feature on breastfeeding, in 'New York Magazine' 29 October 1979.
Water-colour and gouache.

Illustration pour an article sur l'allaitement au sein, dans 'New York Magazine'
le 29 octobre 1979. Aquarelle et gouache.

Illustration zu einem Sachbericht über Bruststillen, in 'New York Magazine'
29. Oktober 1979. Wasserfarben und Gouache.

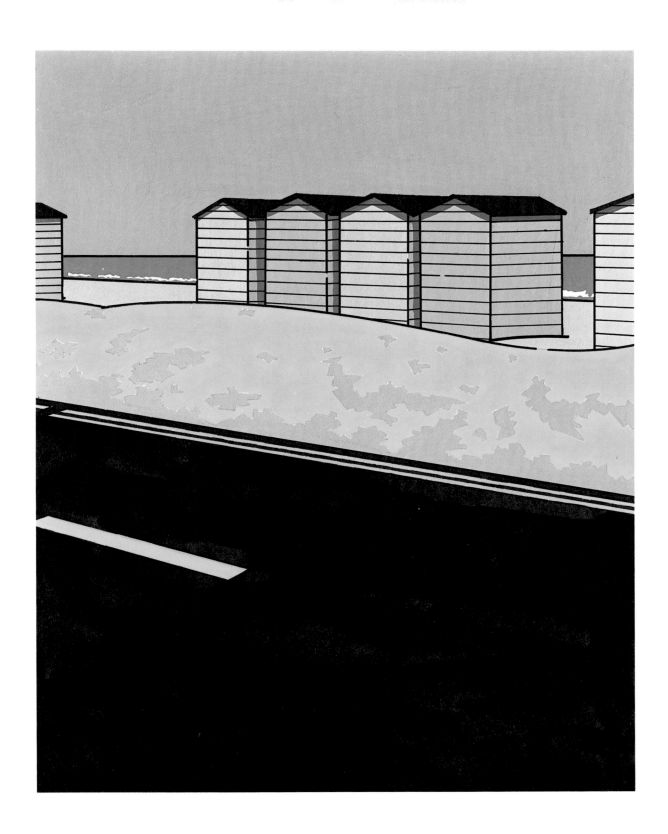

115

Artist/Artiste/Künstler/**Jean Pierre Lyonnet**
Designer/Maquettiste/Gestalter/**Jean Pierre Lyonnet**

Unpublished illustration entitled "Le Beau Samedi" (The Lovely Saturday).
In acrylic paint and ink.

Illustration inedite intitulée "Le Beau Samedi." Peinture acrylique et encre.

Unveröffentlichte Illustration betitelt "Le Beau Samedi"
(Der Wunderschöne Samstag). Acrylfarbe und Tusche.

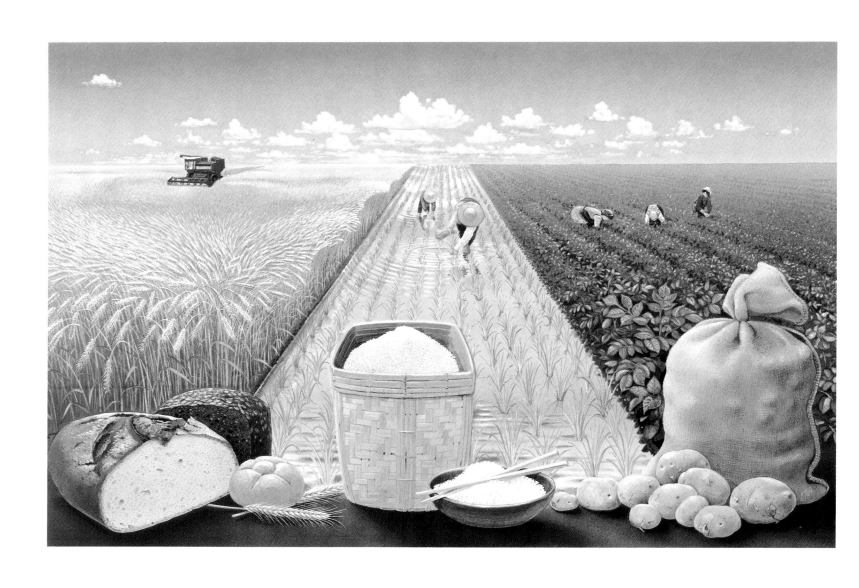

116

Artist/Artiste/Künstler/**Harro Maas**
Designer/Maquettiste/Gestalter/**Harro Maas**
Art Director/Directeur Artistique/**Helga Colle-Tiz**
Publisher/Editeur/Verlag/**Burda Verlag GMBH**

Illustration for "Dickmacher die Schlank Machen" (Fatteners Which Have a
Slimming Effect), in 'Freundin' 1979. Water-colour.

Illustration pour "Dickmacher die Schlank Machen" (Aliments Engraissants
Qui Font Maigrir), dans 'Freundin' 1979. Aquarelle.

Illustration für "Dickmacher, die schlank machen," in 'Freundin' 1979.
Wasserfarben.

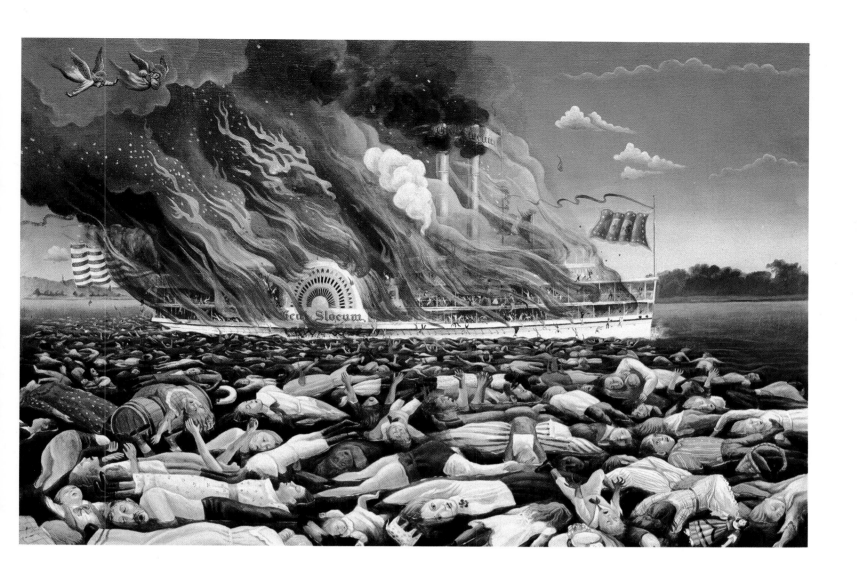

Artist/Artiste/Künstler/**Kinuko Craft**
Designer/Maquettiste/Gestalter/**Angi Bronder**
Art Director/Directeur Artistique/**Rainer Wörtmann**
Publisher/Editeur/Verlag/**Heinrich Bauer Verlag**

Illustration for "Ausflug in den Tod" (Journey into Death) by Thomas Plate,
in German 'Playboy' 1979. Oil on wood.

Illustration pour "Ausflug in den Töd" (Voyage à la Mort) par Thomas Plate,
dans 'Playboy' allemand 1979. Huile sur panneau.

Illustration für "Ausflug in den Tod" von Thomas Plate,
im Deutschen 'Playboy' 1979. Öl auf Holz.

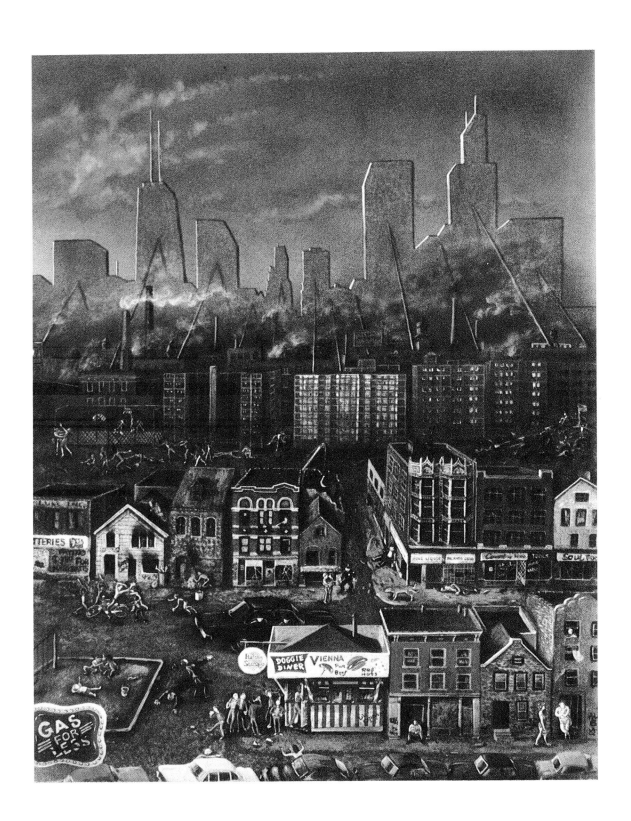

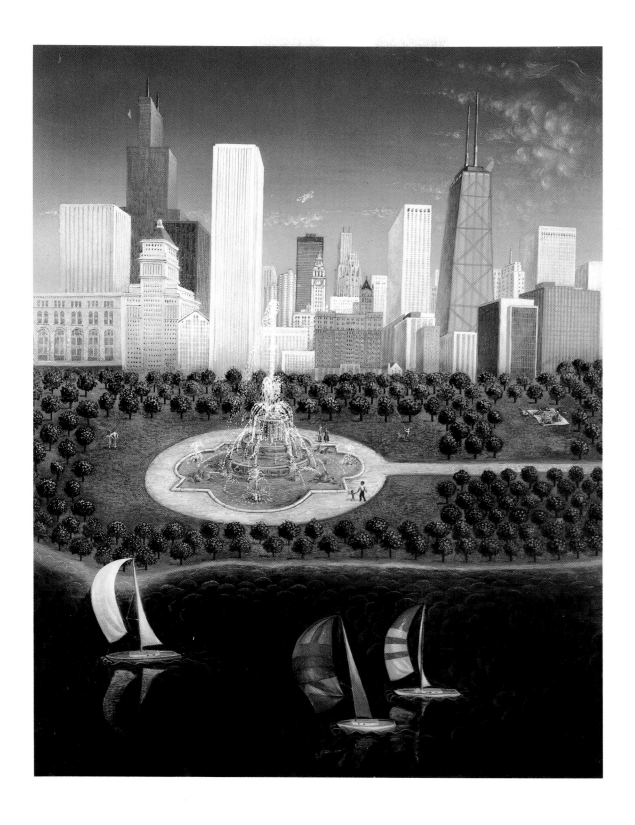

118, 119

Artist/Artiste/Künstler/**Kinuko Craft**
Designer/Maquettiste/Gestalter/**Christl Böhm**
Art Director/Directeur Artistique/**Rainer Wörtmann**
Publisher/Editeur/Verlag/**Heinrich Bauer Verlag**

Illustration for "Zerstörung einer Legende" (Destruction of a Legend)
by Manfred Lütgenhorst, in German 'Playboy' 1979. Mixed media.

Illustration pour "Zerstörung einer Legende" (La Déstruction d'une Légende)
par Manfred Lütgenhorst, dans 'Playboy' allemand 1979. Média divers.

Illustration für "Zerstörung einer Legende" von Manfred Lütgenhorst,
im Deutschen 'Playboy' 1979. Mediakombination.

BOOKS

This section includes work commissioned for
book jackets, paperback covers, and all types of
illustrated books, fiction and non-fiction.

Cette section comprend des travaux commandés
pour des jaquettes de livres reliés, des couvertures
de livres de poche, et toutes sortes de livres
illustrés.

Dieser Abschnitt umfasst Arbeiten für
Schutzumschläge, Paperback-Umschläge und
Bücher aller Art, Romane und Sachbücher.

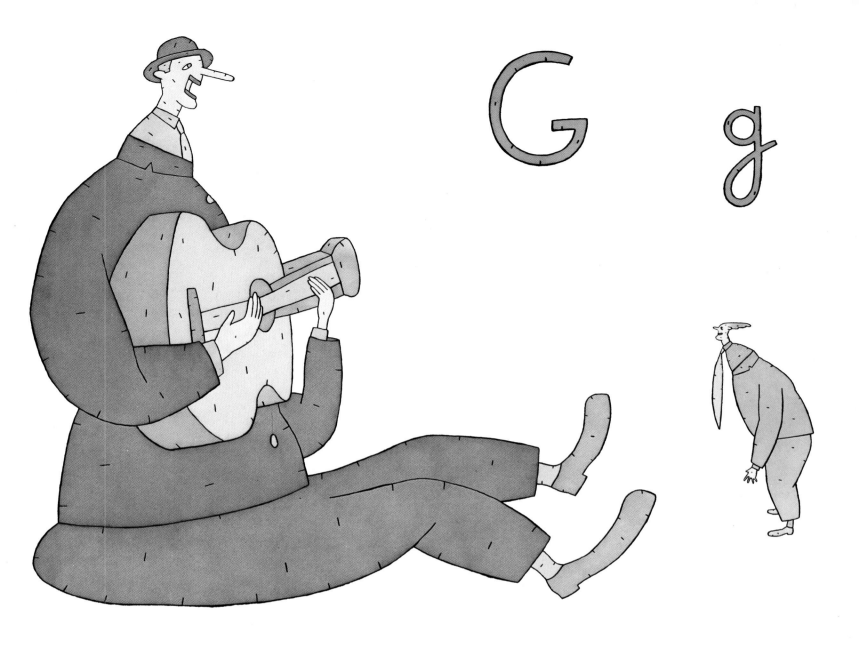

122, 123

Artist/Artiste/Künstler/**Lionel Koechlin**
Art Director/Directeur Artistique/**Lionel Koechlin**
Publisher/Editeur/Verlag/**Editions Jannink**

Book illustrations for Alphabet book by Lionel Koechlin,
published November 1979. Water-colour.

Illustrations de livre d'un abécédaire par Lionel Koechlin,
publié en novembre 1979. Aquarelle.

Buchillustrationen für das Alphabet-Buch von Lionel Koechlin,
veröffentlicht im November 1979.

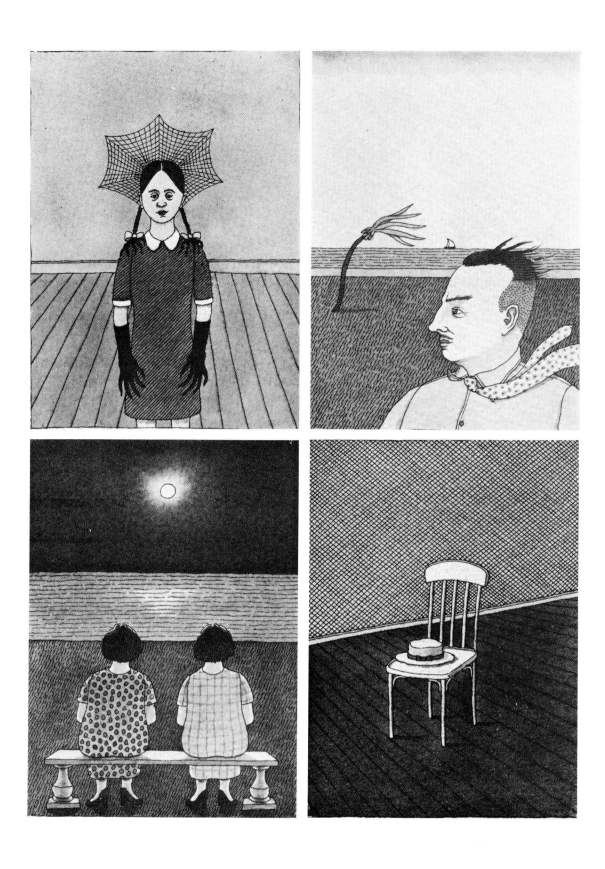

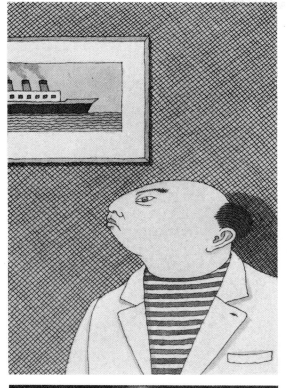
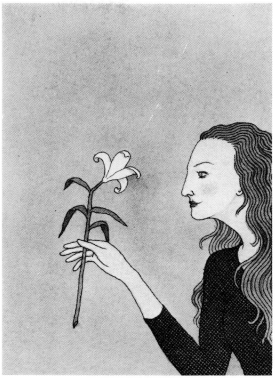
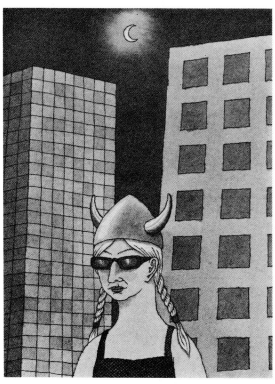
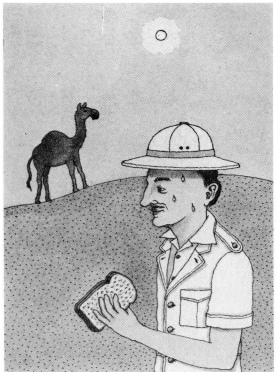

124, 125

Artist/Artiste/Künstler/**Pierre Le-Tan**
Designer/Maquettiste/Gestalter/**Carol Southern**
Publisher/Editeur/Verlag/**Clarkson Potter Incorporated**

Book cover illustration for 'Even More Remarkable Names' compiled and
annotated by John Train, published 1979. Black and white, in pen, ink and wash.

Illustration de couverture de livre pour 'Even More Remarkable Names'
(Des Noms de Plus en Plus Remarquables) compilé et annoté par John Train,
publié en 1979. Noir et blanc, en plume, encre et lavis.

Buchumschlagillustration für 'Even More Remarkable Names'
(Noch erstaunlichere Namen) zusammengestellt und kommentiert von John Train,
veröffentlicht 1979. Schwarzweisse Federzeichnung.

FOLON

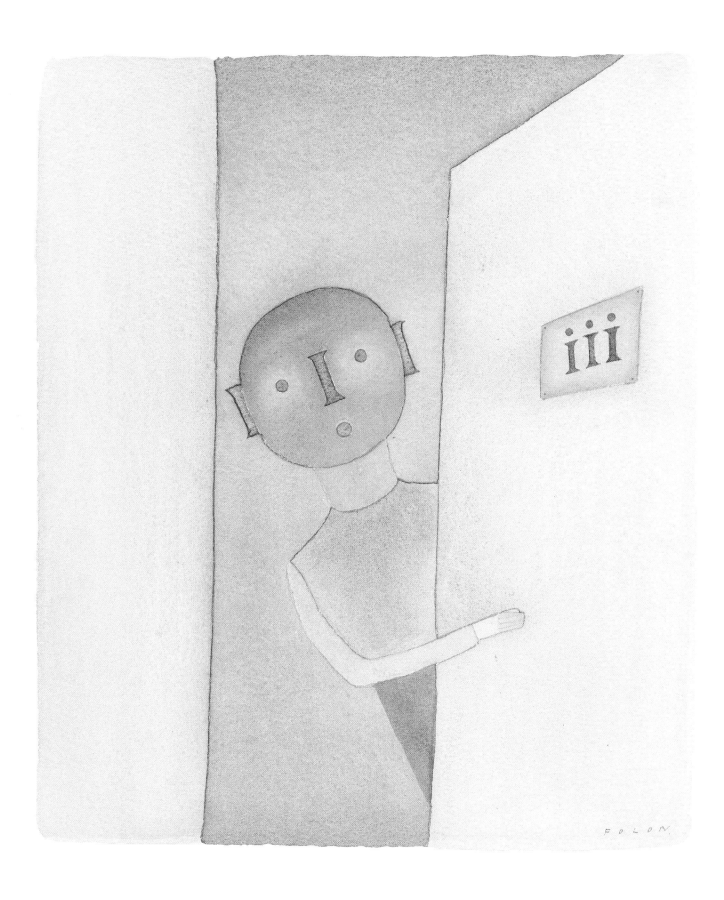

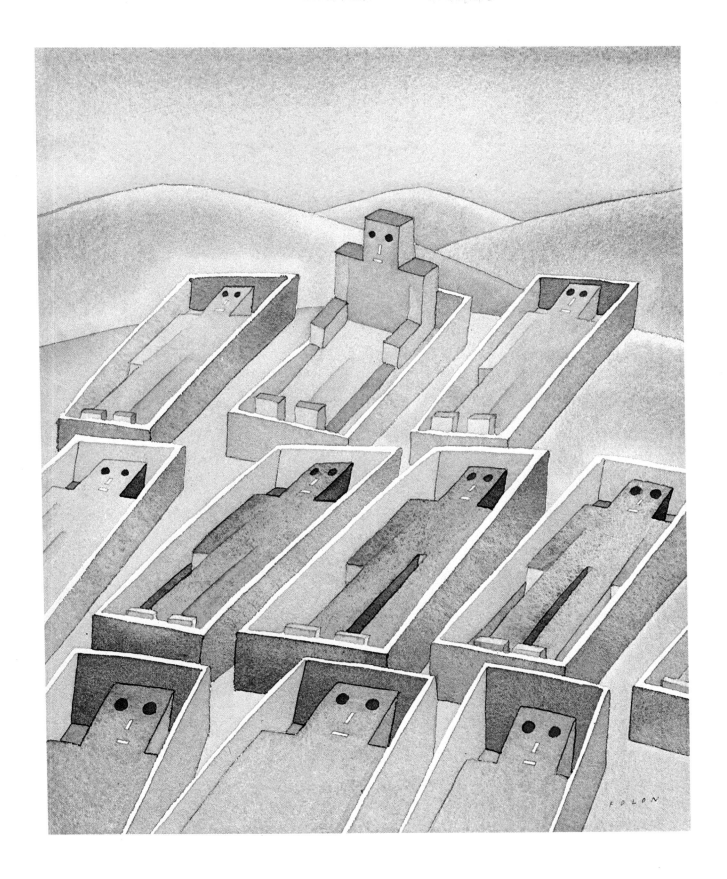

126, 127, 128, 129

Artist/Artiste/Künstler/**Jean-Michel Folon**
Art Director/Directeur Artistique/**Giorgio Soavi**
Publisher/Editeur/Verlag/**Ing C Olivetti & C SpA**

Book illustrations for 'The Martian Chronicles' by Ray Bradbury,
published December 1979. Water-colour.

Illustrations de livre pour 'The Martian Chronicles' (Les Chroniques Martiennes)
de Ray Bradbury, publié en décembre 1979. Aquarelle.

Buchillustrationen für 'The Martian Chronicles' (Die Chronic der Marsmenschen)
von Ray Bradbury, erschienen im Dezember 1979. Wasserfarben.

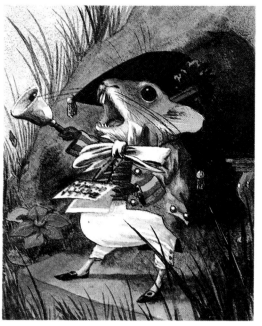
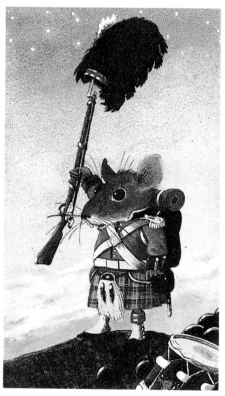
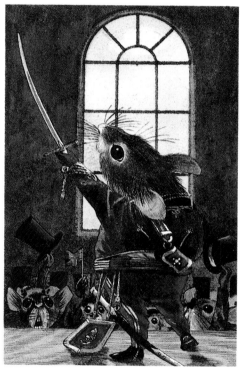

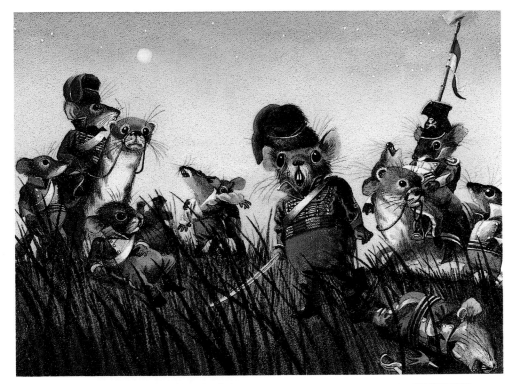

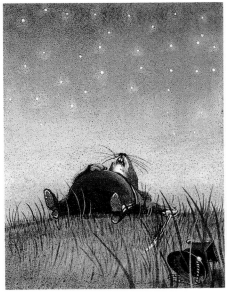

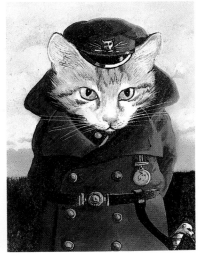

130, 131

Artist/Artiste/Künstler/**Tony Ross**
Art Director/Directeur Artistique/**Klaus Flugge**
Publisher/Editeur/Verlag/**Anderson Press Limited**

Book illustrations for 'The Charge of the Mouse Brigade' by Bernard Stone.
Water-colour.

Illustrations de livre pour 'The Charge of the Mouse Brigade'
(La Charge de la Brigade de Souris) par Bernard Stone. Aquarelle.

Buchillustrationen für 'The Charge of the Mouse Brigade'
(Der Angriff der Mausebrigade) von Bernard Stone. Wasserfarben.

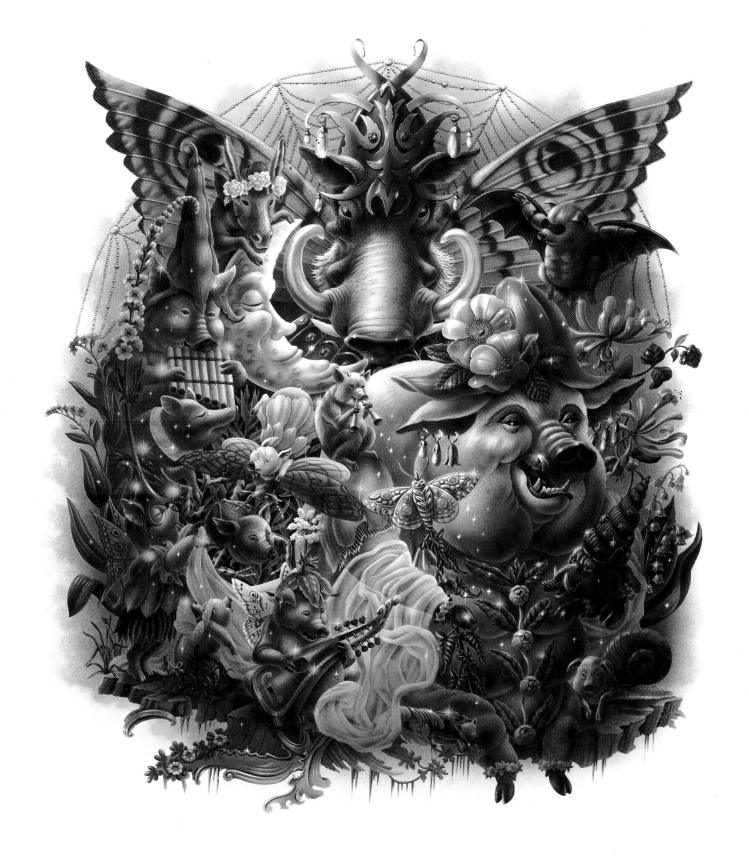

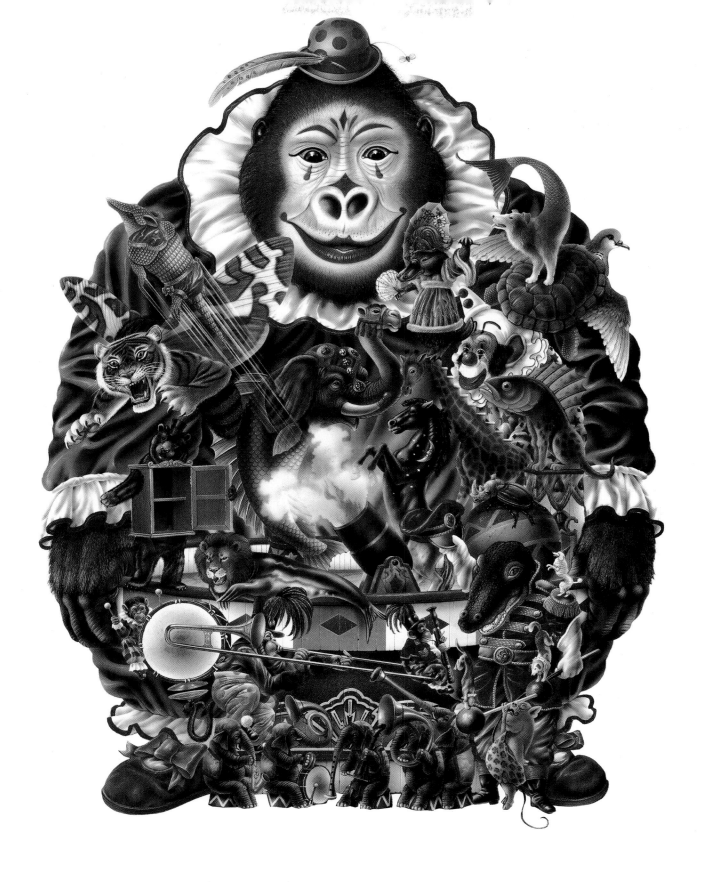

132, 133

Artist/Artiste/Künstler/**Alan Aldridge, Harry Willock**
Designer/Maquettïste/Gestalter/**Ian Craig**
Art Director/Directeur Artistique/**Alan Aldridge**
Publisher/Editeur/Verlag/**Jonathan Cape Limited**

Illustrations for a book of poetry 'The Lion's Cavalcade' by Ted Walker,
published September 1980. Airbrush.

Illustrations pour le livre de poésie 'The Lion's Cavalcade' (La Cavalcade du Lion)
de Ted Walker, publié en septembre 1980. Aérographe.

Illustrationen zu einem Gedichtband 'The Lion's Cavalcade'
(Die Kavalkade der Löwen) von Ted Walker, veröffentlicht im September 1980.
Spritzpistole.

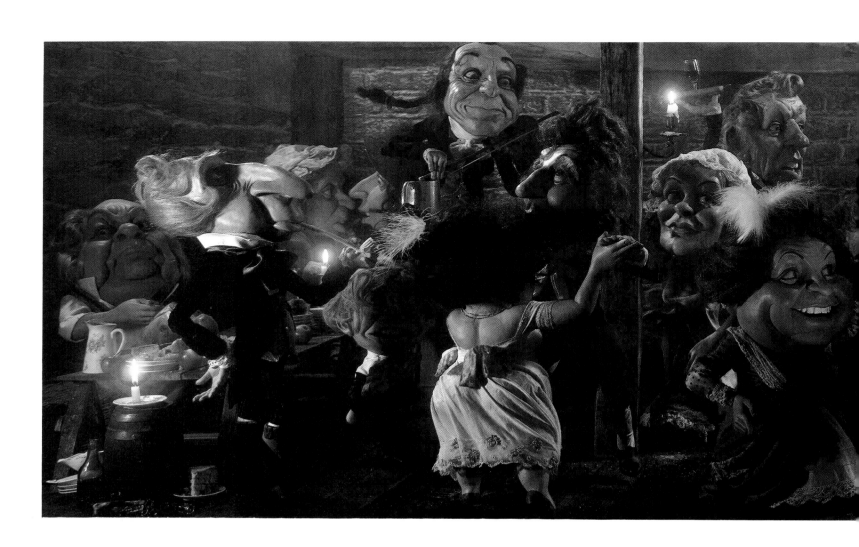

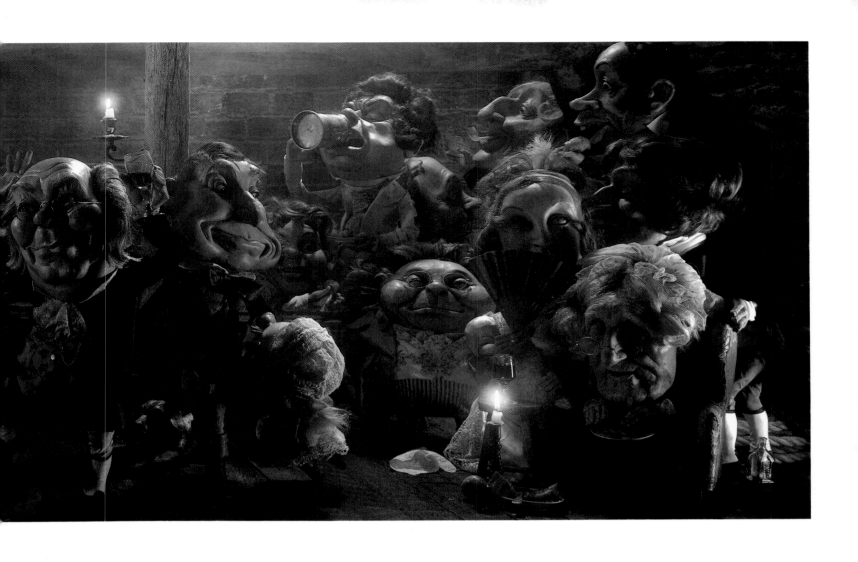

135

Artists/Artistes/Künstler/**Luck & Flaw**
Art Director/Directeur Artistique/**Jessica Smith**
Publisher/Editeur/Verlag/**Allen Lane**

Book illustration for 'A Christmas Carol' by Charles Dickens. Plasticine model,
photographed in colour.

Illustration de livre pour 'A Christmas Carol' (Conte de Noël)
de Charles Dickens. En pâte à modeler, photographiée en couleur.

Buchillustration für 'A Christmas Carol' (Ein Weinachtslied) von Charles Dickens.
Plasticinmodell, farbig fotografiert.

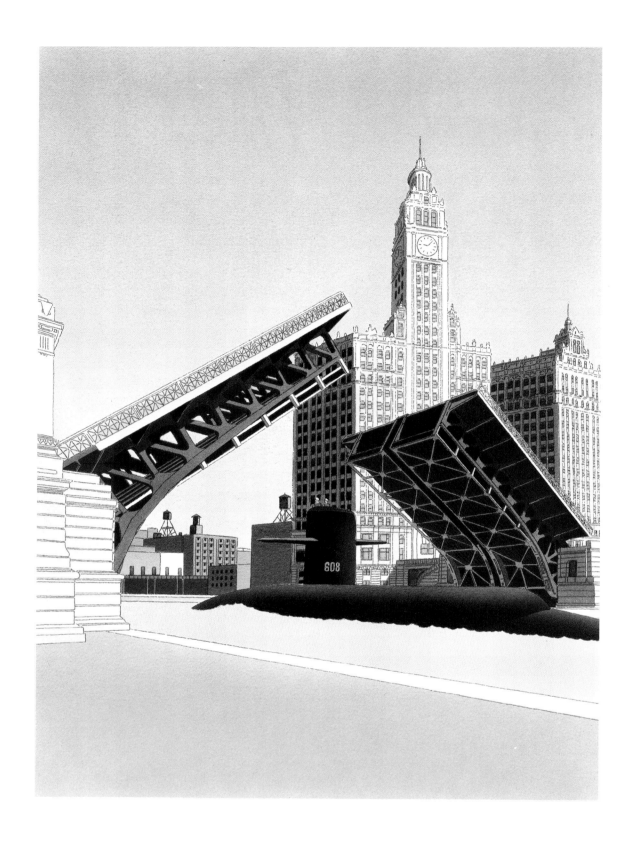

136

Artist/Artiste/Künstler/**Guy Billout**
Designer/Maquettiste/Gestalter/**Carl Barile**
Art Editors/Rédacteurs Artistiques/Kunstredakteur/
Ellen Roberts, Cheryl Tortoriello
Publisher/Editeur/Verlag/**Prentice Hall Incorporated**

Book illustration for 'Stone and Steel' by Guy Billout, published June 1980.
Water-colour.

Illustration de livre pour 'Stone and Steel' (Pierre et Acier) par Guy Billout,
publié en juin 1980. Aquarelle.

Buchillustration für 'Stone and Steel' (Stein und Stahl) von Guy Billout,
veröffentlicht im Juni 1980. Wasserfarben.

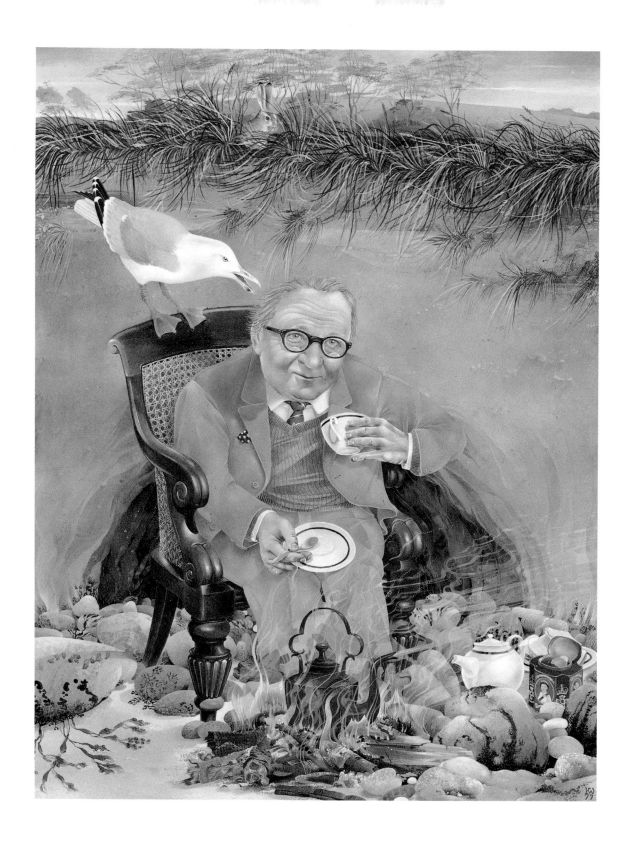

137

Artist/Artiste/Künstler/**Kit Williams**
Designer/Maquettiste/Gestalter/**Ian Craig**
Publisher/Editeur/Verlag/**Jonathan Cape Limited**

Book illustration for 'Masquerade' by Kit Williams,
published September 1979. Oils.

Illustration de livre pour 'Masquerade' par Kit Williams,
publié en september 1979. Huile.

Buchillustration für 'Masquerade' (Maskerade) von Kit Williams,
veröffentlicht im September 1979. Ölfarbe.

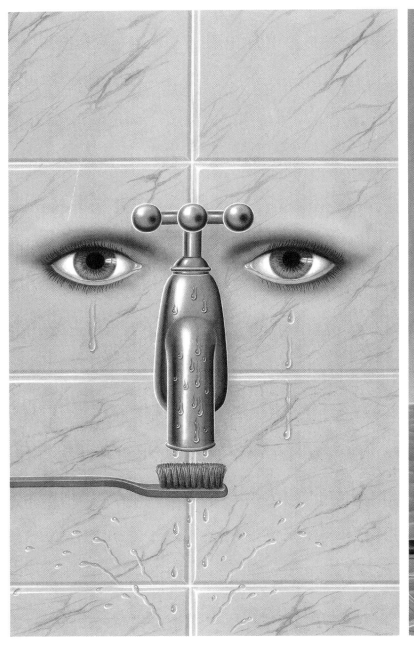 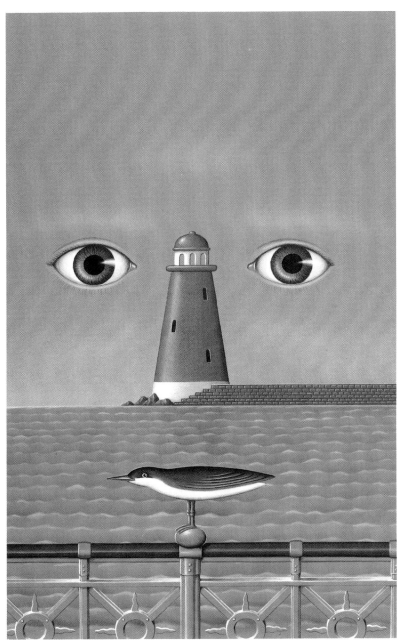

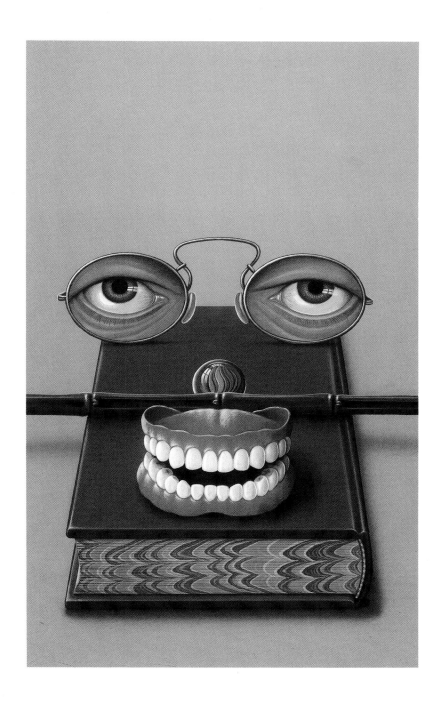

138, 139

Artist/Artiste/Künstler/**James Marsh**
Designer/Maquettiste/Gestalter/**Patrick Edwards**
Art Director/Directeur Artistique/**David Pelham**
Publisher/Editeur/Verlag/**Penguin Books Limited**

Book cover illustrations for three books by William Trevor: 'The Old Boys';
'The Children of Dynmouth'; 'Lovers of their Time'. Oils.

Illustrations de couverture pour trois livres de William Trevor: 'The Old Boys';
'The Children of Dynmouth'; 'Lovers of Their Time'(Les Vieux Copains, Les
Enfants de Dynmouth, Les Amoureux de leurs Temps). Huile.

Buchumschlagillustrationen für drei Bücher von William Trevor: 'The Old Boys';
'The Children of Dynmouth'; 'Lovers of Their Time'(Die alten Herren, Die Kinder
von Dynmouth, Liebhaber ihrer Zeit). Ölfarben.

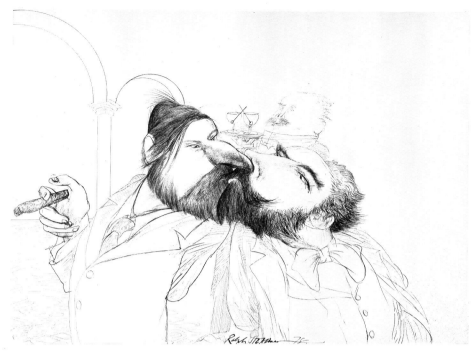

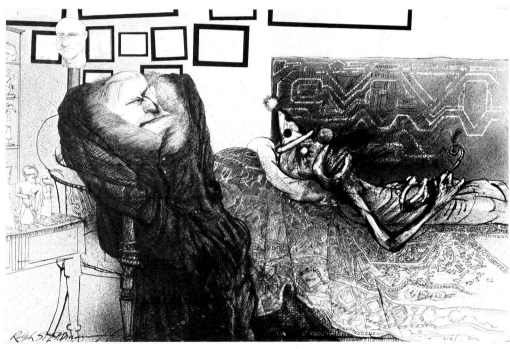

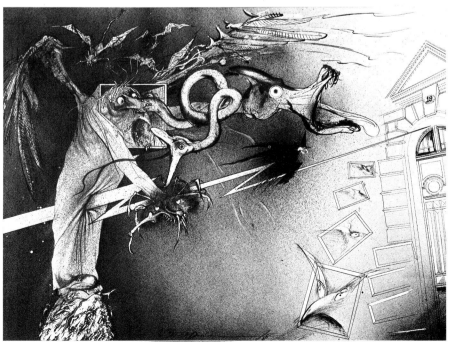

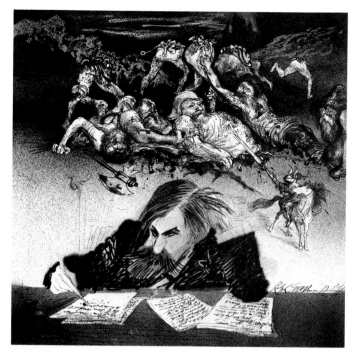

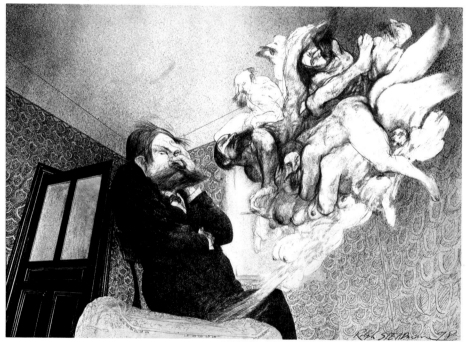

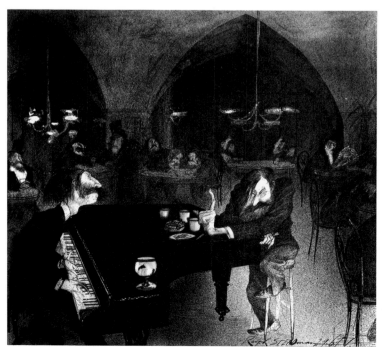

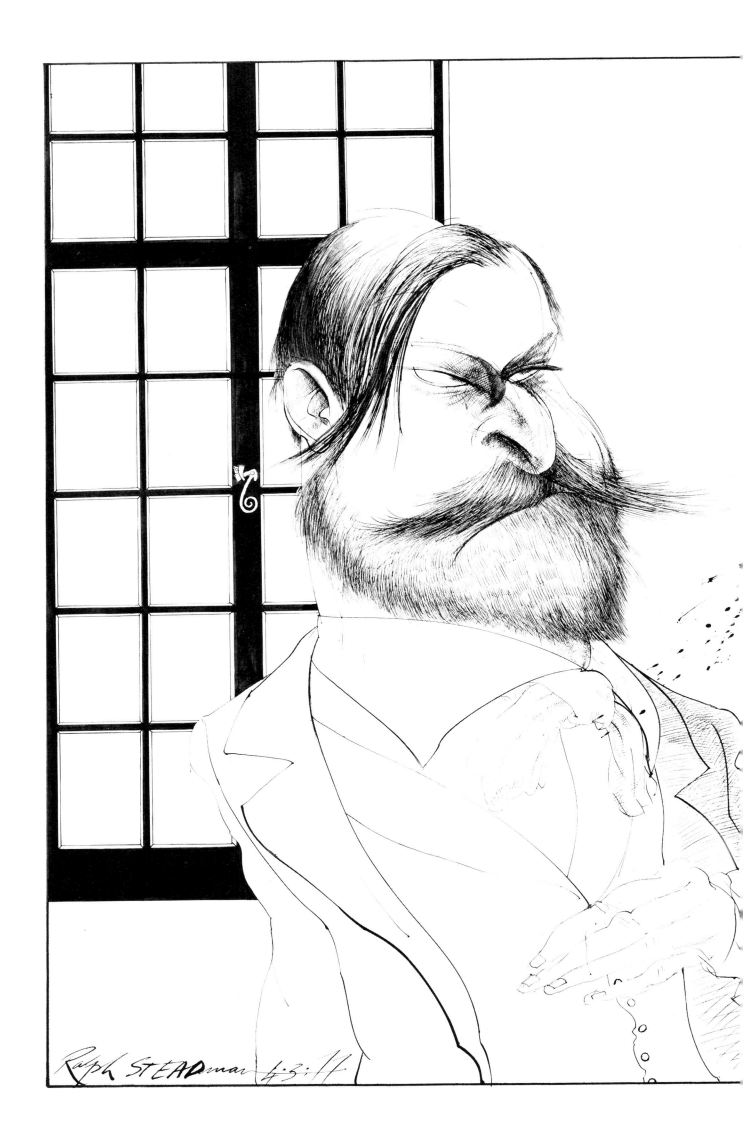

Ralph STEADman 4.3.14

Freud listening to a joke told to him by
a colleague who has just learned of Freud's
intention to publish a paper on the subject.

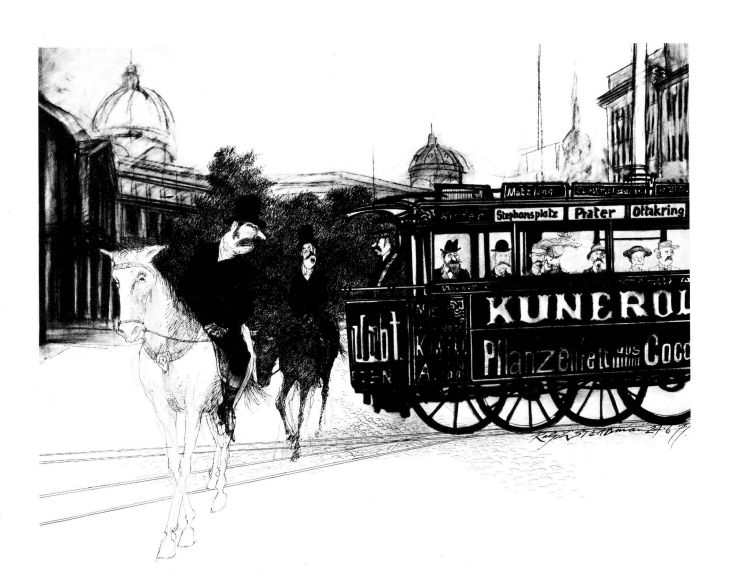

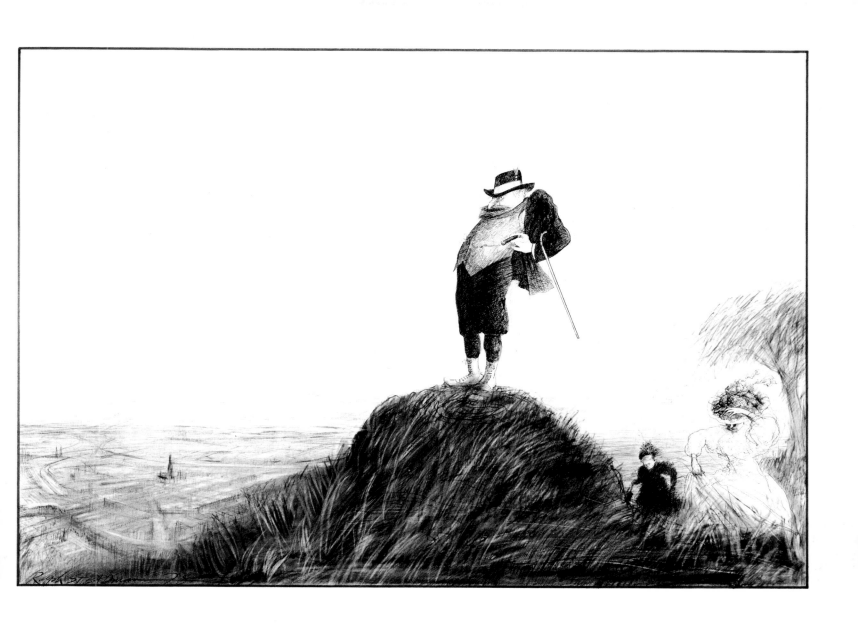

140, 141, 142, 143, 144, 145

Artist/Artiste/Künstler/**Ralph Steadman**
Art Director/Directeur Artistique/**Colin Lewis**
Publisher/Editeur/Verlag/**Paddington Press Limited**

Book illustrations for 'Sigmund Freud' by Ralph Steadman.
Indian ink, charcoal and wash.

Illustrations de livre pour 'Sigmund Freud' par Ralph Steadman.
À l'encre de chine, fusain et lavis.

Buchillustrationen für 'Sigmund Freud' von Ralph Steadman.
Tusche, Kohle und Tuschzeichnung.

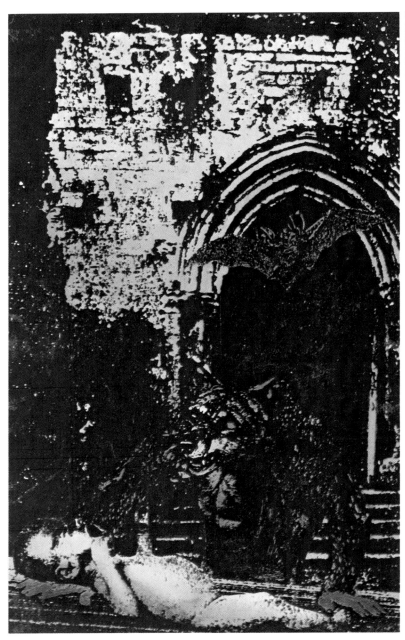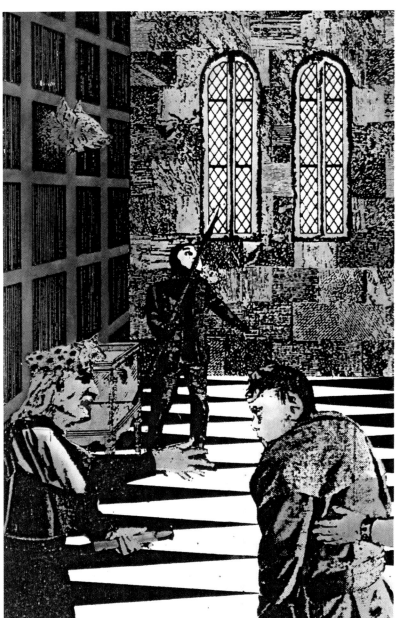

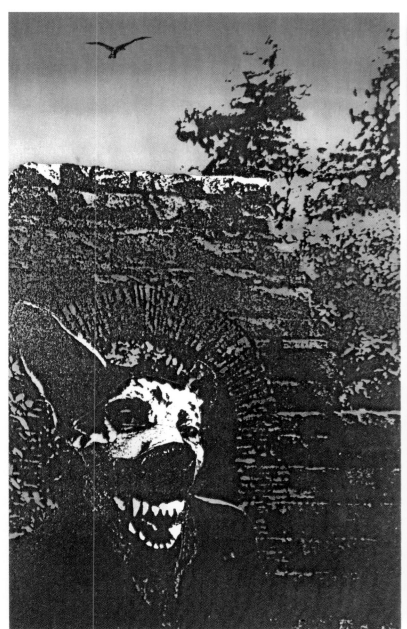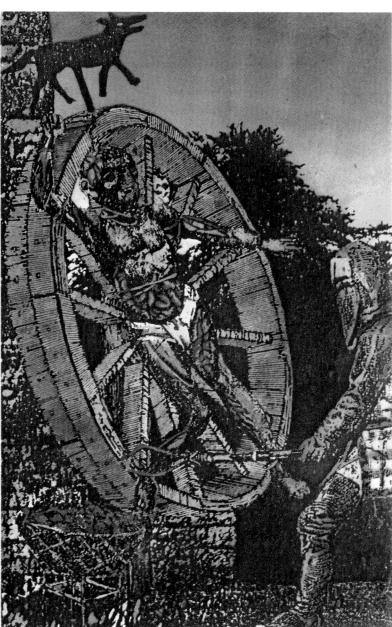

146, 147

Artist/Artiste/Künstler/**Mike Litherland**
Designer/Maquettiste/Gestalter/**Mike Litherland**
Publisher/Editeur/Verlag/**Royal College of Art**

Book illustrations for 'The Werewolf' with text by Montague Summers,
published April 1979. Collage, colour Xerox and photo-tint.

Illustrations de livre pour 'The Werewolf' (Le Loup Garou), avec une texte de
Montague Summers, publié en avril 1979. Collage,
Xerox couleur et ombres photographiques.

Buchillustrationen für 'The Werewolf' (Der Werwolf), mit einem Text
von Montague Summers, veröffentlicht im April 1979.
Collage, farbige Fotokopie und Fototusche.

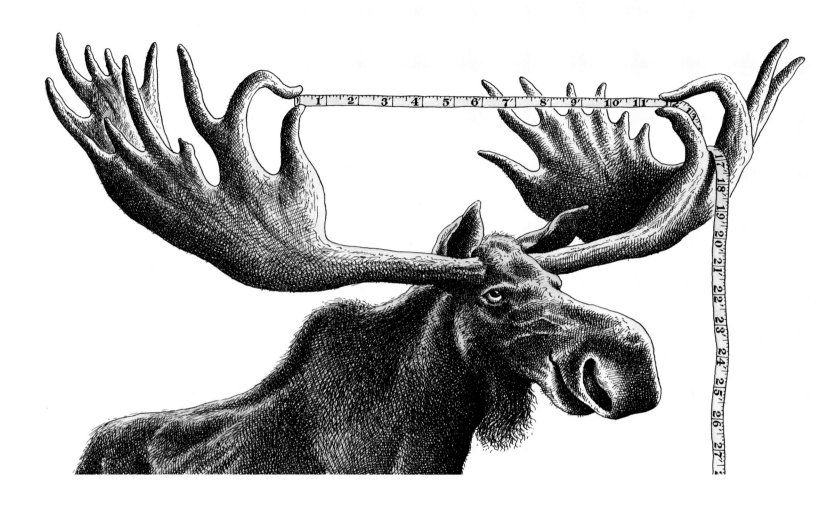

Artist/Artiste/Künstler/**Peter Brookes**
Designer/Maquettiste/Gestalter/**Peter Rozcyki**
Art Director/Directeur Artistique/**David Pelham**
Publisher/Editeur/Verlag/**Penguin Books Limited**

Book cover illustration for 'Ever Since Darwin' by Stephen Jay Gould.
Pen and ink, in colour.

Illustration de couverture de livre pour 'Ever Since Darwin' (Depuis Darwin)
par Stephen Jay Gould. Plume et encres, en couleur.

Buchumschlagillustration für 'Ever Since Darwin' (Seit Darwins Zeiten)
von Stephen Jay Gould. Farbige Federzeichnung.

ROARED!

seized him

and was about to eat him.

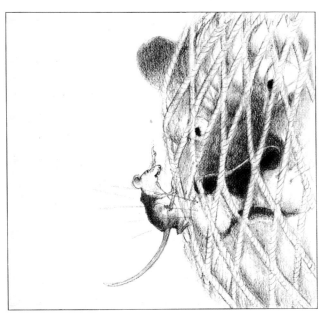

149

Artist/Artiste/Künstler/**Ed Young**
Art Editor/Rédacteur Artistique/Kunstredakteur/
Susan Benn
Publisher/Editeur/Verlag/**Ernest Benn Limited**

Illustration of an Aesop fable 'The Lion and the Mouse' adapted by Ed Young,
published September 1979. Coloured pencil.

Illustration de la fable d'Esope 'The Lion and the Mouse' (Le Lion et la Souris)
adaptée par Ed Young, publié en septembre 1979. Crayon de couleur.

Illustration zu Äsops Fabel 'The Lion and the Mouse' (Der Löwe und die Maus)
bearbeitet von Ed Young, veröffentlicht September 1979. Farbstifte.

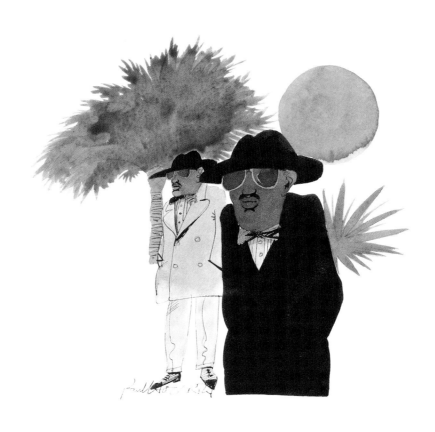

Artist/Artiste/Künstler/**Paul Hogarth**
Designer/Maquettiste/Gestalter/**Paul Hogarth**
Art Director/Directeur Artistique/**David Pelham**
Publisher/Editeur/Verlag/**Penguin Books Limited**

Book cover illustration for 'The Comedians' by Graham Greene. Water-colour.

Illustration de couverture de livre pour 'The Comedians' (Les Comédiens) par Graham Greene. Aquarelle.

Buchumschlagillustration für 'The Comedians' (Die Komödianten) von Graham Greene. Wasserfarben.

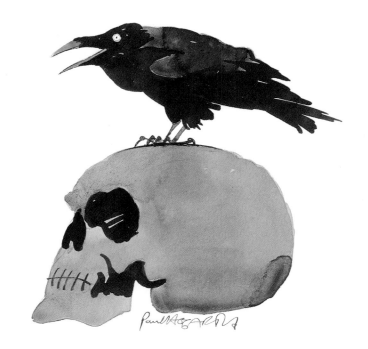

Artist/Artiste/Künstler/**Paul Hogarth**
Art Director/Directeur Artistique/**David Pelham**
Publisher/Editeur/Verlag/**Penguin Books Limited**

Book cover illustration for Shakespeare's 'Hamlet'. Ink and water-colour.

Illustration de couverture de livre pour 'Hamlet' de Shakespeare.
Encre et aquarelle.

Buchumschlagillustration für 'Hamlet' von Shakespeare.
Tusche und Wasserfarben.

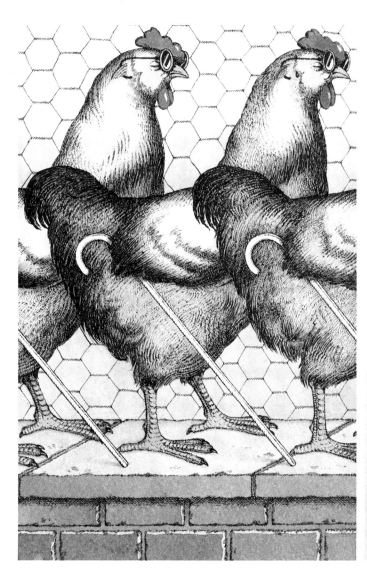

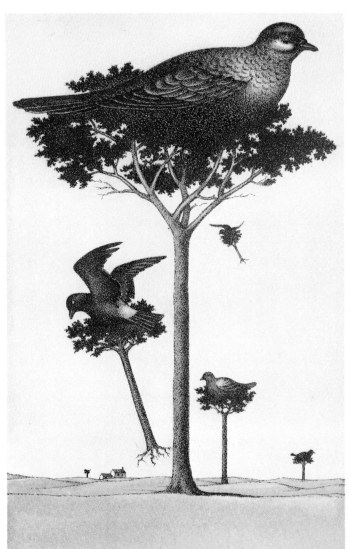 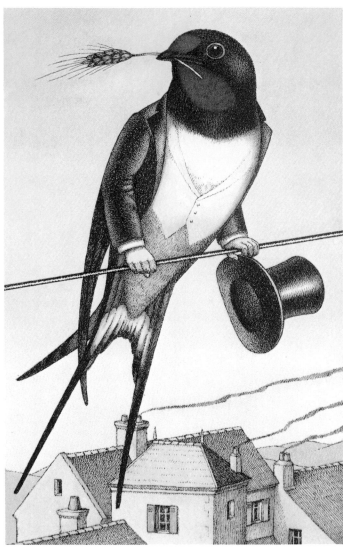

152, 153

Artist/Artiste/Künstler/**Henri Galeron**
Art Director/Directeur Artistique/**Pierre Marchand**
Publisher/Editeur/Verlag/**Editions Gallimard**

Book illustrations for 'En Cherchant la Petite Bête' (In Search of the Small Animal)
par Jacques Charpentreau. Ink and water-colour.

Illustrations de livre pour 'En Cherchant la Petite Bête' par Jacques Charpentreau.
Encre et aquarelle.

Buchillustrationen für 'En Cherchant la Petite Bête' (Auf der Suche nach dem
kleinen Biest), von Jacques Charpentreau. Tusche und Wasserfarben.

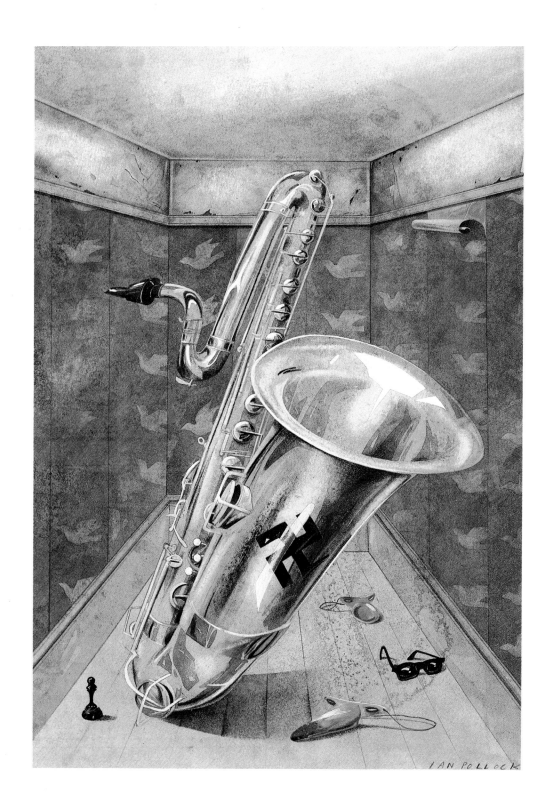

154

Artist/Artiste/Künstler/**Ian Pollock**
Art Director/Directeur Artistique/**David Larkin**
Publisher/Editeur/Verlag/**Pan Books Limited**

Book cover illustration for 'The Bass Saxophone' by Josef Skvorecky. Gouache.

Illustration de couverture de livre pour 'The Bass Saxophone'
(Le Saxophone de Basse) par Josef Skvorecky. Gouache.

Buchumschlagillustration für 'The Bass Saxophone' (Das Bass-Saxophon)
von Josef Skvorecky. Gouache.

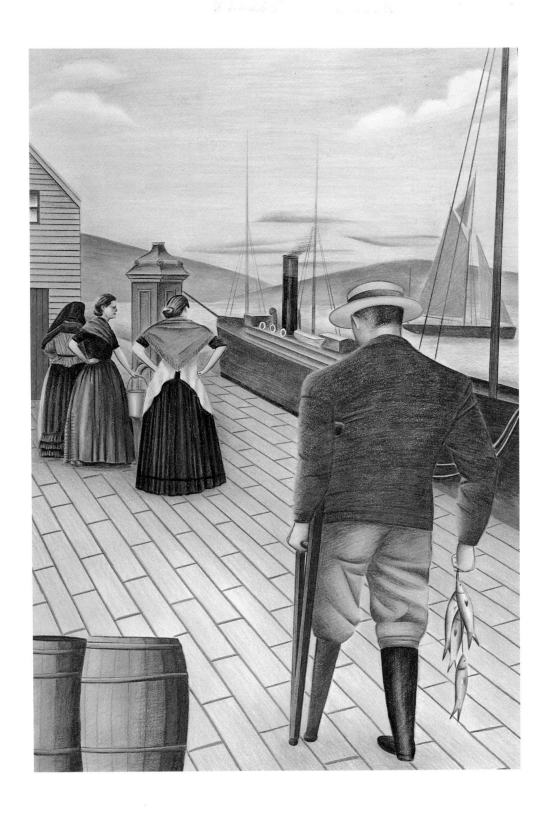

155

Artist/Artiste/Künstler/**Paul Leith**
Art Director/Directeur Artistique/**David Larkin**
Publisher/Editeur/Verlag/**Pan Books Limited**

Book cover illustration for 'The Women at the Pump' by Knut Hamsun,
published in the Picador series. Coloured pencil.

Illustration de couverture de livre pour 'The Women at the Pump'
(les Femmes à la Pompe) par Knut Hamsun, publié dans la série Picador.

Buchumschlagillustration für 'The Women at the Pump'
(Die Frauen an der Pumpe) von Knut Hamsun, Picador-Serie. Farbstifte.

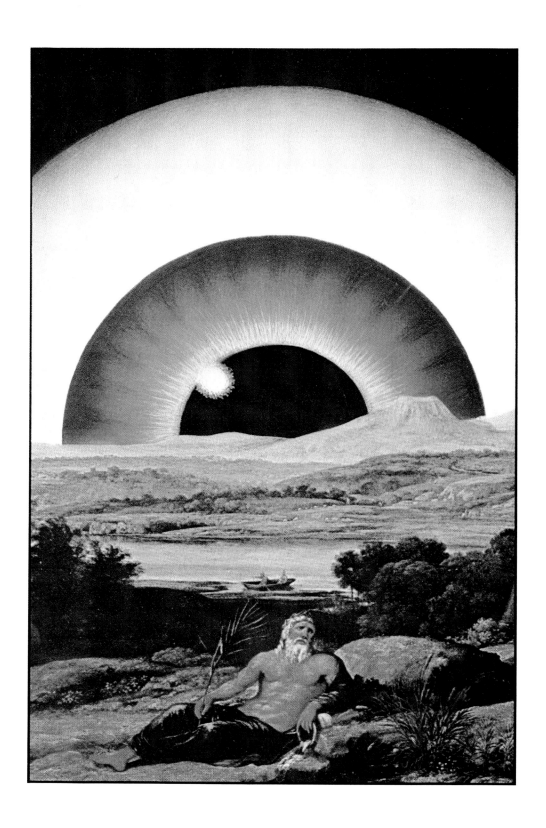

156

Artist/Artiste/Künstler/**Patrick Couratin**
Art Director/Directeur Artistique/**Pierre Marchand**
Publisher/Editeur/Verlag/**Editions Gallimard**

Illustration for a poem by Victor Hugo, in 'Choses du Soir' (Evening Things),
published October 1979. In colour.

Illustration pour un poème de Victor Hugo dans 'Choses du Soir',
publié en octobre 1979. En couleur.

Illustration zu einem Gedicht von Victor Hugo in 'Choses du Soir'
(Dinge des Abends), veröffentlicht im Oktober 1979. Farbig.

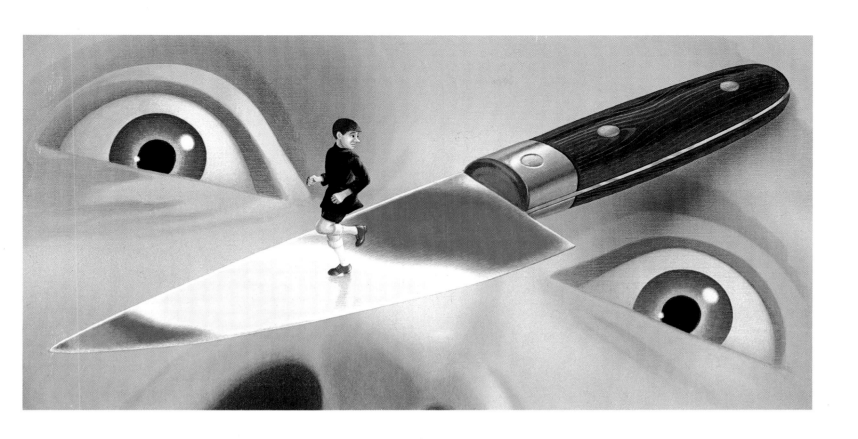

157
Artist/Artiste/Künstler/**Henri Galeron**
Art Director/Directeur Artistique/**Pierre Marchand**
Publisher/Editeur/Verlag/**Editions Gallimard**

Illustration for a poem by Jacques Prévert in 'La Pêche à la Baleine'
(Fish on the Line), published October 1979. Full colour, in acrylic paint.

Illustration pour un poème de Jacques Prévert dans 'La Pêche à la Baleine',
publié en octobre 1979. Acrylique, en couleur.

Illustration zu einem Gedicht von Jacques Prévert in 'La Pêche à la Baleine'
(Fischgang mit dem Besen), veröffentlicht Oktober 1979. Acryl, farbig.

Bericht von **AARON LATHAM** Dew Westbrook ist ein Asphalt-Cowboy. Seine Weide liegt in der Millionenstadt Houston, US-Staat Texas, und heißt Gilley's, ein Honky-tonk-Saloon, der fast so groß wie eine Ranch ist. Das Tier, auf dem Dew reitet, ist ein wilder Stier. An der Südseite des Saloons zwingt er den rasenden Bullen zwischen seine Knie – in einer Landschaft, die statt mit Büschen mit langhalsigen Bierflaschen übersät ist,und in der statt saftiger Wiesen filzige Billardtische grünen. Der Stier ist nur eine Maschine, doch er bockt genauso kräftig wie ein echter. Gelegentlich bricht er einem Reiter Arme und Beine. Manchmal quetscht er noch empfindlichere Teile. Ein Honky-tonk-Cowboy muß seine Männlichkeit schon mal riskieren, wenn er sie überzeugend

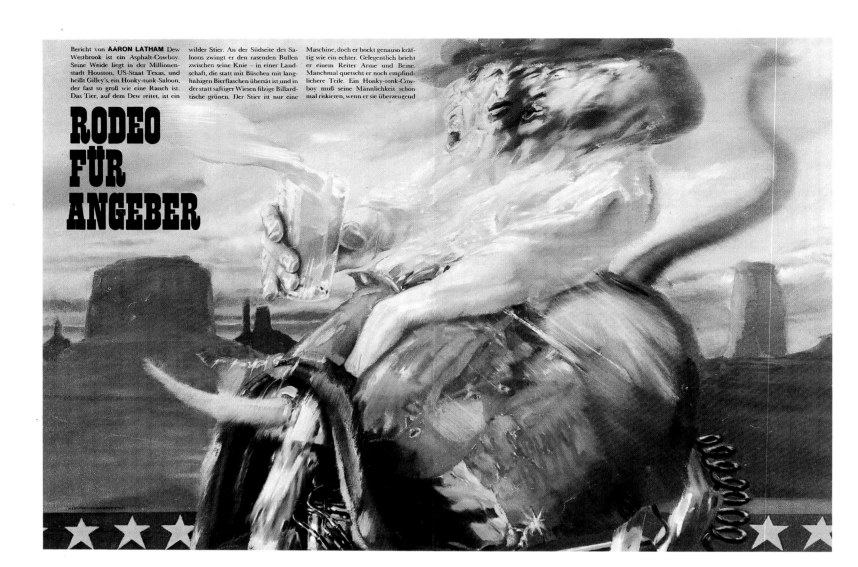

RODEO FÜR ANGEBER

158

Artist/Artiste/Künstler/**Manfred Vogel**
Designer/Maquettiste/Gestalter/**Angi Bronder**
Art Directors/Directeurs Artistique/**Wolf Thieme, Rainer Wörtmann**
Publisher/Editeur/Verlag/**Heinrich Bauer Verlag**

Illustration for "Rodeo für Angeber" (Rodeo for Reporters) by Aaron Latham, in Germay 'Playboy' December 1979. Oils.

Illustration pour "Rodeo für Angeber" (Rodeo pour Poseurs) par Aaron Latham, dans 'Playboy' allemand décembre 1979. Huile.

Illustration für "Rodeo für Angeber" von Aaron Latham, im Deutschen 'Playboy' Dezember 1979. Ölfarben.

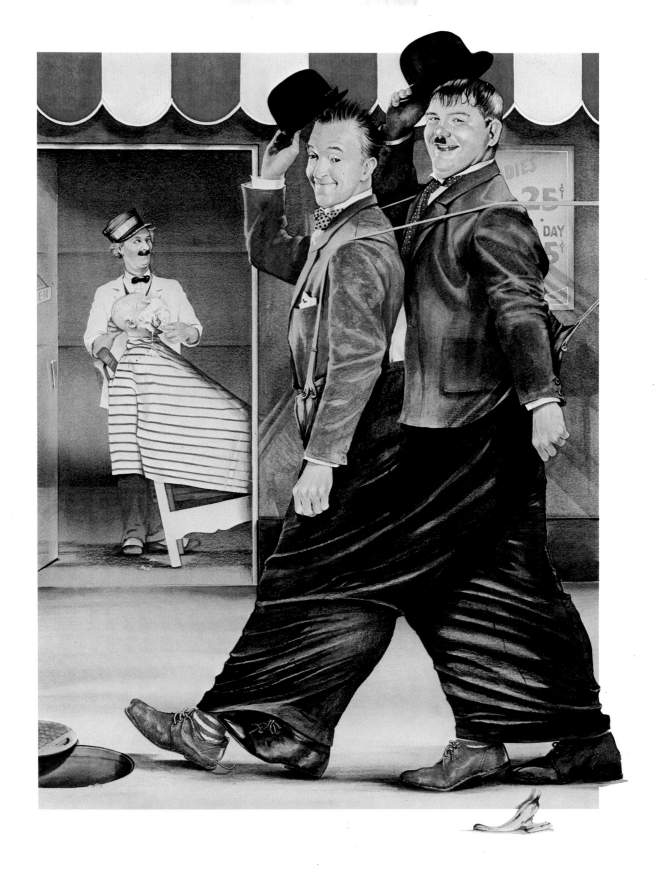

159

Artist/Artiste/Künstler/**Kathy Wyatt**
Editor/Monteur/Cutter/**Tim Dowley**
Art Director/Directeur Artistique/**Nigel Soper**
Publisher/Editeur/Verlag/**Mitchell Beazley Publishers Limited**

Book illustration entitled "Comedy Genre" for 'The Book of the Cinema',
compiled by Chris Milisome with a foreword by François Truffaut,
published September 1979. Water-colour.

Illustration intitulée "Comedy Genre" (Le Genre Comédie) pour 'The Book of the
Cinema' (Livre du Cinéma), compilé par Chris Milisome avec une
préface de François Truffaut, publié en september 1979. Aquarelle.

Illustration betitelt "Comedy Genre" (Kommödiengenre) für 'The Book of Cinema'
(Das Filmbuch), zusammengestellt von Chris Milisome mit einem Vorwort von
François Truffaut, veröffentlicht im September 1979.

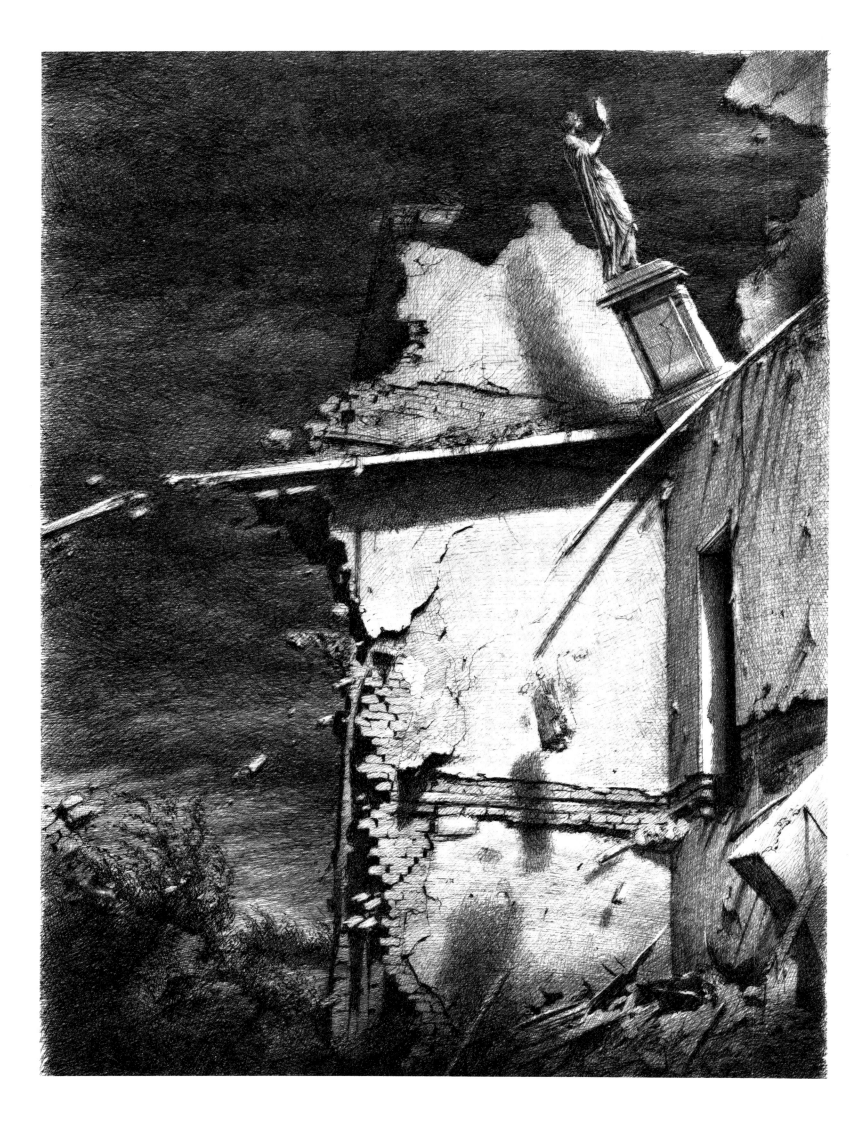

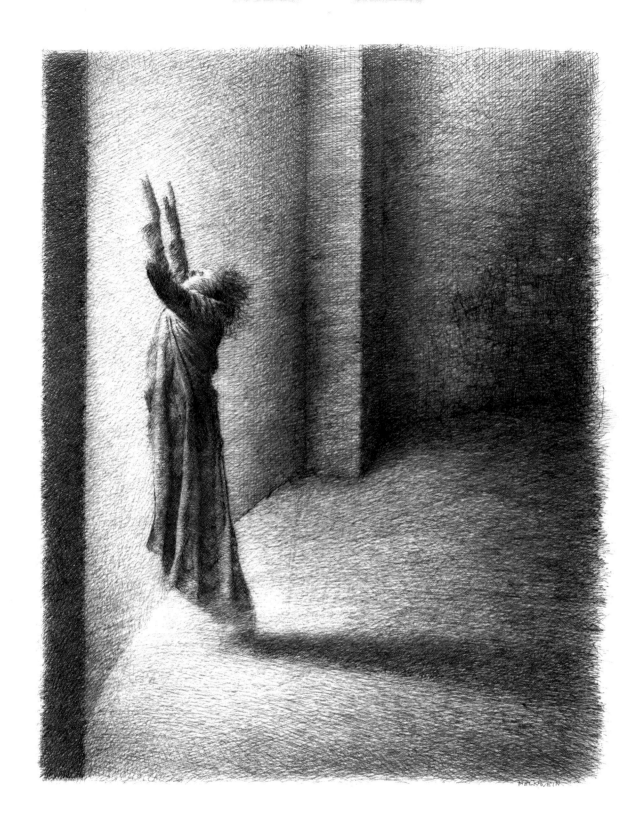

160, 161

Artist/Artiste/Künstler/**Gottfried Helnwein**
Art Director/Directeur Artistique/**Gottfried Helnwein**
Publisher/Editeur/Verlag/**Weingarten Kunstverlag**

Book illustrations for 'Unheimliche Geschichten' (Strange Stories)
by Edgar Allan Poe, published 1979. Black and white, in ink.

Illustrations de livre pour 'Unheimliche Geschichten' (Histoires Extraordinaires)
de Edgar Allan Poe, publié 1979. Noir et blanc, en encre.

Buchillustrationen für 'Unheimliche Geschichten' von Edgar Allan Poe,
veröffentlicht 1979. Schwarzweiss, Tusche.

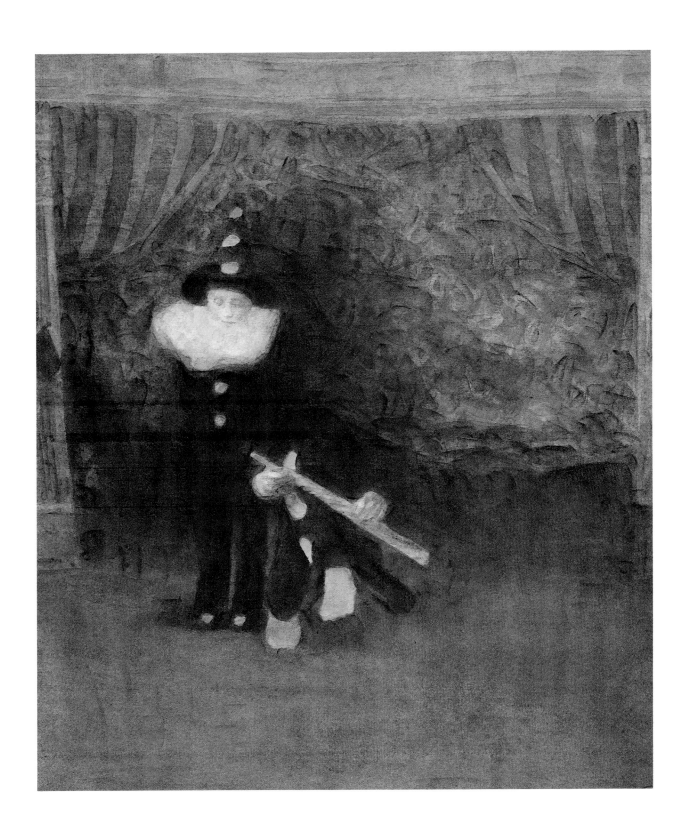

162, 163

Artist/Artiste/Künstler/**Guillermo Roux**
Art Director/Directeur Artistique/**Giorgio Soavi**
Publisher/Editeur/Verlag/**Ing C Olivetti & C SpA**

Illustrations for the 1980 Olivetti Diary. Water-colour.

Illustrations pour le calendrier Olivetti 1980. Aquarelle.

Illustrationen zum Olivetti Tagebuch 1980. Wasserfarben.

ADVERTISING
AND POSTERS

This section includes work commissioned for
posters, prints and advertisements for consumer
magazines.

Cette section comprend des travaux commandés
pour des affiches, des illustrations et de la
publicité pour les magazines de consommateurs.

Dieser Abschnitt umfasst Auftragsarbeiten für
Plakate, Drucksachen und Anzeigen für
Verbraucherzeitschriften.

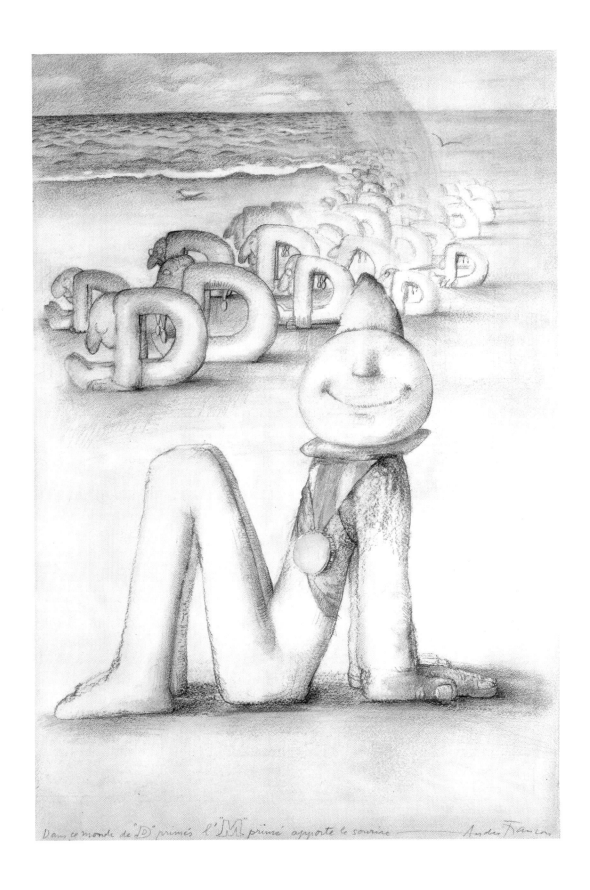

Dans ce monde de "D" primés l' "M" primé apporte le sourire — Andre François

Artist/Artiste/Künstler/**Andre François**
Designer/Maquettiste/Gestalter/**Andre François**
Art Director/Directeur Artistique/**Jean-Louis Redval**
Advertising Agency/Agéncé de Publicité/Werbeagentur/**Semios**
Client/Auftraggeber/**Fédération Française de l'Imprimerie**

Poster with slogan "Dans ce monde de 'D' primes l' 'M' prime apporte
le sourire" (In this world of 'D' pression, our 'M' pression brings a smile)
to publicise the Fédération Française de l'Imprimerie.

Affiche portant le slogan "Dans ce monde de 'D' primes l' 'M' prime apporte
le sourire," pour faire connaitre le Fédération Française de l'Imprimerie.

Poster mit Werbeschlagwort "Dans ce monde de 'D' primes l' 'M' prime apporte
le sourire" (In dieser Welt der 'Bedrückten' läßt das 'Bedruckte' vider lächeln)
die für die Fédération Française de l'Imprimerie.

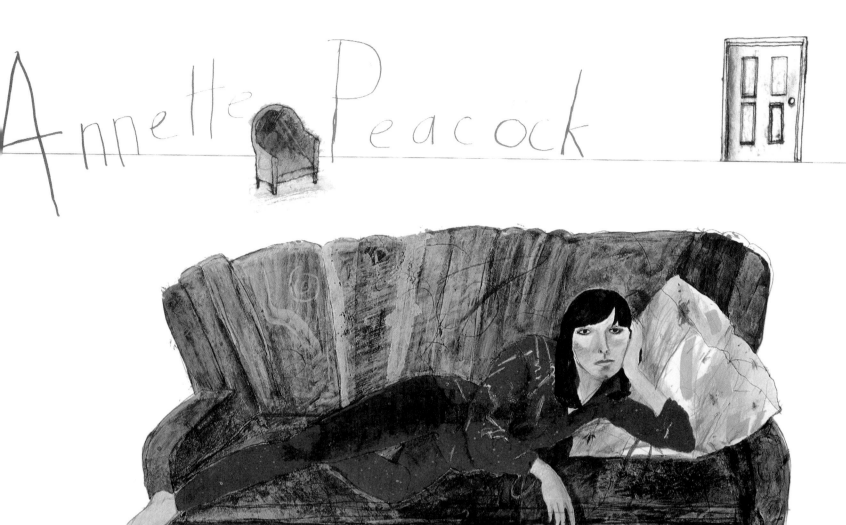

167

Artist/Artiste/Künstler/**Chloë Cheese**
Art Director/Directeur Artistique/**Aaron Sixx**
Client/Auftraggeber/**Aura Records**

Poster to accompany LP record sleeve "The Perfect Release" by Annette Peacock.
Ink, paint and crayon.

Affiche pour pochette de disque de longue durée "The Perfect Release"
(La Délivrance Parfaite) par Annette Peacock. Encre, peinture et pastel.

Werbeposter zur Plattenhülle "The Perfect Release" (Die perfekte Erscheinung)
von Annette Peacock. Tusche, Farbe und Kreide.

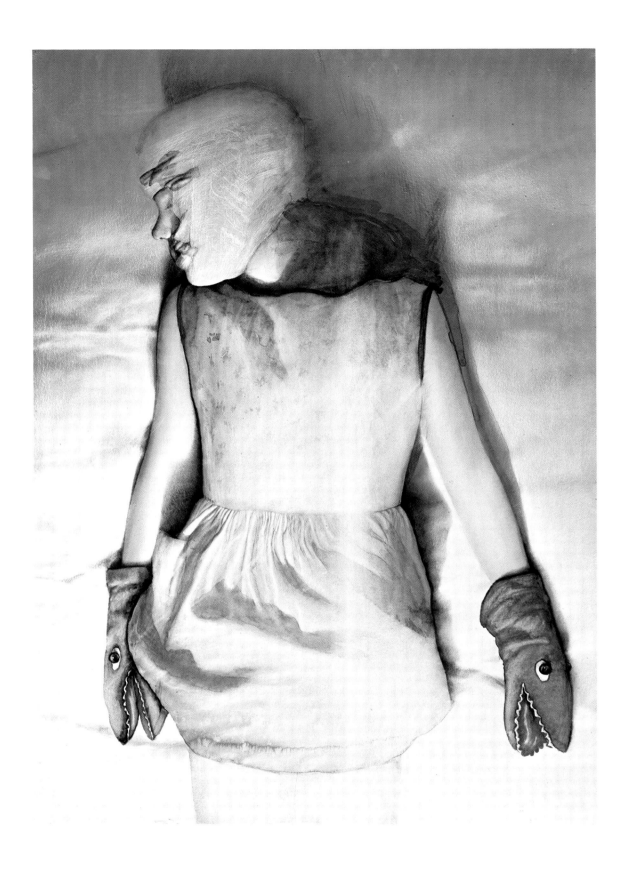

168

Artist/Artiste/Künstler/**Gottfried Helnwein**
Art Director/Directeur Artistique/**Gottfried Helnwein**

Poster to publicise an exhibition of the artist's work, which appeared in Stuttgart,
Amsterdam and Vienna. Water-colour.

Affiche de publicité pour une exposition d'art par l'artiste, qui a paru à Stuttgart,
Amsterdam et Vienne. Aquarelle.

Werbeposter für eine Ausstellung des Künstlers, erschienen in Stuttgart,
Amsterdam und Wien. Wasserfarben.

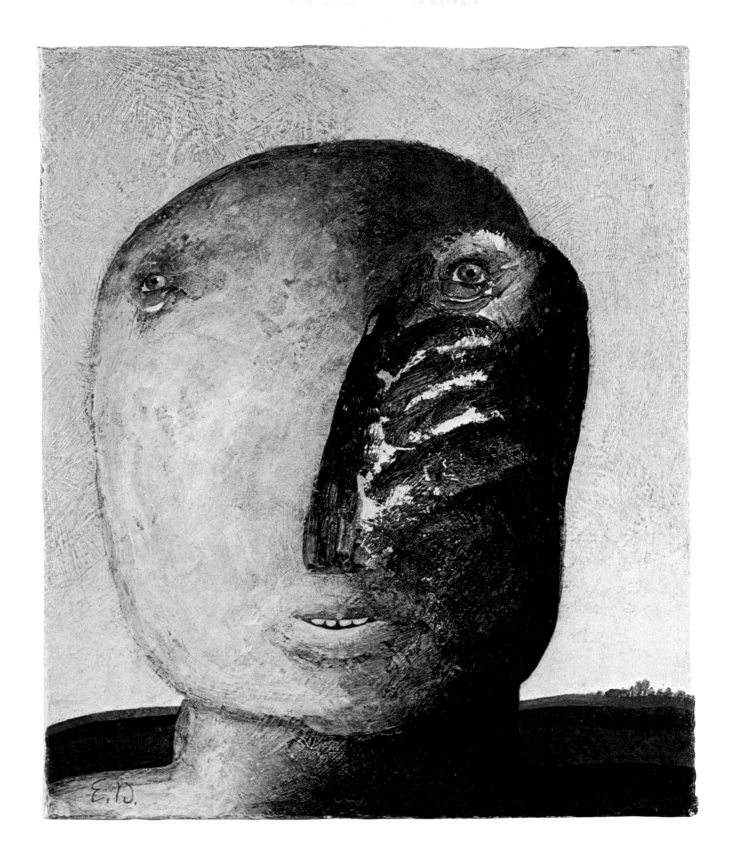

169

Artist/Artiste/Künstler/**Etienne Delessert**
Art Director/Directeur Artistique/**Etienne Delessert**
Advertising Agency/Agence de Publicité/Werbeagentur/**Carabosse SA**

Limited edition New Year's poster card, commissioned by Albin Uldry. Acrylic paint.

Édition à tirage restreint d'une affichette de Nouvel An, commandée par Albin Uldry. Peinture acrylique.

Begrenzte Auflage eines Plakats einer Neujahrskarte, beauftragt von Albin Uldry. Acrylfarbe.

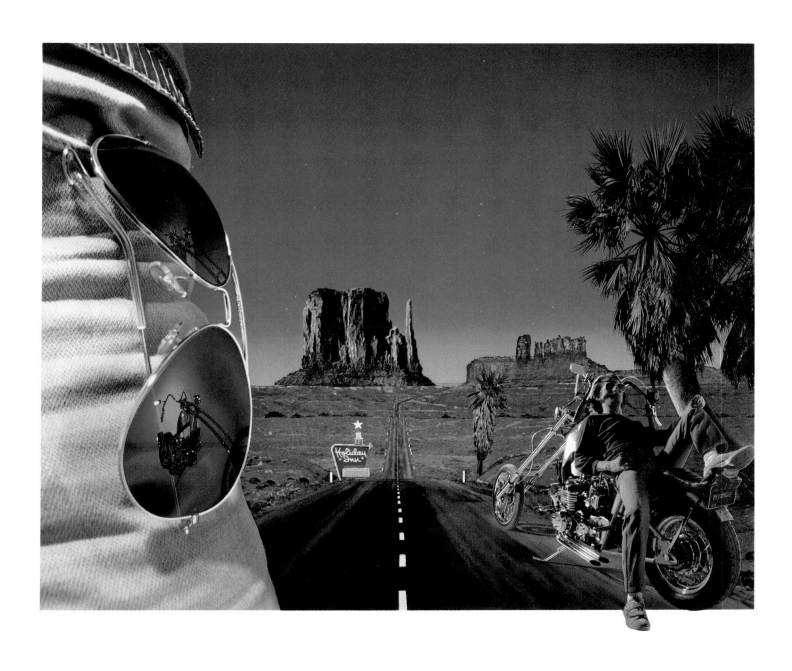

170

Artist/Artiste/Künstler/**Pierre Peyrolle**
Art Director/Directeur Artistique/**Pierre Peyrolle**
Advertising Agency/Agence de Publicité/Werbeagentur/**Pierre Bories**
Client/Auftraggeber/**Ray Ban Sunglasses**

Poster to advertise Ray Ban Sunglasses. Oils.

Affiche de publicité pour les lunettes de soleil Ray Ban. Huile.

Werbeposter für Ray Ban Sonnenbrillen. Ölfarbe.

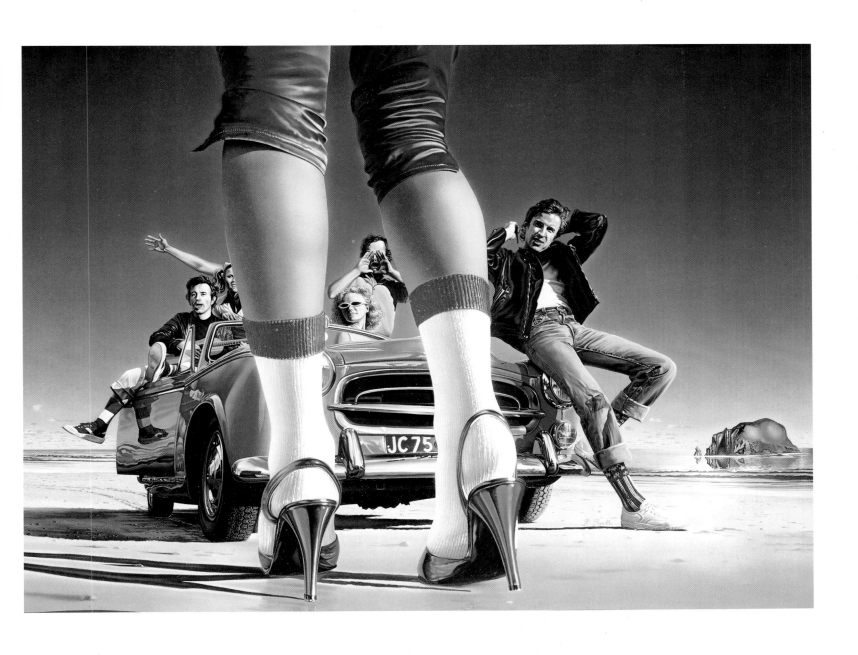

171

Artist/Artiste/Künstler/**Pierre Peyrolle**
Art Director/Directeur Artistique/**U R S Glaser, J C L Lachery**
Advertising Agency/Agence de Publicité/Werbeagentur/**Greener Grass**
Client/Auftraggeber/**Chesterfield Shoes**

Poster to advertise Chesterfield's Junior Shoes. Oils.

Affiche publicitaire pour les chaussures de jeunes Chesterfield. Huile.

Werbeposter für Chesterfields Kinderschuhe. Ölfarbe.

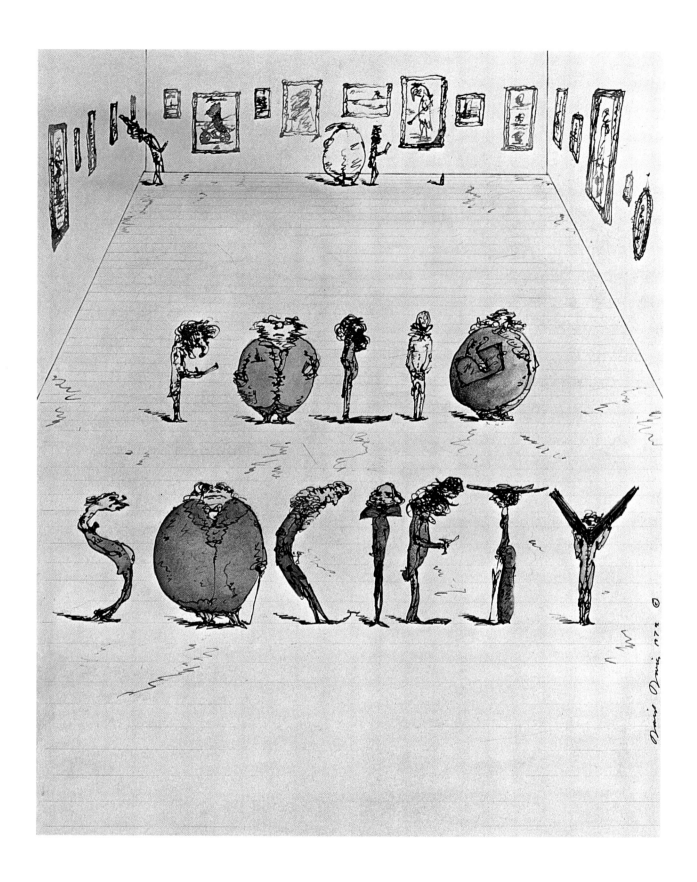

172

Artist/Artiste/Künstler/**David Davies**
Designer/Maquettiste/Gestalter/**David Davies**
Publisher/Editeur/Verlag/**Royal College of Art**

Poster to publicise the Folio Society exhibition at the Royal College of Art,
March 1979. Ink and water-colour.

Affiche de publicité pour l'exposition de la Folio Society au Royal College of Art,
mars 1979. Encre et aquarelle.

Werbeposter für die Ausstellung der Folio Society im Royal College of Art,
März 1979. Tusche und Wasserfarben.

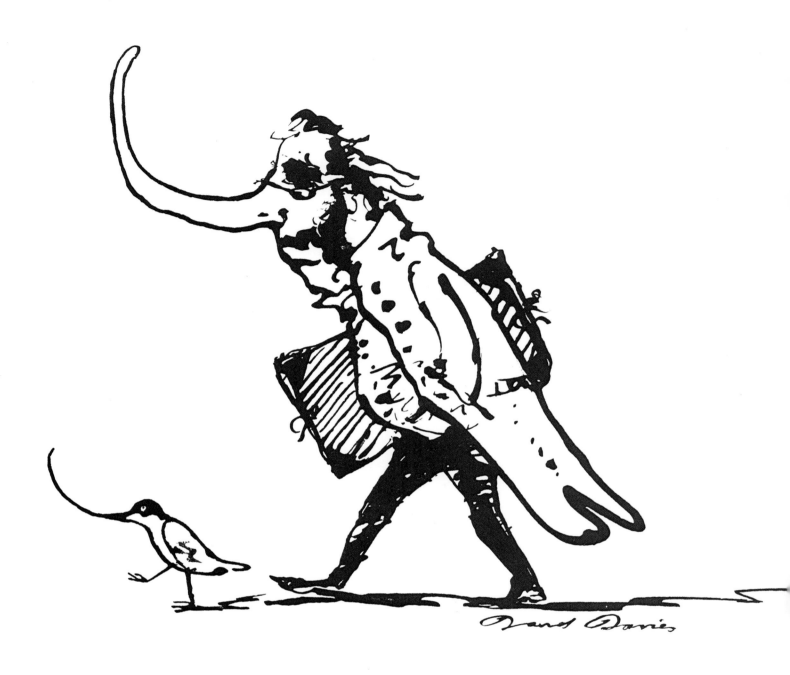

173

Artist/Artiste/Künstler/**David Davies**
Designer/Maquettiste/Gestalter/**David Davies**
Publisher/Editeur/Verlag/**Royal College of Art**

Poster to publicise an exhibition of work by Royal College of Art staff and recent graduates, at the Gardner Centre Gallery September 1979. Pen and ink.

Affiche de publicité pour une exposition de travaux du personnel et de diplômes récents du Royal College of Art, à la Gardner Centre Gallery septembre 1979. Plume et encre.

Werbeposter für eine Ausstellung der Werke von Kunsterziehern und neueren Absolventen des Royal College of Art in der Gardner Centre Gallery September 1979. Bleistift und Tusche.

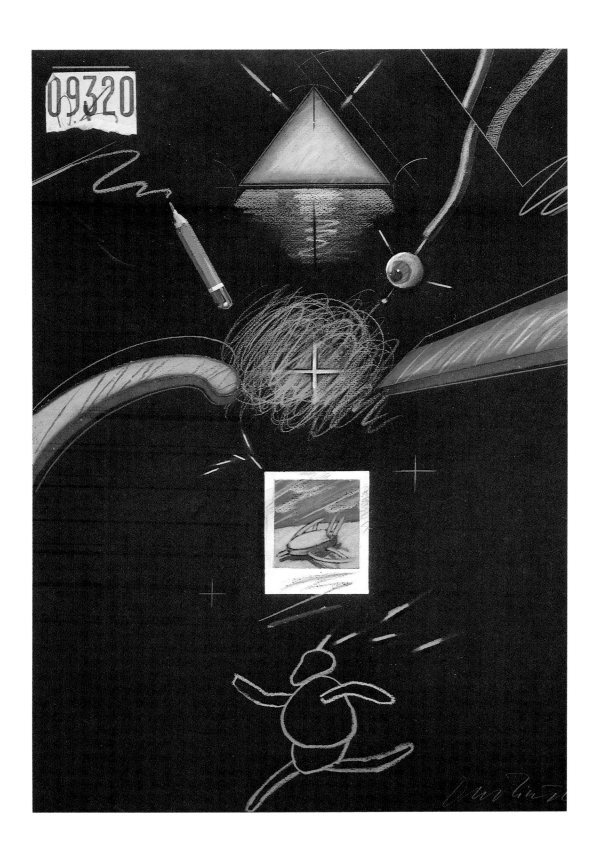

174

Artist/Artiste/Künstler/**Andrzej Dudzinski**
Art Director/Directeur Artistique/**Andrzej Dudzinski**
Client/Auftraggeber/**Gallery Lax 814**

Unpublished promotional poster for an art exhibition at Galley Lax 814 entitled
"Park Your Dream Here." Mixed media.

Affiche de promotion inédite pour une exposition d'art à Gallery Lax 814 intitulée
"Park Your Dream Here" (Gare ton Rêve ici). Média divers.

Unveröffentlichtes Werbeposter für eine Kunstausstellung in der Gallery Lax 814
betitelt "Park Your Dream Here" (Lass Deine Träume hier stehen).
Mediakombination.

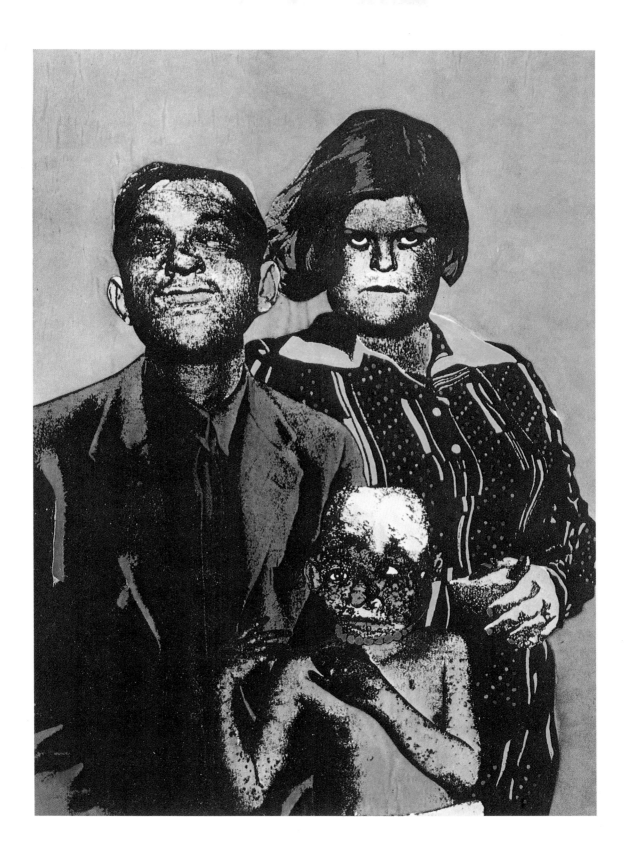

175

Artist/Artiste/Künstler/**Mike Litherland**
Designer/Maquettiste/Gestalter/**Mike Litherland**
Publisher/Editeur/Verlag/**Royal College of Art**

Poster to publicise an exhibition of students' work on the theme of sex, at the Royal
College of Art May 1979. Collage and Xerox, in colour.

Affiche pour la promotion d'une exposition de travail d'étudiants sur le thème de
sexe, au Royal College of Art mai 1979. Collage et Xerox, en couleur.

Werbeposter für eine Ausstellung von Studenten des Royal College of Art über das
Thema Sex, Mai 1979. Farbige Fotokopie und Collage.

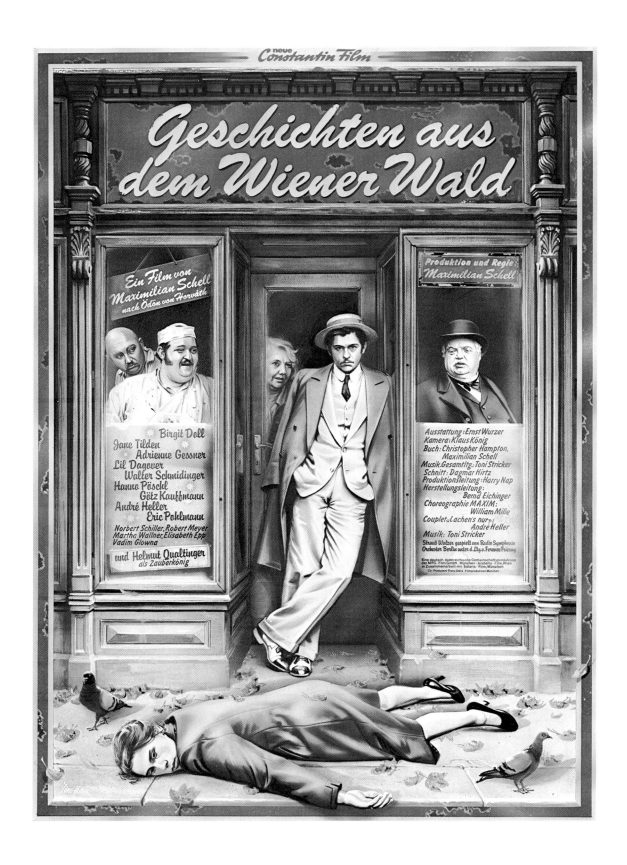

176

Artist/Artiste/Künstler/**Jörg Huber**
Art Director/Directeur Artistique/**Peter Sickert**
Copywriter/Rédacteur/Texter/**Jörg Huber**
Client/Auftraggeber/**Neue Constantin Film GmbH**

Poster to promote a film by Maximilian Schell "Geschichten aus dem Wiener Wald" (Stories from the Vienna Forest). Water-colour, gouache, kase intempera and Letraset.

Affiche de publicité pour un film de Maximilian Schell "Geschichten aus dem Wiener Wald" (Légendes de la Fôret Viennoise). Aquarelle, gouache, kase intempera, Letraset.

Werbeposter für einen Film von Maximilian Schell "Geschichten aus dem Wienerwald." Wasserfarben, Gouache, Kaseintempera, Letraset.

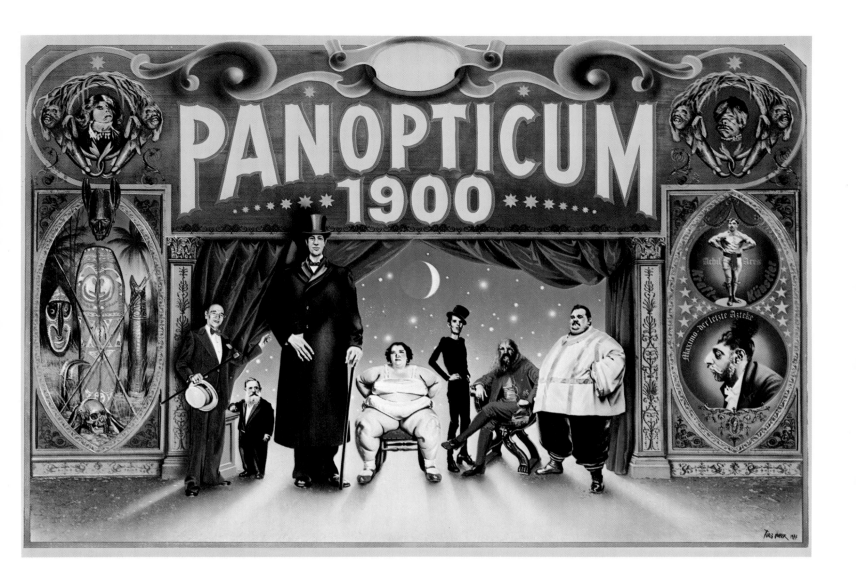

177

Artist/Artiste/Künstler/**Jörg Huber**
Art Director/Directeur Artistique/**Klaus Weckert**
Copywriter/Rédacteur/Texter/**Jörg Huber**
Advertising Agency/Agence de Publicité/Werbeagentur/**Weckert & Partner**
Client/Auftraggeber/**Leo Center**

Poster to publicise an exhibition of the photograph collection of Felix Adanos
"Show Freaks and Monsters," shown in West Germany. Water-colour,
gouache and kase intempera.

Affiche de publicité pour une exposition de la collection de photographies de
Felix Adanos "Show Freaks and Monsters" (Phénomènes et Monstres), montrée en
Allemagne de l'Ouest. Aquarelle, gouache et kase intempera.

Werbeposter zur Ausstellung der Fotosammlung von Felix Adanos "Show Freaks
and Monsters" (Menschliche Zirkuskuriositäten und Monster), erschienen in
West-Deutschland. Wasserfarben, Gouache, Kaseintempera.

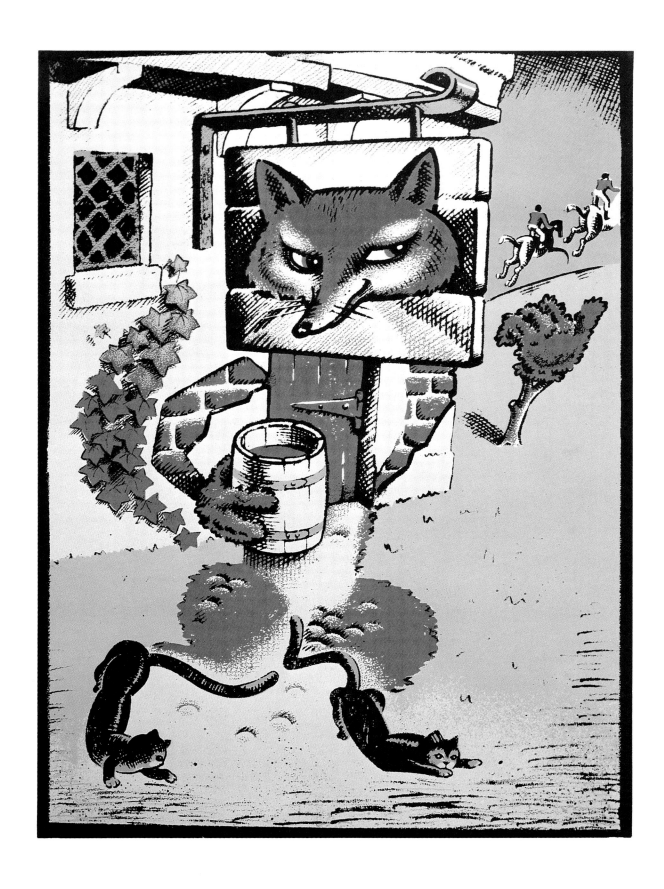

Artist/Artiste/Künstler/**Bush Hollyhead**
Art Director/Directeur Artistique/**David Stuart**
Client/Auftraggeber/**Watney Mann & Truman Brewers Ltd**

Poster to publicise "The Fox" pub for Watney's Brewers. Pencil drawing, colour
overlaid.

Affiche de publicité du Pub "The Fox" pour Watney's Brewers. Dessin au crayon,
coloré.

Werbeposter für den Pub "The Fox" der Watney's Brauerei. Bleistiftskizze, Koloriert.

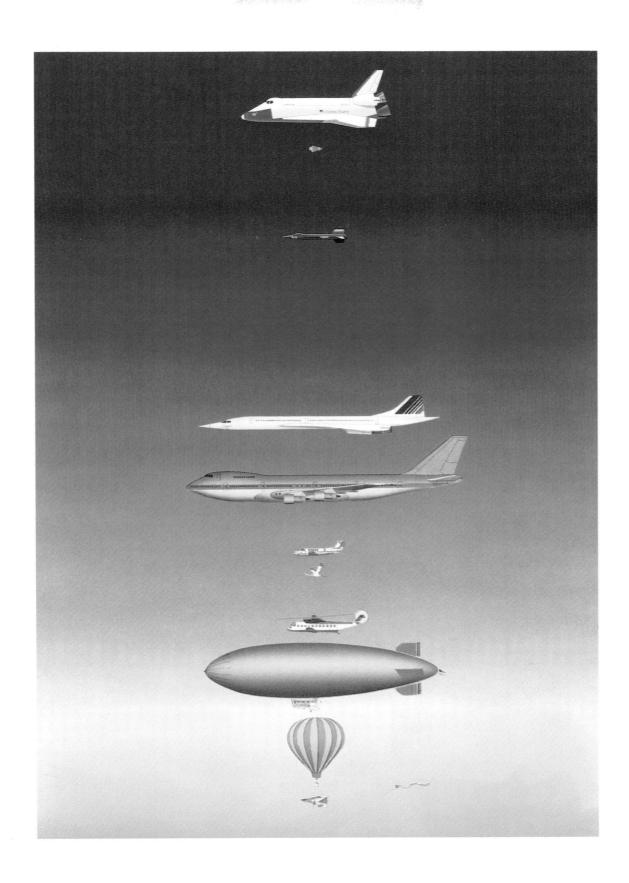

179

Artist/Artiste/Künstler/**Guy Billout**
Art Director/Directeur Artistique/**Carol Carson**
Publisher/Editeur/Verlag/**Scholastic Magazine**
Copywriter/Rédacteur/Texter/**Jean Marzello**

Poster with slogan "What's That Up in the Sky?", commissioned by 'Scholastic'
magazine April 1980. Water-colour.

Affiche portant le slogan "What's That Up in the Sky?" (Quelles sont ces choses
dans le Ciel?), commandée par 'Scholastic' magazine avril 1980. Aquarelle.

Poster mit Werbeschlagwort "What's That Up in the Sky?" (Was ist los im
Himmel?), im Auftrag des 'Scholastic' Magazins April 1980. Wasserfarben.

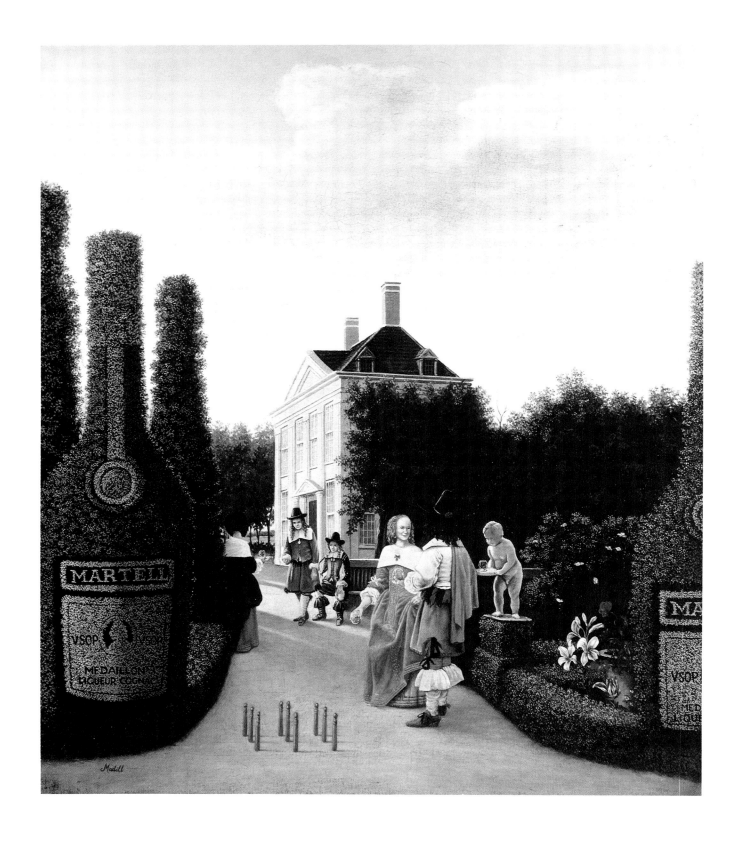

180

Artist/Artiste/Künstler/**Warren Madill**
Art Director/Directeur Artistique/**Max Henry**
Copywriter/Rédacteur/Texter/**Stuart Blake**
Advertising Agency/Agence de Publicité/Werbeagentur/
Doyle Dane Bernbach Limited
Client/Auftraggeber/**Martell**

Illustration advertising Medaillon VSOP Cognac, in 'The Observer Magazine'
11 November 1979. Oils.

Illustration de publicité pour Médaillon VSOP Cognac, dans 'The Observer
Magazine' le 11 novembre 1979. Huile.

Werbung für Medaillon VSOP Cognac in 'The Observer Magazine' 11. November
1979. Ölfarbe.

MADAME TUSSAUD'S
BAKER STREET

181
Artist/Artiste/Künstler/**Robert Crowther**
Client/Auftraggeber/**Madame Tussaud's**
Photographer/Photographe/Photograph/**Kenneth Griffiths**

A poster to advertise Madam Tussaud's Waxworks Museum, especially designed
for escalator sites on London Transport. Gouache.

Affiche de publicité pour le Musée de figures de cire de Madame Tussaud, créée
pour les murs des escaliers roulants du métro londonien. Gouache.

Werbeposter für Madame Tussaud's Wachsfiguren Kabinett, entworfen für die
Reklamefläche der Rolltreppe in der Londoner U-Bahn. Gouache.

182

Artist/Artiste/Künstler/**Jeffery Edwards**
Art Director/Directeur Artistique/**Tony Muranka**
Copywriter/Rédacteur/Texter/**Geoffrey Seymour**
Advertising Agency/Agence de Publicité/Werbeagentur/**Cherry Hedger &
Seymour Limited**
Client/Auftraggeber/**Standard Brands Limited**

Poster with slogan "Temptation Beyond Endurance," one of a series of posters to
publicise Planters Peanuts. Full colour, in gouache.

Affiche portant le slogan "Temptation Beyond Endurance" (Tentation Intolérable),
une d'une série pour faire connaître Planters Peanuts. Couleur, en gouache.

Poster mit Werbeschlagwort "Temptation Beyond Endurance" (Unwiderstehliche
Verlockung), aus einer Serie die für Planters Erdnusse wirbt. Gouache, in Farbe.

183

Artist/Artiste/Künstler/**Warren Madill**
Art Director/Directeur Artistique/**Tony Muranka**
Copywriter/Rédacteur/Texter/**Geoffrey Seymour**
Advertising Agency/Agence de Publicité/Werbeagentur/**Cherry Hedger &
Seymour Limited**
Client/Auftraggeber/**Standard Brands Ltd**

Poster with slogan "Temptation Beyond Endurance," one of a series of posters to
publicise Planters Peanuts. Full colour, in acrylic paint.

Affiche portant le slogan "Temptation Beyond Endurance" (Tentation Intolérable),
une d'une série pour faire connaître Planters Peanuts. Couleur, en acrylique.

Poster mit Werbeschlagwort "Temptation Beyond Endurance" (Unwiderstehliche
Verlockung), aus einer Serie die für Planters Erdnusse wirbt. Acryl, in Farbe.

DESIGN

This section includes work commissioned for calendars, diaries, direct mail announcements, greetings cards, packaging, promotional booklets, promotional mailings, record sleeves, stationery, technical and industrial catalogues.

Cette section comprend des travaux commandés pour les calendriers, agendas, lettres circulaires, cartes de voeux, emballages, livrets de promotion, promotion par poste, pochettes de disques, papeterie, catalogues techniques et industriels.

Dieser Abschnitt umfasst Arbeiten für Agenden, Kalender, Werbesendungen, Grusskarten, Verpackungsartikel, Prospekte, Schallplattenhüllen, Briefköpfe, technische und Industriekataloge.

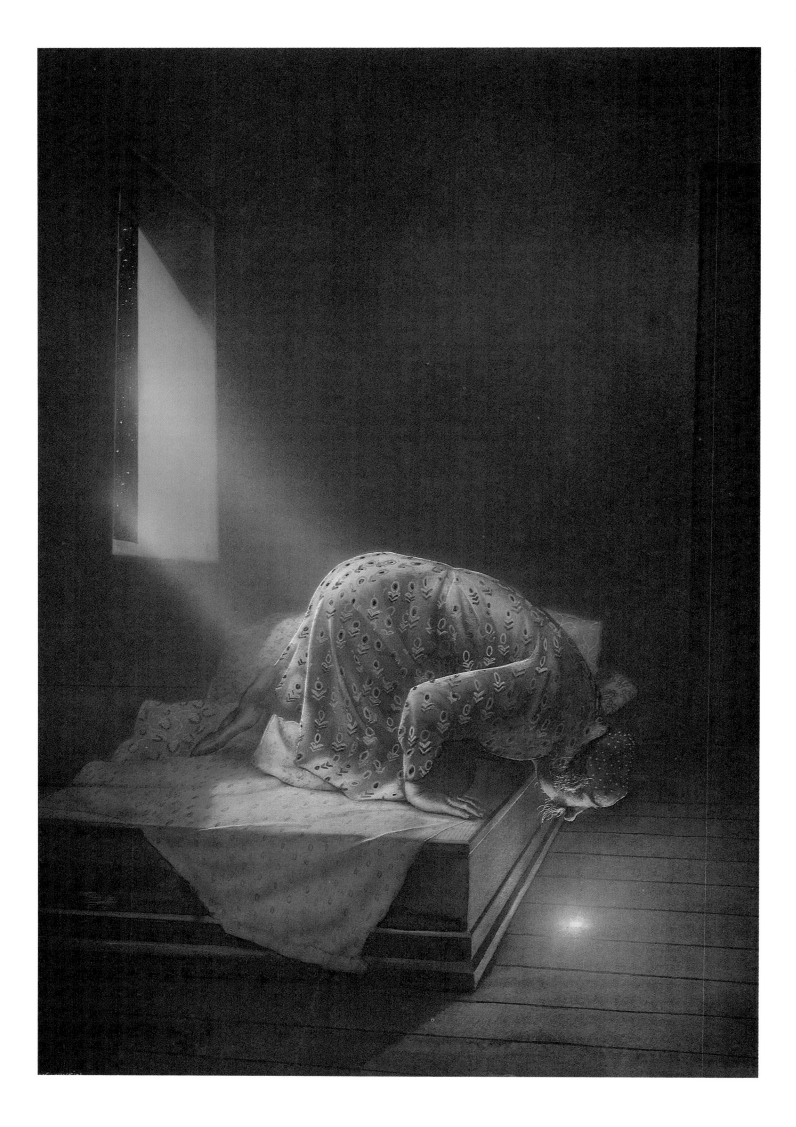

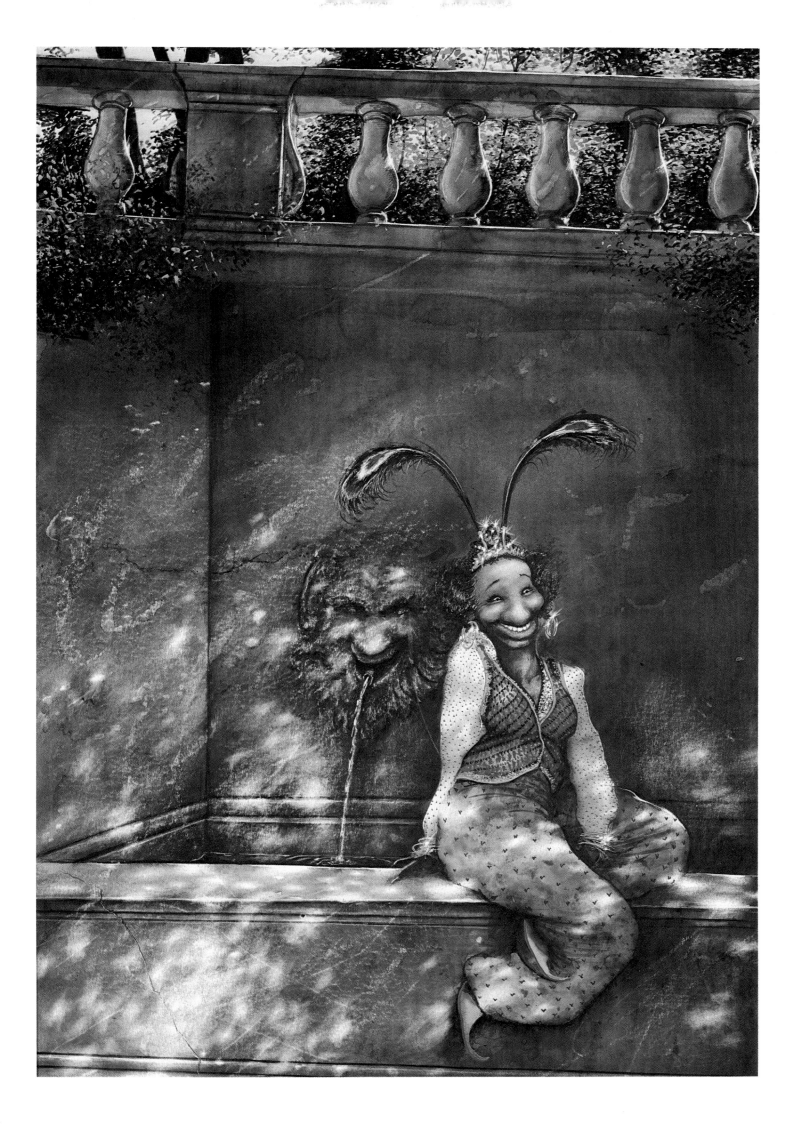

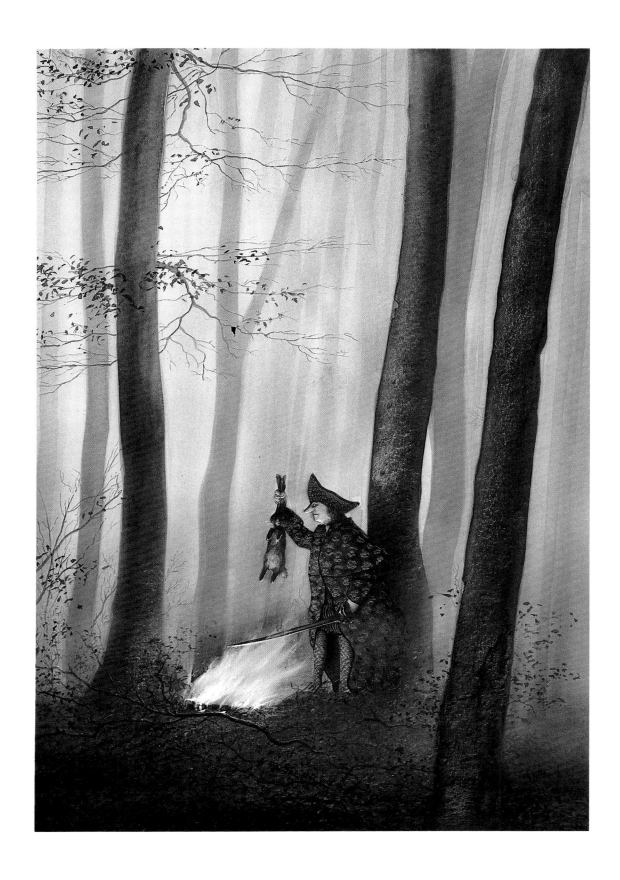

186, 187, 188

Artist/Artiste/Künstler/**Gottfried Helnwein**
Art Editor/Rédacteur Artistique/Kunstredakteur/**Rainer Berger**
Publisher/Editeur/Verlag/**Weingarten Kunstverlag**

Designs for 1980 calendar "Europäische Märchen" (European Fairytales).
Water-colour.

Projets pour un calendrier 1980 "Europäische Märchen"
(Contes de fées Européens). Aquarelle.

Kalenderentwurf für 1980 "Europäische Märchen." Wasserfarben.

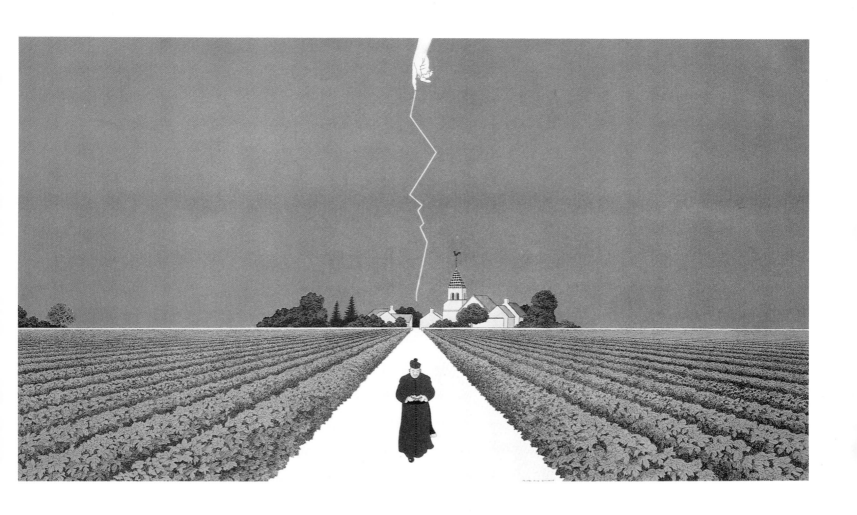

189

Artist/Artiste/Künstler/**Guy Billout**
Art Director/Directeur Artistique/**Jitsuo Hoashi**
Client/Auftraggeber/**Japanese Bartender Association**

A design for 1980 Cocktail Calendar commissioned by the Japanese Bartender
Association. The above illustration features Kir. Water-colour.

Une présentation pour le Calendrier Cocktail 1980 commandé par l'Association
Japonaise de Bartenders. Cette illustration représente le Kir. Aquarelle.

Ein Entwurf für Cocktail-Kalender 1980, beauftragt von der Japanischen Bartender
Association. Die Illustration zeigt Kir. Wasserfarben.

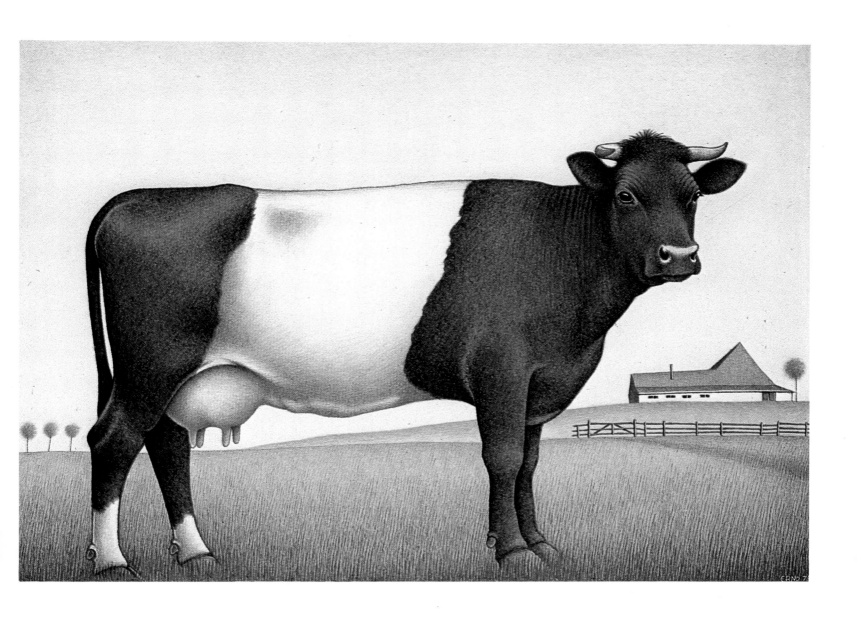

190, 191

Artist/Artiste/Künstler/**Erno Tromp**
Art Director/Directeur Artistique/**Erno Tromp, Deborah Wolf**
Publisher/Editeur/Verlag/**Galerie Balans**

"The Five Dutch Cows," design to promote an exhibition featuring Dutch
landscape and cows, December 1979. Water-colour.

Une présentation "The Five Dutch Cows" (Les Cinq Vaches Hollandaises) pour
la promotion d'une exposition comprenant un paysage hollandais avec vaches,
décembre 1979. Aquarelle.

Ein Entwurf "The Five Dutch Cows" (Die fünf holländischen Kühe), Werbung
für eine Ausstellung, welche die holländische Landschaft und Kühe darstellt,
Dezember 1979. Wasserfarben.

UNPUBLISHED

This section consists of commissioned but not
published illustration, personal work produced
and the work of students.

Cette section comprend l'illustration
commandée mais non publiée, le travail
pesonnel et le travail d'étudiants.

Dieser Abschnitt enthält nicht veröffentlichte
Auftragsillustrationen, persönliche Arbeiten
und die Arbeiten von Studenten.

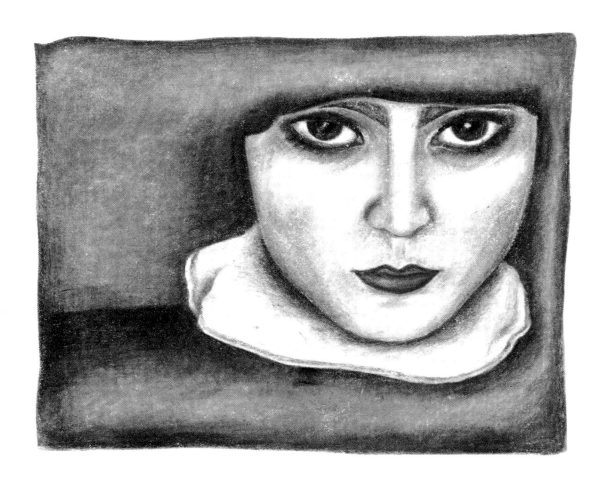

194

Artist/Artiste/Künstler/**Renate Belina**

Illustration for artist's portfolio. Coloured pencils.

Illustration pour la réserve de l'artiste. Crayons de couleur.

Illustration für die persönliche Mappe des Künstlers. Farbstifte.

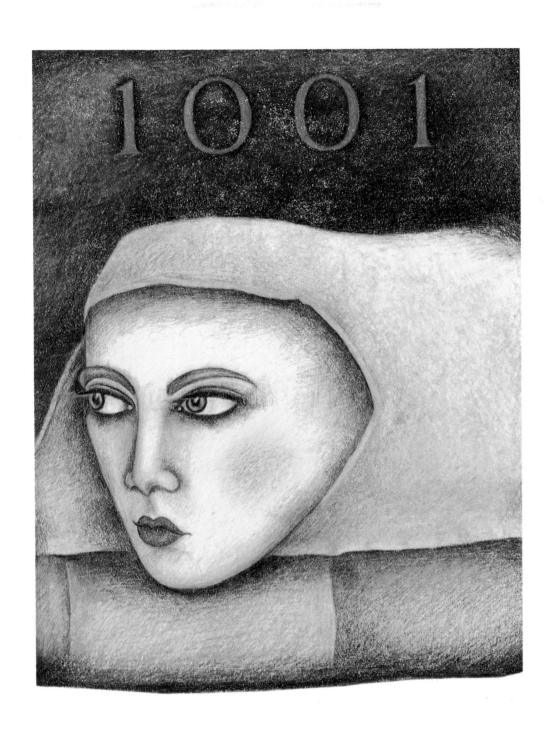

195

Artist/Artiste/Künstler/**Renate Belina**

Illustration for artist's portfolio. Coloured pencils.

Illustration pour la réserve de l'artiste. Crayons de couleur.

Illustration für die persönliche Mappe des Künstlers. Farbstifte.

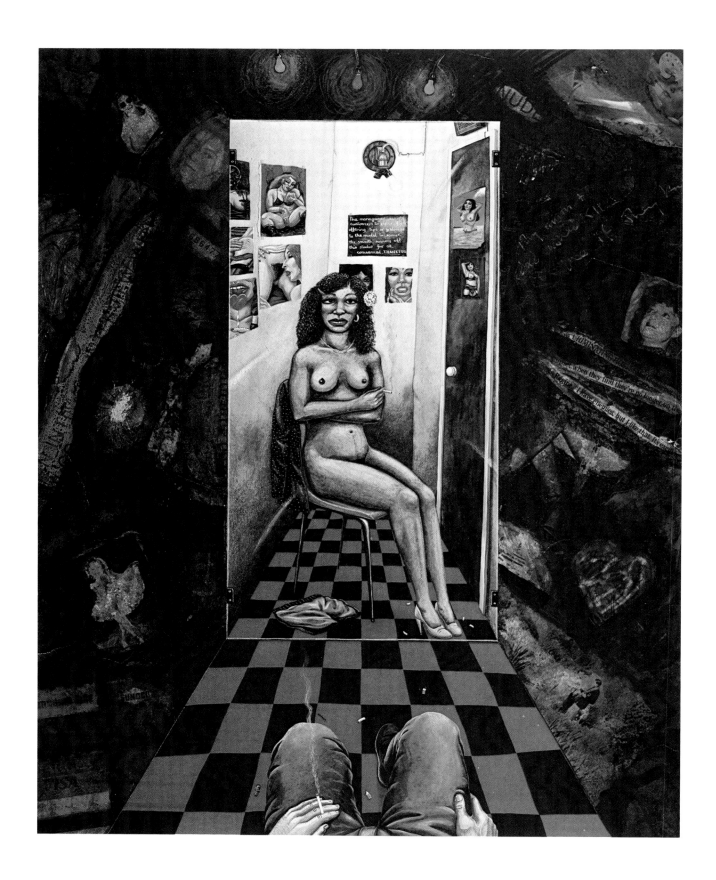

196

Artist/Artiste/Künstler/**Robert Mason**

"An Intimate Interview with a Gorgeous Nude Female in a Completely Private Studio." Gouache, inks and collage. In colour.

"An Intimate Interview with a Gorgeous Nude Female in a Completely Private Studio" (Une Interview Intime avec une Splendide Femme Nue dans un Studio Complètement Privé). Gouache, encres et collage. En couleur.

"An Intimate Interview with a Gorgeous Nude Female in a Completely Private Studio" (Ein Intimes Interview mit einer berauschenden, nackten Frau in einem sehr privaten Studio). Gouache, Tusche und Collage. Farbig.

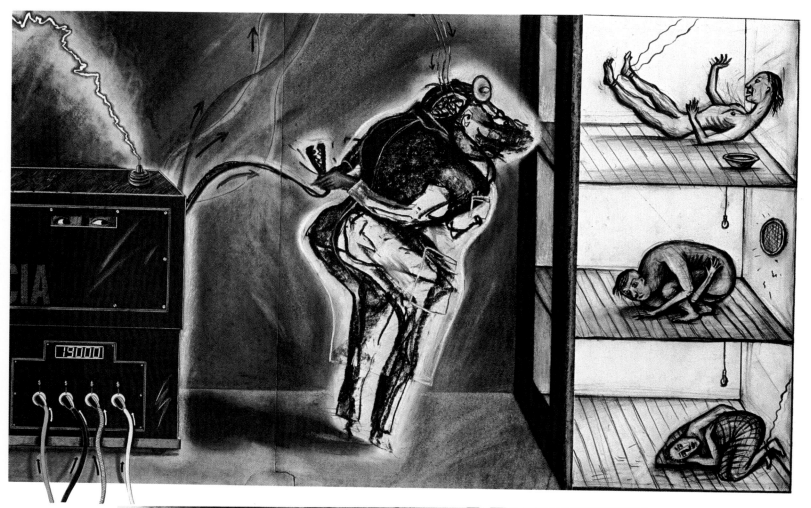

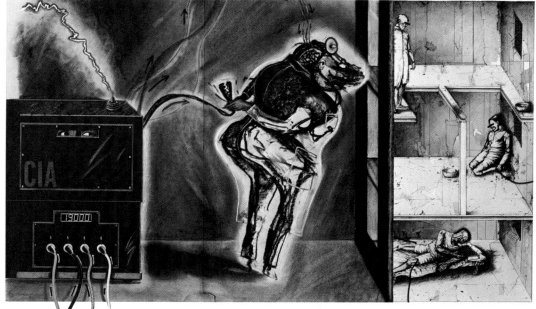

197

Artist/Artiste/Künstler/**Anne Howeson, Robert Mason, Liz Pyle**
Art Director/Directeur Artistique/Art Direktor/**Tim Cottrell**
Publisher/Editeur/Verlag/**The Observer Limited**

Illustration for an article about an illegal, experimental electrotherapy program run by CIA during 1950's using prison and mental inmates as subjects. Commissioned by 'The Observer' but not published. Mixed media.

Illustration commandée par 'The Observer' pour un article sur un programme d'électrothérapie expérimental illégal mis en place par la CIA dans les années 1950 utilisant comme sujets des prisonniers et des débiles mentaux. L'article et l'illustration n'ont pas été publiés par la suite. Média divers.

Illustration im Auftrag von 'The Observer' zu einem Artikel über ein illegales elektrotherapeutisches Versuchsprogramm, das vom CIA in den fünfziger Jahren geführt wurde. Häftlinge und Geistegestörte wurden als Versuchsobjekte benutzt. Der Artikel und die Illustration wurden schliesslich nicht veröffentlicht. Mediakombination.

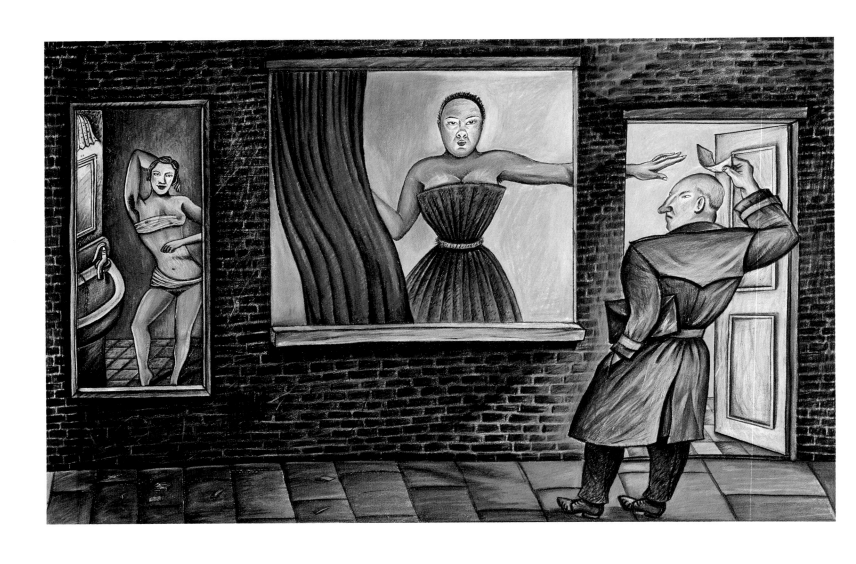

198

Artist/Artiste/Künstler/**Anne Howeson**

"Red Light District, Amsterdam," part of a forthcoming exhibition on prostitution (November 1981). Crayon and gouache.

"Red Light District, Amsterdam" (Quartier réservé, Amsterdam), partie d'une prochaine exposition sur la prostitution (novembre 1981). Crayon et gouache.

"Red Light District, Amsterdam" (Das Dirnenviertel in Amsterdam), Teil einer zukünftigen Ausstellung über Prostitution (November 1981). Kreide und Gouache.

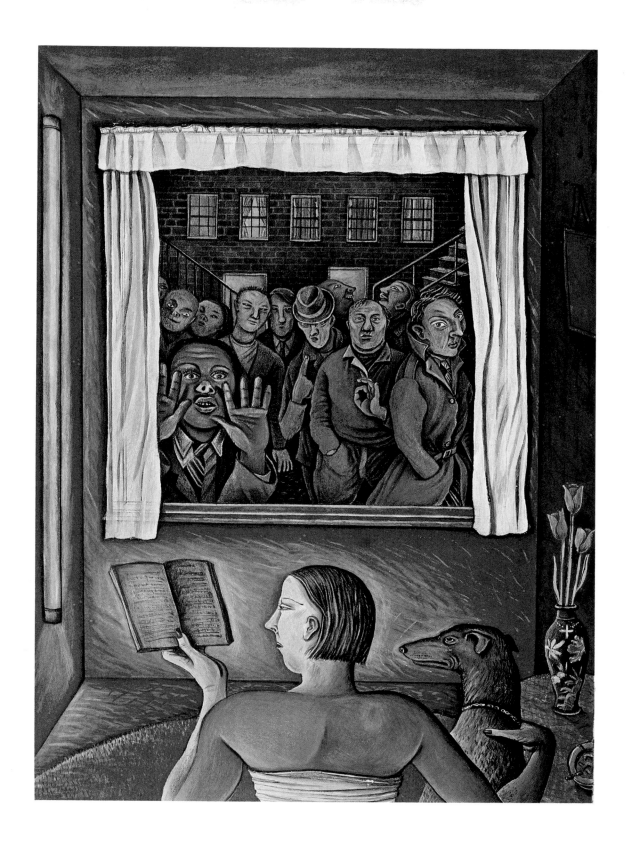

199

Artist/Artiste/Künstler/**Anne Howeson**

"Prostitute Reading with Dog and Tulips," part of a forthcoming exhibition on prostitution (November 1981). Mixed media.

"Prostitute Reading with Dog and Tulips" (Prostituée lisant avec Chien et Tulipes), partie d'une prochaine exposition sur la prostitution (novembre 1981). Média divers.

"Prostitute Reading with Dog and Tulips" (Lesende Prostituierte mit Hund und Tulpen), Teil einer zukünftigen Ausstellung über Prostitution (Novembre 1981). Mediakombination.

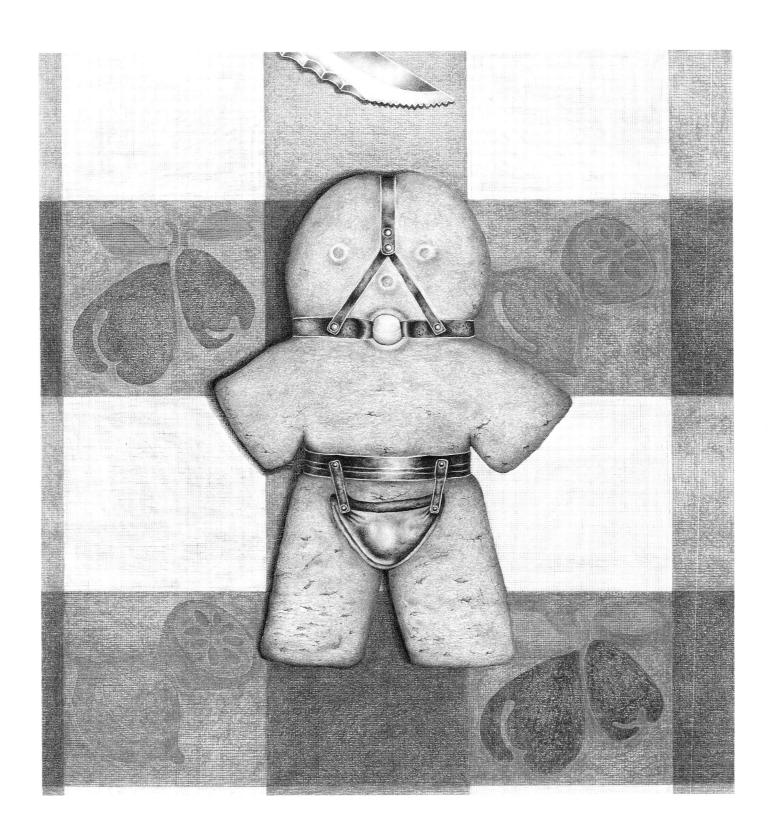

200

Artist/Artiste/Künstler/**Peter Coker**

"Ginger Bread Bondage." Coloured pencil. Peter Coker is a student at Maidstone
College of Art.

"Ginger Bread Bondage" (Esclavage Clinquant). Crayons de couleur.
Peter Coker est étudiant au Maidstone College of Art.

"Ginger Bread Bondage" (Die Pfefferkuchen Liaison). Farbstifte. Peter Coker ist
Student am Maidstone College of Art.

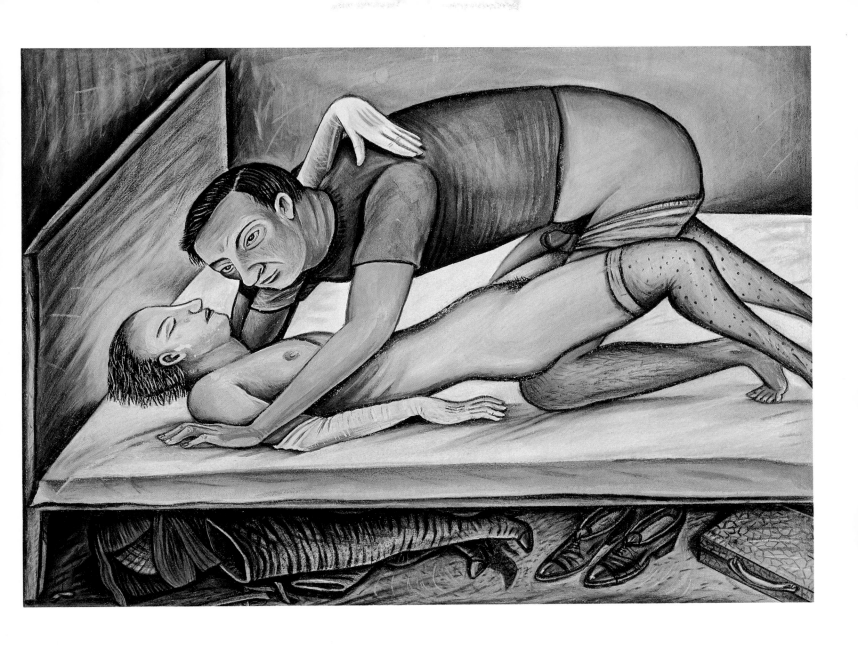

201

Artist/Artiste/Künstler/ **Anne Howeson**

Untitled, part of a forthcoming exhibition on prostitution (November 1981).
Gouache and water-colour.

Non titrée, partie d'une prochaine exposition sur la prostitution (novembre 1981).
Gouache et aquarelle.

Unbetitelter, Teil einer zukünftigen Ausstellung über Prostitution
(November 1981). Gouache und Wasserfarben.

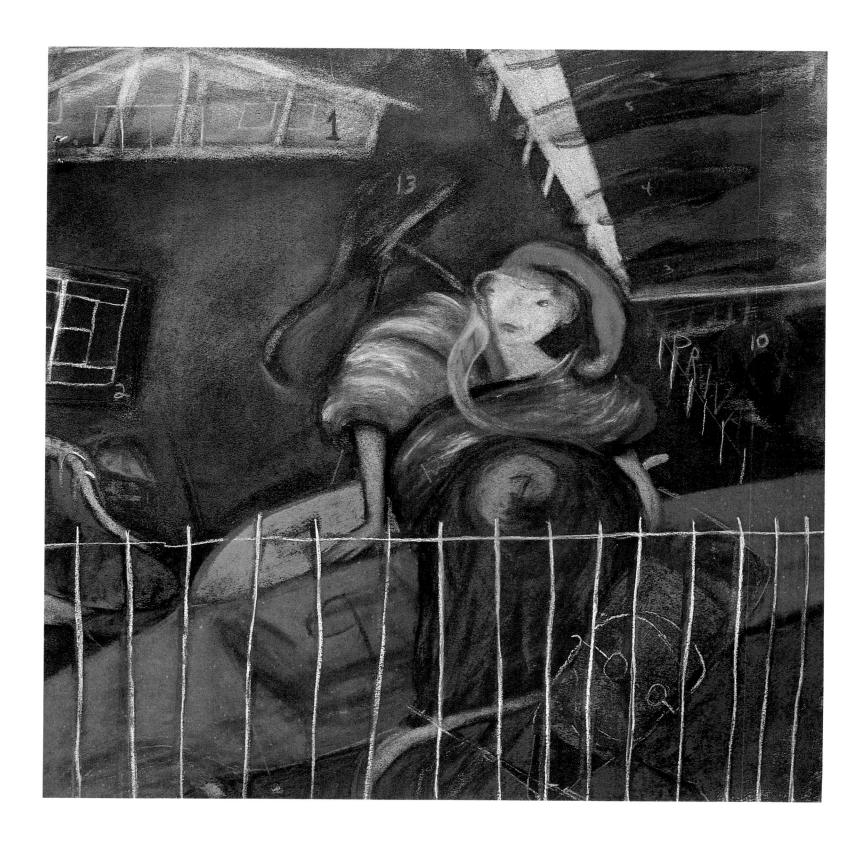

202

Artist/Artiste/Künstler/**Liz Pyle**

One of a series of 9 illustrations for 'The Invisible Man' by H G Wells. Pastel.

Une d'une série de 9 illustrations pour 'The Invisible Man' (L'Homme Invisible) par
H G Wells. Pastel.

Aus einer Reihe von 9 Illustrationen zu 'The Invisible Man'
(Der Unsichtbare Mann) von H G Wells. Pastell.

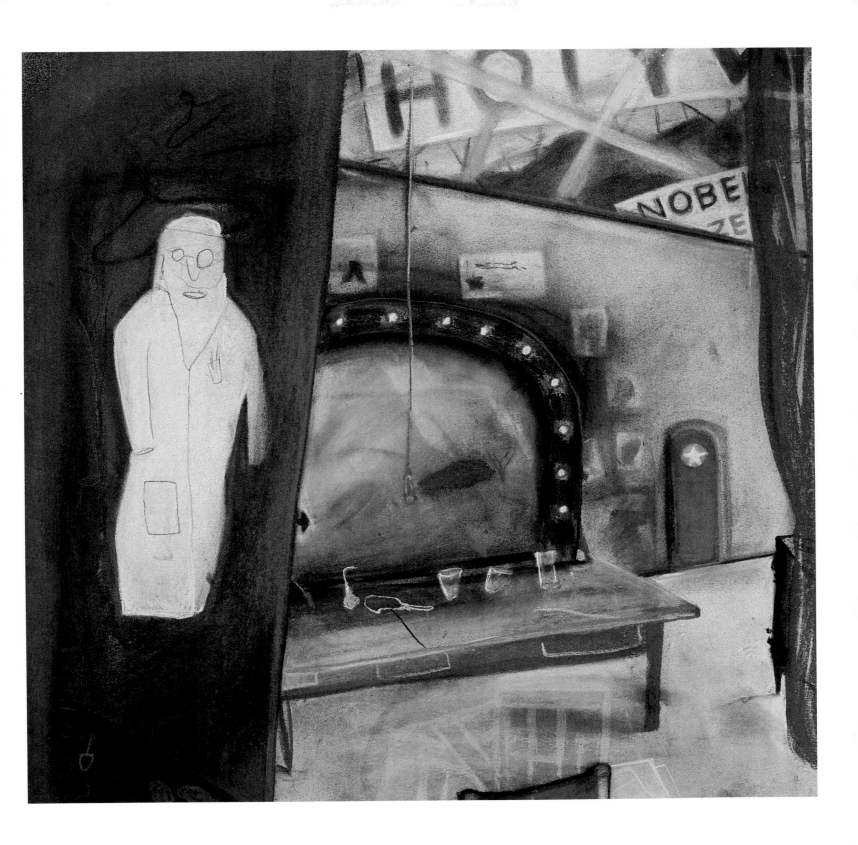

203

Artist/Artiste/Künstler/Liz Pyle

One of a series of 9 illustrations for 'The Invisible Man' by H G Wells. Pastel.

Une d'une série de 9 illustrations pour 'The Invisible Man' (L'Homme Invisible)
par H G Wells. Pastel.

Aus einer Reihe von 9 Illustrations 'The Invisible Man'
(Der Unsichtbare Mann) von H G Wells. Pastell.

204

Artist/Artiste/Künstler/**Peter Jordaan**
Designer/Maquettiste/Gestalter/**Peter Jordaan**

Poster to promote the book 'The Picture of Dorian Gray'
by Oscar Wilde. Pen and ink on screen print.

Affiche pour promouvoir le livre 'The Picture of Dorian Gray'
(Le Portrait de Dorian Gray) par Oscar Wilde. Plume et encre sur cliché tramé.

Werbeplakat zum Buch 'The Picture of Dorian Gray'
(Das Bildnis des Dorian Gray) von Oscar Wilde. Schreibfeder
und Siebdruckfarbe.

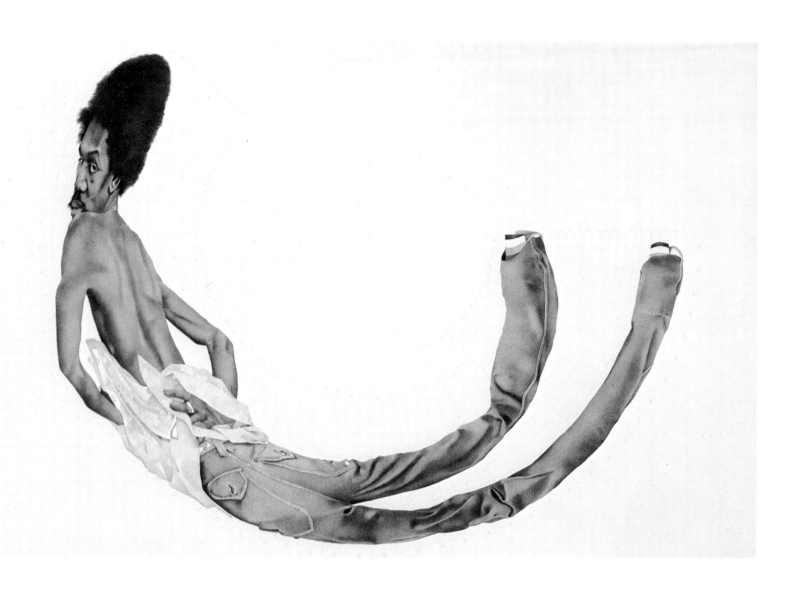

205

Artist/Artiste/Künstler/**Peter Grundy**
"Versatile Dancer Number 1," one of a series of four drawings. Pencil and crayon.

"Versatile Dancer Number 1" (Danceur Souple Numéro 1), un d'une série de
quatre dessins. Crayon et pastel.

"Versatile Dancer Number 1" (Vielseitiger Tänzer Nummer 1), aus einer
Vierteiligen Serie von Zeichnungen. Bleistift und Kreide.

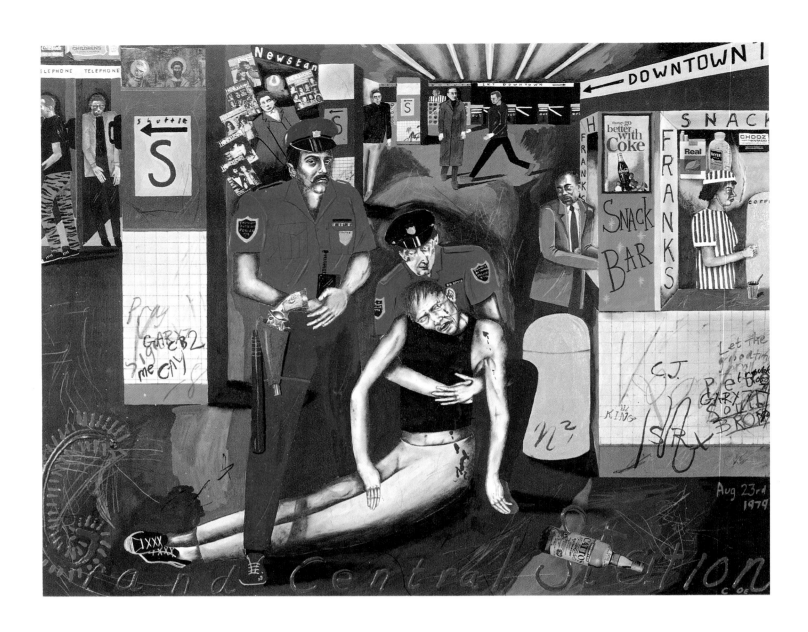

206

Artist/Artiste/Künstler/Sue Coe

"Grand Central Station," part of a series entitled 'Manhattan'. Paint and collage.

"Grand Central Station," partie d'une série intitulée 'Manhattan'. Peinture et collage.

"Grand Central Station," aus einer Serie 'Manhattan'. Ölfarbe und Collage.

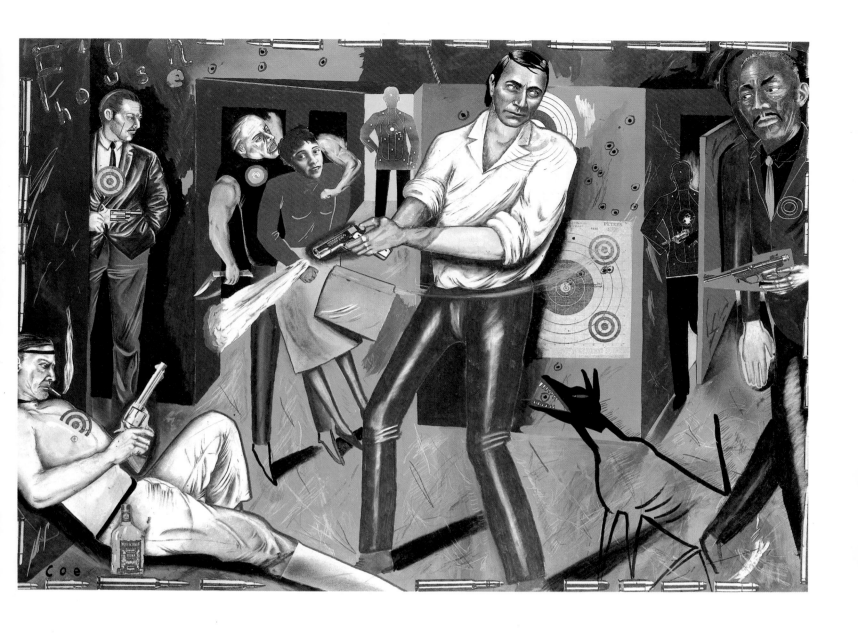

Artist/Artiste/Künstler/**Sue Coe**
Art Director/Directeur Artistique/**Robert Priest**
Publisher/Editeur/Verlag/**Esquire Incorporated**

Illustration commissioned by 'Esquire' for a feature "Gunsite Ranch," as yet
unpublished. Oils and pencil.

Illustration commandée par 'Esquire' pour un article "Gunsite Ranch" (Ranch dans
un Centre de Tir), encore inédite. Huile et crayon.

Illustration im Auftrag von 'Esquire' für einen Bericht betitelt "Gunsite Ranch"
(Ranch auf einem Schiessplatz), noch nicht erschienen. Ölfarbe und Bleistift.

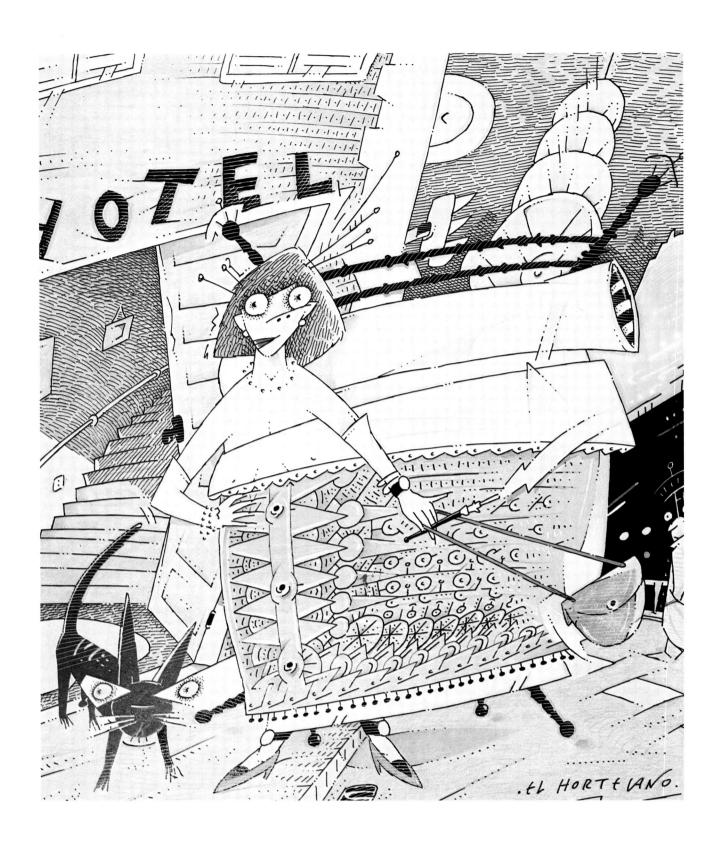

Artist/Artiste/Künstler/**El Hortelano**
Art Director/Directeur Artistique/ **Francisco Crosta**

Untitled illustration. Ink and coloured crayon.

Illustration sans titre. Encre et pastel de couleur.

Unbetitelte Illustration. Tusche und farbige Kreidestifte.

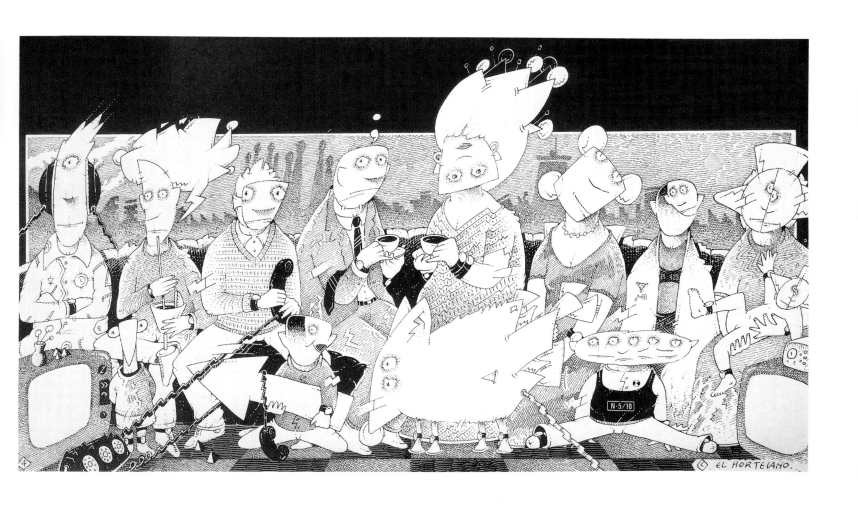

209

Artist/Artiste/Künstler/**El Hortelano**

Untitled illustration commissioned for 'Libro Moda'. Ink and coloured crayons.

Illustration sans titre commandée pour 'Libro Moda'. Encre et pastels de couleur.

Unbetitelte Illustration im Auftrag von 'Libro Moda'. Tusche und farbige
Kreide.

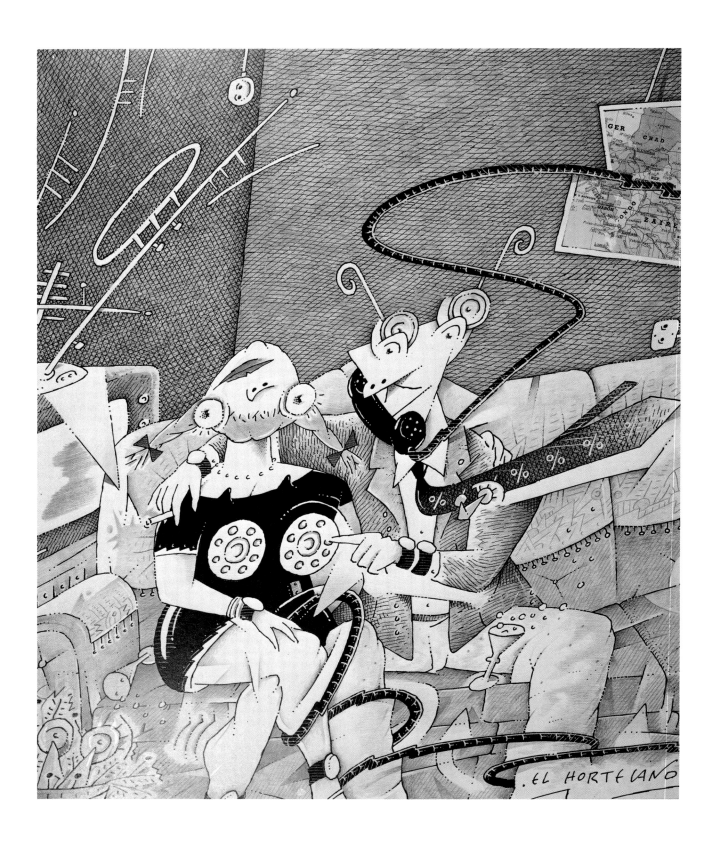

210

Artist/Artiste/Künstler/**El Hortelano**
Art Director/Directeur Artistique/**Francisco Crosta**

Untitled illustration for Spanish 'Penthouse'. Ink and coloured crayons.

Illustration sans titre pour 'Penthouse'. Encre et pastels de couleur.

Unbetitelte Illustration zu 'Penthouse'. Tusche und farbige Kreidestifte.

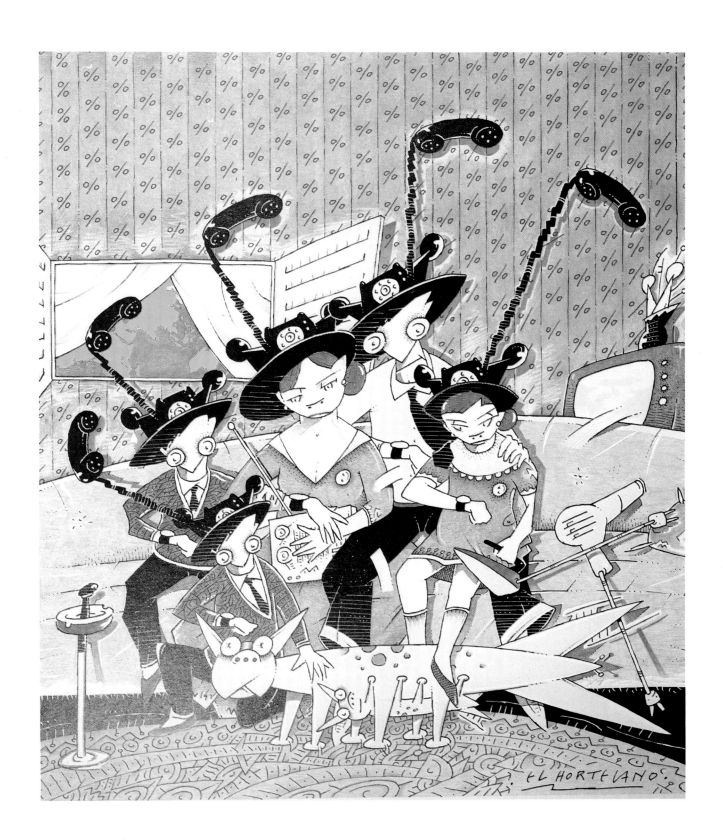

211

Artist/Artiste/Künstler/**El Hortelano**
Art Director/Directeur Artistique/**Francisco Crosta**

Untitled illustration. Ink and coloured crayon.

Illustration sans titre. Encre et pastel de couleur.

Unbetitelte Illustration. Tusche und farbige Kreidestifte.

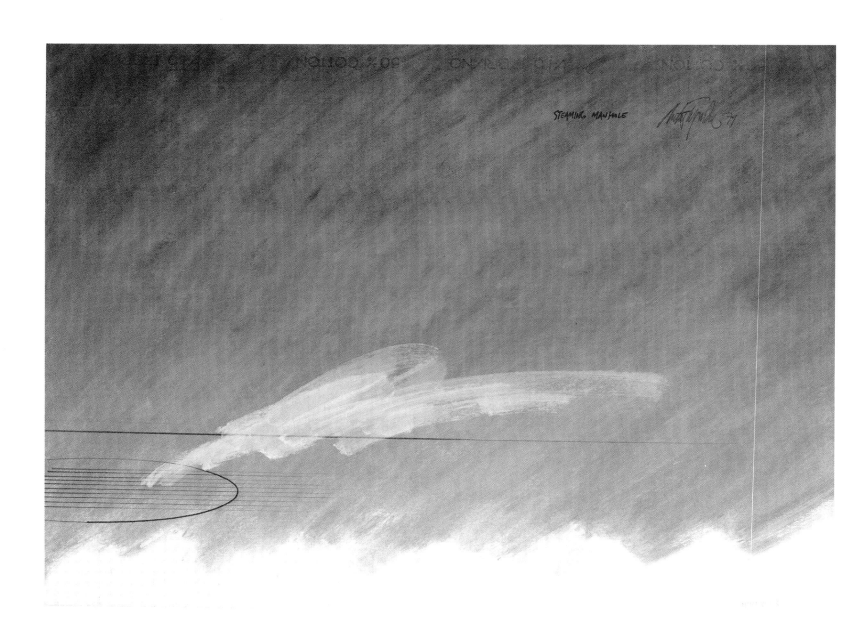

212

Artist/Artiste/Künstler/**André Thijssen**

"Steaming Manhole," New York 1979. Gouache and pencil, in colour.

"Steaming Manhole" (Bouche d'Accès qui Fume), New York 1979.
Gouache et crayon, en couleur.

"Steaming Manhole" (Dampfender Schacht), New York 1979. Gouache und
Bleistift, farbig.

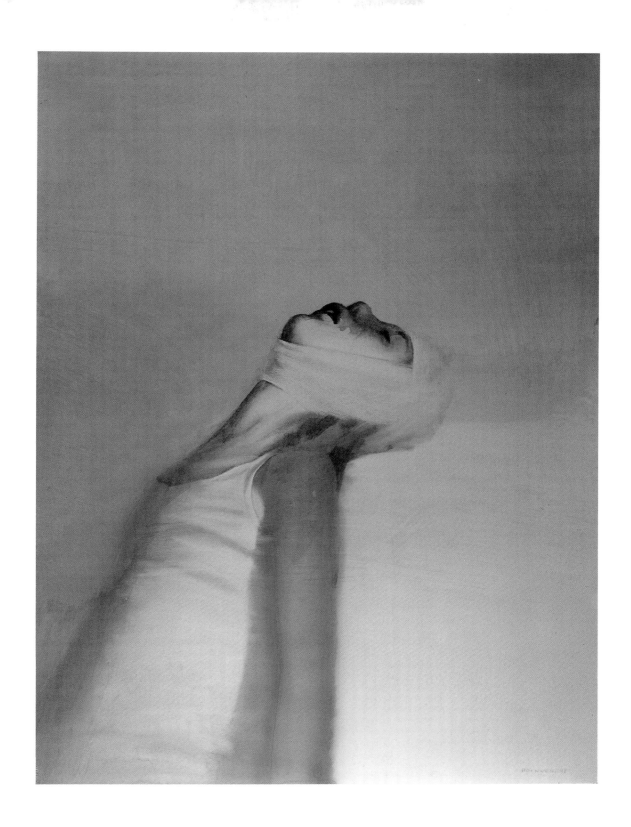

213

Artist/Artiste/Künstler/**Gottfried Helnwein**

Unpublished illustration for 'Gottfried Helnwein Paintings' art book.
Water-colour.

Illustration inédite pour le livre d'art 'Gottfried Helnwein Paintings'. Aquarelle.

Unveröffentlichte Illustration zu 'Gottfried Helnwein Paintings' Kunstbuch.
Wasserfarben.

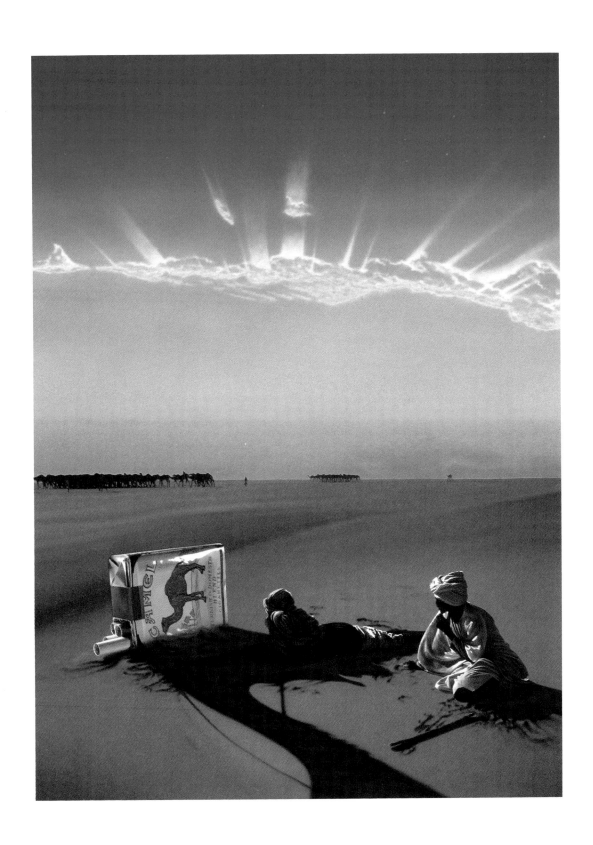

214

Artist/Artiste/Künstler/**Guy Fery**
Designer/Maquettiste/Gestalter/**Guy Fery**

Unpublished illustration promoting Camel Cigarettes. Oils and airbrush.

Illustration non publiée pour la promotion de Cigarettes Camel.
Huile et aérographe.

Unveröffentlichte Illustration, Werbung für Camel Zigaretten. Ölfarbe und
Spritzpistole.

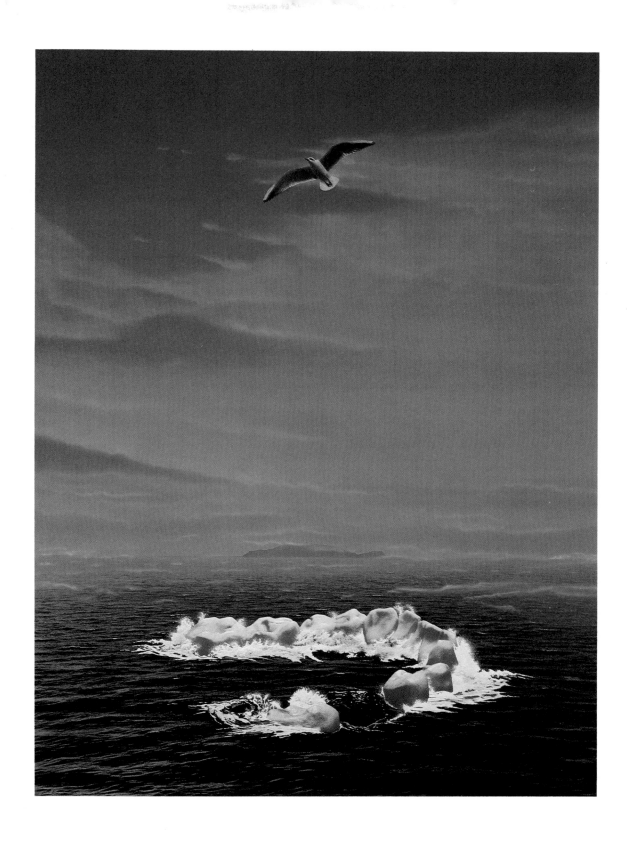

215

Artist/Artiste/Künstler/ **Art Ringer**

"Der Zahn der Zeit" (The Passage of Time). Black and white photomontage,
hand coloured.

"Der Zahn der Zeit" (Temps passager). Photomontage en noir et blanc,
colorié à la main.

"Der Zahn der Zeit." Schwarzweisse Fotomontage, handkoloriert.

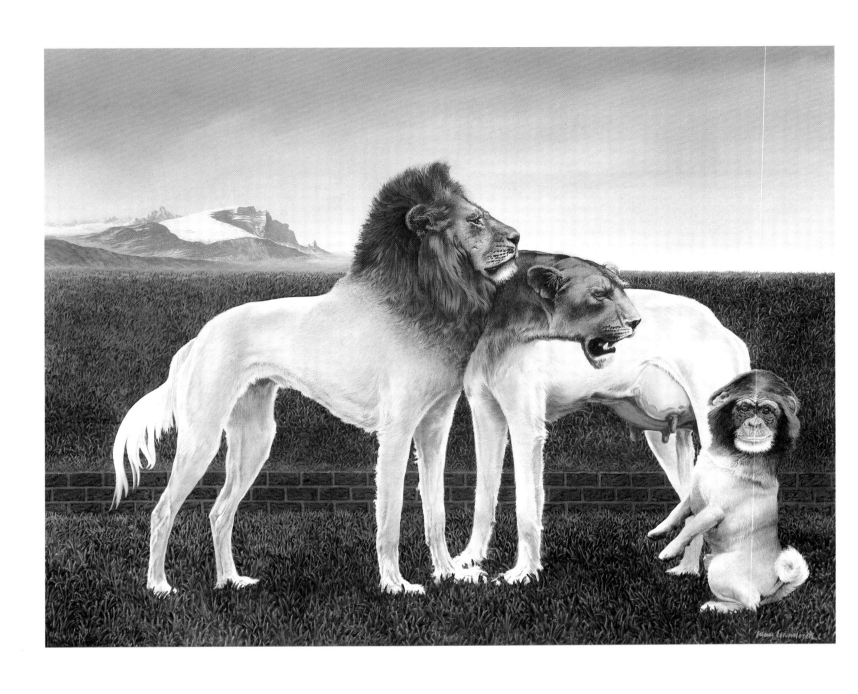

216

Artist/Artiste/Künstler/**Larry Learmonth**

Untitled illustration. Oil on canvas.

Illustration sans titre. Huile sur toile.

Unbetitelte Illustration. Öl auf Leinwand.

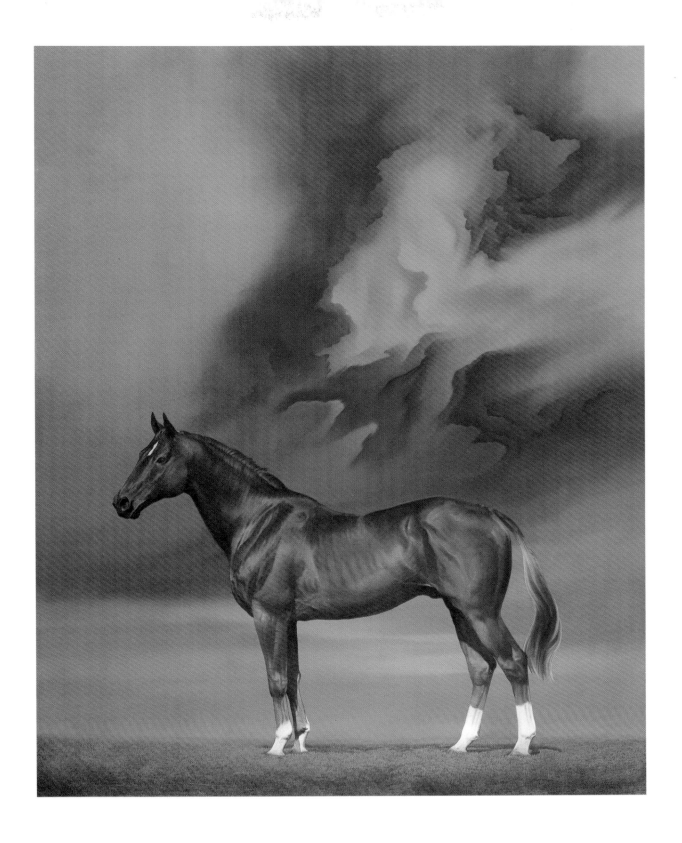

217

Artist/Artiste/Künstler/**Larry Learmonth**

Untitled illustration. Oils on canvas.

Illustration sans titre. Huile sur toile.

Unbetitelte Illustration. Öl auf Leinwand.

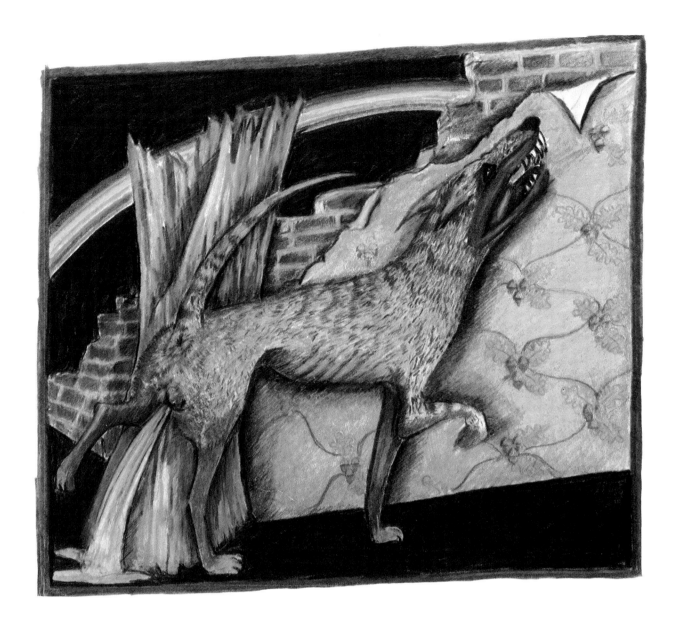

218

Artist/Artiste/Künstler/**Wendy Hoile**
Art Director/Directeur Artistique/**Robert Priest**
Publisher/Editeur/Verlag/**Esquire Incorporated**

Illustration commissioned by 'Esquire' for "Gravity's Rainbow," as yet unpublished.
Coloured pencils.

Illustration commandée par 'Esquire' pour "Gravity's Rainbow" (L'Arc en Ciel de
Gravité), pas encore publiée. Crayons de couleur.

Illustration im Auftrag von 'Esquire' zu "Gravity's Rainbow" (Regenbogen der
Schwerkraft), noch nicht erschienen. Farbstifte.

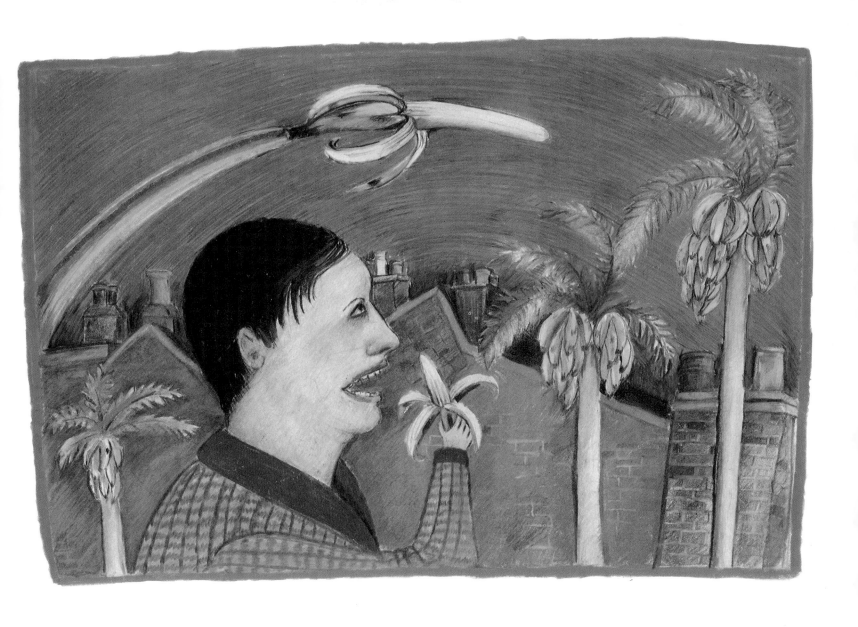

Artist/Artiste/Künstler/**Wendy Hoile**
Art Director/Directeur Artistique/**Robert Priest**
Publisher/Editeur/Verlag/**Esquire Incorporated**

Illustration commissioned by 'Esquire' for "Gravity's Rainbow," as yet unpublished.
Coloured pencils.

Illustration commandée par 'Esquire' pour "Gravity's Rainbow" (L'Arc en Ciel de
Gravité), pas encore publiée. Crayons de couleur.

Illustration im Auftrag von 'Esquire' zu "Gravity's Rainbow" (Regenbogen der
Schwerkraft), noch nicht erschienen. Farbstifte.

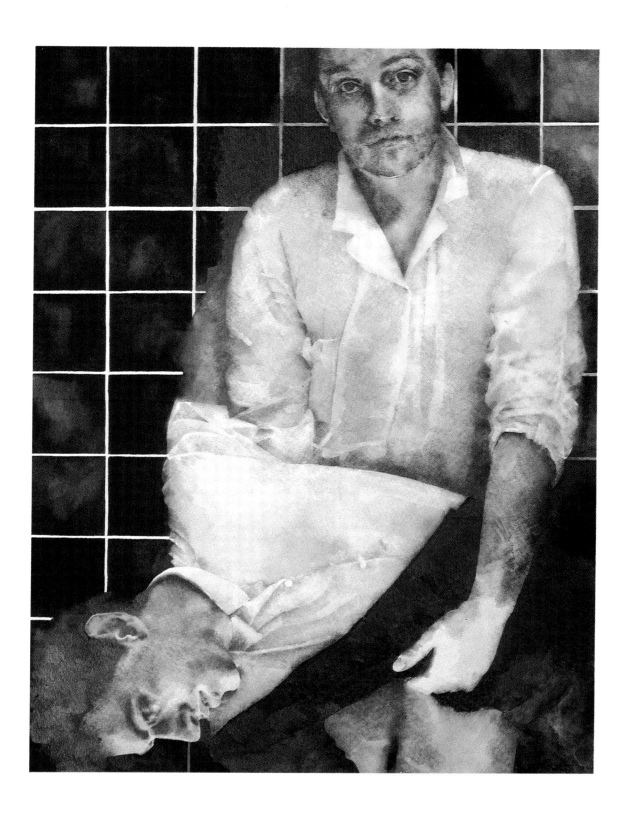

220

Artist/Artiste/Künstler/**Linda Flower**
Part of artist's portfolio. Oils.
Partie de la réserve de l'artiste. Huile.
Aus der Mappe des Künstlers. Ölfarbe.

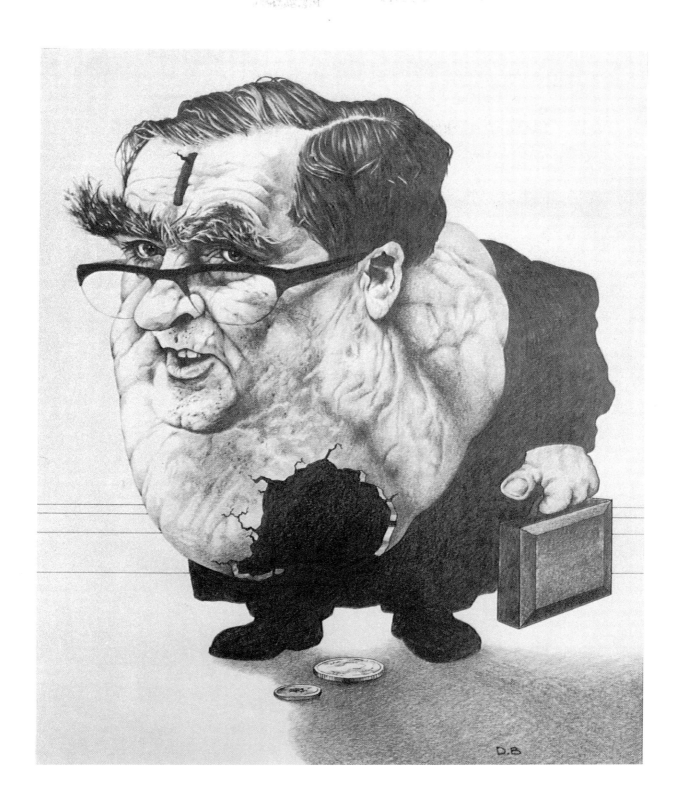

221

Artist/Artiste/Künstler/**David Brett**

One of a series of caricatures of political figures and friends of the artist.
Pencil and ink.

Une d'une série de caricatures de personnages politiques et d'amis de l'artiste.
Encre et crayon.

Aus einer Reihe von Karrikaturen von Politikern und Freunden des Künstlers.
Bleistift und Tusche.

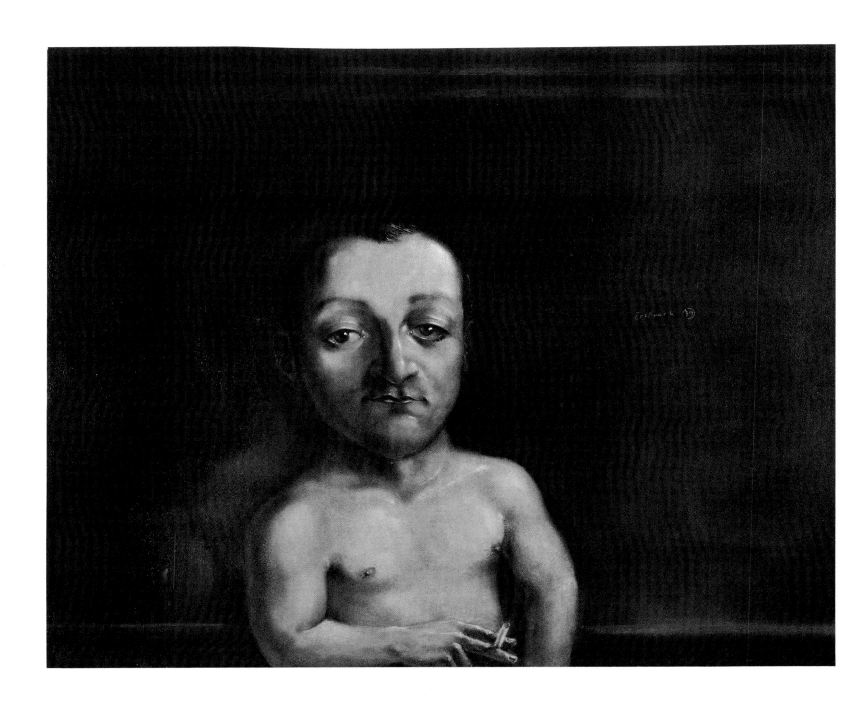

222

Artist/Artiste/Künstler/**Wolf Erlbruch**

Untitled work. Oil on wood, in colour.

Oeuvre sans titre. Huile sur bois, en couleur.

Unbetitelte Arbeit. Öl auf Holz, farbig.

223
Artist/Artiste/Künstler/**Wolf Erlbruch**
Untitled work. Oil on wood, in colour.
Oeuvre sans titre. Huile sur bois, en couleur.
Unbetitelte Arbeit. Öl auf Holz, farbig.

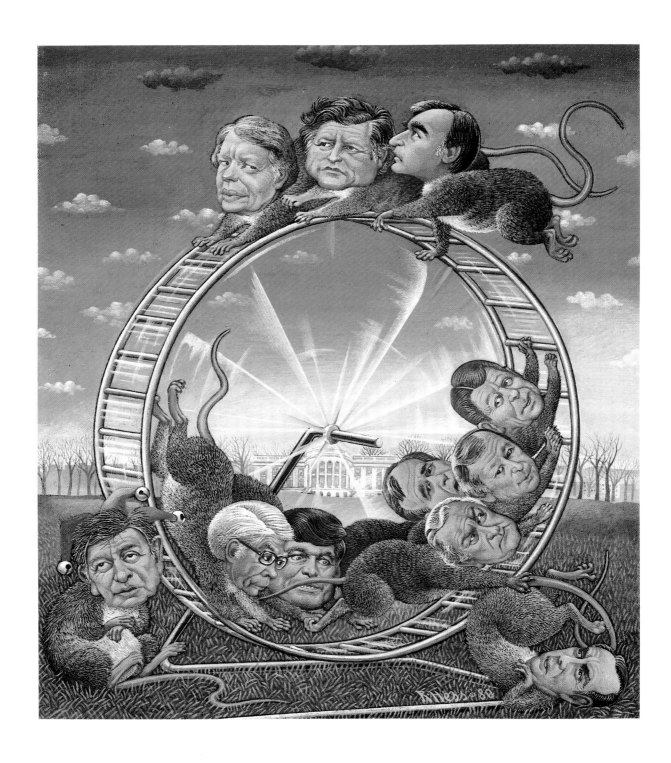

Artist/Artiste/Künstler/**Richard Hess**
Art Director/Directeur Artistique/**Robert Priest**
Publisher/Editeur/Verlag/**Esquire Incorporated**

Illustration commissioned by 'Esquire' for "Election Candidates 1980," as yet
unpublished. Oils.

Illustration commandée par 'Esquire' pour "Election Candidates 1980" (Candidats
aux Élections 1980), pas encore publiée. Huile.

Illustration im Auftrag von 'Esquire' zu "Election Candidates 1980"
(Wahlkandidaten 1980), noch nicht erschienen. Ölfarbe.

225

Artist/Artiste/Künstler/**Michael Mau**
Art Director/Directeur Artistique/Art Direktor/**Wolfgang Behnken**
Publisher/Editeur/Verlag/**Gruner & Jahr AG & Co**

Untitled illustration commissioned by 'Stern'. Oils.

Illustration sans titre commandée par 'Stern'. Huile.

Unbetitelte Illustration im Auftrag von 'Stern'. Ölfarben.

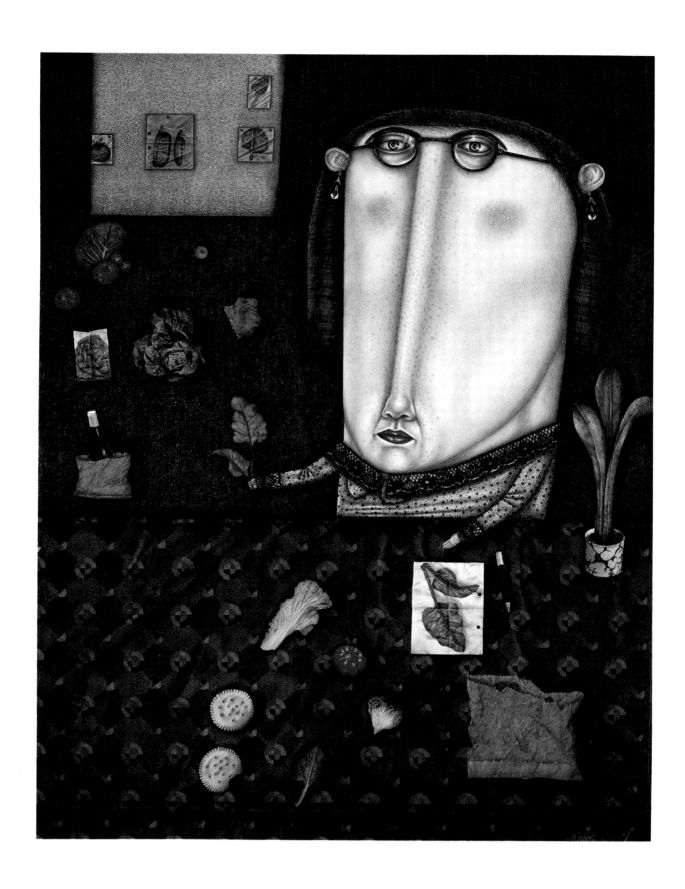

226

Artist/Artiste/Künstler/**Janet R Woolley**

"Girl at Table." Crayon, ink and collage.

"Girl at Table" (Fille à Table). Pastel, encre et collage.

"Girl at Table" (Mädchen am Tisch). Kreide, Tusche und Collage.

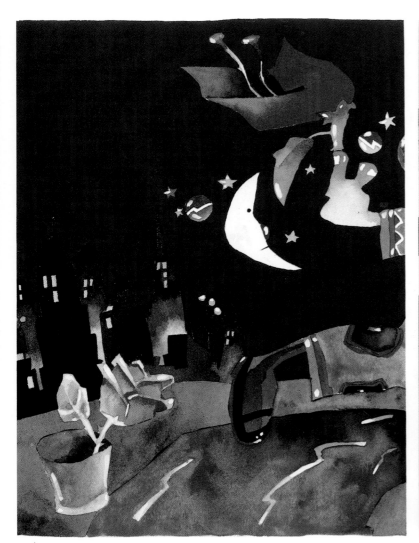
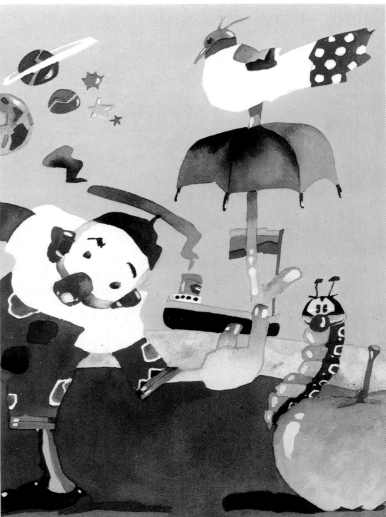

227

Artist/Artiste/Künstler/**Oscar Grillo**

Drawing from a series of illustrations for a children's book.

Dessin d'une série d'illustrations pour un livre d'enfants .

Zeichnung von einer Serie von Illustrationen für ein Kinderbuch.

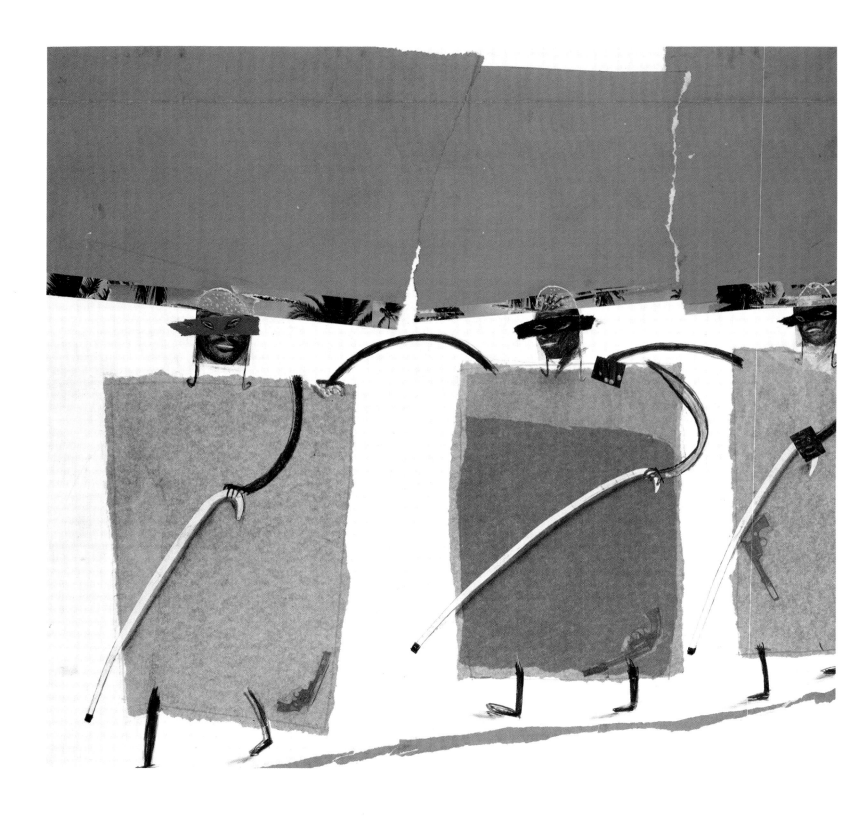

228

Artist/Artiste/Künstler/**Susan Curtis**

"Three Blind Men" for Ian Fleming's book 'Dr No'. Susan Curtis is a student of the
Royal College of Art.

"Three Blind Men" (Trois Hommes Aveugles) pour 'Dr No' de Ian Fleming.
Susan Curtis est étudiante au Royal College of Art.

"Three Blind Men" (Drei Blinde Männer) zu Ian Flemings Buch 'Dr No'.
Susan Curtis studiert am Royal College of Art.

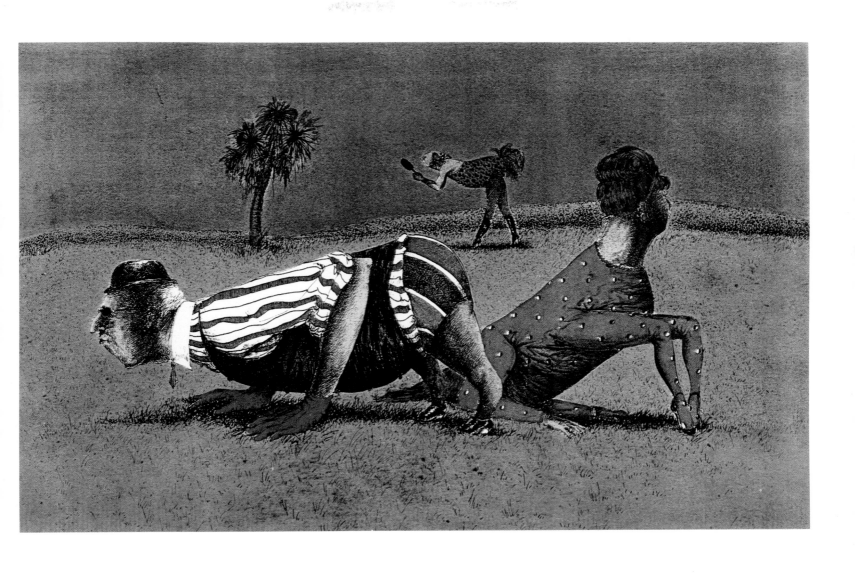

229

Artist/Artiste/Künstler/**Gillian Fraser**

Unpublished, to appear in the forthcoming 'The New Wavers' by Arthur Baysting.
Coloured inks.

Non publié, qui doit paraître dans 'The New Wavers' (Ceux de la Nouvelle Vague)
par Arthur Baysting. Encres de couleur.

Unveröffentlichte, in Erscheinen begriffenen 'The New Wavers'
(Die von der neuen Welle) von Arthur Baysting. Farbtusche.

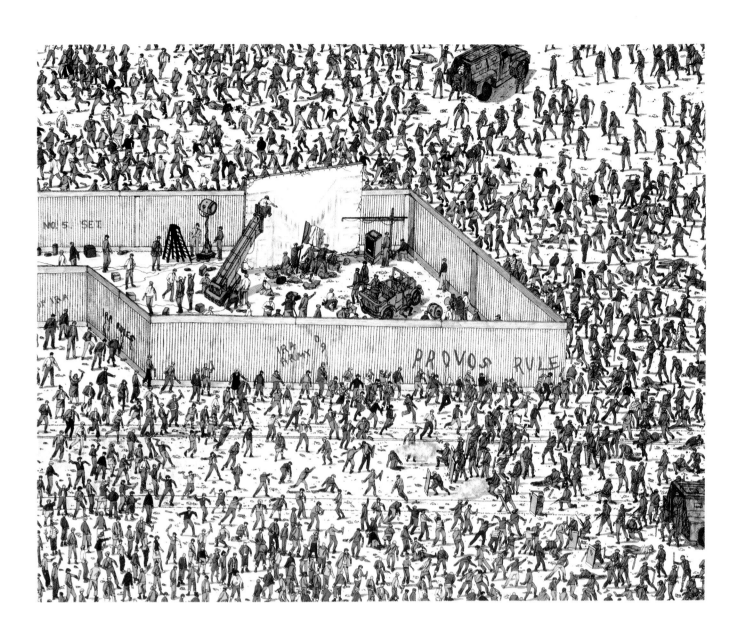

230

Artist/Artiste/Künstler/**Martin Handford**

"Ireland, the Nostalgia amid the Reality." Felt tip, pen and pencil, in colour.

"Ireland, the Nostalgia amid the Reality" (L'Irlande, la Nostalgie à Travers la Réalité). Stylo feutre, plume et crayon, en couleur.

"Ireland, the Nostalgia amid the Reality" (Irland, Wehmütige Erinnerung inmitten der Wirklichkeit). Filzstift, Feder und Bleistift, Farbig.

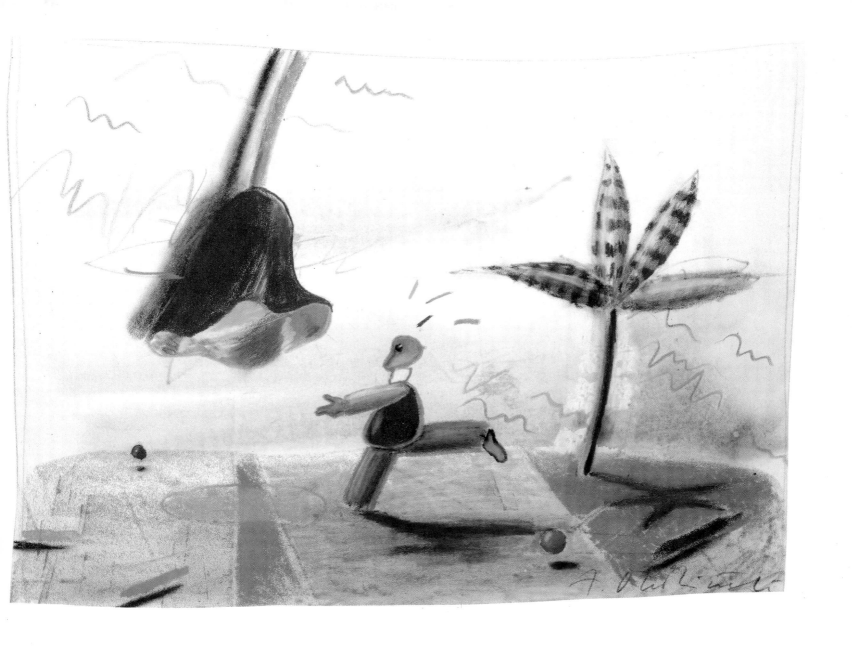

231

Artist/Artiste/Künstler/**Andrzej Dudzinski**

"Runnin' on Empty." Water-colour.

"Runnin' on Empty" (Courant à Vide). Aquarelle.

"Runnin' on Empty" (Leeflauf). Wasserfarben.

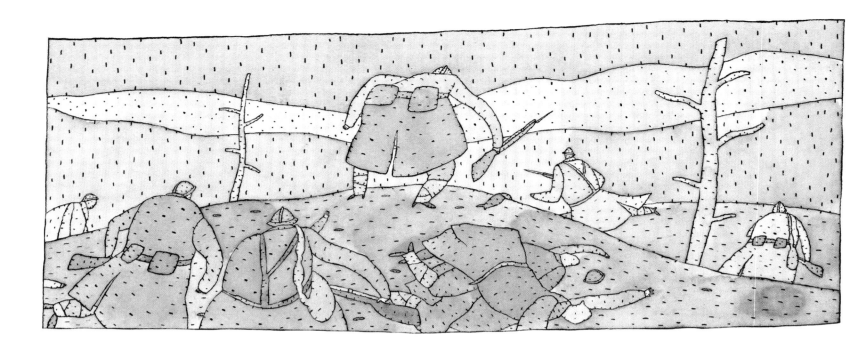

232

Artist/Artiste/Künstler/**Lionel Koechlin**

"Guerre de 14-18" (1914-1918 War). Water-colour.

"Guerre de 14-18." Aquarelle.

"Guerre de 14-18" (Der Krieg 1914-18). Wasserfarben.

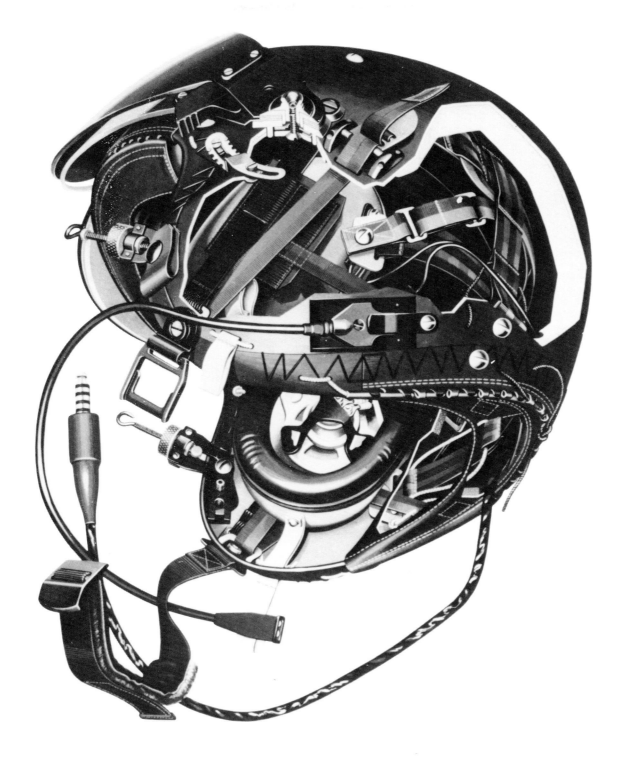

233

Artist/Artiste/Künstler/**Tony Matthews**
Designer/Maquettiste/Gestalter/**Michael Jordan**
Art Director/Directeur Artistique/Art Direktor/**Michael Jordan**
Publisher/Editeur/Verlag/**MJL Limited**

Unpublished illustration for a technical booklet for Helmets Ltd,
"MK4A Flying Helmet" by Tony Marsden, July 1980. Gouache.

Illustration non publiée pour une notice technique pour Helmets Ltd,
"MK4A Flying Helmet" (Casque de Pilote MK4A) par Tony Marsden, juillet 1980.
Gouache.

Unveröffentlichte Illustration zu einem technischen Buch für Helmets Ltd,
"MK4A Flying Helmet" (MK4A Fliegender Helm) von Tony Marsden, Juli 1980.
Gouache.

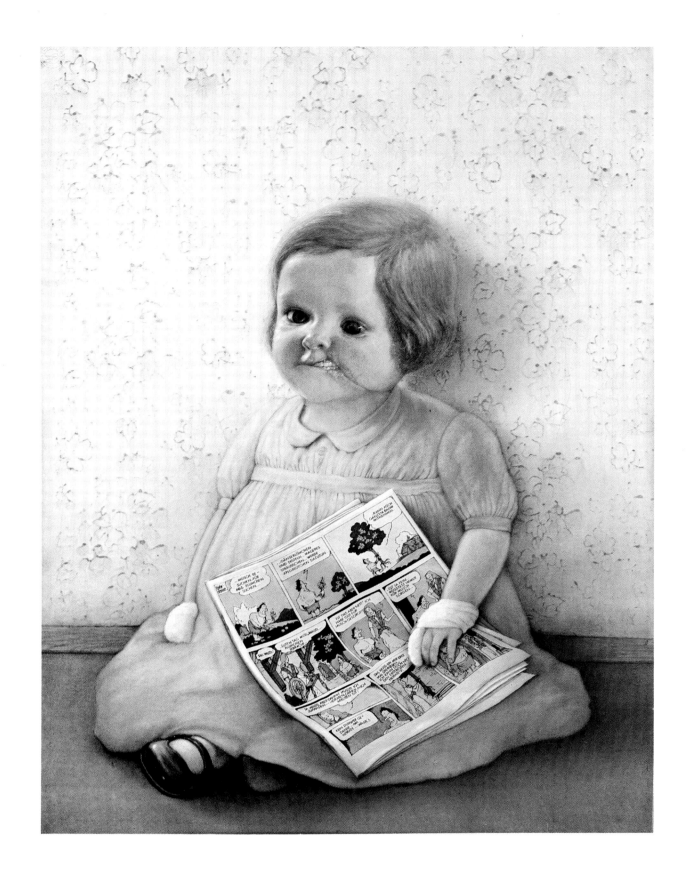

234

Artist/Artiste/Künstler/**Gottfried Helnwein**

"Peinlich" (Painful) for 'Gottfried Helnwein Paintings' art book. Water-colour.

"Peinlich" (Pénible) pour le livre d'art 'Gottfried Helnwein Paintings'. Aquarelle.

"Peinlich" zu 'Gottfried Helnweins Paintings', Kunstbuch. Wasserfarben.

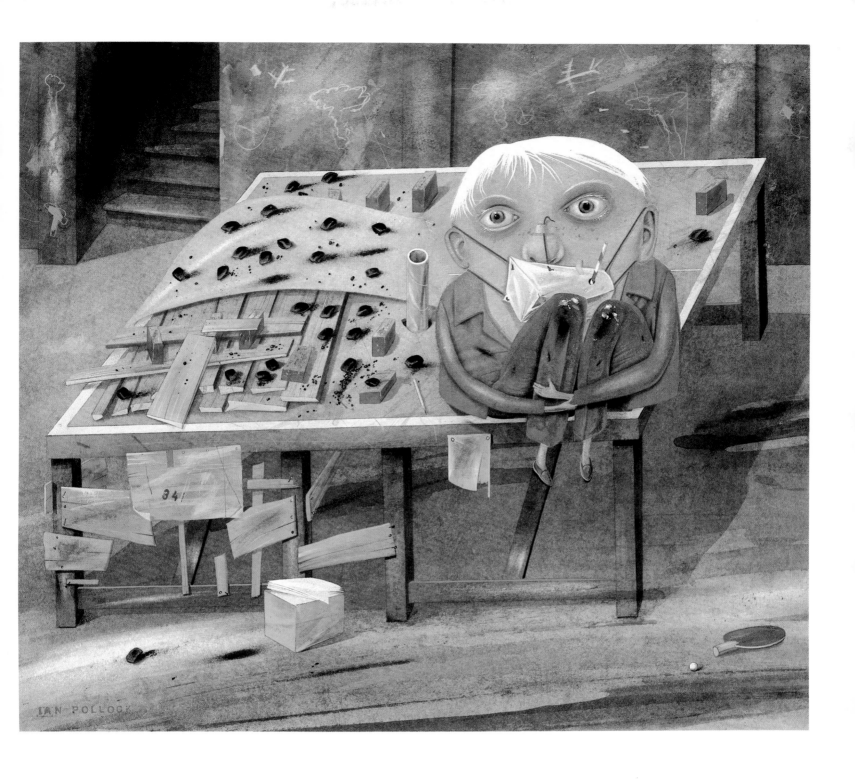

235

Artist/Artiste/Künstler/**Ian Pollock**
Designer/Maquettiste/Gestalter/**April Silver**
Art Director/Directeur Artistique/**Robert Priest**
Publisher/Editeur/Verlag/**Esquire Incorporated**

Illustration commissioned by 'Esquire' for a short story "Civil Defense"
by Tim O'Brien, as yet unpublished. Water-colour.

Illustration commandée par 'Esquire' pour une nouvelle "Civil Defense" (Défense
Passive) par Tim O'Brien, encore inédite. Aquarelle.

Illustration im Auftrag von 'Esquire' zur Kurzgeschichte "Civil Defense" (Zivil-
verteidigung) von Tim O'Brien, noch nicht erschienen. Wasserfarben.

FILMS

This section includes film animation for
television and cinema advertising and 'short' films.

Cette section comprend animation filmée pour la
publicité télévisée et cinématographique, et les
films de court métrage.

Dieser Abschnitt umfasst Trickfilme für Kino-
und Fernsehwerbung sowie für Kurzfilme.

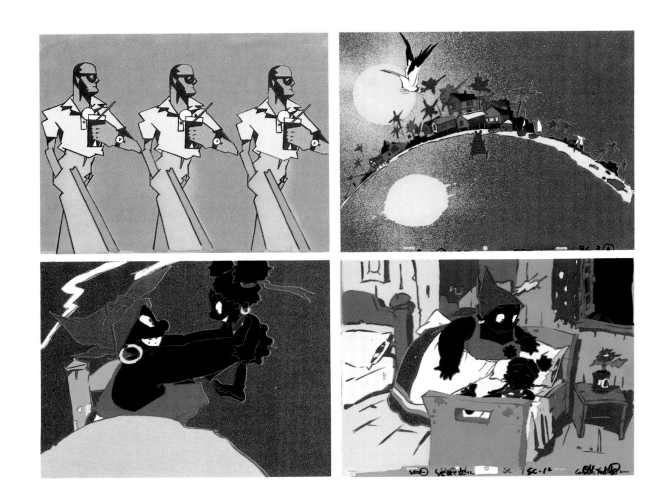

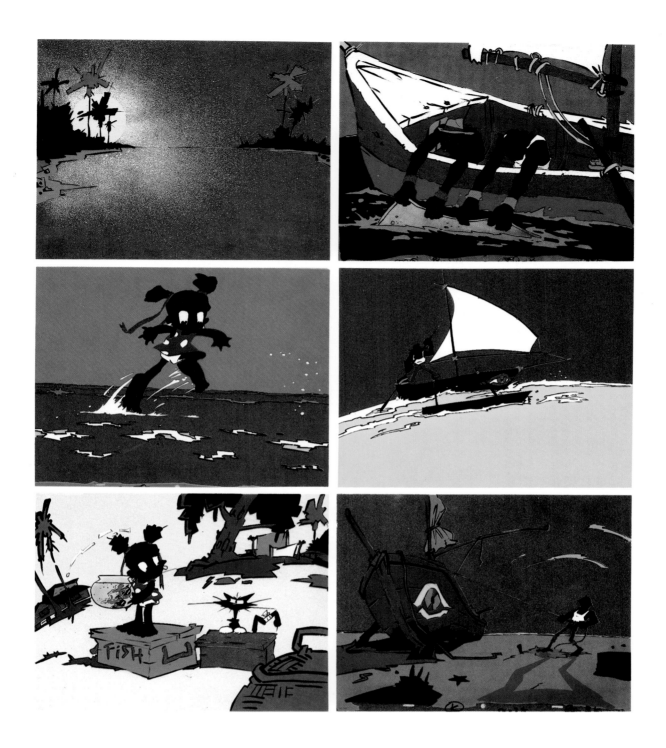

238, 239

Artist/Artiste/Künstler/**Oscar Grillo**
Animator/Dessinateur de Films d'Animation/Trickfilmzeichner/**Oscar Grillo**
Director/Réalisateur/Regisseur/**Oscar Grillo**
Producer/Directeur/Produzent/**Kevin Malloy, Sarah Parish**
Editor/Monteur/Cutter/**Terry Brown**
Rostrum Camera/Caméra du Rostre/Rostrum Kamera/**Richard Wolff**
Production Company/Compagnie de Productions/Produktionsgesellschaft/
Dragon Productions
Client/Auftraggeber/**MPL Communications Limited**
Composer/Compositeur/Komponist/**Linda McCartney**

A five-minute animated feature film based on the song "The Seaside Woman"
written by Linda McCartney and performed by Linda and Wings.

Film vedette animé de cinq minutes à partir de la chanson "The Seaside Woman"
(Femme de la Plage) écrite par Linda McCartney et interprêtée par Linda et Wings.

Fünfminütiger Trickfilm zum Lied "The Seaside Woman" (Die Frau an der Küste)
geschrieben von Linda McCartney und aufgeführt von Linda und Wings.

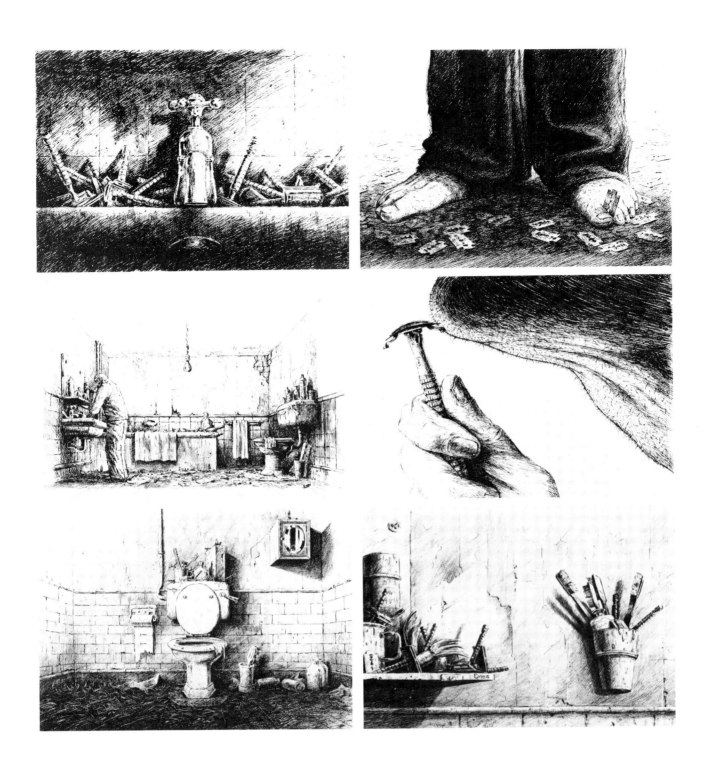

240

Artist/Artiste/Künstler/**Peter Till**
Animator/Dessinateur de Films d'Animation/Trickfilmzeichner/**Ian Emes**
Director/Réalisateur/Regisseur/**Ian Emes**
Editor/Monteur/Cutter/**Ian Emes**
Rostrum Camera/Caméra du Rostre/Rostrum Kamera/**Roy Watford**
Production Company/Compagnie de Productions/Produktionsgesellschaft/
Timeless Films
Client/Auftraggeber/**Boyd's Company/Electronic Picture House Production**

A twelve-minute 'short' film entitled "The Beard."

Film de court métrage de 12 minutes intitulé "The Beard" (La Barbe).

Zwölf-Minuten 'Kurzfilm' betitelt "The Beard" (Der Bart).

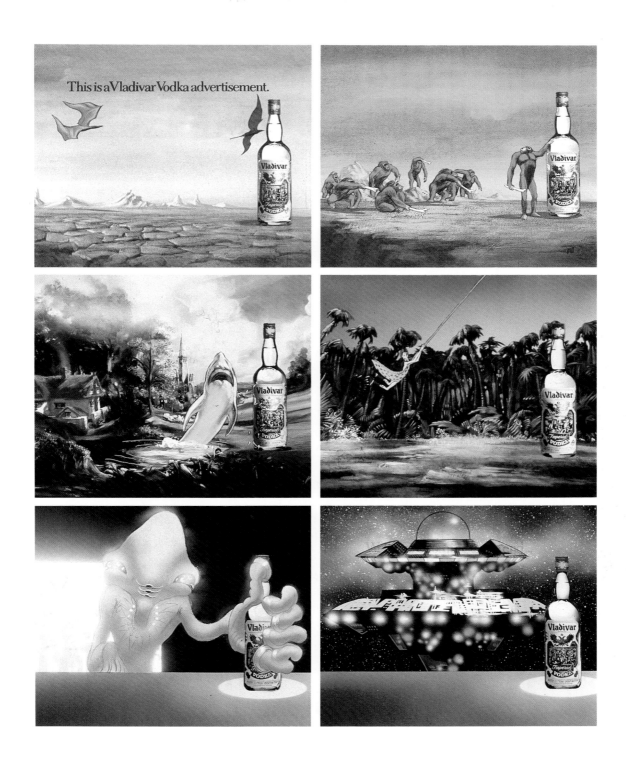

Background Artists/Artistes/Künstler/**Micky Cook, Ed Hirth, Carol Kieffer,
Lou Police**
Animators/Dessinateurs de Films d'Animation/Trickfilmzeichner/
Dale Baer, Carol Kieffer, Lou Police, Toln Roth, Richard Williams
Director/Réalisateur/Regisseur/**Richard Williams**
Art Director/Directeur Artistique/**Michael Stephenson**
Copywriter/Rédacteur/Texter/**Derek Apps**
Producer/Directeur/Produzent/**Alistair Fryer**
Editor/Monteur/Cutter/**Ean Woods**
Advertising Agency/Agence de Publicité/Werbeagentur/
The Kirkwood Company
Production Company/Compagnie de Productions/Produktionsgesellschaft/
Richard Williams Animation Inc
Client/Auftraggeber/**G J Greenhall**

A 60-second commercial film for cinema to advertise Vladivar Vodka.

Film publicitaire pour cinéma de 60 secondes pour la Vodka Vladivar.

Ein 60-Sekunden Werbefilm für Vladivar Vodka.

Artists' addresses
Adresses des Artistes
Adressen der Künstler

Alan Aldridge, 132, 133
c/o European Illustration,
12 Carlton House Terrace,
London SW1, England.
Julian Allen, 77, 79, 104, 105
31 Walker Street, New York,
NY 10013, USA.
Renate Belina, 194, 195
83 Hodford Road,
London NW11, England.
Guy Billout, 136, 179, 189
222 West 15th Street,
New York, NY 10011, USA.
Gunter Blum, 97
Bruckenstrasse 28,
69 Heidelberg, W. Germany.
Braldt Bralds, 88
Spoorsingel 69B, Rotterdam,
Netherlands.
Pierre Brauchli, 15
c/o Tanner Staehelin,
PO Box 8702,
Zollikorn, Anna Strasse 2,
Zurich, Switzerland.
David Brett, 221
23 Plomer Hill,
West Wycombe,
Bucks, England.
Pieter Breughel, 15
c/o Tanner Staehelin,
PO Box 8702,
Zollikorn, Anna Strasse 2,
Zurich, Switzerland.
Peter Brookes, 37, 42, 44, 48,
49, 52, 53, 148
30 Vanbrugh Hill,
London SE9, England.
Chloë Cheese, 167
118 Leander Road,
London SW2, England.
Sue Coe, 38, 39, 206, 207
214 East 84th Street,
New York, NY 10028, USA.
Peter Coker, 200
24 Chigwell View,
Lodge Lane, Collier Row,
Essex, England.
Micky Cook, 241
c/o Richard Williams
Animation Inc,
5631 Hollywood Boulevard,
California, CA 90028, USA.
Patrick Couratin, 156
24 Rue Charlot, 78003 Paris,
France.
Kinuko Craft, 25, 117, 118, 119
1940 N Hudson Street,
Chicago, Illinois 60614,
USA.
Robert Crowther, 181
2 Church Green, Witney,
Oxon, England.
Susan Curtis, 228
21A Topsfield Parade,
Crouch End, London N8,
England.
David Davies, 172, 173
19 Nordelph Corner,
Hardingham, Norwich,
England.
Etienne Delessert, 61, 63, 66,
169
c/o Carabosse,
Domaine du Bochet,
1025 St Sulpice, Switzerland.
Christian Desbois, 101
8 rue du Rocher,
75008 Paris, France.
Andrzej Dudzinski, 174, 231
44-15 43rd Avenue, LIC,
New York, NY 11104, USA.
Jeffery Edwards, 182
c/o European Illustration,
12 Carlton House Terrace,
London SW1, England.
Wolf Erlbruch, 222, 223
Laurentius Strasse 20,
56 Wuppertal, W. Germany.
Frans Evenhuis, 30
3712 Arbolada Road,
Los Angeles,
California 90027, USA.
Jean Luc Falque, 67
c/o J'Illustre,
43 Faubourg Saint Honoré,
75008 Paris, France.

Vince Farrell, 72
5 Sandbrook Road,
London N16, England.
Guy Fery, 214
117 East 57th Street,
New York, NY 10022, USA.
Lynda Flower, 220
23 Westfields Avenue,
London SW13, England.
Jean-Michel Folon, 126, 127,
128, 129
c/o European Illustration,
12 Carlton House Terrace,
London SW1, England.
André François, 166
Hameau les Picots,
Auderville,
50440 Beaumont/Havre,
France.
Gillian Fraser, 229
2/35 Figtree Avenue,
Randwick, Sidney,
NSW 2031, Australia.
Rainer C Friz, 31
Mendelsohnstrasse 5a,
8 München 60,
W. Germany.
Gil Funccius, 40, 41
Bundesstrasse 3,
2000 Hamburg 13,
W. Germany.
Henri Galeron, 152, 153, 157
45 rue Racine,
92120 Montrouge, France.
Patrick Gaudard, 60
c/o Carabosse SA,
Domaine du Bochet,
CH 1025 St Sulpice,
Switzerland.
Adrian George, 45
28 Westbourne Terrace,
London W2, England.
Ramon Gonzalez Teja,
24
Ruiz Perello 13,
Madrid 28, Spain.
Erhard Göttlicher, 76
Neuweg 5,
D-2082 Uetersen bei
Hamburg, W. Germany.
Angus Grey-Burbridge, 96
c/o The Garden Studio,
11/13 Broad Court,
London WC2, England.
Oscar Grillo, 227, 238,
239
59 The Ridgeway,
London W3, England.
Peter Grundy, 205
Grundy & Northedge Design,
10 Barleymow Passage,
Chiswick, London W4,
England.
Martin Handford, 230
"Elmwood", All Saints,
Axminster, Devon.
Robin Harris, 32, 86, 87
60 Weltje Road,
London W6, England.
Gottfried Helnwein, 54, 55,
56, 57, 160, 161, 168, 186, 187,
188, 213, 234
Neustiftgasse 36,
1070 Vienna, Austria.
Richard Hess, 224
Southover Farm, Roxbury,
Connecticut 66783, USA.
Ed Hirth, 241
c/o Richard Williams
Animation Inc,
5631 Hollywood Boulevard,
California 90028, USA.
Paul Hogarth, 150, 151
25 Church Road,
Hampstead, London NW3,
England.
Wendy Hoile, 218, 219
65 Prebend Gardens,
London W6, England.
Bush Hollyhead, 178
5 Albion House,
34 Vanston Place,
London SW6, England.
El Hortelano, 208, 209, 210,
211
c/o Bizarre Bizness SAFIA,
Gran Via 399, 4a 2a,
Barcelona 15, Spain.

Anne Howeson, 34, 197, 198,
199, 201
91 Cloudesley Road,
London N1, England.
Jörg Huber, 28, 29, 46, 47,
176, 177
Albertgasse 34-14,
A1080 Vienna, Austria.
Manus Hüller, 84
Leopoldstrasse 42,
8000 München 40,
W. Germany.
Peter Jordaan, 204
Richersweg 182,
6865 GM Doorwerth,
Netherlands.
Ri Kaiser, 43
Frohmestrasse 126,
D 2000 Hamburg 61,
W. Germany.
Carol Kieffer, 241
c/o Richard Williams
Animation Inc,
5631 Hollywood Boulevard,
California 90028, USA.
Lionel Koechlin, 26, 27, 122,
123, 232
6 rue Edmond About,
75016 Paris, France.
Larry Learmonth, 111, 216,
217
13 Loom Lane, Radlett,
Hertfordshire, England.
Paul Leith, 155
37 Therapia Road,
London SE22, England.
Pierre Le-Tan, 124
4 rue St Augustin,
75002 Paris, France.
Birney Lettick, 36
121 E 35th Street, New York,
NY 10016, USA.
Mike Litherland, 146, 147,
175
53 Gleneagle Road,
Streatham, London SW16,
England.
Luck & Flaw, 108, 134
Victoria Hall, Victoria Street,
Cambridge, England.
Jean Pierre Lyonnet, 115
6 rue des Abesses,
75018 Paris, France.
Harro Maas, 116
c/o Petra Much,
Artusstrasse 43, W. Gemany.
Warren Madill, 180, 183
28 Shelton Street,
London WC2H 9JN,
England.
Federico Maggioni, 51
Via Bergognone 27, Milan,
Italy.
James Marsh, 138, 139
16 Iveley Road,
London SW4, England.
Robert Mason, 102, 103, 196,
197
91 Cloudesley Road,
London N1, England.
Tony Matthews, 233
34 Springfield Mount,
Kingsbury, London NW9,
England.
Michael Mau, 225
c/o European Illustration,
12 Carlton House Terrace,
London SW1, England.
Guy Merat, 64
c/o Carabosse,
Domaine du Bochet,
CH 1025 St Sulpice,
Switzerland.
Russell Mills, 70, 71, 94, 197
22 Torriano Cottages,
London NW5, England.
Willi Mitscka, 50
Dustmannweg 39,
A-1160 Vienna, Austria.
Joyce MacDonald, 114
342 East 76th Street,
New York, NY 10021, USA.
Keith McEwan, 92
c/o Top Drawers,
Lijnbaansgracht 162,
Amsterdam, Netherlands.
Tony McSweeney, 17
99 Casewick Road,
West Norwood,
London SE27, England.

Guillemot Navares, 35, 85
c/o Bizarre Bizness,
Gran Via 399, Safia,
Barcelona 15, Spain.
Wolfgang Oppermann, 110
c/o Stern Magazine,
Warburgstrasse 53,
2000 Hamburg 36,
W. Germany.
Ulrich Österwalder, 74, 75
Rombergstrasse 15,
2000 Hamburg 19,
W. Germany.
Iris de Paoli, 68
Corriere della Sera,
Via Scarsellini 17,
Milan, Italy.
Paul-Perret, 65
13 Chemin Montloisir,
CH Lausanne, Switzerland.
Pierre Peyrolle, 73, 170, 171
c/o European Illustration,
12 Carlton House Terrace,
London SW1, England.
Christian Piper, 98, 99
PO Box 290, Times Square,
New York, NY 10036, USA.
Lou Police, 241
c/o Richard Williams
Animation Inc,
5631 Hollywood Boulevard,
California 90028, USA.
Ian Pollock, 80, 81, 106, 107,
154, 235
1 St Andrews Road,
London W14, England.
Liz Pyle, 197, 202, 203
91 Cloudesley Road,
London N1, England.
Ken Rinciari, 58, 59
Verzpeyckweg 7,
Bergen aan Zee, Netherlands.
Art Ringer, 215
Freudenbergstrasse 103,
8044 Zurich, Switzerland.
Tony Ross, 130, 131
5 Timber Street, Macclesfield,
Cheshire.
Guillermo Roux, 162, 163
c/o European Illustration,
12 Carlton House Terrace,
London SW1, England.
Manfred Scharpf, 82
Zeigelbachkreut 37,
7954 Bad Wurzbach,
W. Germany.
Peter Schössow, 100
Emilienstrasse 78,
2000 Hamburg 19,
W. Germany.
Romain Slocombe, 33
11 bis rue Schoelcher,
75014 Paris, France.
Ed Soyka, 62
231 Lafayette Avenue,
Peekskill, New York,
NY 10566, USA.
Ralph Steadman, 18, 19, 20,
21, 22, 23, 140, 141, 142, 143,
144, 145
c/o European Illustration,
12 Carlton House Terrace,
London SW1, England.
Bohumil Stepan, 95
Sendlinger-Tor-Platz 3,
8 München 3, W. Germany.
André Thijssen, 78, 212
Kempering 717, 1104 KE
Amsterdam Zuidoost,
Netherlands.
Guenther Thumer, 14
Sulzbergstrasse 3,
8201 Grossholzhausen,
W. Germany.
Peter Till, 16, 90, 113, 240
42 Berkeley Road,
London N8, England.
Roland Topor, 69, 91
47 rue de Boulainvilliers,
Paris 75016, France.
Erno Tromp, 190, 191
Keizergracht 584,
Amsterdam, Netherlands.

Manfred Vogel, 158
Oreigiebelhaus,
Nonnengassen 8,
4100 Duisburg, W Germany.
Tom Wenner, 83, 89
Leerbachstrasse 92,
6 Frankfurt 1, W. Germany.

Joachim Widmann,
112
Papenhuder Strasse 35,
2000 Hamburg 36,
W Germany.
Kit Williams, 137
c/o European Illustration,
12 Carlton House Terrace,
London SW1, England.
Harry Willock, 132, 133
c/o European Illustration,
12 Carlton House Terrace,
London SW1, England.
Rolf Witt, 93
Beckhausstrasse 256,
D 48 Bielefeld 1,
W Germany.
Janet R Woolley, 226
34 Stanhope Road,
London N6, England.
Kathy Wyatt, 159
16 Stanmore Road, Watford,
Hertfordshire, England.
Ed Young, 149
12 Villard Avenue,
Hastings-on-Hudson,
New York, NY 10706, USA.
Michail Zlatkovski, 109
c/o European Illustration,
12 Carlton House Terrace,
London SW1, England.

Art Colleges,
Ecoles de Beaux-Arts,
Kunstakademien

Maidstone College of Art,
Oakwood Park, Maidstone.
Student:
Peter Coker, 200

Royal College of Art,
Kensington Gore,
London SW7
Student:
Susan Curtis, 228

Designers
Maquettistes
Gestalter

Sue Aldworth 102, 113
Carl Barile 136
Hans van Blommenstein 88
Christl Böhm 50, 82, 118, 119
Angi Bronder 31, 117, 158
Ian Craig 132, 133, 137
David Davies 172, 173
Christian Desbois 101
Patrick Edwards 138, 139
Franz Epping 15, 40, 41
Jenny Fleet 44, 45, 48, 52
Barbara Jane Galbraith 38, 62,
71, 103, 108
Patrick Gaudard 60
Milton Glaser 104
Ramon Gonzales Teja 24
Angus Grey-Burbridge 96
Oscar Grillo 238, 239
George Guther 14, 25, 76, 92,
95, 98, 99
Paul Hogarth 150
Michael Jordan 204, 233
Lionel Koechlin 27
Mike Litherland 146, 147, 175
Jean Pierre Lyonnet 115
Harro Maas 116
Henk Maas 58, 59
Joyce MacDonald 114
Louise Moreau 94
Paul-Perret 65
Peter Rozcyki 148
Karin Schmidt-Polex 97
Peter Schossöw 100
April Silver 36, 77, 235
Romain Slocombe 33
Carol Southern 124
André Thijssen 78
Peter Till 240
Derek Ungless 36, 38, 39, 62,
71, 79, 87, 94, 103, 108
Louis Voogt 69, 91

Bob Abrahams
Stephen Adams
Tom Adams
Gillian Adsett
Anita Albus
Susan Alcantarilla
John Alcorn
Paul Allen
John Allin
Andrew Aloof
Hal Ambro
Kjell Ivan Anderson
Wayne Anderson
Apicella
Areopage
Marshall Arisman
Jean Marie Assenat
Babs
Gilles Bachelet
Sydney Badmin
Wasyl Bagdaschwilli
Claude Bailleul
Alan Baker
Richard Baldwin
Juan Ballesta
Norman Barber
Arthur Barbosa
Henry Barnett
Peter Barrett
Alberte Barsacq
Saul Bass
John Bauer
David Baxter
Nicola Bayley
Pete Beard
Ian Beck
Anthon Beeke
Wolfgang Bellingradt
Derek Benee
Madeleine Bennet
M J Bennallack Hart
Peter Bentley
Arja van den Berg
Torsten Bergentz
Jean Louis Besson
Liz Bijl
Jacques Billebeau
Carol Binch
Paul Birbeck
Malcolm Bird
Robert Blagden
Peter Blake
Quentin Blake
Bernard Blatch
Karin Blume
Stuart Bodek
Keith Bonen
Bernard Bonhomme
Fernando Botero
René Botti
Joelle Boucher
Pierre Bouille
Roger Bourne
Glynn Boyd Harte
Leonora Box
Marc Boxer
Carl Brenders
Bob Brett
Tom Brooks
Christian Broutin
Mick Brownfield
Salvador Bru

Béat Brüsch
A Brusilovsky
David Bryant
Roman Buj
David Bull
Bill Butcher
Bill Butt
Patricia Caley
Alastair Campbell
Pier Canosa
Philippe Caron
Pauline Carr
Roy Carruthers
Giovanni Caselli
Philip Castle
Hector Cattolica
Olivier Cauquil
Leslie Chapman
Henri Chauvin
Adrian Chesterman
Seymour Chwast
Graham Clarke
John Clark
Peter Clark
Nicole Claveloux
Alwyn Clayden
Marina Clément
Alan Cober
Roger Coleman
Chris Collicott
Terry Collins
Michel Comte
Robert Comte
Max Condula
Peter Cook
Roy Coombs
Peta Coplans
Boogie Corke
Christopher Corr
Bob Cosford
Ken Cox
Patrick Cox
Alan Cracknell
Barry Craddock
Brian Craker
Mick Crane
Jon Cramer
Jan Cremer
Heriberto Cuadrado
Jeff Cummins
Alan Curless
Gino D'Achille
Salvador Dali
Rosalind Dallas
Terence Dalley
Pierre Paul Darigo
Claire Davies
David Davies
Keith Davis
Paul Davis
Graham Dean
Richard Dearing
Hermann Degkwitz
Brian Delf
Carlo Demand
Mike Dempsey
Christian Desbois
Gerard Deshayes
Serge Clément Desprès
Phil Dobson
David Draper
Blair Drawson
Michel Dubré
Pierre Ducordeau
Leo Duff
Jean Louis Dufour
Gert Dumbar
Bernard Durin
Jennifer Eachus
Anthony Earnshaw
Heinz Edelmann
Yrjo Edelmann
Jeffery Edwards
Colin Elgie
Robert Ellis
Pauline Ellison
Roy Ellsworth
David English
Malcolm English
Michael English
Gil Evans
Gerald Eveno
Graham Evernden
John Farman
Michael Farrell
Beatrice Fassell
Patricia Faulkner
Cathie Felstead
Christine Fenech
Serge Fenech

Dan Fern
Claude Ferrand
Alan Fisher
Peter Fischer
Philippe Fix
Mel Flatt
Alan Fletcher
David Forbes
Michael Foreman
M Forgas
Nancy Fouts
Malcolm Fowler
Francès
François Frances
David Frankland
Harriet Freedman
David Freeman
Rainer Cornelius Friz
Brian Froud
Michael Gabriel
Gallardo
Dominique Gangloff
Joyce Garrett
Pat Gavin
Gaudriault
Harry Geelen
Kees van Gelder
Ginger Gibbons
John Gibbs
Anne Yvonne Gilbert
Robert Gillmore
Girodroux
Bernard Giroudroux
Guy Gladwell
Milton Glaser
John Glashan
Alain Godefroid
Josse Goffin
Michael Golding
Derek Goldsmith
Bengt Good
Rick Goodale
John Gorham
Jean Paul Goude
Alex Gnidziejko
Julian Graddon
Alastair Graham
Sophie Grandval
Giovanni Grasso
Lyn Gray
Leslie Greenwood
Brian Grimwood
Robert Grossman
Rene Gruau
Walter Gudel
Jean Paul Guiems
Nicolas Guilbert
Jean Pierre Guillemot
Russell Hall
David Hancock
Hargrave Hands
Harry Hants
George Hardie
Ken Harris
Malcolm Harrison
Clare Hatcher
Hergé
Jean Olivier Héron
Jerry Hibbert
Christopher Hill
Hans Hillman
Gillian Hills
Arnold Hinz
David Hockney
Godi Hofmann
Marie Hofmann
Werner Hofmann
Heiner Hoier
Lars Hokanson
John Holmes
Nigel Holmes
Alun Hood
Bob Hook
Pierre Houles
Jannat Houston
Su Huntley
John Hurford
Peter Hutton
Vera Ibbett
John Ireland
David Jackson
Faith Jacques
Brian James
Ray Jelliffe
Werner Jeker
Michael Johnson
Allan Jones
Chris Jones
Dan Jonsson
Jerry Joyner

David Juniper
Loris Kalasat
Rory Kee
Keleck
Pete Kelley
Peter Kelley
Gyorgy Kemeny
Ron Kirby
Traudy Klemm
Laurence Klonaris
Peter Knock
Edda Köchl
M Koether
Brian Knight
Royston Knipe
Andrzej Krauze
Sabine Krawczyk
Dana Kubrick
H P Kunkel
Ray Kyte
J Lacroix
Jean Laguarrigue
Ken Laidlaw
Pete Lampert
Urs Iandis
Marina Langer-Rosa
Frank Langford
Wouter Lap
Claude Lapointe
Jean Jacques Larrière
Patrice Larue
Sally Launder
John Lawrence
Bob Lawrie
Michel Leconte
Alan Lee
Alain LeFoll
Martin Leman
Georges Lemoine
Michael Leonard
Alain Leray
Ulrich Lichthardt
Tom Liddell
Philip Lincoln
Katrin Lindley
Sue Llewellyn
Gaye Lockwood
Barbara Lofthouse
Clive Lumbers
Michael Lunt
Jean Claude Lutton
Jean Lessenich
Ave Levitow
Richard Lewis
Kenneth Lilly
Ernst Litter
Bernard Lodge
Catherine Loeb
Antonio Lopez
M Loris
Lucques
Jean Claude Lutton
Jean Pierre Lyonnet
John Mac
Muriel Mackenzie
Stewart Mackinnon
Euphemia Mactavish
Gerlinde Mader
Warren Madill
Kevin W Maddison
Magenta Studios
Helene Majera
Allan Manham
Richard Manning
Graham Marsh
Grzegorz Marszalek
Pauline Martin
Mina Martinez
Fernando Maza
Tony Meeuwissen
Ann Meisel
Lars Melander
Maupeou Merre
Sara Midda
Pino Milas
Roland Millet
Santiago Miranda
Glen Mitchell
Andrzej Mleckzo
Jan Mlodozeniec
Anthony Moore
Chris Moore
Norman Moore
Ian Moo-Young
Claude Morchoisne
Jonathan de Morgan
Morrillon
Anne Morrow
Donna Muir
Jean Mulatier

Giovannia Mulazzani
Alex Murawski
Bob Murdoch
Roger Murray
Yves Musnier
Lawrence Mynott
Neil McDonald
Mike McInnery
Sean McMillan
Jeames McMullan
Colin McNaughton
Ellis Nadler
Navarres
George Nicholas
Robert Nix
Mike Noomé
Bob Norrington
Peter North
Mariet Numan
Bengt Nystrom
Maximillien Odello
Ray Ogden
OPS
Barry O'Riordan
Richard Orr
Lucinda Osmond
Anders Osterlin
Peter Owen
Helen Oxenbury
Patrick Oxenham
Francoise Pages
Jean Palayer
Jacques Parnel
Gabriel Pascalini
Terry Pastor
Neil Patterson
David Pearce
David Penney
Graham Percy
Jean Maxim Perramon
Chantal Petit
Walter Pfeiffer
Cynthia Pickard
Antonio Pimentel
Tom Piper
Laurent Pizzoti
Gillian Platt
Philippe Plaquin
David Pocknell
Monica Polasz
Philippe Poncet de la Grave
Michel Ponnighaus
Gerry Preston
Nick Price
Anna Pugh
Richard Purdum
Michel Quarez
QED
René van Raalte
Tony Randall
Josephine Ranken
Hans George Rauch
Charles Raymond
Paul Rayne
Alan Rees
Dietmar Reinhard
Willi Reiser
Berselli Remo
Jean Marie Renard
Jean Michel Renault
Patrice Ricord
Jean Edouard Robert
Arthur Robins
Christine Robins
Joost Roelofsz
John Rose
Kristin Rosenberg
M Rosenthal
Maurice Rosy
Helmut Rottke
Will Rowlands
Rozier
Ken Rush
George Russell
Paul Sample
Brian Sanders
Bill Sanderson
G Sannicolo
Sanseau
Claude Sardet
Gerald Scarfe
Renate Schlohmann
Binnette Schroeder
Monica Schultz
Arnold Schwartzman
Ronald Searle
Manfried Seelow
Roger Selden
Sylvie Selig
Morgan Sendall

Ken Sequin
Faith Shannon
Anne Sharp
George Sharp
Barbara Siedlecka
Yves Simard
Michel Simeon
Enrico Sio
Gerard Skogberg
Paul Slater
Andrew Smee
Anne Smith
Caroline Smith
Janet Smith
Ken Smith
Trevor Smith
George Snow
Heinz Spohr
Grzegorz Stanczyk
Birgitta Steen
Swip Stolk
Anne Strugnell
Brian Stymest
Karel Suyling
Peter Swan
Simms Taback
Nick Taggart
Don Tait
Jacques Tardi
Tom Taylor
Eric Tenney
Mike Terry
Ivan Theimer
John Thirsk
Graham Thompson
John Thompson-Steinkrauss
Jenny Thorne
Graham Thos
Yves Thos
Guenther Thumer
Titus
Jacques Tosetto
Tessa Traeger
Barry Trengove
Michael Trevithick
John Tribe
Jan Peter Tripp
Claude Trouche
George Underwood
Guire Vaka
Celestino Valenti
Ans Vanemden
Claude Varieras
Pierre Varlet
Peter Le Vasseur
Cyril Vassiliev
John Verberk
Cecil Vieweg
Friedrich Karl Waechter
Dorothee Walter
Peter Wandrey
Pete Wane
Warwickshire Illustrators
Donald Watson
Norman Weaver
Paul Webb
Peter Weever
Dietmar Wefers
Karin Welponer
Jeker Werner
Beatrix Wetter
Martin White
Tony White
Lily Whitlock
Kay Wiedemann
Bruno K Wiese
Dieter Wiesmuller
John Wilkinson
Richard Williams
Bob Wilson
Chrissy Wilson
Franklin Wilson
John Wilson
Roland Wilson
Ray Winder
Ann Winterbotham
Charles White
Jonathon Wolstenholme
Owen Wood
Sidney Wood
Chris Woolmer
Geoff Woolston
David Worth
Freire Wright
Joseph Wright
Tony Wright
Matthew Wurr
Peter Wyss
Sato Yamamoto
Michail Zlatkovski